The Golden Thread

The Story of Writing

Ewan Clayton

Atlantic Books • LONDON

First published in hardback in Great Britain in 2013 by Atlantic Books, an imprint of Atlantic Books Ltd.

Published in paperback in Great Britain in 2015 by Atlantic Books.

Copyright © Ewan Clayton, 2013

The moral right of Ewan Clayton to be identified as the author of this work has been asserted by him in accordance with the Copyright, Designs and Patents Act of 1988.

All rights reserved. No part of this publication may be reproduced, stored in a retrieval system, or transmitted in any form or by any means, electronic, mechanical, photocopying, recording, or otherwise, without the prior permission of both the copyright owner and the above publisher of this book.

Every effort has been made to trace or contact all copyright holders. The publishers will be pleased to make good any omissions or rectify any mistakes brought to their attention at the earliest opportunity.

10 9 8 7 6 5 4 3 2 1

A CIP catalogue record for this book is available from the British Library.

Hardback ISBN: 978-1-84887-362-9
Ebook ISBN: 978-1-78239-034-3
Paperback ISBN: 978-1-84887-363-6

Printed in Great Britain.

Atlantic Books
An Imprint of Atlantic Books Ltd
Ormond House
26–27 Boswell Street
London
WC1N 3JZ

www.atlantic-books.co.uk

Z958242

THE GOLDEN THREAD

Ewan Clayton is Professor in Design at the University of Sunderland and co-director of the International Research Centre for Calligraphy. For a number of years he was a consultant for Xerox PARC (Palo Alto Research Center) where he worked within a research group that focused on documents and contemporary communications. He is an award-winning calligrapher and has exhibited and taught calligraphy in many parts of the world. In 2014, he was awarded an MBE for services to calligraphy and heritage crafts.

'Ewan Clayton has written a rich and highly accessible history of why we write as we do, and his timing is superb. To think we may lose all this is heartbreaking.'

Simon Garfield, author of *Just My Type*

'Clayton writes with ingenuous charm and contagious enthusiasm, often illustrating his points with "calligraphic studies" of his own... He turns a line of type into an object of contemplation and makes it okay to be curious, all over again, about the ancient symbols we all spent so long learning to use, and to ignore.'

Lori Stein, *The Paris Review*

'Clayton reawakens readers to the versatility and nuances of something so ubiquitous as to be almost invisible... A book no bibliophile should miss'

Publishers Weekly, Starred Review

'Clayton builds on his far-reaching experiences in this avidly researched and enthusiastically told history of writing in the West... Will delight fans of Simon Garfield and Nicholas Basbanes'

Booklist, Starred Review

To my parents, Ian and Clare Clayton

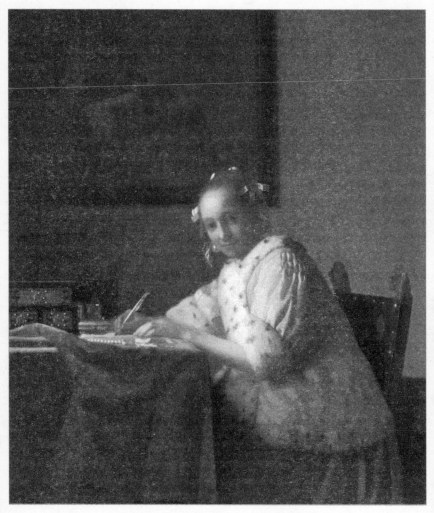

Fig. 1. Johannes Vermeer, *A Lady Writing*, c. 1665.

Contents

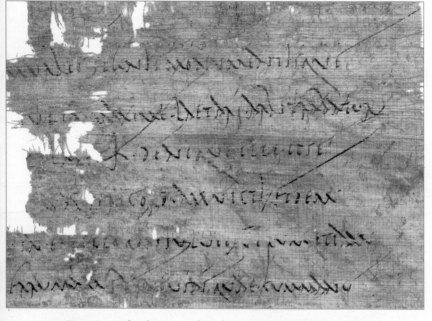

Fig. 2. Roman handwriting with reed pen on papyrus scroll fragment.
An extract from Cicero's speech *In Verram*, first half of 1st century CE.

Introduction

We are at one of those turning points, for the written word, that come only rarely in human history. We are witnessing the introduction of new writing tools and media. It has only happened twice before as far as the Roman alphabet is concerned – once in a process that was several centuries long when papyrus scrolls gave way to vellum books in late antiquity, and again when Gutenberg invented printing using movable type and change swept over Europe in the course of just one generation, during the late fifteenth century. Changing times now mean that for a brief period many of the conventions that surround the written word appear fluid; we are free to re-imagine the quality of the relationship we will make with writing, and shape new technologies. How will our choices be informed – how much do we know about the medium's past? What work does writing do for us? What writing tools do we need? Perhaps the first step towards answering these questions is to learn something of how writing got to be the way it is.

My own involvement with these questions began when I was twelve years old and I was put back into the most junior class of the school to relearn how to write. I had been taught three different styles of hand-writing in my first four years of schooling and as a result I was hopelessly confused about what shapes letters ought to be. I can still remember bursting into tears aged six when I was told my print script **f** was 'wrong' – in this class **f** had lots of loops, and I simply could not understand why.

Being back in the bottom class was ignominious. But my family and family friends gave me books on writing well. My mother gave me a calligraphy pen set. My grandmother lent me a biography to read: a life of Edward Johnston, a man who lived in the village where I had my early schooling. He was the person who had revived an interest in the

lost art of calligraphy in the English-speaking world at the beginning of the twentieth century. It turned out that my grandmother knew him, she used to go Scottish country dancing with Mrs Johnston, and my godmother, Joy Sinden, had been one of Mr Johnston's nurses. 'Tell me,' he had said to her in the dark watches of one night, in his slow, deliberate, sonorous voice, '**What** would **happen** if you **planted** a **rose** in a **desert**?…I say **try** it and **see**.'

Johnston developed the typeface that London Transport uses to this day. I was soon hooked on pens and ink and letter-shapes and so began a lifelong quest to discover more about writing.

Several other experiences enriched this quest. My grandparents lived in a community of craftspeople near Ditchling in Sussex, founded in the 1920s by the sculptor and letter-cutter Eric Gill. Next door to my grandfather's weaving shed was the workshop of Joseph Cribb, who had been Eric's first apprentice. On days off from school I was allowed to go into Joseph's workshop, where he showed me how to use a chisel and carve zigzag patterns into blocks of white limestone. He also showed me how to cut the V-shaped incisions that carved letters are made from. I acquired a sense of where letters had begun. Then, after leaving university, I trained as a calligrapher and bookbinder and went on to earn my living in the craft. It meant I learned to cut a quill pen, to prepare parchment and vellum for writing and to make books out of a stack of smooth paper, boards and glue, needle and thread.

In my twenties, after a serious illness, I decided to enter a monastery. I lived there for four years, first as a layman and then as a monk. I thought it would mean turning my back on calligraphy for ever, but I was wrong. The Abbot, Victor Farwell, had a favourite sister, Ursula, who had once been the secretary of the Society of Scribes and Illuminators, to which I belonged. She saw my name on the list of monks and said to her brother, 'You *must* let him practise his craft.' So like a scribe in days of old, I became a twentieth-century monastic calligrapher. But I learned something else there also. When many hours of the day are spent in silence, words come to have a new power. I learned to listen and read in new ways.

Finally, when I left the monastery in the late 1980s, there was one more unusual experience awaiting me. I was hired as a consultant to

Xerox PARC, the Palo Alto Research Center of the Xerox Corporation in California. This was the lab that invented the networked personal computer, the concept of Windows, the Ethernet and laser printer and much of the basic technology that lies behind our current information revolution. It is where Steve Jobs first saw the graphical user interface which gave the look and feel to the products from Apple that we have all come to know so well. So when Xerox PARC wanted an expert on the craft of writing to sit alongside their scientists as they built the brave new digital world we now all live in – somehow I became that person. It was a life-changing experience and transformed my view of what writing is.

Crucial to this experience was David Levy, a computer scientist whom I had met while he was taking time out to study calligraphy in London. It was he who invited me out to PARC and from whom I learned the essential perspectives that have shaped this history.[1] So I think it is to PARC and to David Levy in particular that I owe a debt of gratitude for bringing me to write this story.

So far my experience of what it means to be literate has been one of contrasts, from monastery to high-tech research centre, quill pen and bound books to email and the digital future. But throughout my journey I have found it important to hold past, present and future in a creative tension, neither to be too nostalgic about the way things were nor too hyped-up about the digital as the answer to everything – salvation by technology. I see everything that is happening now – the web, mobile computing, email, new digital media – as in continuity with the past. There are two things of which we can be certain: first, not every previous writing technology will disappear in years to come, and second, new technologies will continue to come along – every generation has to rethink what it means to be literate in their own times.

In fact our education in writing seems never to cease. My father, who is over eighty years old, has written a letter to his six children every Monday for the last forty-seven years. In that time his 'My Dears' have migrated from fountain pen on small sheets of headed notepaper, to biro and felt-tip; and then in the mid-seventies he taught himself to type, using carbon paper to make copies which were typed on A4 sized sheets. The next step was to use a photocopier for copying his originals

and today he has bought a Mac and the letters are emailed, each of my brother and sisters' addresses carefully pasted into the 'cc' box in his mail application. He is learning a new language of fonts and leading, control clicks, right clicks, modems and wi-fi. Last birthday we bought him a digital camera, and his letters now contain images and short movies.

The book in your hands has come about because I wanted to piece together a history of writing using the Roman alphabet that draws all the various disciplines surrounding it together, though fundamentally my perspective is that of a calligrapher. Knowledge of writing is held in so many different places by experts on different cultures, by students of epigraphy (writing in stone) and palaeography (the study of ancient writing), calligraphers, typographers, lawyers, artists, designers, letter-carvers, sign-writers, forensic scientists, biographers and many more besides. Indeed writing this book felt at times like an impossible task: it seemed that every decade and topic had its experts, and how could one possibly master 5,000 years' worth of this? I have had to accept that I cannot, but I hope I can give you a taste of it, a broad sweep that might lead you to explore further aspects of the story for yourselves.

In some sense this book is a history of craftsmanship in relation to the written word. It seems perhaps an old-fashioned concept. But as I was writing this book, in October 2011, Steve Jobs, the co-founder of Apple, sadly died. That month also saw the release of his authorized biography. All the writers reviewing Jobs's life and work agreed on one thing: he had a passion for craftsmanship and design, and it was this that had made all the difference for Apple, and for Jobs himself. Two perspectives seem to have been complementary to his sense of design. 'You have got to start with the customer experience and work back to the technology.'[2] And that great products are a triumph of taste and taste happens, said Jobs, 'by exposing yourself to the best things humans have done and then trying to bring the same things into what you are doing'.[3]

One of the significant experiences in confirming Jobs's viewpoint, it turns out, had been his exposure to the history and practice of 'writing' whilst dropping out from a degree course at Reed College in Portland, Oregon. Reed was one of the few colleges in North America to hold

calligraphy classes. When Jobs followed his heart and took up calligraphy he was introduced to a broad sweep of cultural history and fine craftsmanship in handwriting and typography that was a revelation to him. It complemented the perspective he learned from his adoptive father, who was a mechanical engineer, that craftsmanship mattered.

Steve Jobs was a technologist that got it, he knew the look and feel of things mattered; the way we interact with them was not just value added, it was part of their soul, it carried meaning, it enabled us to relate to and live with them, to bring as much of our humanity to communicating as possible. The truth is that there are many people like Steve Jobs stretching back through this history, each of whom has struggled to make communication between people a more enriching and fulfilled experience. This is their story, and because we are the heirs to the choices they made, this story is ours also.

One of the perspectives that writing this book has made me aware of is how young we all are in our relationship towards the written word. It is only in the last century that writing became a common experience, and it is only in the last few decades that young people began to develop their own distinctive graphic culture. Writing has an exciting future in front of it. Can we continue to re-imagine how the world of the written word can speak to the fullness of our humanity? I say yes…try it and see.

Roman Foundations

Fig. 3. Election posters painted with a square-edged brush on the
wall of the house of Trebius Valens, Pompeii, 79 CE.

The origins of the alphabet are prosaic indeed. They lie in a handful of symbols used towards the end of the Middle Kingdom period in Egypt (around 1850 BCE), by the lower ranking administrative officials to write their immigrant tongues. The earliest traces of the alphabet have been found on a cliff-face full of graffiti near a harsh desert highway in the Wadi el-Hol (the Terrible Valley) that cuts through the desert between Abydos and Thebes in Upper Egypt (Fig. 4). The discoverers of these simple, yet undeciphered, inscriptions were John and Deborah Darnell – Egyptologists from Yale. When they found the Wadi el-Hol inscriptions in 1993, they immediately recognized certain forms from the Proto-Sinaitic and Proto-Canaanite script associated with earliest alphabetical writing in the Sinai peninsula and further north into Canaanite territory in Syria-Palestine that dated from 1600 BCE onwards. But these inscriptions, from within Egypt itself, could be dated from associated material to perhaps 250 years earlier. Here was the ox head 'aleph'; the wavy sign for *water* in hieroglyphs, perhaps already being adapted from the Egyptian **n** (nt and nwy / water) to the Semitic **m** (from mayim / water); the curled round sign for *house* that in Egyptian reads **p-r** but in the western Semitic forms eventually gave us *beth* in Hebrew, *beit* in Arabic and *beta* in Greek.

The suggestion is that here is writing that has moved away from the ideographs and syllabic symbols of hieroglyphics and has chosen to use only its consonantal elements (hieroglyphics has twenty-four).

Fig. 4. Inscription I, Wadi el-Hol, *c.* 1850 BCE.

An inscription in the Pyramid of Unas at Saqqara from before 2400 BCE already shows Egyptian symbols being used to spell Semitic words (a charm for protection against snakes). The Wadi el-Hol evidence makes one ask whether Egyptians and western Semitic peoples (the Egyptians called them 'Aamou' or Asiatics) living in Egypt had already evolved a fully alphabetic way of writing a western Semitic language, which would prove to be in continuity with the later Proto-Sinaitic and Proto-Canaanite scripts, even whilst around them the vastly more sophisticated Egyptian milieu of sacred hieroglyphics and priestly hieratic continued.

That fewer than thirty signs could be used to depict a word, in any language, would seem crude to an Egyptian scribe used to employing hundreds. But utilitarian this first alphabet was and utilitarian it needed to be. The great points in this alphabetical method's favour were that the principle was comparatively easy to learn, it could be adapted to most languages and it freed the merchant from the power of the temple, royal or military scribe. One could keep one's own records, one could conduct one's own business. Around 1700 BCE a similar system to the Wadi el-Hol inscription was certainly being used by Semitic mineworkers at Serabit el-Khadem in the Sinai; from 1600 this Proto-Sinaitic script is appearing further north in the Syria-Palestine area; and around 1000 BCE, in its Phoenician form, it was being used to carve a protective verse around the tomb of Ahiram, King of Byblos, a city known for its export trade in papyrus, and from whence the Greek word for book, *biblios*, takes its name.

Since my purpose is primarily to give an account of the history of writing using Roman letters, not every detail of the comings and goings of alphabetical and syllabic scripts in the eastern Mediterranean area is germane to tracing the movement of the alphabet towards Greece and thence to Rome. But we should note that it was from the semi-cursive script of the Phoenicians, the Canaanite coastal inhabitants of cities such as Byblos, Tyre, Sidon, Beirut and Ashkelon, that all the subsequent branches of alphabetic writing descend. The most significant was the Aramaic, from which came in turn the Hebrew, Arabic and Indian script families.

In contrast to the proliferation of forms as the alphabet moved southeast, its north-westward journey saw a narrowing of focus. Eventually

one version of the alphabet came to dominate the areas from Scandinavia down to the Mediterranean. It was the alphabet that spread from the city of Rome.

The Greeks

Beneath the slopes of sleeping Vesuvius, the Bay of Naples curves south for over thirty kilometres (twenty miles). Just round the headland to the north stood the Greek colony of Cumae, one of the first Greek settlements in Italy. Two islands guard the entrance to the bay: to the south lies Capri and to the north Ischia, with its thermal springs and volcanic mud, it too a candidate for the earliest Greek colony in Latium. Inland the rich volcanic soils still produce the wines that were famous in Roman times. The striking beauty of the bay made it then, as now, a playground for the rich and famous. It was through Ischia and Cumae, whose colonies were established in the eighth century BCE, that the writing from which the Roman alphabet would spring first arrived in Italy. And it is because of one day of horror in the bay on 24 August 79 CE, when Vesuvius erupted and buried the Roman towns and settlements at the volcano's foot, that we have, from this same area, the greatest cache of evidence for Roman writing practices.

Since around 1400 BCE in the overlapping Minoan and Mycenaean period the Greeks had been using a syllabic system of writing (Linear B). But Greek merchants who traded with Phoenician cities in the Levant had come across the new simpler alphabet that spelled out each consonant singly. It was probably in Cyprus, which is just 200 kilometres (125 miles) away from the Lebanese coast, that this new alphabet began to take root. It was adapted for Greek speakers by using letters to stand not only for consonants but also for vowels; this was now a fully phonetic alphabetic script, and every sound a Greek speaker made could be represented with a sign. Recent research into how the alphabet was adapted indicates that those who carried this out knew an earlier syllabic system, probably the Greek Cypriot syllabary, which was certainly in use from around the year 1000 BCE.[4] The implication is that instead of thinking that writing came to Greece in two phases – with two different script

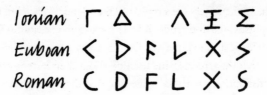

Fig. 5. Some principal differences between the Ionian,
Euboan and Roman alphabets.

cultures – the Minoan Greek Linear A and Mycenaean Greek Linear B on
the one hand, and the alphabet on the other (with a mysterious barren
gap in time between) – we are beginning to understand that the history
of writing in Greece may have been a continuous one that shifted to the
more popular and accessible alphabetical system from a more restricted
and complex syllabic one. The syllabic script's use was anyway limited;
surviving texts are mainly just lists of property. The new system, origi-
nating in the early to mid-ninth century BCE, spread widely. In the early
days of adaptation different cities in Greece had their own variants.
Eventually two scripts predominated, the eastern Ionic alphabet, which
would become the standard script in Greece, and the western variation,
centred on the island of Euboea (Fig. 5). It was this western version that
was carried from Euboea on to Italy less than two centuries after its
introduction to Greece. The western Greek alphabet is characterized by
narrowness and verticality in comparison to the square Ionic; perhaps
its most distinguishing feature to modern eyes is the fact that the letter
Delta is a triangle that stands upright projecting right from a vertical
stem like our modern **D**, as opposed to the **D** in the Ionic version, where
Delta sits on a base like a pyramid. It also includes the letters **F**, **S** and an
L in orientations similar to the Roman and Etruscan varieties.

All the earliest surviving Greek alphabetical writing is carved in
stone, incised in bronze or scratched into and painted upon pots. And
it is monoline, it has no thick and thin parts and no serifs.* Whilst the

* Serif – a word from the Dutch that describes the flared bracketed finishing parts at the
terminations of letters.

lines that make the letters are simple and blunt-ended, they are far from being unsophisticated and crude. A brief look at an inscription from the end of the classical Greek period, from 334 BCE, should be enough to convince us that the Greeks came to think about their letters, at least for important inscriptions, with the same care that they brought to shaping their architecture and statuary.

Related form

If you visit the British Museum in London today and turn left just within the entrance, past the gallery displaying the Rosetta Stone and through the Assyrian galleries, you come to the rooms displaying material from ancient Greece. At the top of a short run of steps stands a massive block of stone. This is the dedication plaque (Fig. 6) of the temple to Athena at Priene, a city which today lies in eastern Turkey. At the beginning of his journey into Asia, Alexander the Great stayed at Priene whilst besieging the nearby town of Miletus. He gave money to rebuild the temple and dedicated this stone at that time. We can see his name at the start of the first line of the dedication: 'Basileus Alexandros', meaning 'King Alexander'. To those of us used only to looking at Roman letter shapes these Greek letters might look a little odd: the top bowl of the initial **B** (Beta) looks larger than the bottom one; the arms of the letter **K** (Kappa) are short and stubby; none of the letters quite line up top and bottom; the horizontals of the **E** (Epsilon – descended from the Egyptian hieroglyph

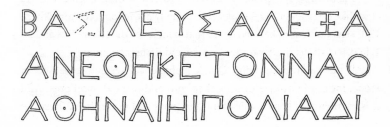

Fig. 6. Section of the dedication stone to Athena Polias, 334 BCE.
The letters are around 2.5 cm tall.

of a man with upraised arms meaning 'you give joy with your presence') look very long, except for the middle stroke, which is rather short.

The typographer Stanley Morison singled out this inscription for containing the first dated occurrence of serifs.* We can see how the carver has begun to widen out the ends of the strokes into graceful wedges. These serifs remind Morison of cuneiform. Alexander, who would go on to conquer Babylon and Persepolis, wanted to unify the Greek and Babylonian cultures that he came to rule. The inscription could be read as an early sign of this new identity finding visible form. But this is not why I have asked you to look at it.

The temple at Priene was one of the classic examples of a building constructed according to the modular principle. It was built by Pytheos, the architect of the Mausoleum of Halicarnassus, one of the seven wonders of the ancient world. Every part of his building at Priene is in proportion to every other part; the width of the columns relates to their height, to the spaces between them, to the size of the sanctuary and the scale of the ornament. The whole building resonates with an enlivening harmony: in this temple even the paving stones were cut according to the modular unit. The module at Priene (as in the many temples like it that used a modular system of proportion) was taken from the length of the radius of the base of the columns on the temple front. Following this example, I urge you to measure the radius of the O in this inscription, picking one from near the centre, thus discounting any photographic distortion. Use this length of line to measure the parts of the other letters. Though the letters do not adhere precisely to fixed measurements in terms of length and radius, it seems the makers of this inscription were thinking proportionally about letterforms, and the logic here *is* linear. These letters appear to be constructed out of modular line lengths. The apparent incongruities now fall into place. The **K** arms are short because they measure one and a half units. If they had been two units, **K**'s arms would have looked enormous, and at

* Though a signed base for a statue of Kleiokrateia, daughter of Polyeuctos (No. 14165 Museum of the Athenian Agora) carved by Praxiteles (360–50 BCE), seems also to show serifs.

one unit they would have looked very short. The maker of the inscription is not thinking of making letters that fit between two lines, top and bottom, as we do, but rather of making each letter with parts that are in some kind of proportion to all the other parts, and in proportion across the alphabet.

Since studying the Priene inscription I have seen few examples of Greek letter-carving that do not have some kind of similar proportional system behind them. They can be sophisticated or functional and simple, along the lines proposed by Stephen Tracy of Princeton, where, for the Athenian letter-cutters he has studied, the carver is using the length of the cutting edge of their chisel as a standard measure.[5] The inscriptions Tracy has looked at, with letters mostly under 1 cm high, are cut differently to larger incised letters in that they use a method called stem cutting, where the chisel is held upright and the entire letter stroke is cut at one time by hammering the edge into the surface vertically rather than cutting in with the edge of the chisel along a furrow. For the large amount of lettering that was required when laws and other notices were displayed for public dissemination – from 500 to several thousand characters at a time – this was a pragmatic, though not always beautiful solution. H. T. Wade-Gery established the length of the chisel edges used by one Attic letter-carver as 11 mm, 9 mm and 7 mm long.[6] The entire small-scale alphabet could be constructed using three chisels of these lengths.

That some kind of proportional system was in use for Greek lettering is not surprising. From the late sixth century Pythagoras had explored how number lay behind musical intervals, and he and his followers had extended the concept of harmonious proportions to many phenomena. Then in the late fifth century Polycleitus had argued, in his influential canon on aesthetics, that beauty lay in the commensurability of parts, one to another and to the whole.

In the Hellenic period, following Alexander's conquests, Athenian letter-carving becomes more conservative. For innovations we have to look eastwards: flared serifs and decorative effects become common. But it is from this period that we have the first surviving written texts in Greek on papyrus. They survive from Egypt and show a well-developed

script with cursive features and fine contrasts between small tight **o**'s and longer extended **T**'s and **Y**'s, for instance. But by now it is clear that the written version of the letters is beginning to diverge from the incised forms.

The most significant understanding to draw from these examples may be that when Greek letters passed via the Greek settlements in Italy into the Roman system of writing, whether directly or via Etruria, it was not just the letter shapes that were transmitted, but the concept of an alphabet as an interrelated system of proportional forms. Later, when Roman letter-carvers looked back at more developed Greek forms, this message would have been reinforced. This provides a key to understanding the subsequent development of Roman lettering. Greek and Roman alphabets came to be viewed not as twenty-two or twenty-six individually random shapes, but as an interrelated system of proportional elements similar to the classical idea of 'orders' in architecture or Polycleitus's canon in sculpture. The particular nature of the interrelationships varies in detail between 'schools' of lettering artists and sometimes consciously within the work of individuals over the years. These relationships are responsible for the particular look or family likeness of a lettering style. The whole art of letter designing, even today, lies in considering and playing with this system of subtle relationships between parts, sometimes intuitively, sometimes with more self-awareness. At a deeper level of analysis these relationships of line, weight, curvature, repetition, etc. can create a graphic picture of the way in which a letter-designer or calligrapher perceives relationships in the wider world. Of course much lettering can also be hack work, knocked out quickly to meet the demands of an impatient client, but in the hands of a master it can tell other stories, it contains visions of the kinds of relationships that are possible between people and things, it can speak to the nature of beauty, truth and goodness. And so, just as a mathematician can be blown away by the beauty of an equation, or a computer scientist by that of an algorithm, so a lettering artist can respond in a similar way to the disposition of forms and proportions within a particular recreation of an alphabet. Calligraphy adds yet another dimension to these forms – movement, gesture – the traces of a

real-time performance laid down by pen, brush and ink as the hand finds its way through sequences of these remembered shapes.

Early Roman inscriptions: the tomb of the Scipios

The earliest carved Roman letterforms are monoline like the Greek, and date from around the year 600 BCE. The evidence is not plentiful. There are just four inscriptions surviving from this era and it is not until the third century BCE that we have substantial Roman inscriptions to look at. They too show a distinctive creative intelligence at work.

Carved into a hillside along the Apennine Way, the family tomb of the Scipios was lost until rediscovered in a vineyard in 1614. The family's most distinguished member, the general Scipio Africanus, victor over Hannibal's Carthage in 202 BCE, was buried elsewhere but this tomb contained about thirty family members, buried between the third century BCE and the first century CE. The three earliest sarcophagi have substantial inscriptions. The very earliest belongs to Africanus's great-grandfather, Scipio Barbatus, who died in 280 BCE and who most likely commissioned the tomb. His own monument is intact save for the curious erasure of a line and a half of text at the beginning of his epitaph.[7] The lettering shows some interesting anomalies, as does that on the tomb of his son, Lucius Cornelius junior, who died some time in the latter half of the third century (Fig. 7). Both have an **S** falling backwards, a circular **O** compared to the slender **R** and not so slender **C**. Cornelius junior has a very narrow **D** and **R** in the heading. But as soon as we look at these forms as if they were composed of simple proportional elements, a circle (the **O**), a half circle (the **C** and **D**), two semicircles stacked on top of each other around a central line

CORNELIOLFSCIPIO
AIDILES·COSOL·CESOR

Fig. 7. Study of the lettering from the tomb of Lucius
Cornelius Scipio, Consul in 295 BCE.

(the **S**), the odd shapes make logical sense. Similar pragmatic geometric thinking explains why the letters of the early Roman alphabet break into groups. If the **O** is full width, **C** and **D** (made of semicircles) would be half as wide as the **O**, and letters employing smaller half-height semicircles such as **B**, **R**, **P**, **S** would be one quarter the width of the **O**. Letters with marked horizontal elements, like **L** and **E** and **F**, are also kept narrow, for this narrowing balances an optical illusion which makes letters with horizontal elements look wider than letters with many vertical parts, and **M** (and the later invention of **W**) is made wider than average. As time went by (reaching a peak in the first half of the second century CE), the Roman lettering artists who worked with large-scale letters on prestige commissions made more and more adjustments to letters to overcome a variety of optical illusions: the **A**'s and **V**'s, for instance, are made slightly taller than the other letters because the V-shapes or apex at the top and bottom normally make them look smaller.

Roman letters from the mid-Republican period were capable of considerable sophistication and beautifully proportioned design. But from the middle of the first century BCE onwards this visual sophistication would shift up a gear. The previously monoline style of writing (meaning all lines are of an even thickness) that was inherited from the

Fig. 8. Detail from the memorial to the children of the Freedman Sextus Pompeius Justus, Appian Way, Rome, 1st to 2nd century CE.

Greeks gradually gives way to a style that employs a modulated line that has thick and thin parts (Fig. 8), like the letters in the typeface in which this book is set.

Public inscriptions and brush-made writing

The full Roman system of scripts is one that became elaborated over time, for Rome as a significant political entity lasted for at least 1,000 years. Whilst the archaeological evidence from Rome's Palatine Hill shows that the first settlement on the site can be dated to the ninth century, the traditional date for the founding of the city was set by the late Republican scholar Varro at 753 BCE. The end of Roman rule in Italy can be marked by the transfer of the Empire's capital to Constantinople in 330 CE.

The evidence for how the Romans used writing across this huge expanse of time comes from references in the surviving literature, from images in paintings, from many isolated and scattered inscriptions across the territory Rome came to control, from fragments of written text preserved in libraries and five major finds of archaeological material. The most significant collection of written artefacts comes from the cities of Pompeii and Herculaneum. Here we find preserved the full range of lettering employed in the early Empire, when the power and economy of Rome was about to reach its peak. There are large formal carved stone inscriptions on public monuments and tombs, temporary sign-written public notices (over 2,500 of them survive), box files of wax tablets containing legal, trading and tax records, an almost complete library of carbonized papyrus scrolls, labels on containers and amphora listing their content, inscriptions of ownership on property, and graffiti everywhere, by children and adults, both literary and obscene.

The early excavations at Pompeii and Herculaneum were undertaken by Austrian army officers in the eighteenth century, during a period of Austrian rule in Italy. Alerted by well-diggers to unusual finds, they tunnelled into buried buildings seeking statuary and other ancient artefacts that could be resold or used to grace their own mansions. But whilst inscriptions were of little interest to these early robber

archaeologists and were tossed aside, to the Romans themselves they were highly significant. Indeed, formal public lettering carved into stone constitutes a distinctive genre of Roman writing. Inscriptions represented a way for individuals or corporations to boost their social status by commemorating their contributions to public life – to the building of temples, aqueducts and bridges and to their upkeep and repair. Funerary monuments proclaimed their owners' deeds in perpetuity.

Tombs lining the roads were one of the first indications to a Roman traveller that a city lay nearby. Built on private plots, but maintained by the city government, these monuments grew more grand as they neared the city gates. As Ray Laurence points out in *The Roads of Roman Italy*, 'travellers in antiquity, whose perceptions of date, style, and knowledge were far greater than our own...would have been able to read a cemetery or tomb group and establish a meaning about who lived, had lived, and was socially significant in the town...the gaze of travellers on cemeteries lining the roads provided them with a sense of the history of the place at which they were arriving'.[8]

Once one had entered a city the public lettering carved into the façades of buildings was equally significant and visible. From the way that monumental architecture was arranged within towns, facing the main road in complexes, jostling around the Forum through which this road always ran, it is clear that travellers were consciously shown the city's best side. Triumphal arches crowned the entrance to certain spaces, and milestones and statuary lined the route, inscribed with the names and titles of builders or donors. A city's public buildings, its benefactors and famous sons and daughters, gave it status. After the Emperor Claudius (ruled 41–54 CE) decreed that travellers must either dismount on entering a town, or be carried by litter (to prevent the mowing down of its citizens by horse and chariot), these amenities and inscriptions would have become an even more prominent feature of a traveller's experience.

'Roman imperial capitals', the principal letterform that evolved for use in such inscriptions, are a surprising phenomenon in the Roman family of scripts, for many of them were first written directly on to the stone with brushes and then cut into the surface to make that brush-writing

permanent (Fig. 9). We tend to think of the Chinese as the only culture that wrote with brushes, but it is likely that writing with brushes on stone, stucco or prepared boards is a practice with a long history in the west; we see it on many earlier Etruscan funerary monuments. Greek inscriptions were certainly painted in with colour after being carved, and the larger-lettered inscriptions may have been brushed upon the stone first. Following the Roman period, direct brush-writing died out.

The brushes used for the Roman imperial capitals were not pointed like a Chinese brush but cut square at the end like a chisel – this is where the thicks and thins in these letters come from, thick as the brush is moved down its full width, and thin as the brush is moved sideways. It was a trumpet-playing American Roman Catholic priest from Daven-port, Iowa, who first demonstrated this fact in modern times. Growing up in an orphanage in the midwestern United States, Edward Catich, 'Ned' to friends, was trained initially as a sign-writer in Chicago but went on to study for the priesthood in Rome in the 1930s. While he was there, he looked at examples of Roman lettering. He noticed, partic-ularly through a study of the letters on Trajan's column, from which he made rubbings and tracings and eventually a cast,[9] that these letters

Fig. 9. Benefactor's inscription from the shrine of
the Augustales, Herculaneum, before 79 CE.

showed characteristics of having been written with a sign-writer's brush. The telltale signs included areas where pressure has caused a swelling of the strokes, and the way the brush is twisted slightly as it makes a curve, thinning the width of the stroke as it proceeds, a necessary action if the hairs at the edge of the brush are not to splay out at the ending of a curve. Once written on to the stone the letters were cut to make them permanent and then painted once again to make them stand out. Brush-made roman imperial capitals were the most formal and carefully constructed letters of the Roman world and our present-day capital letters descend from them.

Brushes were also used for large-scale temporary signage and posters. In Pompeii several walls survive that were used for such purposes, and the house of one of the sign-painters, Aemilius Celer, has been discovered. Aemilius identifies himself on several of his inscriptions with added comments: 'Aemilius Celer wrote this on his own by the light of the Moon.' An inscription higher up on the same wall by another hand is accompanied by the words: 'Lantern-carrier steady the ladder.' The idea of these sign-writers writing at night is intriguing. Were the streets too busy during the daytime or the sun too hot, drying the paint on the brush too quickly? Or were they just trying to be first with the news for the next day?

As well as the painter and the lantern-carrier, a full sign-writing team would have included a man who whitewashed the walls to provide a fresh surface to paint upon. During the months before Vesuvius erupted, an election had been in process in Pompeii; some of the notices surviving from that campaign are preserved on the ruined walls (Fig. 3, p. 8). In comparison with the roman imperial capitals, the letters in these advertisements are more compressed in shape, taking up less space and massed for impact. Aemilius Celer uses two scripts, the first of which was a compressed form of the imperial capital. It is called *scriptura actuaria*, referring to the fact that the acts of the Roman Senate were posted up in this form. It is written with a brush, mostly held straight, i.e. aligned parallel to the lines of the text. In Aemilius's other script, *capitalis*, the whole weighting system of the letters is altered. The brush is held with its edge at a steep angle or slant to the line of writing rather than straight

on and parallel to it. The result is that the vertical parts of the letters are thin and the horizontals are all given a thick emphasis. Historians of letterform have called these letters 'rustic capitals', in contrast to the roman imperial capitals.

These two scripts, roman imperial capitals and rustic capitals, are the result of two strategies that naturally present themselves to someone thinking how to write a script with modulated lines, i.e. thicks and thins, when previously the letters had always been written with a monoline stroke of even thickness. One can either hold the nib or brush flat, which produces more formal-looking letters that are slightly slower to write (the imperial capitals adopt this position for the main stems of letters but move the angle around for other parts); or one can hold the pen or brush steeply slanted, which works well with a narrower letter that is quicker to write and more dynamically stressed with weight. This latter strategy, it seems, was adopted for more everyday writing.

Imperial capitals and rustics evolved from a common source in mono-line capitals, around the middle of the first century BCE. Coincidentally this is the period when Rome becomes exposed to a wider range of aesthetic influences, particularly from Egypt (where writing has long had thick and thin elements, owing to the way they made their brush and reed pens, with a nibbed or square chisel edge rather than a point).[10] The mid-first century BCE was an eventful period in Roman history: the resolution of a destructive civil war led to the replacement of the old Republican system with an imperial system of patronage and government under Augustus, the first Emperor, great-nephew and designated heir of Julius Caesar. It was during his reign (27 BCE–14 CE) that the new pattern of roman imperial capitals became securely established. A fine early example of the style is seen on a votive shield carved in Carrara marble and found in France, dating to 27 BCE.[11]

Sign-writers' skills were called upon for painting not only on walls but also on wooden boards, as this was how the decrees of the Senate and other public pronouncements were displayed for public scrutiny in many Roman cities. They were sometimes also engraved into metal. The boards used for the public display of notices often had a distinctive form, with wedge-shaped handles that allowed them to be carried,

hung or keyed into a surface. Many stone inscriptions show a similarly shaped panel. Bronze tablets were once abundant. One of their most common uses was for the discharge 'papers' of Roman legionaries, who received miniature copies of the decree posted on the Capitoline Hill in Rome relating to the disbandment of their unit. When the Temple of Jupiter burned down on the Capitoline Hill in 69 CE we know, because of the Emperor Vespasian's attempt to replace them, that over 3,000 metal tablets stored inside the temple were destroyed by the fire, many relating to Rome's earliest history; they were the equivalent of the state archives.

Roman libraries

In the Villa of the Papyri in Herculaneum we can glimpse another aspect of the Roman world of letters: its libraries. Today we know that several generations before the eruption this villa had been built by Lucius Calpurnius Piso Caesoninus, Julius Caesar's father-in-law, and that it was used as a meeting place for a well-known circle of Epicurean philosophers, the poet Virgil amongst them; the villa had stayed in the family ever since. During the excavations that followed its discovery in the autumn of 1752 a number of scrolls were found scattered through the property, as if they had been gathered up by their owner in an effort to rescue the library before it was buried beneath the 20 metres (60 feet) of volcanic debris that cover it today. Most of the surviving scrolls are in Greek, hinting perhaps that the Latin half of this library still remains to be found.

The original eighteenth-century excavations yielded over 1,800 scrolls. They had been kept in a room 3 metres by 3 metres (10 feet by 10 feet), with shelves around the wall and one free-standing cedarwood bookcase in the centre with shelves on either side. The scrolls would have been taken into the cloister of an adjacent courtyard in order that they could be read in good light. In this the architect of the villa was following Greek precedent. The great library at Pergamum in western Anatolia had covered colonnades and lounges in which readers could consult the collection.

All the books found so far at the Villa of the Papyri are in the form of papyrus scrolls following the Greek pattern, which they had learned from the Egyptians. The papyrus plant is unusual in having a triangular stem that allows strips to be shaved off the sides. These strips can then be laid on top of each other in two layers, one with the strips lying vertically and the other horizontally (the grain giving one lines to write along). A wooden mallet is used to hammer the two layers lightly together, the sap released from the bruised strips acting as a natural glue. Sheets of papyrus could then be laid together with about 1 cm overlap and glued into a long roll, using a flour and water paste. The surface of the sheets was prepared for writing by being rubbed smooth with an abrasive, polished with bone or ivory, or whitened with chalk, according to the purchaser's taste; expensive scrolls might also have their edges dusted with coloured pigments. Scrolls measured from 13 to 30 cm (5 to 12 inches) high and ran from around 10 metres (30 feet) in length upwards. One scroll in the Villa of the Papyri was 25 metres (75 feet) long, whilst the longest scroll in the Egyptian collection of the British Museum, the Harris papyrus, was originally almost twice as long again at 41 metres (135 feet). The inner end of the scroll was wound around a turned wooden bar called an *umbilicus* (navel). A small label in ivory or parchment was attached to one end, either directly to the page or to the end of the turned wooden roller. These *syllabi* (meaning lists) had the book's content marked upon them, often the first line of the text which was designed to tell the reader what the book contained – books with titles were a later idea.

Scrolls were kept in *nidi*, a Latin word meaning nest, the equivalent of our pigeon-holes. Later Roman libraries would have been equipped with rows of *nidi* along the walls, tables on which to read the scrolls, and leather buckets called *capsa* which could be used for carrying bundles of scrolls. The length of an average papyrus scroll determined the quantity of text that Roman authors wrote. The *nidi* and *capsa* were made to hold up to ten scrolls at a time, which is why works such as Livy's history of Rome (*Ab Urbe Condita*) are divided up into 'decades', groups of tens of books. In the scroll itself the text was placed in columns; line length varied according to the type of literature, and oratory was

known for containing shorter lines than any other kind. In a scroll these columns were continuous from beginning to end; sections were some-times marked as a chapter, *capitulum*, and shorter segments of meaning by a dash in the margin called in Greek a *paragraphos*.* The Latin word for a scroll was *rotulus* or *volumen* (hence our word 'volume' for a book), meaning something that has been rolled up.

Papyrus scrolls had generous top and bottom margins. These areas were where the scroll was most likely to be damaged. At either end of a scroll there were usually a few sheets of blank papyrus, for again these outer sheets were subject to heavier wear. Sometimes the blank opening pages were used to write a short description of the work, and at the end it was not uncommon to find listed the number of lines the work contained. The normal practice was for the scroll to be written on one side only.

The Villa of the Papyri's arrangement of the library as a small room next to the central courtyard of the house was, by the time it was destroyed, a rather old-fashioned design for a library. From imperial times onwards, Roman libraries consisted of two parts, one for Greek and one for Latin books. It was Julius Caesar who had come up with this form when he made plans for the first public library for the city of Rome. Placed on hold by his death, his ideas were eventually put in hand by a supporter, Asinius Pollio, some time before 27 BCE. Augustus built two public librar-ies, one in 28 BCE as part of the new Temple of Apollo on the Palatine Hill, and the second, some time later, built, like Pollio's, within easy walking distance of the Forum. Tiberius (reigned 14–37 CE) and Vespasian (69–79 CE) also added libraries, but the grandest in conception was that of Trajan (98–117 CE). As part of his re-planning of the forum, along with new Courts of Justice, a six-storey shopping centre and market, Trajan built his library. The Forum itself works as a grand processional route towards the main *aula*, or hall, where legal cases were argued and public embassies greeted. Beyond the hall Trajan's architect, Apollodorus of

* The pilcrow often used today as a paragraph mark came from a large illuminated C used an abbreviation for the word *Capitulum* or Chapter in medieval manuscripts.

Damascus, constructed a final courtyard, on the further side of which was planned a small temple to be built after the Emperor's death. In the centre of the final courtyard rose a column, built to house his ashes. The column, which survives to this day, unfurls like a scroll up into the air, proclaiming the Emperor's victories over the Dacians. At its foot, like an ivory *syllabus*, is placed a tablet proclaiming the Emperor's name and titles (this was the inscription Edward Catich studied). On either side of the courtyard were the two library chambers, two storeys high and lit by windows.

Trajan also began a new trend, which would be elaborated on by later emperors, of building libraries into the public baths. This represented the beginnings of a movement that saw these institutions change from strictly bathing only to cultural centres that also had dining rooms, spaces for public lectures and performances, shops, sports facilities, gardens and gymnasiums – the entertainment centres of the later Empire.

Scribes

Many aspects of the workaday Roman literate world depended upon slaves. It was they who kept the records of their masters' legal and financial transactions, educated their children, and worked as managers and secretaries in homes and businesses and on distant estates. They supported the administration of the Empire and its legal system. In Cicero's letters we can see his African slave Tiro performing just these roles; Cicero writes that without him nearby he cannot write, for he needs an amanuensis to do so. At other times he asks Tiro to take care of his taxes and debt collection, to look after his garden and to advise the copyists of Cicero's work when they find his handwriting (probably on wax tablets) difficult to read. Cicero also describes how Tiro invents a kind of shorthand that enables him to take down speeches verbatim. This shorthand, called Tironian notes, continued to be used well into the Middle Ages. Cicero's letters to Tiro reveal him more as right-hand man and family friend than as slave, and he was freed in 53 BCE.

Cicero was assassinated ten years later, in December 43 BCE, having been named in the proscriptions that brought Octavian, the future

Emperor Augustus, to power. Tiro, however, lived on to oversee the publication of Cicero's works and wrote a now lost biography in four volumes as well as several other works on his own account. He died in 4 BCE, aged ninety-four.

From the perspective of the development of the art of the book, the fact that slaves were involved in every aspect of the production of literary works from teaching writing to copying books is perhaps significant. And, since Rome stands at the heart of the western tradition of writing and calligraphy, the use of slaves may have had a formative, and perhaps limiting, effect on the development of that tradition. In contrast, Chinese culture viewed the activity of writing as a personal demonstration not only of one's cultural attainment but also of one's embodied and thus gestural alignment with universal sources of life and energy, and the written mark was thus a creative and expressive act. But since much of the literature in the Roman republic and early Empire was copied by slaves and not by scholars and authors themselves, one has to ask how expressive and creative could the art of the book hope to become? Would such writing ever be understood at large as an expression of individual human creativity? How free would a slave be to develop his own creativity or to transform the tradition?

On the other hand, one of the earliest surviving fragments of writing on papyrus from the Roman world, dating to around 50 BCE, is the text of the first of Cicero's speeches, the one that made his name, *In Verrem*, 'Against Verres', his prosecution of Gaius Verres, the governor of Sicily.[12] The papyrus fragment might even have been written by several of Cicero's specialist library slaves for wider distribution. The writing shows the infiltration of slight differences in thickness in letter parts, and an astonishing recurring flourish added to the tops of letters like **S** and **E**. The flourishes extend upwards diagonally through several lines of writing, seemingly cancelling them out (Fig. 2, p. viii). Calligraphically this is a gesture that moves from tension through increasing speed and intensity to release. It is an assertive movement.

On a wider level the history of slavery with regard to reading and writing is a curious one, and it reveals attitudes to literacy in the ancient world rather different to our own. In modern times the ability to read

and write has been equated with the development of free informed democracy. In the United States, up until the defeat of the Confederacy in 1865, it was illegal in many parts of the South for slaves to learn to write or read,[13] and literate slaves were seen as a threat to the continued institution of slavery. In ancient Greece the thinking was almost exactly the opposite: as Jesper Svenbro shows in *Phrasikleia: An Anthropology of Reading in Ancient Greece* (1993),[14] reading and writing were themselves seen as a threat to the freedom of the individual democratic citizen, whose independence of speech and thought was highly valued. This negative view of the written word was linked to the fact that when reading was first practised in Greece it was always done aloud. One's spirit resided in one's breath. Early Attic funerary inscriptions pleaded with the passer-by to 'Lend me your voice' before announcing who lay buried there. Once the reader looked at the words and began to read them, it was as if the reader experienced a kind of spirit or voice possession; one's voice-box was literally taken over by the breath of the writer. One sixth-century inscription from Thassos in the northern Aegean reads: 'I am the tomb of Glaukos.' Just imagine the feeling of standing in front of it and reading those words aloud to yourself! The experience was equated with loss of control over one's own bodily actions; one's autonomy felt compromised. A love of reading was viewed with some suspicion, as being unsuitable for free citizens and grown men. The metaphors used for this kind of activity in Plato's work, and other writers down to Catullus, are the same as those used for prostitution or for the passive partner in sex. The reader is 'buggered' by the text. Reading is to lend one's body to an unknown writer – it is servitude. Plato's personal resolution of this dilemma is given in his dialogue *Phaedrus*; it is to reposition both writer and reader as engaged in a mutual search for truth, and this forges an equal partnership, based upon a common love of wisdom.

Although much professional reading and writing in the Roman world was done by slaves, ordinary Roman citizens were literate. By the time of Constantine, in the fourth century CE, Rome itself had twenty-nine public libraries. Once Rome had sunk into decline, in the fifth century CE, the general population of Europe would never be so literate again until the sixteenth century.

Everyday writing

Both the wax tablets of Pompeii and the city's graffiti are written in a form of cursive handwriting that was less formal than the scripts used for public monuments and books. This everyday writing, used for lists, note-taking and other informal purposes, is a quick form of capital letters that today's scholars call old Roman cursive, in which very few letters are joined up and some letters, such as the **O**, are made in two halves, left and right, with an opening left at the top and bottom. The letter shapes are influenced by the experience of writing in wax with a stylus, and like all writing on wax these letters remain monoline in form. A tablet from Alexandria, however, the birth certificate of Herennia Gemella (Fig. 10), born five days before the Ides of March in 128 CE, during the reign of the Emperor Hadrian, shows how this kind of writing can approach the calligraphic.[15] Pressure is used to give the line more character, so that letters like **S** swell as the stylus rips through the wax and the line of a flourish thins with speed and then digs in at the end. The record left in the wax of the tactile quality of the writer's movements makes one realize wax would have been a pleasurable surface to write upon. This enjoyable tactile experience might have been an additional factor

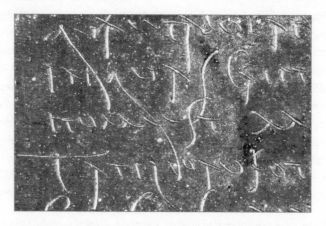

Fig. 10. Detail of writing in wax from birth certificate of
Herrenia Gemella, Alexandria, dated 13 August 128 CE.

favouring the eventual adoption by Roman writers of the edged pen when writing on papyrus, for such a pen can also give thick and thin strokes and an enhanced feeling of resistance from the writing surface. A flexible pointed pen that dug into the surface would not have been an option on papyrus; it could lead to ink bleeding into the surface, always a hazard according to Pliny. The nib would also sputter if the papyrus was not entirely smooth, though a blunt nib could overcome this problem.

Many styluses in metal and bone have survived from the Roman period. Tapering to a point at one end, they broaden out at the other to act as burnishers that can smooth down the wax so that the writer can reuse a tablet or erase a mistake. Two portraits of women from Pompeii (one is thought to represent the Greek poet Sappho) show them gazing out at us with a stylus held artfully against their lips much as an intellectual of the early twentieth century might have held their glasses, a pipe or cigarette. This depiction alerts us to a lost repertoire of gestures and conversational signals in which the stylus might have played a part. Long after the Roman period the stylus was used to enter almost invisible notes (dry point writing) in later medieval manuscripts. When made of softer metals it could be used for sketching on vellum and paper. Styluses and wax tablets continued to be used in some European trades, such as the fish market in Rouen, right down into the mid-nineteenth century.

The main find of wax tablets from Pompeii is in boxes containing the records of Lucius Caecilius Jucundus, an auctioneer. The tablets are hinged pages of wood, made by splitting a block of wood into sheets to ensure a snug fit between the pages and by hollowing out each leaf and filling it in with beeswax. Tablets like this had been used in Greece and even in Mesopotamia. The wood used in the case of Jucundus's tablets was pine, but it could also be box, or walnut, which were finer and closer-grained. Ivory was also used. In the centre of each 'page' in a tablet there was usually a small block of wood placed to stop the surfaces of the wax actually connecting.*

* An addition of 1 part olive oil to 10 beeswax is helpful, stopping the stylus kicking up trails of wax as one writes; orpiment, arsenic sulphide, seems to have been used for a similar purpose in ancient times.

Tablets were used for recording legal work, birth records and documents of 'manumission' (release) from slavery, as well as for personal notes, reminders, personal correspondence and for handwriting practice. They could be sealed with strings and lead stamps to guarantee authenticity or to secure the information within. Just as we use cheap photocopying paper today for innumerable uses, so the writing material that was usually closest to hand for the average Roman was the wax tablet. From a large deposit of material found at Vindolanda on Hadrian's Wall in Britain we can also see examples of notebook-sized objects made from plain wooden leaves or strips of wood, folded concertina style and made from birch. The wood was cut from the trees when the sap was running in the spring, to ensure their pliability. These books were written on in ink and could be whitewashed over and reused. Such books formed the germ of the idea for the later book structures of vellum leaves (*codices*) that would one day overtake the scroll as a more convenient medium for containing longer written texts. The Roman word for book, *liber*, comes from the word for the inner bark of a tree, presumably also once a common writing material.

The Roman imperial bureaucracy

As the Roman world expanded and developed under the rule of Augustus, the pace of economic and administrative business increased, and so did the pressure for more systematic document keeping, effective organization of writing offices, and faster forms of writing itself. In Republican days it was private citizens who kept archives and staffed their own administrative writing offices; there was no central state archive for correspondence. But Augustus initiated a new imperial bureaucracy, staffed by slaves and freedmen, directly answerable to him. Out of his own pocket he also expanded Italy's network of roadways and established a postal service, the *Cursus Publicus*, which could be used for a fee by administrators who travelled from post house to post house with changes of horses, straw and overnight accommodation supplied. The Emperor Claudius began the changeover from personal slave administrators to salaried staff.

From the late Empire, Diocletian's 303 CE empire-wide edict on

maximum prices shows us the relative value placed upon a scribe's work. For writing one hundred lines in 'best writing' the maximum price was 25 denarii, the same as the daily wage of an agricultural labourer, whereas a wall painter was paid 70 denarii a day.* One hundred lines of ordinary functional writing was 10 denarii. A line was judged on the average length of a line in the verse of Virgil.[16]

By the late Roman period there were three main organizational bodies that ran throughout the Empire: the imperial administration, the army and the system of local town councils. The army reached its maximum strength around 200 CE, when it stood at 440,000 strong. It had a well-established bureaucracy, with clerks preparing morning reports of a unit's strength, that day's departures and arrivals, the watchword and the names of the soldiers assigned the honour of guarding the unit's standard. They also produced tabular duty rosters, night watch orders, written confirmations of orders, prepared financial reports and ordered up supplies, and there were also documents associated with longer-term planning. Literacy in the army was a help to promotion. Standardized formulaic documents and similarly fluent handwriting from different parts of the Empire attest to some kind of training system for military clerks and perhaps to literacy in the army in general. Units down to century level had clerks attached to them.

The town councils were the main administrative body that citizens would have come into contact with. Once the legions began to withdraw from many parts of the Empire from the end of the fourth century onwards, this local administration continued relatively undisturbed, and town councils still maintained local written records. To have the force of law, documents such as land agreements and wills had to be entered into the council's rolls and it was this official copy, rather than the private document, that carried legal weight. Their records were on open access to the public. This administrative system continued well into the seventh century in parts of France and Italy.

* The denarius was a small silver coin first minted in 211 BCE, believed originally to have been worth ten asses. The word derives from the Latin *deni*, meaning 'in tens'.

Many aspects of the late Roman administrative system were eventually adopted by the Christian Church. The papal archives in Rome copied the imperial *commentarii* by keeping annually gathered and chronologically arranged registers of correspondence with copies of texts received and sent, though by the ninth century it was only letters sent that were being recorded. Some of our earliest knowledge of British history comes from these documents copied out by friends of the monk Bede during visits to Rome and sent back to him for inclusion in his *Historia ecclesiastica gentis Anglorum* (*The Ecclesiastical History of the English People*), believed to have been completed around 731. The papal originals were subsequently destroyed.

It should be emphasized that the material we have from the ancient world is a small amount compared to the number of documents that were then in circulation. In modern excavations about 10 per cent of papyri fragments are works of literature, while the remaining 90 per cent are correspondence and administrative documents. But taking that 10 per cent as an example, and tracking the survival rate of important literary or philosophical authors within that 10 per cent, we know for instance that Euripides wrote ninety-five plays, of which we have at the most nineteen today; Aeschylus wrote another ninety, of which we have six; three ancient catalogues of Aristotle's works list over 170 titles, of which thirty have survived; nothing by Pythagoras has come down to us – we have also lost all thirty-one books of Pliny the Elder's history of his times *A fine Aufidii Bassi* (a continuation of an earlier history by Aufidius Bassus) and 107 books of Livy's 142-book history of the City of Rome, *Ab Urbe Condita Libri* (Chapters from the Foundation of the City). The loss and destruction has been immense.

Cursive hands across the Empire

As the first century CE ended and the second century began, Rome reached its peak of population at over a million inhabitants. Everyday handwriting from this period shows evidence of increased ligaturing, and new styles of cursive scripts. In the history of writing two pressures compete in the generation of new forms: one is the breakdown

of formal hands into new shapes as a result of speed, and the other is the promotion of fast handwriting up into a more formal style that is faster to write than the old formal hands. Both of these forces apply at this time. But before drawing sweeping conclusions about trends in the development of Roman lettering we should recognize the extent of the earth's surface over which the Roman writing system was now used and the time span during which this culture endured.

The Roman world was centred upon the middle sea, the Mediter-ranean or *Mare nostrum* (Our Sea) as the Romans themselves called it. In expanding out from Rome, the Romans were not initially following a deliberate policy of empire creation. They began as one of a number of small towns in Italy that sought to secure themselves by conquer-ing their nearest rivals and buffering their territory with client states. But once one circle of land had been secured, another buffer area was needed to support the first and so the extent of Roman territory grew until by 100 CE it stretched north to the borders of Scotland and south to the margins of the Sahara desert in Morocco, Algeria, Libya, and Egypt; from west to east it took in Spain, France, the Alpine regions and the Balkans, Greece, Turkey and Syria and then ran down into the Arabian peninsula. Greek was still the main written language in the eastern half of the Empire but Latin was its administrative language. The Empire eventually began to collapse inwards once again when its frontiers became too extensive to maintain, and the process of collapse culmi-nated in the sack of Rome by the invading Visigoths on 24 August 410 CE. That year also the legions were withdrawn from outlying areas such as Britain, where the province was placed in charge of its own defence.

Roman writing and record-keeping, temple archives, literature, tax offices and businesses ran right across this territory and with that range came an inevitable diversity of documentary practices. Some centres, lost in a time-warp, continued with the old ways for longer than others, yet other sites rose to be dynamic instigators of innova-tion and reform. Nonetheless some broad trends are discernible. By the mid-second century CE old Roman cursive had developed a more economical 'ductus' – that is the number, order and direction of letter strokes required to create a character. Writing was speeding up, and the

first sign of this was a rounding out of certain letters such as **E D H L M**. This faster script was then put to new uses. In more carefully formed versions it was employed for writing books. Using a pen that gives thicks and thins to the strokes instead of the pointed stylus, a rather spacious round hand developed; an example of a new script originating in ordinary handwriting and then being deliberately elevated into a formal script through the use of tools that entail more careful handling – in this case the edged pen. The evidence shows this began in North Africa, where Greek influence was still strong and the letters of Greek formal bookhands already had a round character. The hand that resulted we know today as 'uncial script'. It was St Jerome (d. 420) who gave the script this name in a tirade against letters in large sizes (uncial is derived from the Roman word *uncia*, meaning inch), for by his day this script had become over-elaborated and had drifted away from its workmanlike origins towards more ostentatious display (Fig. 11). But uncials come in many forms and were written across the entire Empire. They continued in use for 1,000 years, into the Middle Ages, being used, for instance, for great golden Gospel books in the time of Charlemagne and for the three late seventh- or early eighth-century Bibles written in a single volume in the famous double monastery of Wearmouth-Jarrow in England, where Bede was a member of the community. They appear as decorated initials in elaborate manuscripts from the High Middle Ages and become one of the sources for the curved forms of exotic blackletter capitals. Whereas today we are used to giving a type design a name, like Palatino or Times Roman, at this point of history there were no definite forms,

Fig. 11. Calligraphic study by the author of writing in uncials, from the letters of Cyprian, early 5th century CE.

just shifting family groups of letters – uncials, roman imperial capitals, rustic capitals and others – that came in a myriad local variations.

Having originated in North Africa, it is unsurprising that it was in uncial letters that the works of Augustine, Bishop of Hippo, were originally written – we even have some examples surviving from within his lifetime (354–430). The rapid spread of this style of letter highlights a phenomenon that occurs several times in the course of this history. The layout and lettering style seen in books written by popular authors spreads rapidly. Not only does their style of writing and layout become emblematic of an association with a desirable cultural context, but a large demand for these books carries the style across a wide geographical area.

After old Roman cursive had spun off uncials it continued to develop, eventually giving rise to another distinctively different form of cursive known as new Roman cursive, characterized by further changes in stroke number, order, direction and speed (Fig. 12). It was in new Roman cursive that the alphabet first began to develop ascenders and descenders and considerable numbers of joins or ligatures between letters. By the fifth century new Roman cursive writing is using letterforms that echo the lower-case roman forms we use today: **b** and **d** are upright with ascenders, **g** had developed a loop below the line, **m** and **n** have their typically arched form.

Fig. 12. The evolution of key letters in old Roman cursive into new Roman cursive (the ancestor of our modern lower-case letters).

As long as writing is a living system, being written by many hands in the service of human flourishing, its shapes will evolve, just as the words and sounds of a spoken language do. And so it was that new Roman cursive itself finally generated the last script to emerge from the classical world. Initially it was used in legal settings and as a semi-formal book script. To make it appropriate for more formal use, a pen with a square-cut nib was employed, held fairly flat to the writing line so that the vertical elements of the script were favoured with weight and the horizontal elements were thin. Though there is absolutely no structural or developmental relationship between these forms and uncials, these new letters were given the name half-uncials by the two French Benedictine monks who first classified them in the eighteenth century, and the name has stuck. Uncials, new Roman cursive and roman half-uncials (Fig. 13) were the scripts that survived in the provinces as the Roman Empire itself began to fall apart.

Just as the old Latin language, once isolated and separated from the mainstream, began to develop into the romance languages of French, Spanish and Italian, so also the old writing of Rome, and in particular the half-uncial, began to develop its own distinctive regional variations. They have been christened Visigoth scripts in Spain, Beneventan in southern Italy (after the Duchy of Benevento), Merovingian in France and insular half-uncial in the British Isles. Although this period of history following late antiquity is sometimes called the Dark Ages, a surprising amount of written material has survived from it. One of the principal reasons for this is that it was copied in the form of a covered book with parchment pages, rather than the more vulnerable scroll of earlier Roman, Greek and Egyptian times. This changeover from scroll to book format was one the most significant events in the history of writing in the west.

Fig. 13. Calligraphic study of roman half-uncial letters, 6th century CE.

CHAPTER 2

The Convenience of the Codex

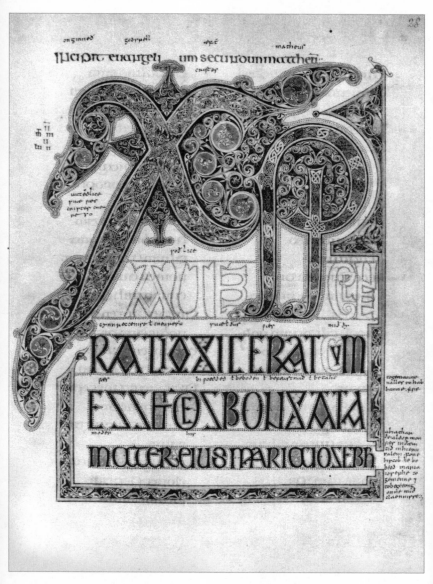

Fig. 14. The Chi-Rho page from the book of the Lindisfarne Gospels, before 721 CE. The monogram of Christ's name in Greek (XPI) opens the passage in Matthew's Gospel that narrates the birth of Christ.

As Augustus lay dying, in August 14 CE, he wrote his will. The first few pages were in his own hand, the last were executed with help from two of his freedmen; and the will was then sealed and placed for security in the temple of the Vestal Virgins. The document was in the form of a codex (Latin for a billet of wood) composed of a multi-leaved block of wax tablets bound together at the spine. By 85–6 CE the Roman poet Martial mentions that such book forms, now made with parchment leaves and still a novelty,* can be found at the shop of Secundus the freedman, near the Temple of Peace: one of the four booksellers in Rome that sold Martial's work. In addition he tells us that the works of Virgil, Ovid, Cicero and Livy are also available in this form, and he comments:

> You want to take my poems wherever you go,
> As companions, say, on a trip to some distant land?
> Buy this. It's packed tight into parchment pages, so,
> Leave your rolls at home, for this takes just one hand.[17]

The book was compact because it was made from parchment, which can be written on both sides. Parchment as a material was associated both with the Hebrew tradition and the Greek library at Pergamum, from which parchment (*pergamenta*) takes its name. Legend has it that rivalry between the upstart library founded by Eumenes II of Pergamum in 190 BC and the library of the Ptolemys in Alexandria went as far as the Egyptians imposing a ban on the export of papyrus to Pergamum; and

* Though see a reference in Suetonius, *Lives of Twelve Caesars*, Bk 1, Ch. 56, regarding Julius Caesar: 'There are extant some letters of his to the senate, written in a manner never practised by any before him; for they are distinguished into pages in the form of a memorandum book whereas the consuls and commanders till then, used constantly in their letters to continue the line quite across the sheet, without any folding or distinction of pages.' http://www.gutenberg.org/files/6400/6400-h/6400-h.htm#2H_4_0002, accessed 9 February 2012.

that it was in response to this that the librarians turned to the old Middle Eastern tradition of writing on leather, and developed a new more durable material. Parchment is made from animal skins, usually calf or sheep, which are leached in lime for several weeks before being dried whilst stretched upon a wooden frame. It is this stretching that aligns the fibres in the skin to form a durable and smooth writing surface, which can then be scraped down to the desired thickness and whiteness.

The codex form was easier to read than the scroll simply because it falls open at the point of reading rather than needing to be unrolled and held by both hands; rolling the scroll back up again could also be awkward. Martial describes, in two poems, the practice of readers holding the outer edge of the book roll under their chins whilst they re-roll it round its core.

By the sixth century the parchment codex was dominant. With the progressive breakdown of law and order in and around the Mediterranean basin during the sixth century regular supplies of papyrus from Egypt were harder to guarantee, and the reed beds were suffering from over-exploitation. Papyrus continued to be used for administrative documents to a later date than for books: the papal record of yearly correspondence was kept on papyrus up to the ninth century. Amongst the earliest users of the parchment codex was the Christian community.

In their book *The Birth of the Codex* (1983), C. H. Roberts and T. C. Skeat calculated that 172 Christian biblical manuscripts and fragments survive from before 400 CE. Of these, 158 come from codices and only fourteen are written on rolls, whereas the proportion of non-Christian literature that survives in codex form is just 2 per cent of the total.[18] It is thought that the codex would have been useful to early preachers and readers as a source of quick reference, and this form of artefact is far more robust for a book collection on the move than the more fragile scroll.

Martial died some time between 102 and 104 CE. He had lived his life as a poet thriving off the social scene in Rome, courting the favour of some of its most notorious emperors, including Caligula. He had at times lived in poverty, and he had dined at the Emperor Domitian's table. He invented the epigram as a literary form, and wrote twelve volumes of them, almost one a year, satirizing the people and events of

his circle. His books were published as Roman and Greek literary works always had been, by giving public readings. Authors had to have two skills, they had not only to write but also to perform their works, and to be an author was not to retire to an ivory tower and work in isolation but to move within the heart of the community. Martial retired to die in his much-loved Spain, though it is clear he missed the gossip, cut and thrust of high society back in Rome. Within a century of his death the persecuted Christian community of his day, blamed by Nero for the fire of Rome in 64 CE, had come of age. It was from within this community that the codex form would find its earliest expositors and designers and a new concept of the role of scribe and author would appear.

Caesarea and the growth of Christian textual scholarship

The setting for the most striking developments in this field was far from Rome itself, in the city of Caesarea. Following the destruction of Jerusalem in 70 CE the city had become capital of the Roman province of Syria-Palestine. The town was built by Herod the Great and named after his friend Caesar Augustus. Caesarea was elegant, famed for its spacious colonnaded streets, fresh water channelled in from Mount Carmel and an extraordinarily effective sewage system that harnessed the sea's tidal energy. Its position as a provincial capital on the Mediterranean coast midway between modern-day Haifa and Tel Aviv meant that it was poised between the Roman, Greek and Jewish worlds. For the Christian scholars who lived there, in a challenging intellectual atmosphere, this context served to emphasize their lack of a solid supporting base of textual scholarship for the claims of their faith, and in consequence they felt they needed to establish one. Three remarkable men assisted this process: Origen (184–254), who arrived in Caesarea around the year 234; Pamphilus, who was martyred there in 310, and Eusebius (260–339), friend and pupil of Pamphilus, who later became the bishop of the town and built on the work of his forebears to produce a completely new kind of document. Though much of the writings these scholars produced was originally in Greek, their impact reached right across the ancient world and up into early modern times.

Origen had already taught in Alexandria and travelled to Rome, Athens and Antioch before he arrived in Syria-Palestine, a pattern of travel that was not unusual for a literary man in the late Roman world. In Caesarea he was supported by a wealthy patron, Ambrose, who supplied him with seven secretaries to take down his dictation, other scribes to work up these notes into presentable texts and a number of girls 'trained in beautiful writing' to write the final copies.[19] Ambrose and Origen saw their studies of Christian sources as a pagan philosopher might have done, as a kind of ascetic practice. In a letter to Bishop Fabian in Rome, Origen comments that Ambrose far excels him in his devotion to this work: 'For we are not permitted to dine without discussion or, having dined, to take a walk so that the flesh may recover. Even at those times we are required to engage in textual studies and to correct texts. Nor are we allowed to sleep through the night for the health of the body, since our textual studies continue until late in the evening.'[20]

The centrepiece of Origen's life in Caesarea as a scholar, philosopher and Christian apologist was his creation of the *Hexapla*. In his day the Old Testament was read in a variety of versions in Greek and Hebrew. He set out to provide the basis for a comparison between texts by placing the main Greek translations in parallel columns alongside the Hebrew original. Most of the book was arranged in six columns (hence *Hexapla*, meaning six-fold in Greek), but it expanded to eight or nine columns for the Book of Psalms. It was an immensely complicated and expensive task to first assemble reliable versions of the various texts, and then to design the layout page by page and write the volumes out.

Origen was one of the most prolific writers of the early Christian community. When he died, as the result of rough treatment in the persecution of 254, he can have had little idea of the impact his *Hexapla* would have. It became a vital reference for future scholars studying biblical texts, including St Jerome, who, in the fourth century when he translated the Old Testament into Latin, travelled to Caesarea to consult Origen's original manuscript. The translation Jerome made remains the official text of the Bible for the Roman Catholic Church today.

Following his death, Origen's work was continued by his admirer Pamphilus. Pamphilus, like Origen, had studied in Alexandria and

came from a well-to-do family. He amassed a collection of Origen's work; Isidore of Seville says the library he built held 30,000 volumes. The greatest depository of Christian books in the ancient world, it was eventually destroyed during the Arab invasions of the seventh century. But one of the striking aspects of Pamphilus's life is that he worked in a collaborative fashion. For him too it was a kind of ascetic discipline. He so inspired the young scholars and copyists who worked with him that they voluntarily accompanied him into prison during one of the last great persecutions of Christians in 307, and there they continued to work for the last two years of their lives before all being put to death on 16 February 310, just three years before the imperial Edict of Milan would announce toleration of all religions in the western Empire. One notable example of the courage Pamphilus inspired was Porphyry, a skilled calligrapher at just seventeen years of age, who went to the judge to demand the bodies of his friends following their execution. He was himself then condemned to death and, having been abraded by hair clothes, was put to death over a slow fire. These scholar-martyrs saw their work on scriptural texts as an act of selfless devotion, justifying any sacrifice. Their muscular asceticism was similar to that which inspired the early Christian monastic movement that would make its appearance in the next few decades after their deaths.

The codex comes of age

Although all seemed lost following Pamphilus's execution, his most gifted student had survived. As Anthony Grafton and Megan Williams show in *Christianity and the Transformation of the Book*, Eusebius, later Bishop of Caesarea, built upon the collaborative working practices and textual skills he had learned from Pamphilus to develop a new style and method of book production.[21] In this he was helped by the new legal status of Christianity, which became tolerated in the eastern Empire in 324, and by the larger resources available to him as bishop from an increase in the size of the Christian population: possibly more than 6 million, and rising fast, during the last three decades of Eusebius's lifetime.

Learning from Origen's *Hexapla*, Eusebius saw the potential of the codex for arranging information in tabular form, with all the possibilities of linking across subject areas and sources that this could yield. His greatest achievements in this form were twofold: a *Chronicle*, which he was working on whilst Pamphilus was imprisoned (as was Eusebius also for a short time), and his *Canon*.

The *Chronicle* is a work in two parts, a rationale and tables. The tables harmonize the histories Eusebius had collected from Roman, Greek, Jewish, Egyptian and Assyrian sources, arranged by dates that include the reigns of kings and Olympiads, each column marked off by decades. The work itself required not only visual imagination but also a large number of helpers to excerpt or track down references, and a skilful team of scribes to compile the complex page layouts. The layouts involved dividing up texts, numbering and cross-referencing the parts using coloured inks, and devising columnar layouts along with notes and running headings. Eusebius was re-imagining the kinds of literature that the codex could support.

In the *Canon*, the Christian Gospels were divided into ten sections each, with tables listing all passages in one Gospel that had parallel incidents in the others, first across all four Gospels, then those appearing only in three, then in two. In the text, inset numbers allowed cross-referencing to the other Gospels. Instead of four separate books, Eusebius had created one, with a complex web of links running across and in between its parts. The tables from the *Canon* would become standard accompaniments to biblical manuscripts throughout the Middle Ages; they appeared at the front, usually separated out from each other by elaborately painted columns and arches. They were one of the earliest elements in the medieval book to receive illuminated decoration. Eusebius also wrote a Church history, acclaimed by scholars as the first to introduce evidence based upon quotation. No library in the later Middle Ages could lay a claim to greatness without owning his works.

Towards the end of his life in the 330s, Eusebius received a commission from the Emperor Constantine himself. With Christianity now a legal religion, churches had begun to spring up in the new capital, Constantinople. Constantine wished to furnish them with reliable

copies of the Bible, and it fell to Eusebius to supply them. Fifty great codices were sent to the Emperor in threes and fours, using the imperial *cursus velox* or state express cart service. There is one surviving example of such a book, containing the complete canon of Christian scripture, from this time or shortly thereafter, the *Codex Sinaiticus*. This codex was originally in the library of St Catherine's monastery at the foot of Mount Sinai. The monastery, founded some time before 565 by the Emperor Justinian, enclosed a chapel built some time after 330 by Helena, the British-born mother of the Emperor Constantine. There the book had remained, perhaps since Constantine's time, until 'liberated' from the care of the monks for a pittance in the late nineteenth century by Constantin Tichendorf, a German biblical scholar who was ennobled (to the Russian aristocracy) by the Tsar for his gift of the *Codex*. Subsequently the book was bought by the British Library from the Soviet government in the 1930s. In 1975, during building work at St Catherine's, another lost part of the book was found in a disused chamber. Today the text has been digitally reunited through an international programme of scholarship.*

The *Codex Sinaiticus* is the oldest almost complete Bible in existence and contains the earliest example of the complete New Testament text. It is written in Greek uncials, simply and without decoration. The text is spaciously laid out but with no waste or superfluity, and the writing has an unpretentious beauty. It is written on parchment with four columns to a page so that when the book is open it makes a long horizontally aligned rectangle eight columns in width. This layout is not dissimilar to how a scroll would have looked when opened, with narrow spaces between the columns and a large margin of space at the top and bottom to protect the text. This layout reveals how close in time this book form is to the period when the scroll was still 'how a book should look'. Endnotes to some of the sections of the books in the codex show it was corrected against originals once written by Pamphilus and his followers, perhaps in some instances copied directly from them.

* See http://codexsinaiticus.org/en/.

With Constantine's enormous commission of fifty volumes of the Christian Bible, the codex as a form had come of age. This achievement, the making of the books, the editing of the texts, was built on the work of several generations of scholars and employed a scribal expertise honed in the production of Eusebius's complex arrangements of texts in other books.

The *Codex Sinaiticus* itself endured in the monastic library in which it had come to rest as wars raged around it. The monastery survived the rise of Islam owing to a letter of protection granted in 628 by the Prophet himself, and it still survives, fortress-like, in a dry mountainous landscape. The scholarly and spiritual institutions associated with these two religions – Christianity and Islam – became the primary vehicles for carrying forward, in the west, the literature and learning of the classical world by conserving, recopying and translating them as required.

Foundations of monasticism – *Institutions* and a Rule

At about the same time that Pamphilus was beginning his working life in the second quarter of the third century, monasticism as a way of life began to appear in the Near East. Christian men, and a small number of women, fled the urban world of late classical Rome for the wilderness of the Egyptian desert, where, outside the laws and customs of their time and free from persecution, they could build a new life of complete commitment to their God, whose presence they sought to continuously discern in thought and deed. Some monastics like Antony (251–356), the founding father of the movement, lived alone. Others, guided initially by Pachomius, once a centurion in the Roman legions, banded together to live in their own monastic cities. They followed a shared rule of life, ate and prayed together and elected their own leaders. It was not until the sixth century CE that the full potential for these communities as significant places for book learning and literacy became apparent. They would come to house libraries of books and educate several generations of readers and writers, whilst the world around them descended slowly into chaos. Those contexts that had supported literature in the west – an organized and political public life, a literate population, an ordered legal

and tax and accounting system – faded away until only the Christian Church provided a Europe-wide context in which literacy could be cultivated. Two influences proved crucial to this future: the first was the most unlikely.

Cassiodorus, born around 485, was heir to a line of imperial administrators. He was a natural conciliator with a romantic view of Rome's erstwhile glories. His father had been prefect of the Praetorian Guard and he himself rose to the same post, the highest office in the Roman government. He became the sixth-century equivalent of prime minister to Theodoric, king of the Goths, who then ruled Italy. Cassiodorus helped Theodoric revive a sense of Roman government and culture. After the death of Theodoric in 526 CE, Cassiodorus served his successors until the reconquest of Italy began from Constantinople under the Emperor Justinian. The invasion of southern Italy by the Byzantine general Belisarius in 535–6 left Cassiodorus's life's work in ruins, and his pet project of founding a theological school in Rome was shattered by the violence. After some years of enforced exile in Constantinople he returned to retire, aged sixty, to the family estates at Squillace in Calabria, southern Italy, where a monastery had already been founded.

By all accounts the Vivarium, as it was called, was beautifully sited, close to the sea with channels running in from the ocean to provide ample fishponds (*vivaria* in Latin). There were baths and a nearby mountain hermitage for those on retreat. But 'Vivarium' means more than fishpond: the Latin literally means a 'place for life'. In a modern context, it can be used to refer to any enclosure used for raising animals or plants for research and observation. The whole setting of Cassiodorus's monastery was such a place, and vital to its intellectual life was a well-equipped library and scriptorium. This simple monk's workplace stood in stark contrast to Cassiodorus's previous workspace as Praetorian Prefect with its symbols of office: a massive silver inkstand, golden reed pen case and a silver bowl on a silver tripod, into which petitioners' letters were placed. He now set himself and his monks to work to provide the bare bones of a classical education for those who would come after them, translating where necessary works from the Greek into Latin, recognizing that the days of Greek literacy in the west

were passing. He distilled the knowledge he felt important into the two volumes of his *Institutions of Divine and Secular Learning*. This included advice on copying manuscripts and the care of books. The list of recommended books and authors in the first volume was often used by later monasteries as the basis for establishing and organizing their libraries. These *Institutions* provided practical advice and a rationale for a Christian and monastic education. The Vivarium outlived Cassiodorus by just a few decades; his books seem to have passed to the Lateran Library in Rome. His *Institutions* were fated to be one of the most copied and excerpted books of the Middle Ages. How ironic that Cassiodorus, the great Roman statesman whose political career – based on toleration, diplomacy and compromise – was ended by the violence of military invasion, found his reputation secured by a work compiled in obscure retirement as a humble monk. This work would have a greater effect on European culture than all the seemingly great events of his own ninety-six long years.

The second seminal influence on monastic culture was that of Cassiodorus's close contemporary, Benedict of Nursia (*c.* 480–543). Benedict had begun life seeking an education in the schools of rhetoric at Rome but had then retired to live as a solitary in the hills above Subiaco, east of Rome. He soon attracted followers, for whom he wrote a little Rule of the monastic life for beginners. This simple and practical Rule stood the test of time. It was promoted by Charlemagne in his reforms of the monasteries in the ninth century, and provided a viable way of life for most of the great monastic houses of the early Middle Ages; it is still in use today.

Chapter eight in the Rule of St Benedict stipulates that every monk must be issued with a book to read during Lent, the period of forty days that leads up to the annual remembrance of the death and resurrection of Jesus at Easter; to enable this Benedictine monasteries needed libraries. But monastic reading was different from the kind of reading we are used to. Today's followers of St Benedict, who have preserved his ancient practice of *lectio divina*, holy reading, liken it to the ruminations of a cow chewing the cud of the text. You take your time, reading short passages slowly and over again in the mind, spending time with each and allowing

the words to speak to you. I know from my own few years of living as a Benedictine monk that a rich range of associations can arise from this meditative engagement. This is very different from the forced-paced reading designed to extract information from the text, which many of us do today. Since a monastic book was designed to be read slowly and many times, libraries did not need to be extensive; wisdom was to be bathed in rather than simply acquired.

A second use for texts in the monastery was liturgical: for reading aloud in a service, and as guides to church ceremonial. Services were repeated in cycles which one soon learned by heart, and the core of these services – the Psalms – were deliberately learned as the first educational task any young monk undertook.

Writing as a form of devotion

He may fill his mind with the Scriptures while copying the sayings of the Lord. With his fingers he gives life to men and arms them against the wiles of the devil. So many wounds does Satan receive as the 'antiquarius' copies words of Christ. What he writes in his cell will be scattered far and wide over distant Provinces. Man multiplies the heavenly words.

These words from Cassiodorus's *Institutions* cast the act of writing in a different light. The very act of copying books is now an end in itself and the scribe – no longer a slave copying works for his master – has received a different kind of dignity and task; character and holiness can be formed within the activity of bookmaking. Allegory, which is employed as a means of scriptural interpretation in this period, also comes to be applied to the tools and materials of writing. Isidore of Seville likens the quill pen with its split nib to divinity manifesting itself through old and new testaments, and the ink to the blood of Christ pouring out for the sake of creation. Allegorical interpretations of the letters of the alphabet also abound: the Greek upsilon (**Y**) with its two arms echoes the life choices we as human beings must make as we grow to maturity. This tradition of interpreting the shape and character of letters goes back as least as far as Plato. In his dialogue *Cratylus* he has Socrates describe letters as representing different forces: the letter **R** stands for motion,

the **L** for suppleness and smoothness – though in fact Socrates is gently mocking these associations. Allegory extended so far into the making of letters during the early Middle Ages that one tenth-century manuscript in the town library of Bern, Switzerland, shows novice monks being taught the shape of the letters by likening them to theological truths that are held in the mind as the letter is formed. The three strokes of **A** stand for the Trinity, the central cross bar representing the Holy Spirit that flows between Father and Son; the descending movement with which **L** is made recalls the birth of Christ who humbled himself by descending from Heaven to Earth to assume the condition of a servant.[22]

Scribes even have miracles attributed to them: in later Anglo-Saxon England an unknown daughter house of the monastery on Lindisfarne was celebrated for its miracle-working shrine of the Irish scribe Ultán. From the mid-sixth century we also see that the scriptural book with its jewelled treasure bindings becomes incorporated into Christian iconography. The Christ Pantocrater above the chancel arch of Sant' Apollinare in Classe, Ravenna, holds such a book, as do the saintly bishops behind the altar, and so does a member of the procession formed behind the mosaic portrait of the Emperor Justinian and his consort Theodora in Ravenna's San Vitale: both buildings were completed shortly before 550. An important influence on this new theology of the book was Philo of Alexandria's attempt to fuse Greek and Jewish learning by naming the divine force and order behind creation as the Word or *logos* of God. 'In the beginning was the word,' wrote St John in the opening of his Gospel. This gave a powerful penumbra of associations to Christian scriptural text, which came to be seen as embodying the presence of the divine and honoured as such – enshrined on altars and carried in procession. In earlier Roman times the closest we get to a book with supernatural power is the famous Books of the Sybil that were kept in the Temple of Jupiter on the Capitol and consulted in times of national emergency; but they were prophetic of world events, they did not embody the presence of the gods themselves.

The Christian appropriation of the book as a theological symbol opened up new decorative possibilities. Book pages were coloured imperial purple and writing was wrought in silver and golden inks. Eusebius's

canon tables were placed at the front of the Gospel Books in elabo-
rately decorated portals. Significantly, the words themselves became a
decorative element. Roman books had been illustrated in a number of
ways. The first known occurrence is in Varro's (c. 113–27 BCE) *Imagines* –
a lost book, but described by Pliny – detailing the lives of 700 famous
Greeks and Romans and completed around the year 39 BCE. It twinned
a portrait of each famous person (yes, all 700!) with an epigram and
description. Virgil's works are known to have been issued with portraits
of the author at the front, and two late fifth-century copies of Virgil's
works surviving in the Vatican Library (*The Vatican Virgil*: Cod. Vat. Lat.
3225 and *The Roman Virgil*: Cod. Vat. Lat. 3867) show framed illustrations
that follow the narrative of the text. Medieval copies of herbals and
books of astronomy point to earlier Greek and Roman exemplars that
included diagrams without frames, set more freely with the text flowing
around them. Roman poets such as Virgil, Ennius and Porphyrius, and
earlier Greek precursors from the third century BCE, Aratus and Simias
of Rhodes, had also played visual games with text, inventing acrostics,
palindromes and figural compositions. But from the sixth and seventh
centuries CE forward, under this new Christian influence, book decora-
tors began to elaborate the words themselves. Particularly notable was
the emerging tradition in the British Isles built upon the diminuendo, the
Roman way of marking the beginning of a text by writing the first letter
large and each successive letter slightly smaller until the normal size is
reached. Books developed great display pages of interlaced and banded
lettering celebrating the life-giving power of the word of God. Begin-
ning in modest form in the Catach of St Columba from the early 600s,
the best later examples of this work come from the family of monaster-
ies founded by St Columba, which included those on the islands of Iona
and then Lindisfarne.

With the scribe of the Lindisfarne Gospels we see the act of writing
achieving an intensity of focus and athletic endurance seldom encoun-
tered – though not untypical of early northern European monastic
books. The entire Gospels and their decoration are the work of one
person, though there are signs that work was not quite complete when
the scribe died and that another hand wrote the headings in red (Fig. 15).

The book was most probably written by Eadfrith, the leader of the monastic community on Lindisfarne, some time before 720 CE. It seems likely that part of his religious practice involved retiring to a hermitage for parts of the year, and the act of writing the book was an undertaking that resonated with similar acts of self-denial, such as fasting and the chanting of psalms.

I have spent sixteen autumns and a few springs on Holy Island, where Eadfrith wrote, and I have imagined the wide horizon of clouds and sea that surrounded him, the moaning of seals out on the sand-bar at night, the whistling of eider ducks closer in-shore and on nearby islands, the stirring sight and sound of great colonies of nesting gulls whose shapes he weaves into the elaborate decorative pages that begin each Gospel. These motifs would have recalled to him the seething presence of a living, moving, squawking creation.

Eadfrith accomplished his task in honour of the cult and shrine of his monastic 'father', Cuthbert, who had died a little while before (687 CE). Eadfrith deliberately embraces a spirit of newness and change in the way he frames this book. He opens by decorating the first words of Jerome's letter introducing his new translation, the first such decorative treatment of these words in the western tradition: 'Out of something old you have commanded me to make something new.' These words set out the whole programme of this book, in which he uses new colours, invents new letterforms, draws on a new text, imagines new iconography and new decorative elements, all blended together to make a picture of all the traditions that reached his far island on the edge of the known world (for a similarly innovative page, see fig. 14, p. 40).

But to the fellow scribe what is astonishing in Eadfrith's work is the human achievement involved. The ability to embrace change and otherness without fear and trembling but with an eye for making new

Fig. 15. Calligraphic study of key half-uncial letters
from the Lindisfarne Gospels, before 721 CE.

relationships is, in art, as in our personal lives, a challenge to openness and hospitality towards 'the other' that can only be accomplished with wonder, humility, patience, an empathetic ability to listen and to forgive failings, first in oneself and thus in others. This is the real nature of Eadfrith's tribute to Cuthbert, his spiritual master.[23]

The impact on writing of the Carolingian renaissance

In the British Isles – the first province of the Roman Empire to be left to fend for itself after the withdrawal of the legions in 410 CE – the common cursive hand of the later Empire, new Roman cursive, was gradually adapted to provide the full diversified range of scripts that sixth- and seventh-century Britain needed. Like Darwin's famous finches on the Galapagos, variants of this simple script were adapted to fit a variety of niche uses, from the formal and most elaborate display scripts such as those we see in the Lindisfarne Gospels and the later Book of Kells, to the small writing used for note-taking. On the mainland of Europe, uncials, half uncials, rustics and roman capitals continued to be written, but here too the informal hands of late classical times took on a life of their own and considerable regional variation developed. Individual monasteries had their own writing styles, which ranged from the complex knotted script of Luxeuil (a monastery in eastern France, founded by St Columbanus in the late sixth century) to the open round formation of letters from Corbie, a monastery founded from Luxeuil, from which a new form of writing would ultimately stem. That reform, part of the Carolingian renaissance, would confirm the shapes of our lower-case letters.

Documents of the seventh and early eighth century show a steady decline in the carefulness of their preparation, their spelling and their Latin grammar. Yet a rudimentary literacy was still widespread, and at a local level the archives of large monasteries, like St Gallen in Switzerland and Fulda in Germany, founded in 720 and 744 respectively, show that laymen as well as clergy were writing legal documents and the local priest in the villages was probably giving a limited education to those who wanted it.[24] At this time people learned to read once they had first learned a basic text like the psalms by heart, which then provided their

first reading book. Some would go on to also learn how to write, but this more complex activity involved acquiring craft skills: materials did not come ready-made, vellum needed finishing and ruling, pens had to be cut and trimmed from quills or reeds, and there was a variety of writing styles that could be employed.

Following a century or more of gradually declining literacy, in September 768 came a turning point in Frankish history. Pippin the Short, the founder of the Carolingian dynasty, died, and his two sons Charles and Carloman inherited the Frankish throne. After the death of Carloman in 771 Charles reigned over the united territories we know today as France, the Low Countries and Germany. His father had usurped the throne in 751 from the previous dynasty – the Merovingians – who had ruled Francia since the mid-fifth century: in other words, since Roman times. The energy and vision of the new Carolingian house – and in particular, the life's work of Pippin's son Charles, whose reign lasted forty-three years – shaped many aspects of the Europe we know today, including its relationship to Christianity, its script and even the recurring theme of European reunification.

For a man whose father was described as 'the Short', it is surprising to discover that Charles was over six foot three inches in height, a giant for his time, when the average was close to five foot. The Frankish scholar Einhard, in a memoir written twenty years after the King's death, paints a vivid picture. Charles's face was round, with fair hair, and his eyes large and animated. Though tall with a thick neck and slight paunch, his voice came as a surprise, lighter in tone than his stature suggested. He dressed as the common folk except on feast days, when he allowed himself an embroidered cloak, small crown and jewelled shoes. A keen huntsman, he suffered from arthritis late in life and this was a contributory factor in his choice of Aachen for the purpose-built palace where he settled for his last two decades. At Aachen, as well as the important cult site of the Royal Chapel, there were the remains of Roman baths built over natural hot springs. Charles was a keen swimmer and delighted in holding court in the baths themselves, inviting visiting guests, his bodyguards and, Einhard tells us, up to 'one hundred people at a time' to come in and join him.[25]

Charles's thoughts turned to how to better the life of the people under his rule. He sought in particular to raise the standard of Church discipline. The Church was useful to him. Its network ran throughout the expanding kingdom, its personnel were literate, and religion could provide a unifying force as well as a body of competent administrators. In the early 780s at court a serious attempt to collect books was initiated, and some time in 781 Charles and his wife Hildegard commissioned a new manuscript to celebrate the baptism of their son Pippin at Easter that year by the Pope in Rome. This book,[26] written by the scribe Godescalc, is an evangelistary: a book of readings from the four evangelists (Gospel writers), set in an order that could be used at services through the course of a year. It represented an elaborate sacred timetable for the court to follow. It was a commission on an unprecedented scale; there had been nothing like it in the west for a century or more. The manuscript contained 170 pages of vellum; the pages were stained purple and were written in columns of gold and silver ink; there were six full-page illuminations, including portraits of the evangelists. The style of decoration incorporated elements from old Roman book culture, insular interlace and Byzantine painting. The main text was in golden uncials but the dedicatory poem that Godescalc wrote at the back of the book was in an incipient new minuscule script that has become for ever associated with the Carolingian name. This script, which in its fully developed form would be known as 'Carolingian minuscule', finds its closest contemporary comparison in writing from the abbey of Corbie on the Somme near Amiens in northern France. The script is derived ultimately from Roman half-uncial writing, with some insular influences. It is the culmination of many years of experimentation in different monastic centres to find a new clear script for writing. Ironically this involved purging the cursive elements from scripts that had survived from late antiquity. Cursiveness breeds ligaturing, individual solutions to letter formation and divergence from the norm, and convergence on recognizable and common standards was what this new era of political and geographical unity required.

The Carolingian minuscule script (Fig. 16) has distinctive clubbed ascenders and a kind of eager, open, optimistic and forward-moving

energy. The letter body shapes are all those we would easily recognize today; they are the originals that lie behind the type that this book is printed in. Without complicated ligaturing or time-consuming archaisms, it is as if a cloud has passed from the face of the sun and a new clarity of purpose has been attained. The pathway by which these letters came down to us today was not a direct one – in the High Middle Ages they would go out of fashion and be eclipsed by gothic letterforms – but their clarity appealed to the Renaissance and the script was undergoing a revival in Italy at the time when the first printers arrived there in 1464. These printers, competing with the scribes, copied what they were doing, and since the printing press is an innately more conservative medium than the scribe (it costs money to re-cut and cast type, whereas a calligrapher can change a form on a whim from one moment to the next), these are still the forms we use today.

Charlemagne never actually promoted the script that bears his dynasty's name, except by example. As part of his campaign to raise

Fig. 16. Calligraphic study of Carolingian minuscule
from a Bible, St Martin's, Tours, 834–843 CE.

Church discipline he recommended in a decree, the General Admonition of 789, that 'there be in every Bishopric and monastery the teaching of psalms, musical notation, singing, the church calendar and grammar and let there be books that have been carefully corrected...And if Psalters and missals are to be written they should be written by men of perfect years [i.e. full age] and with all diligence.' But he never deliberately encouraged the reform of writing as such; it happened by osmosis and by the example of a successful and sought-after author, Alcuin of York.

In 796, Alcuin, the Englishman who had become the principal teacher at court, retired. He had lived the first forty years of his life in the cathedral school of York and had been invited to accompany Charlemagne's court in the early 780s. He had quickly established himself as a charismatic teacher, instructing the sons of the nobles, the King and his daughters in theology, rhetoric, grammar, spelling, arithmetic and astronomy. Alcuin had a gift for friendship – poems of the period picture him as fond of a drink – but with an English reserve, hesitant to take his clothes off and join Charlemagne in the hot baths at Aachen to discuss the finer points of arithmetic or astronomy.

For his retirement, Alcuin was given the abbacy of the monastery of St Martin in Tours. He felt its isolation keenly (and curiously he had his wine sent over from England), but there he began a programme of scribal publication. During the last eight years of his life he was enormously productive. He talks of there being a 'crowd' of scribes – *turba scriptorum* – a flock, a turbulence, a murmuration. Alcuin's new edition of the Bible would become the best-seller of his day, a phenomenal achievement but one that resonated with Charles's desire to provide accurate copies of key texts for his subjects. After Alcuin left the court, the fashion for manuscripts produced in the palace school had reverted to luxury products written in golden uncials. But under Alcuin the scriptorium at Tours modelled their form of the Bible on the style of book that had been the latest thing when Alcuin himself had last moved in the royal circle: the unadorned Carolingian minuscule and plain decoration, mostly confined to functional contrasts of lettering styles, that had first appeared in extended form in the *Opus Caroli Regis*, a work on the theology of images. One other court manuscript of the period also uses the minuscule

script and provided inspiration – the Dagulf Psalter, a collection of psalms originally made for Hildegard, Charlemagne's queen.

During the next fifty years the scriptorium at Tours made up to 100 copies of Alcuin's Bible text, helped no doubt by the fact that the Abbot who followed Alcuin was Fridugisus, an English student of Alcuin's who had headed the royal writing office and so knew a thing or two about document production. It was products such as this – an authoritative and prestigious book, distributed widely across the Frankish territory, during a time when people had an appetite for cultural convergence rather than local distinctiveness – that really spread the new trend in book production represented by Carolingian minuscule and the Bibles from Tours.

These Bibles were the first to place the scripts employed in a strict hierarchy. Roman capitals were reserved for principal headings and initials. Text of the next importance was in uncials followed by half-uncials, Carolingian minuscule and finally rustics (used for some subscriptions at the end of texts). Produced at an average rate of two a year, these books represented a massive investment of time and resources. Some books show that up to twenty scribes worked on them. The books measure a little over half a metre high and about 800 mm across (20¼ x 31 inches) when open. Each contains up to 450 pages, and with one calfskin for four pages – a bifolium – each book requires 113 animal skins. After Eusebius's achievement in producing fifty Bibles for the Emperor Constantine, the programme of book production at Tours ranks as the most significant of the early medieval period. But, alas, it was all to end in tears.

Viking raids and Anglo-Saxon renewal

Already in 793 the Vikings had struck terror into the hearts of northern Europeans. Sailing out in their low dark longships from the fiords and villages of Norway, Sweden and Denmark, the very first place to experience their raiding was the peaceful and undefended monastic settlement of Lindisfarne on the Northumbrian coast. It was its unlucky fate to lie directly west of the Scandinavian coastline. But soon the Vikings were also raiding south. In 853 they reached Tours. Fifty years of carefully

orchestrated artistic and scholarly endeavour went up in smoke or was put to the sword; they attacked again in 862, 869 and 877. As with Lindisfarne, so with Tours, the scriptorium never recovered. A cultural caesura settled on late ninth-century Europe. Any coastline or territory threaded by rivers was open to Viking attack. The advances in the book arts, in royal administration and Church governance that had taken place under Charlemagne's rule shuddered to a halt. For the next two generations, Europeans were principally concerned with maintaining the status quo and at worst with their own simple safety.

In England, by the 870s, the whole northern part of the country was overrun until just one Anglo-Saxon kingdom, Wessex, was left in the south. In April 871, following the death of his three older brothers, Alfred, the fourth son of King Aethelwulf of Wessex, succeeded to the throne. He had visited Rome several times in his lifetime, and even stayed for a while at the court of Charles the Bald in France (in the year following the first attack on Tours). Under his leadership the tide turned. In England the Danes were defeated and Alfred's heirs gradually reconquered the entire country. As part of the reconstitution of the Anglo-Saxon kingdom monasteries were founded. They were important centres of Anglo-Saxon culture, religion, literacy and the arts, and they were seen as protectively cloaking their guardians both with the continuous prayers of the monks and of the saints who were buried there. Within seventy years of Alfred's death in 899, a monastic renewal movement was sweeping England, spreading from Glastonbury, where the movement had its spiritual home under the patronage of its abbot, Dunstan, soon to be Archbishop of Canterbury. With encouragement and help from a cooperative King Edgar (for whom Dunstan wrote the essence of the British coronation service still in use today), communities of English monks refounded monasteries that had been destroyed, built new ones and attached themselves to a number of cathedral churches previously occupied by communities of clerks. Meeting together in around 970, they agreed to adopt a way of life with the rule of St Benedict as its basis. New monasteries meant new libraries and new service books, but the old scribal traditions that had existed before the Danish attacks were in a fragile condition. Alfred himself recalled that when he

came to the throne in 871 he could not remember a single man south of the Thames who could still follow a service in Latin. Scholarship had to come back into the kingdom from outside. The new books, arriving from the continent, were written in Carolingian minuscule and the new monasteries adapted their own writing to this standard – influenced, however, by the visual weight and pen lifts of the Anglo-Saxon half-uncial script that had previously held sway.

Thus in England the Carolingian hand gained weight (it was written with a thicker pen), it grew a little larger in size and had more pen lifts within the letterforms – particularly when moving from the stem into the arch of letters such as **h**, **n**, **m**, **p** and **r** – and their foot serifs had a slightly self-conscious rounded form. All the really well-formed versions of this hand – to a calligraphic eye – come from foundations associated with Bishop Oswald of Worcester and then York. The anonymous scribe of Harley 2904, *The Ramsey Psalter*, is one such exponent (Fig. 17). He writes an English Carolingian minuscule full of unhurried strong curves, gentle unflashy beginning and finishing strokes. He uses forms of letters that resonate with a practised spirit of community; they echo each other's proportions harmoniously, rather than jar with self-conscious individualism. These letters possess as Benedictine an architecture as any early English abbey. At Canterbury, in the second decade of the eleventh century, this script became compressed: the **o** is oval rather than circular, the pen rocks around the arch of letters such as **n** and **m**, and the result changes the way the angle of the nib's edge approaches the page – it becomes flatter, more parallel to the line the scribe writes along – leading to deliberate foot serifs on the bottom of strokes as if the

Fig. 17. Calligraphic study of *The Ramsey Psalter*, 974–86 CE.

letters are each wearing a tiny slipper. This is the beginning of a trend in letter shape that ultimately led to the diamond-shaped foot of the compressed gothic letter, 200 years further down the line.*

But at the same time as these achievements in script were being laid down, after several generations of relative peace, the late tenth and early eleventh centuries saw new waves of Danish armies once more breaking over the heads of the unfortunate English. The kingship of England fell this way and that, between the old house of Wessex and the new Danish invaders. In 1013 the throne passed from Ethelred the Unready to Sweyn Forkbeard, then back to Ethelred the following year, and, on the latter's death, to his son Edmund. After Edmund's short reign came twenty-six years of Danish rule (1016–42) under Cnut, Harald Harefoot and Harthacnut, followed by a Saxon restoration under Ethelred's son Edward (the Confessor). Then, in 1066, Anglo-Saxon kingship came to an abrupt end, as Edward's successor Harold Godwinson lost his life and his realm to the forces of another descendant of the Northmen, Duke William of Normandy.

* When exaggerated the slight flattening of the pen angle involved also leads to the flat-footed style of lower-case gothic known as *prescisse* or 'cut-off' letters.

CHAPTER 3

Speaking through the Senses

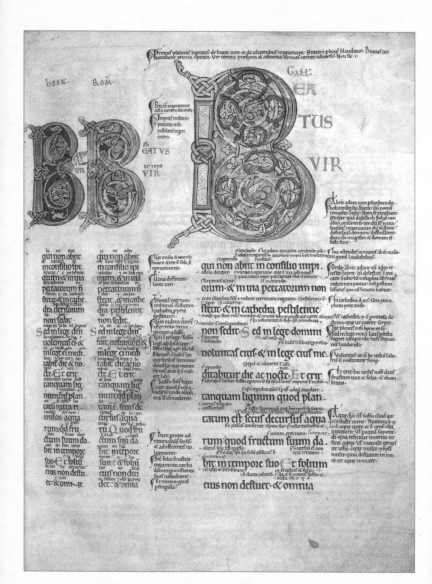

Fig. 18. *The Eadwine Psalter*, an illuminated and glossed book.
The book contains five different versions of the text of the Psalms with
a commentary. Arguably the most complicated manuscript produced
in Britain in the mid-twelfth century, it engaged the talents of
over a dozen artists and scribes.

As the first millennium in the Christian west turned to the second we enter a palpably different age. The origin of these High Middle Ages, as with the English renewal of monasticism and dynastic energy, lies in the response to the very crisis that had undermined the achievements of the Carolingian renewal. Though Charlemagne's empire had disintegrated into chaos and infighting amongst his heirs, the fight against the Danes had eventually strengthened the power of the centre in the smaller kingdoms they had ravaged. When peace treaties were concluded, the inevitable conversion to Christianity that was required from the Scandinavian invaders spread the influence of one unifying body – the Church. This influence grew not only on the unchurched margins of Europe, but also within its own borders where the invaders settled.

How to make a Bible: parchment and ink, gilding and stitching

The late eleventh century saw a revival in the tradition of great Bible-making. These Bibles were written in a large size – often 60 cm high and 1 metre wide (2 feet by 3 feet) when open – richly illuminated with gold and coloured initials and miniatures. Across Europe in Italy, Germany, Austria, Switzerland, France, Belgium and Britain these massive volumes from the late eleventh and early twelfth centuries still survive. A footnote in the two-volume Stavelot Bible in London (London BL, Add. MSS. 28106–7), originally written in Belgium, tells us it was written by the scribe Goderannus with the help of brother Ernestus and that it took four years to complete.[27] The origin of the practice of making these books probably lies in Rome, where a copy of one of the great Tours Bibles survived and seems to have provided the first exemplar.[28] At a time when the papacy was asserting its rights and bishops were being urged to look to the education of their people (in 1079 Gregory VII had asked them to start schools in their cathedrals), it is hard not to

see these large and magnificent books as a conscious symbolic statement of the authority on which the Church's power rested and from which its teaching flowed. These books represent the high-water mark of monastic manuscript production. Like other books of the period they are made from the prepared hides of calves, and represent a considerable expense, with two double-sided sheets cut from one skin. The Stavelot Bible with over 468 pages was on a similar scale to the Alcuin Bibles from Tours. It would have required 117 animals to produce it.

Once the skin had been stripped from the carcass it was put into a pit with lime for up to six weeks. In this process the animal's hair was rotted off, and when the skin emerged and was scraped and washed down it was stretched on a frame and left to dry. When dried, the parchment-maker scraped it to the required thickness. Some animal skins, such as sheepskin, have a fatty layer running through the centre, and with careful handling the skin can be peeled or split into two layers. The split skin sheets are referred to as parchment. Whole skins that cannot be split (and calfskin only appears in this form) are called vellum. Both parchment and vellum have a considerable lifespan. There are documents from the sixth century CE that survive in perfect condition 1,500 years later. As recently as 1999, the British Houses of Parliament voted to continue producing the archive copy of its acts on vellum. It has a continuous record of such vellum documents going back to 1497.

Once the vellum had been cut to size, the surface of the skin was pounced with pumice powder to raise the knap. When you look at vellum under a microscope you will see that it is a random collection of interwoven fibres. The pouncing breaks some of these strands so that the surface becomes velvety rather than smooth to the touch, and this turns the page matt rather than shiny, which makes for easier reading and produces a slightly cushioned and resistant surface for the quill to write upon. The surface holds the pen nib and stops it sliding about. This means that the scribe can write in a highly controlled way and with an astonishing sharpness of detail. Once the knap has been raised the sheets must be ruled. The easiest way is to rule several pages at once. The original ruling on a top sheet can be pricked through to the other side and to a limited number of sheets underneath. It is a difficult process, as

sheets of vellum are not dead flat like sheets of paper, but have a slight rise and fall to their surface and can respond very quickly to changes in the relative humidity of the atmosphere; and of course this kind of ruling really only works when the layout of each page is identical from side to side.

For a pen, the medieval scribe normally used a quill rather than the reed that had been in use at the end of the Roman period.* Goose quills were the most popular: they are just the right size to fit easily in the hand, but the truth is that any feather can be used – crow quills were employed for tiny writing and swan for larger letters. The width of the barrel or shaft of the feather (called the butt in the feather trade) determines how wide the nib can be. Feathers can be used without further preparation, but over time methods were devised for hardening the barrel to produce a more durable and long-lasting nib. This involved heating the butts in hot ash, or by friction (rubbing against a coarse cloth) or in hot sand. This also slightly degreases the butt and assists in separating the barrel's waxy membrane from the main substance of the quill underneath. This helps the ink stay on the nib and also enables the quill cutter to make a clean nib slit which eases the flow of the ink down to the tip and gives the nib a pleasing flexibility. Traditionally it was the five outer feathers of the wing (the flight feathers) of the goose and swan that were used, with those from the left wing being favoured over the right as they curve more naturally into the fingers and knuckles of a right-handed scribe.

An essential part of any scribe's equipment is the quill knife, the sharper the better. It can also be used for scraping out mistakes. This is one of the benefits of using vellum: large areas of text can be scraped off and the surface written upon again. Indeed, vellum could be scarce in disruptive times, and we have whole books from the ancient world that were once reused by medieval scribes who had first scraped and washed off an earlier text. The lost text of some of these books can now be read with imaging techniques that employ digital processing to trace

* Reeds remain in use by some writers right up to the Renaissance; there is a striking portrait in the Louvre of Erasmus by Holbein from 1523, showing him writing with a reed pen.

minute remnants of the original ink still embedded in the fibres of the vellum. As recently as 2005, parts of a lost work by Archimedes were read in a tenth-century manuscript using X-ray technologies. The resulting images were posted on the internet as a Google book.

Up to the end of the eleventh century ruling in medieval manuscripts was usually done with a blunt point, producing an impressed line on one side of the page and a raised line on the other. This meant that because of the awkward bumps and dips involved, scribes invariably wrote a little above the ruled line or in between them, using the lines simply as rough guides rather than absolute measurement of a letter's height. The writing thus preserves an unrestricted liveliness, for as the twentieth-century calligrapher Edward Johnston used to say, 'Writing between ruled lines is like trying to dance in a room your own height.'[29] A tradition of ruling that comes from Arab and Hebrew book culture and is still in use today: a ruling board with pre-drilled holes on either edge is threaded with fine strings, then the paper or fine vellum page is placed on top and an impression of the lines is made into the sheets by pressing or burnishing. Ruling in manuscripts after the eleventh century was with lead plummet (until they noticed it went blotchy over time) and pale ink.

The ink that scribes used varied from place to place. It might be carbon-based (soot bound together with glue), or it might be made from sulphates of iron mixed with tannic acid, or a mixture of the two. The colours employed were mostly ground pigments that lay on the surface of the vellum (like house paint does on a wall rather than as a dye that goes into and stains a substance). The richest colour was vermilion red, often mixed with a little egg yolk as a binder, which gives it a gloss as well as an enhanced depth of tone. The most expensive pigment was ultramarine, made from lapis lazuli traded all the way from Afghanistan. If you hold a medieval initial painted with ultramarine up to the light, you can see it sparkling with small crystals still surviving from the grinding process of the original stone.

In the monastic era there is evidence that writing books was a seasonal activity, for monks often worked on manuscripts in the cloister, the courtyard of the monastery, which was open on one side to the

elements but where the light was good. In winter the weather got too cold to write. One monk records that he wrote on most days – but not during fog! The main problem in fact was not that the writers themselves got cold – in Cistercian monasteries they were allowed in to warm their hands at a fire and they could always wear layers of clothes and hats – but rather that in cold damp conditions the ink did not dry; it could remain wet for days. This slowed production and introduced the possibility of large-scale blots and inadvertent smearing. Oderic Vitalis, a monk in eleventh-century Normandy, noted that he had a pan of glowing coals next to him as he wrote – to dry the ink, we think, rather than to keep himself warm.

The techniques of early medieval gilding are not well understood today. The gold on Anglo-Saxon and Romanesque books glisters rather than gleams, and has a granular quality that suggests it is laid upon a base of gums or resins. Gilding from the twelfth century onwards, however, appears to be laid on a ground of gesso – a plaster base supplemented by white lead with the addition of a glue (perhaps glair – made from beaten white of egg) to bind all the elements together, and thus providing a surface that can be polished smooth. Sugar or honey is added to the mixture, providing moisture-retaining properties and the necessary tack to make the gold leaf stick. A little colour, often Armenian bole, a fine red clay, is combined with the gesso so that scribes can see the shape of the designs they are writing, against the whiter background of the vellum.

Books were made by stitching together a stack of smaller gatherings of pages made from units of up to sixteen pages at a time; then the whole assembly would be placed between wooden board covers which were in turn often covered with stamped or even jewelled bindings in metal or leather and fastened shut with a clasp. They were kept in chests, armoires, or on lecterns, ready for use in church services and for reading aloud during meals in the monastic refectory, and they could be borrowed for private reading.

The great revival of monasticism, for which the monastery at Cluny (founded 911) had been the standard-bearer, saw its full flowering in the eleventh and twelfth centuries. Between 1066, the date of the Norman

conquest, and the accession of the Plantagenet King Henry II in 1154, the number of monasteries in England rose from just under fifty to over 500 and the numbers of monks and nuns rose accordingly by seven or eight times. All this implies a large amount of literary activity, the creation of libraries and service books, the securing of legal titles to land, and the institution of monastic schools. The Carthusian order, who lived as close as possible to a hermit's way of life whilst sharing communal buildings, took the copying of books as their main work. Some of the new monastic movements brought their own particular aesthetics to their calligraphy. Under the influence of Bernard of Clairvaux, the Cistercians stripped the florid and colourful Romanesque book down to its essential architecture. Cistercian Statutes of 1131 required initials to be made without illustrations and with one colour only. The results can be confident displays of pure penmanship which extend, in the Low Countries, to the initials within the text. Based upon pen-flourished rustic letters, these capitals prefigure and perhaps introduce the pen-made gothic capitals we see paired with lower-case blackletter (or *textura*) writing one century later.[30]

What was the attitude of these monastic scribes? The Rule of St Benedict can be taken as speaking for them when it states:

> If there be craftsmen in the monastery let them carry on their craft in all humility, subject to the approval of the Abbot. But if any one of them become conceited because of his knowledge of his craft, which is apparently bringing profit to the monastery, he is to be taken away from his craft; nor is he to come back to it, unless, after he has shown humility, the Abbot gives him a new permission...With regard to the prices charged, the sin of avarice must not creep in; but whatever is sold should be a little cheaper than is possible for lay-persons, 'so that God may be glorified in all things'.

Commenting on this passage, David Parry, a monk of our own times, has written that Benedict is reminding his monks and nuns that 'The monk is essentially God's workman, and if that character is imperilled, the craft may have to be suspended.'[31] Increasingly, in the eleventh

century, it was not only monks who were literate. Administrations in different parts of Europe began to employ writing on a more systematic scale. Indeed the most significant development for writing in western Europe during the eleventh, twelfth and thirteenth centuries was the growth of writing as an instrument of legal authority rather than simply as a resource for contemplation.

Legal texts: Domesday, charters, writs

In England as in Europe, kings going back to the early Anglo-Saxon and Merovingian periods had, following Roman precedent, used charters to confirm the granting of land and privileges, and royal letters to confirm taxes or administrative orders; but nothing like the systematic compilation of information that the Domesday Book represented had been seen in Europe before. Researched and compiled during the course of 1085 to 1086, this book represents an astonishing achievement. In part it appears to be an attempt by the new Norman administration of England to survey the state of the realm and to definitively establish the rights and obligations it was owed. The book was called Domesday for it seemed to issue a judgment on all things, from which there was no appeal. According to the *Anglo-Saxon Chronicle* it was in the winter of 1085 at Gloucester that William the Conqueror sent men all over England to inquire what or how much each landowner had in land and livestock, and what it was worth. 'So very narrowly, indeed, did he commission them to trace it out, that there was not one single hide, nor a yard of land, nay, moreover (it is shameful to tell, though he thought it no shame to do it), not even an ox, nor a cow, nor a swine was there left, that was not set down in his writ. And all the recorded particulars were afterwards brought to him.'[32]

Domesday has come down to us in two parts: Little Domesday, which covers the counties of Suffolk, Essex and Norfolk, and the main book, Great Domesday, which covers the rest of the country excluding the far north and some major towns such as London and Winchester. Officers of the King collected evidence from every other part of England down to village level: 13,418 towns and villages are listed and the entries record who lived on what land, the rent they paid, the amount of ploughland,

pasture, meadow and commons, the mills, woodlands and fisheries that the village or manor contained, its value then, and before the Norman invasion. In his book *From Memory to Written Record*, Michael Clanchy[33] contrasts the Domesday Book with the advance in documentation two centuries later when, around the year 1300, in the reign of Edward I, bailiffs are urged by books on good management such as Walter Henley's *Husbandry* to make a record each autumn which lists 'each tool and horseshoe and everything that remains on the manor great and small'. By the fourteenth century writing has become something available at the village level, not just in the courts of kings and bishops. Yet these kinds of records – the list – depend for their effectiveness not just on the ability to gather their content, but also on their recognition and accessibility as a searchable archive – something that does not happen to Domesday until a century or more after its original compilation, when we finally see it being referred to in judgments in the royal courts.

Charters and writs are the most ubiquitous of medieval documents. Whereas we have just under 2,000 of them surviving from the whole Anglo-Saxon period, in the thirteenth century one single register from Lincoln Cathedral contains no fewer than 2,980. One estimate of the total number of charters produced in England in the thirteenth century puts the figure at 8 million, for by this time serfs – the ordinary peasantry – and not just the King and his nobles were using written instruments to define their property rights and obligations.[34] They even had their own seals. Charters as a documentary form really took off when they began to be seen as proof, in their own right, of the events they described. The advantage of the addition of a written charter to a gifting ceremony was that it listed the witnesses to the event as well as its terms and so, if at some future date the gift were disputed, the team of witnesses could be summoned to testify on oath to the original gift. Because over time this system worked, the witnesses turned up and their oaths were reliable, eventually the production of such a document became sufficient in its own right. The moment when this move occurred, and the emphasis shifted from living testimony to the stand-alone document itself, varied from place to place with the rigour and stability of the documenting procedure. In the case of a large stable institution, such as the monastery

of St Gallen in Switzerland, the widespread use of charters is attested to from as early as the ninth century: the abbey archive has 839 charters dating from before the year 920. They had the literate personnel ready to hand to write them, teams of witnesses to authenticate them and the backing of rich ceremonial to give them force.[35]

In addition to the use of witness lists, charters could also be authenticated by being written in multiple copies. The chirograph was a double copy written on one skin of parchment with a band of carefully drawn letters separating the two texts. The sheet was cut down the centre of the band, so that only authentic originals would match when the two halves were brought together by disputing parties. Seals affixed to the documents could also strengthen their claim to be authentic, and as time went on notable chanceries such as those of the Pope or Emperor developed their own distinctive and exaggerated calligraphy, making forgeries more difficult.

Different genres of document were more or less susceptible to the shift to written evidence from spoken testimony. For instance, until well into the Middle Ages laws were announced in England by proclamation, by town criers in the streets or royal messengers in local courts. The general population could not be expected to be familiar with a written text, and manuscripts were not available in large enough numbers to be widely distributed. One of the earliest records of a document in medieval England being posted up for the public to read was in 1279, when Archbishop Pecham required copies of Magna Carta to be posted on the doors of every cathedral and collegiate church. Copies were to be renewed each spring, but, alarmed at the implications of this mass availability, the Crown soon demanded their removal.

Universities and schools

Whereas a monastery could easily draw on a pool of scribes for its documenting and book-writing activity, where did the increasing lay bureaucracy come from? In England, evidence for schools outside the context of monasteries and aristocratic households dates from shortly before the year 1100. Some time between 1085 and 1087 Lanfranc, the

Archbishop of Canterbury, sanctioned St Gregory's church in Canter-
bury 'to hold within the enclosure of the Church, schools of grammar
and music for the city and its villages'.[36] There are similar charters for
schools in Gloucester, Thetford, Warwick and Colchester. This relatively
wide geographical distribution suggests that the practice may have been
more common than the otherwise small number of surviving founding
charters suggests.

On the continent of Europe it was from the schools formed through
Pope Gregory VII's reform of the Church that the first universities were
to grow: Bologna in 1088, Paris around 1119. The University of Oxford
dates its foundation from 1167. With the exception of Bologna, which
specialized in law, the syllabus of the new universities had been estab-
lished many decades earlier in the premier cathedral schools of France
– Chartres, Laon, Auxerre and Rheims. Rooted in the classical world and
ultimately in Pythagorean thinking, learning was split into three initial
subjects and four subsequent areas of study. The 'trivium' established
the basics: grammar, logic and rhetoric. The 'quadrivium' was the study
of quantity, mass and measured proportion in arithmetic, geometry,
music and astronomy. Finally a student might graduate to the highest
studies of all, philosophy and theology. It was Gerbert of Aurillac (946–
1003), later Pope Sylvester II, who taught this syllabus for the first time,
at Rheims. Gerbert had been profoundly influenced by a period of study
in Spain, where his Abbot had sent him to learn mathematics. He intro-
duced Arabic numerals to the west, as well as reintroducing from the
Muslim world the abacus and the armillary sphere, an astronomical
instrument. It was contact with the Arab world in Spain, Sicily and
the Middle East that gave the universities much new material to work
with, including both texts of Aristotle lost to western Europe since late
antiquity and new mathematical understandings: Leonardo Fibonacci
from Pisa (c. 1175–1250), probably the greatest European mathematician
of the Middle Ages, owed his knowledge to his education as a young
man in Algiers, where his father was consul-general.

Just as the growth of the monasteries had meant an additional
requirement for books, so too did that of the universities. In response to
the straitened circumstances of a student's life, scripts became smaller,

parchment thinner and books reduced in scale.

In the thirteenth century an ingenious system for copying texts – the piece, or 'pecia', system – was introduced at several universities in France, Italy and England. Approved stationers held copies of books that had been checked by the university. These were broken into loose unbound sections, which could be hired out for copying by students or professional scribes. A copy of Thomas Aquinas's *Summa Contra Gentiles* which, in a manuscript surviving in the Bibliothèque Nationale in Paris (Paris BN ms. Lat. 3107) we can see is divided into fifty-seven parts, could potentially be worked on by fifty-seven different individuals at once. In the time in which it had taken one scribe to copy the entire book, fifty-seven could now be produced.

The most important impact of the academic turn of mind that the foundation of the universities represented was a changed relationship between readers, writers and texts. Whereas monastic readers were expected to live with a book and immerse themselves in its wisdom, the academic began to question the authority of the text, to collect up parts of different works in assemblies of Church law or commentaries, and to compare and contrast different opinions. Peter Abelard (1079–1142), one of the charismatic teachers at the University of Paris, wrote a book, *Sic et Non* ('Yes and No'), consisting entirely of opposing statements from the Church Fathers, arranged without commentary on opposite sides of the page.

Reading as rapture

In embracing the arrival of a scholarship we might recognize as more akin to the modern mind, we should not however underestimate the richness of the tradition it was replacing. One of the last teaching resources from the old era is the *Didascalicon* of Hugh of St Victor, written about 1128. St Victor's was a small community of priests on the outskirts of Paris who adopted a common rule of life. The community had grown up around the hermitage of William of Champeaux, a gifted teacher. St Victor's was one of the schools from which the University of Paris was eventually formed. The *Didascalicon* ('On matters instructional') is a handbook

on the art of reading, whose goal, Hugh asserts, is wisdom itself. In a world that believed in one God ruling all, wisdom was the perfect good, wisdom was God, and it could be journeyed into and dwelt within, in all its demanding and healing fullness. This was why a book could be lived with at ever-deeper levels of meaning, not just mined quickly for information.

With the ultimate source of all knowing and knowledge being God, the practice of virtue was an essential part of a course of study, and the virtue of humility was the beginning of wisdom. In his *In the Vineyard of the Text*, Ivan Illich's commentary on Hugh's *Didascalicon*, Illich summarizes Hugh's advice to the new scholar: 'First…hold no knowledge or writing whatsoever in contempt.' Secondly, do 'not blush to learn from any man' and thirdly, once one has attained learning, do 'not look down upon anyone else'.[37] Hugh encourages the student to place all his learning within an imaginary 'arca', a chest, within which the student imagines avenues of columns, like a cloister, stretching to the horizon and within which the reader places his knowledge in order. Hugh was taking the arts of memory pioneered by the rhetoricians of ancient Greece and Rome and applying them, not to public speaking, but to reading and the search for knowledge of truth and goodness. The *Didascalicon* urges advanced students to construct a three-dimensional building in their minds; this is where they will store their knowledge of Everything. The building is structured around the greatest story Hugh knew, that of the creation, God's indwelling within it and its eventual consummation at the end of time. This was a medieval 'theory of everything', and everything the student learned he had to place somewhere within this process of salvation.

This is not so difficult to do as it sounds. Think of a building like Chartres Cathedral, with the arches around its north door depicting creation and around the south the Last Judgment, and its windows telling the stories of the prophets and kings and New Testament writers. This is in effect a giant encyclopaedia, built in space and time from stone, glass, wood and pigment. And think how minutely we might know the architecture of a favourite computer game, its rooms and corridors, pits, galleries, secret entrances, its objects and exotic inhabitants,

its layers. All this we can hold in our minds; but in the medieval mind these 'palaces of memory' were constructed deliberately, and all student learning was to be placed carefully within it, as symbols and quotations, relationships, stories and the order of one part to another, the micro-cosm of individual experience mapping itself as one grew in wisdom on to the macrocosm of creation. This is an immensely sophisticated way of dwelling with all one knows and learns. Following Pope Gregory the Great (540–604), Hugh describes three phases of inner digestion: learning the initial literal and historic facts, pondering on them for their allegorical meaning in the greater order of salvation history – which Hugh calls the Church – and finally recognizing one's own place within this ongoing and daily unfolding story.

The pages of books, in their simple structure, and their meditative illustrations, lead the reader to experience a kind of glow, a ripple effect of meaning, a burning within rather than the acquisitive satisfaction of having covered some ground and gathered some information. The liter-ary object that gives us the closest parallel to this experience today is perhaps the novel, where we enter an imaginary world and find ourselves identifying with an author's characters and, to borrow a phrase from Gandhi, 'their experiments with truth', which we then as readers place ourselves in relation to.

Ivan Illich's commentary on Hugh's work depicts the context within which this reading happened. These texts are the works a monk lived with, principally the scriptures and works of the Church Fathers, and they were choreographed in a cycle of daily readings throughout the year. Each week the full Psalter of 150 psalms would be sung during the daily services in the monastic choir. The reading and singing were embedded into one's physical memory, not only by the way the text sat on a page but also as songs sung or words listened to in procession or standing and sitting in choir, or in the refectory. There would be words remembered because of the season they are chanted in, or because they are sung at that point in the year as the rising sun streams through a particular window of the church, or during the frost when the church had a different echo, or when the swallows are preparing to leave, or at times of feasting or fasting; and one would know the different kinds of

'reading' that suggested themselves to one in the ecstatic privacy of a night vigil, as opposed to the shared silence after breakfast before the morning office. And the reading and chanting would be punctuated by bows or genuflections, turning to face different directions, now towards the altar, now facing one's brethren, now on one's knees, now seated. One would hear the crackle of the pages as they turned at a particular point, the flash of gilding and colour, the same illuminations by candle-light and sunlight or in the cool reflected light of snow. Public readings were sung out in particular chanted tones – one for the gospels, one for the epistles or the prophets – and all this would soak into one's memory, helping the remembering and building up a texture of associations over the years, as one grew in wisdom, or discomfort, or simplicity. As a former monk I know this, I've lived it, this isn't theory, this is how 'reading' can be. It's a very different process of steeping oneself in a *few* texts, rather than extending oneself in a search across many.

But Hugh was living at a moment of change. Already the world he grasped was slipping away and he himself was partially living out new patterns. The community he lived in did not follow the rule of St Bene-dict but that of St Augustine – a rule for shared community amongst ordinary clergy living in an urban context, originally that of the late Roman world. Hugh's community was in a suburb of Paris, not an isolated valley or inaccessible desert. He was teaching not only novice monks but also young adults who were flocking to Paris from across Europe. It is a curious irony that often it is only at such transitional moments, when something that was a 'given' begins to give way to something new, that the previous order can be seen with new clarity and purpose.

The book page as an experimental space

It was under Anselm of Laon (d. 1117), some time just before 1100, that a new kind of written artefact – the 'glossed' book – was developed. The glossed book contained the main text – such as the Psalms or the letters of St Paul (the earliest to receive this treatment) – and then around it, in sepa-rate columns of smaller writing, were arranged selected commentaries

on the central text, compiled from the works of Church Fathers (Fig. 18, p. 66). There was also space for interlinear quotations and comment. In effect one had four or five works by different authors arranged on a single page. Every page of these books required a different layout within the overall rules the scribe had established. By around 1135 all the books of the Bible had commentaries, and by the mid-thirteenth century this was also true of books on philosophy, law and medicine; such books were also being designed with lightly ruled-up marginal columns, to allow successive readers to add their own comments as they read. At the same time a more sophisticated scholarly apparatus was introduced.

Books such as the Bible were now divided into standardized chapters for greater ease of reference; manuscripts had running titles along the top of the page and catchwords that allowed you to preview the next word on the following page. Methods were developed for highlighting quotations, summaries of arguments were included at the beginning of sections, and scholastic writers such as Thomas Aquinas (whose lovely but appalling handwriting has to be seen to be believed – surely the best case of the mind running ahead of the hand) introduced a clearly formatted logic to their writing that made an argument easier to follow and put together. Speed of use and reference was becoming preferable over the slow monastic rumination upon a text, and it was no longer sufficient to merely highlight new themes with the introduction of a coloured initial or an illuminated painting.

From the mid-twelfth century the main text hand in glossed books begins to show an extension of the tendency to compress forms which we first noted in the second decade of the eleventh century in manuscripts from pre-conquest Canterbury. Now, as a consequence of this trend, and anticipating a parallel development in architecture, the robust semicircular arches at the tops of letters like lower-case **m**'s and **n**'s begin to develop a more graceful pointed arch. By the end of the twelfth century this pointedness becomes angular, and in the thirteenth century these letters begin to lose their curves in favour of abrupt changes of direction made from straight or only very subtly curved strokes, and the internal letter space or 'counters' under the arches of **m** and **n** look less like a cathedral's gothic arch and more like the triangular roof of

Fig. 19. Gothic *textura quadrata* writing, 14th century.
The small **q** half way down on the left is an unfulfilled instruction
to the illuminator that a **q** needs to be painted here.

an ordinary town-house (Fig. 19). At first sight one wonders where this fashionable form comes from until one realizes it is expressing, in calligraphic terms, the same breaking down of structures into clearly defined logical components in which the age of scholasticism excelled.

In the most carefully formed scripts of this period right across Europe (for the style becomes 'international') the formal finishings to the feet of letters are drawn with the corner of the nib to finish flat and flush with the baseline; these were called *textus prescisse* or cut-off letters by the scribes – or sometimes *textus sine pedibus*, 'letters without feet'. Small glossed hands on either side of the main text are written in a much more cursive style – a style we see in documents coming out of royal administrations, and in the fragments of daily handwriting that have come to us in account books, lists and letters. It is characterized initially by simplified letterforms, written quickly at a small scale and so without elaborate serifs; and then with fewer and fewer pen lifts happening within and between letterforms, so that letters become ligatured and words sometimes are heavily abbreviated. This renewed interest in developing cursive scripts, after many centuries of neglect, reflects not only the increased pace of business and a wider use for writing, but also leads to a proliferation of writing styles. There are many regional

variations in cursive scripts between countries, universities, and other national and regional organizations, it is a time of experiment and diversification. The use of the quill pen, as opposed to a reed, accounts for some of the differences between this medieval cursive writing and that which developed in Roman times. It is possible to write smaller with a quill and its nib is much more flexible. This feature is exploited by the medieval scribe to give a play of light and heavy strokes to the script, swelling long letter **s**'s and heavily looping **d**'s. Furthermore, vellum, being a smoother surface than papyrus (which has a slight grain), facilitates a different range of pen movements.

The variety of both cursive and formal scripts seen during the High Middle Ages can seem daunting to those who must classify them. The description of hands is complicated by the fact that at least three communities have an interest in naming them: palaeographers, printers and calligraphers. However, several medieval writing masters' advertisement sheets exist, and they show us how they themselves distinguished certain families of writing. All bookhands followed roughly the same narrow letterform, but what varied were the serifs – the way pen-strokes started at the top of a letter and finished at the bottom (Fig. 20). Gothic bookhands were graded. *Prescisse* was the most formal and expensive script; it has diamond-shaped tops to the main stems of letters such as **i**, whilst the foot is generally flat. *Textus quadratus* is the next grade and it has diamond-shaped tops and bottoms. *Semi-quadratus* has a curved introduction to the letter but diamond-shaped feet; and *rotunda*, associated mostly with manuscripts from Italy and Spain, has curved tops but feet like *prescisse*, and these letters – although compressed – still keep

Fig. 20. A study of four **n**'s indicating the different families of formal Gothic bookscript.

Fig. 21. Calligraphic study of a Gothic cursive
bâtarde hand, written in Bruges 1482.

more of the curve in the arches of letters and in letters such **c**, **d**, **e**, **g**, **o**, **p**, **q**, **s** and **u**. Beyond these forms, there are hands for glosses – simpler versions of bookhands and hands for notaries and secretaries – called *secretary*, *bastard* or *cursive* hands (Fig. 21).

Illumination and the Book of Hours

No medieval book, even of the poorest kind, was complete without some illumination, be it a simple capital in red or more rarely a flash of gold leaf. The materials used by illuminators in the High Middle Ages (the thirteenth to early fifteenth centuries) changed little from those used by their forebears in the great Bibles and glossed texts of the preceding two centuries; it was their styles and methods of work that evolved. Here, as with letterforms, an international style developed. It radiated out from France from the first quarter of the thirteenth century. Its centre was Paris, where the trade benefited from continuous aristocratic and royal patronage. The illuminated border of knotted and spiky foliage grew beyond just decorating the initials to encircle the text. Paintings were enhanced with shading and highlighted in fine white lines made with the highly poisonous white lead pigment. Treatments of faces, drapery and landscapes became more naturalistic. Raised and burnished gilding had patterns stamped into the still damp gesso base that enhanced the glitter of the surface.

For the first time we have pictures of scribes at work that are realistic portrayals of their working conditions. No longer seated in draughty

cloisters, they have moved inside, the windows are glazed, fires are lit in the grate. Nonetheless, signs of the cold (an ever-present preoccupation of those with sedentary occupations in northern climates) can be seen in clothing with high collars, fur capes and scarves, hoods and hats, benches with tall backs that act as draught-excluders and rush mats or wooded platforms placed under the feet. The raised platform has the additional benefit of just lifting the underside of one's knees off the edge of the chair, preventing leg pain. Benches allow the scribe some play left to right as you move across a document. Writing desks are shown steeply angled, at between 40 and 60 degrees, raising the work towards the eyes to forestall the back pain and stomach cramps that can occur when one works for hours in a stooped position. The raised board means the pen approaches the page at an almost horizontal angle; this is the secret behind the ease with which the medieval scribe wrote. The position allows the quill to be loaded with ink. Gravity is no longer a problem with a horizontal rather than a vertical pen shaft, the ink is not pouring on to the page and the nib's broad edge can easily be rotated or twisted round corners without losing connection with the writing surface; the *prescisse* or cut-off version of gothic *textura* is easily made in this position.[38]

Paints are kept in shells on the side and inks, usually just black and red, are placed in ink horns that sit naturally at the right angle in holes bored into the writing desk. One of the most splendid portraits of medieval scribes at work is that of Jean Miélot, the scribe and translator to Philip the Good of Burgundy (1396–1467).[39] His desk is supremely practical. I wrote on a reconstruction built at Tokyo's Keio University when I first visited Japan in 1997. The position of the ink horns meant one's posture was never disturbed with the twists and turns that usually occur if the ink is placed on the level surface of a desk. Here it is exactly at the same level of the line of writing, and inking the pen was made with only a minimal disturbance to writing rhythm. A small lectern placed above the board at the level of one's eyes created a similar sense of ease in copying a text. A lead weight that could be moved up and down the copy, and which held the pages flat, also meant it was easy to keep one's place.

By the mid-fourteenth century spectacles had been invented; one late scribal portrait of the Flemish illuminator Simon Bening of Bruges

(1483–1561)[40] shows him seated at his board with a pair of *pince-nez* held in his left hand. But the earliest representation dates from 1352 in the chapter house of San Niccoló's Monastery in Treviso, near Venice. Three different reading aids are shown, including a reading lens with a handle (known from at least a century earlier), and the next step towards the spectacle, a reading lens on a stand. The earliest form of reading aid was a glass placed directly on the page. Additional light could be focused on work using the lens on a pivot or a large globular clear glass jug, filled with water.[41]

Scribes out 'in the field', beyond their workrooms, had much lower angled portable writing desks for their use. The carvings of Pythagoras and the grammarian Donatus on the Portail Royal at Chartres Cathedral show them writing with such boards in their laps. Tools, the quill knife, pens and ink were carried in cases slung on a belt. At the opposite extreme of portability was furniture like the ledger desk seen in a fifteenth-century manuscript of the *Roman de la Rose* (BL Harley 4425). The substantial carved desk is built on an entire raised wooden platform. A large ledge runs along the bottom of the sloped board desk, enabling scribes to write in bound books. Receipts hang from a nail above the desk. The scribe is using two colours to write with, red and black; a second quill (perhaps for the second colour) is tucked behind his ear. This desk is made for an institution in which writing clearly plays a significant and regular role.

Two developments in the sphere of the book in the High Middle Ages catch the eye. The first is the vast increase in the number of books that are now available stimulated by the rise of the universities and a more literate lay population. In response to these changes the book industry moved out from the monastic setting and into lay production in the towns. This in turn facilitated the introduction of non-Latin secular texts. The age of the troubadours lived on in a string of romances: stories of the Knights of King Arthur, the deeds of Alexander, and *The Romance of the Rose* (a young man dreams of falling in love with a rose which he finally wins by breaching the Castle of Jealousy).

From the early thirteenth century makers and sellers of books began to congregate in towns where specific areas became known for their workshops. In Paris it was the rue Neuve Notre-Dame, which ran between the

Royal Palace and the Cathedral of Notre Dame. In London, but on a much lesser scale, booksellers gathered around Pater Noster Row, within the shadow of St Paul's Cathedral. The closeness of the workshops and the quantity of material being ordered from them encouraged specialization. Work could be carried from shop to shop. Some studios specialized just in coloured initials, miniature painting, text production or calendars. Booksellers became more like impresarios, putting together a product that was assembled from a number of parts they had specially commissioned from a variety of people. This, together with the rise of several generations of bibliophiles such as King John II of France (1319–64) and his sons Charles V (1338–80), Louis of Anjou, King of Naples (1339–84), Philip the Bold of Burgundy (1342–1404) and Jean, Duc de Berry (1340–1416), as well as Philip the Good of Burgundy (1396–1467), led to the full, and alas soon to be final, flowering of the illuminated manuscript as a luxury product, the pinnacle thus far of the book as a sensuous object.

Emblematic of both these developments, that is the increased quantity of books and the popularity of illumination, was the Book of Hours, developed in Oxford around the year 1240 by William de Brailes.[42] This was the one book that a relatively prosperous family might aspire to own. But books ranged from exclusive luxury manuscripts such as the *Très Riches Heures* of the Duc de Berry, made between 1411 and 1416 with full-page illuminations by illustrious painters (the Limbourg brothers: Paul, Herman and Jean), to standard products turned out from the manuscript workshops of Europe in the thousands. Though such books never had huge appeal in the German-speaking parts of Europe, they were extremely popular in France, the Low Countries and England, and sought after in Spain and Italy.

Psalters (books of psalms), missals containing the order of the Mass, romances like *The Song of Roland* and *The Romance of the Rose* were made in similarly elaborate decorated forms from the mid-thirteenth century onwards. These books were not made to be put away on the library shelves but to be read from in public, to be displayed. This was why they contained paintings, decorated borders of brightly coloured and gilded leaves and flowers, strange capering beasts or birds and elaborately patterned initials. Some of the larger books contained an

astonishing number of these elements. One volume of a four-volume copy of Vincent of Beauvais's *Speculum Historiale* (Historical Mirror) that was made for the young Prince John, later King John II of France, in 1337 had 450 miniatures. A *Bible Moralisée** made for the same king in the mid-fourteenth century has 5,122 miniatures.[43] The Parker Librarian, Christopher de Hamel, has estimated that if one gathered together all the surviving books attributed to the Parisian workshop of the Boucicaut Master, named after the Book of Hours he illustrated in about 1405–8 for Maréchal Boucicaut (Musée Jacquemart-André, ms.2), they amount to over thirty-two manuscripts covering a fifteen-year period. As they contain just over 1,800 miniatures, we can see that the workshop was completing at least two a week, but this total comes only from the manuscripts that have survived.

Books of Hours were books to pray with rather than to study. They represent cut-down versions of the breviary, the thick book that contained the short services recited by churchmen, monks and nuns, eight times a day throughout the year. This was monastic culture for lay people. The book held the same core of services but without the seasonal variations and additional readings. Lay people recited the hours to themselves, or in household groups; they might also go to a church, perhaps with a friend, and recite the prayers together. The form of each short service was identical. It opened with a hymn and was followed by two or three psalms. There was a brief verse from scripture (called an antiphon) at the beginning and end of each psalm, which highlighted its significance. This was followed by a brief, reflective Bible reading. Finally one's awareness turned back to the world at large with prayers for the needs of others. Often a further cycle of prayers was included at the back of the book, a day's worth of services for the dead which one could use to pray for the souls of departed friends and family on specific occasions, such as their anniversaries.

Surviving paintings show that these books were often wrapped in a cloth chemise with weighted corners that allowed them to be wrapped

* A later name for a Biblia Pauperum (poor person's Bible), an illustrated Bible that taught in words and pictures.

up and carried safely. Owners, many of whom from surviving inscriptions seem to have been women, wrote their family's birth and death dates in them, and they come across as very personal objects. Eamon Duffy, who wrote a study of such 'primers',* *Marking the Hours*, describes the moment when looking through a calendar, a feature that often begins these books, he saw a handwritten inscription by 27 November,† 'My moder departyd to god.' Duffy's own mother had recently died and 'for a moment the centuries between me and the fifteenth century book-owner were gone, swallowed up in the universal human experience of loss'.[44]

Even when the production of such books was organized in a commercial manner, as in Paris in the fourteenth and fifteenth centuries, individual books might still be personalized by their owners. Additional prayers were added in ordinary handwriting and friends might also write in requests for prayers. There is a faint echo of the phenomenon we know from Facebook today; clearly some owners have set out to collect prestigious 'friends'.

The period of Paris's ascendancy in the book trade coincided with the Hundred Years War with England. Following the Battle of Agincourt in 1414, civil war broke out in France and in 1420 Henry V of England occupied Paris. The age of the great illuminators was over, and most fled to the provinces.

In the rest of Europe, whilst illuminated manuscripts were also made at this time in Prague, many parts of Germany, Austria and Switzerland, Italy and Spain, the trade was not organized on such an industrial scale as in France. In these other countries monastic production was still strong quite late into the period. There were also subtly different design influences at work. The Byzantine tradition of painting was still strong in Italy and parts of Germany. The different flavour of Italian manuscripts is also due to the more open texture on the page that a gothic rotunda script creates. In Spain Hebrew and Arabic book arts existed alongside

* Named after the first service of the day, 'Prime'.
† Realizing this was also the date on which *I* wrote *this* passage, I got up and went to light a candle in my room; as I did so my eye was caught by the first flake of snow beginning to fall outside, and again time stood still.

the Latin, and both French and Italian traditions were influential.

The Book of Hours survived longest in Flemish workshops, well into the sixteenth century. The style of illumination changed again, this time towards illusionistic borders with *trompe l'œil* flowers, fruit and insects on powdered gold backgrounds. By the fifteenth century such books were made in considerable numbers. Evidence discovered by the palaeographer Gerard Lieftink in a manuscript from the University of Leyden (B.P.L. 138) dated 1437 clearly shows an order from a bookseller to the chief copyist of a scribal workshop. The invoice is for 200 copies of the seven penitential psalms, 200 of Cato's *Disticha* in Flemish, and 400 copies of a small prayer book. These are quantities that are similar in number to those of an early printed edition.[45]

Documents for business and banking

It was not only scholarly, literary and bureaucratic life that burgeoned from the thirteenth century onwards, but also the forms of writing and documents employed by business. It was the great trading cities of Genoa, Venice, Florence and Bruges that took the lead. The letter of credit, the origin of our modern banknotes, developed towards the end of the thirteenth century, as did simple insurance schemes. Merchants took instruction in reading and writing standard phrases, mostly in the vernacular, solely for the purposes of carrying on their businesses. Banks themselves came into being, named after the trestle tables and benches on which they did their business in the Florentine market-place. And finally book-keeping techniques grew in sophistication, with double-entry book-keeping being used by a number of Italian banks, from possibly as early as 1300, though the system would have to wait for its full elaboration and popularity till 1497. It was then that Luca Pacioli, a Franciscan friar (paradoxically vowed to poverty) who also was teacher of mathematics to Leonardo da Vinci, published a systematic account of book-keeping in his textbook printed in Venice, *Summa de arithmetica, geometria, proportioni et proportionalita*.

Alongside this growing use of documents by business, banking houses, universities and law courts, there was a need for a more

accessible postal service. Throughout the Middle Ages letters had been sent across Europe by personal messengers retained for the purpose by royal and noble households, town councils, universities, monastic houses and merchant companies. Messengers were paid at the outset of their journey and might expect some reward on delivery. Journey times were not unreasonable. Letters sent by the Riccardi banking family from London to Lucca in 1300 took about five weeks to arrive: we know that a letter written on 24 February 1300 arrived on 5 April, and another composed on 8 August was delivered on 22 September.[46] The Italian companies in particular would often carry letters for other private users. For those without connections to one of these institutions, the normal conveyance for letters was through private agreement with the local carrier or cart service. In Britain market towns were an average of seven miles apart in all directions, and the carriers who came to market formed a nationwide network, supplemented by those who travelled longer distances to visit the annual fairs, like that of St Giles in Winchester or St Cuthbert's in Durham. By the late thirteenth century the University of Paris had its own system for sending letters and packages, which was also open for public use. The Roman system of horsemen and staging posts was reintroduced by several European rulers. One family, the Taxis from Bergamo in Italy, who from around 1290 had been acting as couriers between Italian cities, established a Europe-wide service in 1489. By 1500 it was based in Brussels and had more than 24,000 horsemen carrying its mail; this service was maintained into the eighteenth century.

At so many turns of the history of writing in western Europe there has been a hidden *deus ex machina*: Italy. At crucial moments inspiration has come from Italy's vast reservoirs of libraries, its surviving administrative systems, its people, its trading cities with their wide-ranging contacts from North Africa to the Middle East and beyond, its architectural heritage, and most of all, its history of the imagination as the cradle of western European civilization (rooted, lest we forget, in Greece, and travelling and diversifying via Constantinople and Arabic scholarship). At this point in our story Italy is about to have its second finest hour, but first – a tragedy.

The New World: Script and Print

Fig. 22. Detail of a page from a Roman Grammar, printed by Nicholas Jenson in Venice, 1476, with marginal annotations by the humanist scholar Pomponius Leto.

There were dead bodies all over, and all were treated in pretty much the same manner by their neighbours, who were moved no less by fear that the corrupted bodies would infect them than by any pity they felt toward the deceased. They would drag the dead bodies out of their homes (either themselves or with the aid of porters, when they could get them) and left them in front of their doors. In the morning great numbers of them could be seen by any passerby...[47]

So wrote Boccaccio in the preface to his *Decameron*, begun in 1349, the year after the great plague arrived in Europe. By the end of the pestilence in Florence, where he lived, between 40,000 and 60,000 people had died: up to 60 per cent of the population. The city would not be as populous again until the eighteenth century. Scholars put the global impact of this first wave of the plague at 75 million deaths.

'Oh happy people of the future, who have not known these miseries and perchance will class our testimony with the fables,' wrote Petrarch to his brother Gherardo, a Carthusian monk of Monrieux in Provence. Gherardo was the sole survivor from his community of thirty-five, and had stayed on with his dog to guard the property; Petrarch, a leading scholar, poet and diplomat, had seen out the storm in Parma. Already he was playing a crucial role in the next great unfolding of intellectual life in Europe – the revival of classical learning.

Petrarch and humanism

Francesco Petrarca (Petrarch in English) was born near Arezzo in Florence in 1304, and his studies had culminated in law at the University of Bologna from 1323 to 1325. When his parents died, Petrarch gave up his legal studies and returned to the family home near Avignon, where his father, a political exile from Florence, had settled to be close to the papal

court.* Petrarch then began to follow his real love: a passion for books, poetry, history and a fascination with all things Roman, interests that had first arisen in his early adolescence. By accepting an honorary position within the Church and living simply, Petrarch was able to give time to these private concerns. His project was extraordinary in its scope: he would attempt to re-imagine the classical world. 'My mind,' he wrote in a letter to posterity, 'is characterized by a certain versatility and readiness rather than strength'.[48] He was an enthuser, an initiator, but because he combined a poet's imagination with a scholar's concern for accuracy – a well-balanced intellect, as he himself put it – his work could readily be built upon. He read deeply. His emotional life could be turbulent, ruled as it was by love for Laura, a woman, recently married, whom he saw first at an afternoon Good Friday service in Avignon on 6 April 1327. She died at the same hour, on the same day, twenty-one years later, in the plague of 1348. The love poetry Petrarch wrote to her both before and after her death has been celebrated ever since. Petrarch was the inventor of the sonnet form.

Petrarch's study of the Latin classics had made him realize how little his own age knew, and how narrow its vision of life and learning had become. His response was to dedicate himself to recovering as much of classical literature as he could find, collecting, collating and reading it. 'I have constantly striven to place myself in the spirit of other ages,' he wrote.[49] His imaginative recreations brought the past alive for all who met or corresponded with him. To him, Cicero, Seneca and Augustine were real people. When he discovered Cicero's letters to Atticus, which revealed that in the last years of his life Cicero had been heavily engaged in politics, he wrote a letter to Cicero's ghost and then yet another deploring his choices. In his 'Secret Book', which he kept by him for the whole of his life, he conducted discussions with Augustine on searching issues. By bringing the classical world to life in his own imagination he was able to spread an enthusiasm for it amongst a new generation.

Petrarch was not alone. In the late thirteenth century a group of scholars had gathered around Lovato dei Lovati (1241–1309) in Padua,

* Then also in exile from Rome.

where Petrarch himself lived in the later part of his life. After 1350 the writer and poet Boccaccio became one of Petrarch's closest friends, and he was responsible during the years he lived in Florence for kindling a new generation of scholars with enthusiasm for Petrarch's work and ideals in that city. This no doubt prepared the path, in some small way, for the election in 1375 of the humanist scholar Coluccio Salutati as Chancellor of the city. Under his patronage the achievements of Petrarch and his followers became rooted solidly in the dynamic of the resurgent Florentine republic.

The essence of the change of attitude that Petrarch heralded was a turning away from the scholasticism that had dominated European learning for more than a century to insist there was more to the sum of human knowledge and wisdom than Aristotelian logic. Arguments could be won, and worlds changed, not only by dialectical debate, but also by study, engagement with the arts, the emotions, imagination, poetry and other literature. All these aspects of life changed hearts and minds. In fact, Petrarch realized, there was the company of the whole of human culture to be engaged with. In this he speaks also to our own time.

In his sixties Petrarch's sight began to worsen and, much to his annoyance, he had to resort to glasses. He prized simple clear writing and made some reforms to his own handwriting. He found the manuscripts from northern Italy, from the twelfth century, easiest to read. Indeed, this late form of Carolingian minuscule is a particularly fine hand (Fig. 23). To a calligrapher's eye it is the internal spaces of the letters (the 'counters') that make them work so well. They are wide and round in comparison to the compression of the Italian hands that came after (yet evolved from them). Italian twelfth-century manuscripts also maintain the wide space between lines characteristic of most Carolingian writing,

Fig. 23. Calligraphic study of an Italian Carolingian hand,
northern Italy, first half of the 12th century.

a feature that was lost in the move to pages of closely woven texture in the thirteenth century.

Following Petrarch's example and encouraged by Salutati, who also made modest experiments in reforming his own bookhand, a new generation of humanists in Florence began to attempt the production of books written in clearer, simpler forms and a more spacious layout, based on the twelfth-century books Petrarch had himself admired. Two individuals, who became lifelong friends, made the greatest impact: Poggio Bracciolini, then in his early twenties, and Niccolò Niccoli, who was soon to turn forty.

In manuscripts commissioned by Salutati, Poggio developed the *littera antiqua* ('antique letter'), a name that stood in contrast to *littera moderna*, the gothic of the time. Although this 'antique' letter is now the one we use every day, in our lower-case roman typefaces, at the time it was revolutionary. *Littera antiqua* eliminated all traces of the gothic and reverted to rounded wider Carolingian forms, with an upright **d** and simple rounded or curved serifs at the top and bottom of pen-strokes. All these changes took place in writing that was much smaller than the average size of handwriting today. Small writing was the norm in the Middle Ages – about the same size as the type in a modern book. Of the books I have mentioned so far, the height of the main text hand in the *Codex Sinaiticus* is about 4mm; in the Lindisfarne Gospels the main body of the letter excluding ascenders and descenders is 3mm; in the Tours Bibles it is around 2.5 mm. Poggio's minuscule is around 2 mm high, with baselines on the page being ruled up at 7 mm intervals. Work for use in church or other public reading places – missals or Bibles – could be larger, but 2 mm was the standard adopted by most of Poggio's contemporaries. One change they made from the twelfth-century books they admired was that they abandoned the use of double columns of text on a page, which necessitates frequent word division, and wrote instead in a single block of text, with lines up to seventy characters long. This was one reason why a larger space was needed between lines, for a long line without space around it is hard for the eye to scan. They also tended to write words in full, dropping the heavy use of abbreviations that could so easily lead to a corrupted text.

*

The vision for book design developed by these early humanists was exacting, sometimes to the point of pedantry, as the invective of Guarino of Verona written against Niccolò Niccoli shows:

> Neglecting the other aspects of books as quite superfluous he expends his interest and acumen on the points (or dots) in the manuscript. As to the lines, how accurately, how copiously, how elegantly he discusses them…You would think you hear Diodorus or Ptolemy when he discusses with such precision that they should be drawn rather with an iron stylus than a lead one…As to the paper, that is the 'surface', his expertise is not to be dismissed and he displays his eloquence in praising or disapproving of it. What a vacuous way to spend so many years if the final fruit of it is a discussion of the shape of letters, the colour of the paper and the varieties of ink…[50]

But Guarino misses the point – a point well made, as I experienced when I read out the above passage in a talk at Xerox PARC in the late 1980s. The scientists began to laugh in sympathy! They recognized themselves in Niccoli's concern with detail and precise description. This insistence on an exacting critique of present practice and of one's own pre-formed assumptions is the ground from which new thinking springs, and it is clear from another passage in the invective that Niccoli's vision encompassed far more than the book: it extended to the whole order of classical art:

> Who could help bursting with laughter when this man, in order to appear also to expound the laws of architecture, bares his arm and probes ancient buildings, surveys the walls, diligently explains the ruins and half collapsed vaults of destroyed cities, how many steps there were in the ruined theatre, how many columns either lie dispersed in the square of stand still erect, how many feet the basis is wide, how high the point of the obelisque rises. In truth mortals are smitten with blindness. He thinks he will please the people while everywhere they make fun of him.[51]

As a close friend of Cosimo de' Medici, surrounded by young follow-ers earnestly disputing the finer points of literature, Niccoli in his long red gown (he always wore red) was an easy target. Today Niccolò Niccoli is recognized as an important instigator of developments in book struc-ture and design. Recent scholarship has placed his experiments with *littera antiqua* at the same time as those of Poggio.

In 1403 Poggio moved to Rome, where he continued to work as copyist for both Salutati and Niccoli during his spare hours. He worked now in the papal chancery. He trained up many scribes to write the new hand, set up a scrivener's business on the side and over the years amassed a substantial fortune. There was much work around. Frederigo, the Duke of Urbino, employed between thirty and forty '*scritori*' or professional copyists. For one commission from Cosimo de' Medici, Vespasiano da Bisticci, a bookseller in Florence, boasts in his memoirs that he hired forty-five scribes to write more than 200 books – which they did in just twenty-two months.[52] This was a Rolls-Royce of a contract. Careful modern examination of the accounts, however, show that da Bisticci over-egged the pudding: quite a number of books were bought in from other booksellers and some supplied second-hand.[53]

Niccolò Niccoli remained in Florence. His father had owned a substantial cloth manufacturing business in the city and when his father died, Niccoli left the running of it to his three brothers, living off the wealth he had inherited. His avidity for books became notorious; people were reluctant to lend him copies, for once a manuscript was in his hands it was difficult to get it returned. He often copied manuscripts himself and frequently found himself in circumstances where this must be done quickly. In his late fifties he evolved a hybrid hand that crossed the new *littera antiqua* (with its associated 'roman' capitals*) with the familiar lightweight Italian gothic cursive, the script that Niccoli would have learned to write in his youth. The result was an extremely rapid flowing script. The underlying rhythm of writing is from the cursive – as

* Poggio, a short time into copying manuscripts in the new style, added a capital letter script to his repertoire. It is a cross between simple roman inscriptional capitals and the version of rustics that appeared in twelfth-century manuscripts.

aedificatam euentus rebus

Fig. 24. A calligraphic study of the rhythmical qualities in
Niccolò Niccoli's hand, though in this case I have written it
with a wider pen nib than he commonly used.

in the **m**'s and **n**'s, where the pen never leaves the page but makes the
letter in a continuous, bouncing movement (Fig. 24). The basic forms of
the lower-case letters, with their slender upright ascenders, came from
the Carolingian, even though some – such as the horn-headed **e** – still
betray a gothic cursive ductus. Niccoli's innovation was to use the diag-
onal join of gothic cursive to link the Carolingian letters, which, when
written at speed, developed a natural slope and slight compression. It
is this script, soon much imitated, that gave us the italic hand. Niccoli
is one of the few individuals, perhaps the only one from the later half
of the manuscript age, who we can identify as the specific inventor of a
new script family.*

The humanist vision of re-imagining the classical world quickly
spread beyond the pages of the books in which we see its first flames
kindled. It created, as it had for Petrarch, a new perspective on life, less
awed by theology and the Church, more open to the arts as a whole. It
was lived out at every level of choice, from clothing to evenings spent
learning Latin together in the Dominican church in Florence. It influ-
enced the style and habits of painters, sculptors, architects and collectors.

Textual discoveries and inventions in the Veneto

In the mid-1450s in Padua and Verona (the north-eastern part of Italy
under Venetian influence), experiments by a number of scribes and illu-
minators resulted in a further influx of classical letters and imagery into
manuscripts. Foremost amongst them is Bartolomeo Sanvito (1433–1511).

* Another might be Eadfrith, scribe of the Lindisfarne Gospels, who both consolidated
insular half-uncials in their canonical Phase II form and invented a new range of display
capitals.

From this time book initials begin to imitate the appearance of classical inscriptional lettering; these letters are based not on the carved rustics of the Roman period, or on early monoline republican letterforms, but rather on imperial capitals. The style spread to Rome, Florence, Naples and Venice, influencing not only manuscript production but also carved inscriptions.[54] In the manuscripts they appear in the context of what scholars have called the *all' antica* style. On pages tinged around the edge with colour (just as Pliny describes the edges of Roman scrolls), with

Fig. 25. Initial **N** and portrait of Petrarch from his *Trionfi* written by Bartolomeo Sanvito with *all' antica* decoration, late 1480s.

elaborate classical architectural detail, letters are framed as if in sculptural panels, on tombs or urns (Fig. 25). There are coins, medals and other classical artefacts painted into the margins of the manuscripts. A whole antique world is now being conjured up.

It is worth pausing for a moment to explore the subtle blend of ideas, behaviour and experiences that together produce shifts like this in taste for letterform and its context. As Ernst Gombrich has pointed out, developments in manuscripts happen not simply because they are utilitarian but also because they appeal to people; their appetites, dreams, friendships, sense of self-worth and status, all that excites us. Padua in the mid-fifteenth century was a stimulating place. The painter Francesco Squarcione (c. 1397–1468) dominated the artistic life of the town. His studio, in which Andrea Mantegna the painter studied, has been described by the historian Mary Bergstein as 'a kind of workshop as exhibition-space, where objects and ideas could be visited'.[55] It made Padua a point of reference for artists. The workshop was full of classical statuary, plaster casts of limbs and torsos, architectural detail, coins, vases and antique jewellery. It was just this kind of mixture of aspirational objects that we find assembled on the pages of manuscripts in the *all' antica* style – and in Mantegna's paintings.

This blending of objects, ideas, new work and old seems to have been a feature not only of the workshops of Renaissance artists and sculptors, but also of the homes of the new scholars and patrons. Niccoli's house in Florence contained a collection of objects for use, which included fine linens, antique glass and crystal, bronzes and books. Mantegna established an archaeological museum in his house in Mantua, and Sanvito collected jewellery, antiques and richly coloured fabrics. The enthusiasm for all things classical comes alive in the story of an adventure to Lake Garda undertaken by four friends: Andrea Mantegna, the painter who included some of the first examples of well-observed classical inscriptions in his paintings;* Felice Feliciano, who compiled one of the first albums of carefully drawn Roman inscriptional capital letters; Giovanni Marcanova, who commissioned some of the earliest syllogies – books

* See his 'Triumphs of Caesar' series at Hampton Court.

recording the text and layout of known classical Roman inscriptions, and their friend Samuele da Tradete. Felice Feliciano records that their expedition took place in September 1464. They set off from Toscolano. In an old chapel of St Dominic nearby they found an inscription of Marcus Antoninus, and a little further on another from the time of Antoninus Pius. They wandered along the shore of Lake Garda, spending the weekend visiting churches and ancient ruins, including what they surmised must be a shrine to the goddess Diana, recording the inscriptions they found along the way. They picnicked, crowned Samuele as their emperor with leaves and flowers, and then, wearing myrtle and ivy and playing the lute and drinking wine, embarked on a boat for the tiny church of San Pietro at Sirmione, where they gave thanks for the twenty-two inscriptions they had found.

Sanvito, who grew up in Padua, became an expert in rendering these classical letters with his pen. His early examples, from his late teens, are stiff and brittle, but some time between 1459 and 1460 it appears possible that he visited Mantegna in Mantua. In these years his penmanship gained a much subtler line and well-knit solidity,[56] the serifs have more carefully chosen angles and straight lines have subtle curves such as those on the foot of the E. It is as if his eyes have been opened; he is seeing more in the forms of the letters and has a clearer view of his intentions for them. Sanvito went on to an illustrious career in Rome at the court of the Mantuan Cardinal Francisco Gonzaga. The influence of his roman capitals can be discerned in inscriptional work from the school of the sculptor Andrea Bregno from 1465 forwards.[57]

Because of the prestige of the roman capitals, Sanvito and other scribes begin to adapt their *littera antiqua* (humanistic minuscule) to take this influence into account. They add small clear sharp serifs to the feet of the letters which, as the palaeographer James Wardrop wrote: 'seem to clinch the letters, as a good rhyme compacts a verse'.[58] This adjustment of the lower-case towards a harmonious integration with the capitals only truly came to fruition in early Venetian metal types, but already in the work of Italian scribes from the second half of the fifteenth century the roman lower-case letters are losing a little of their weight, becoming

more oval and less circular in form and beginning to separate slightly from one another. The existence of these cross-influences demonstrates the need to always look at written culture as a whole: inscriptional, hand-written, typographic. Now and into the future influences flow across the boundaries of different written genres and technologies. Handwriting and handmade lettering will continue to affect type right down into the twenty-first century, just as type will in its turn seed the visual imaginations of those who continue to create letters by hand.

Behind the inscription-hunting expedition on Lake Garda lay the influence of another Renaissance impresario, a merchant, Ciriaco of Ancona, whom Feliciano and his circle much admired. Ciriaco, who lived from 1391 to 1452, was remarkable for the extent of his travels. He visited Alexandria and traded through the Greek islands, in Turkey and the Levant. He brought back sculptures, drawings of monuments and stories of his adventures, and helped many Renaissance collectors expand their holdings of antiquities. He himself developed a cursive hand of unusual form, combining Greek and Roman elements, expressing both his own experience of the world and the unity of Greece and Rome in classical history. In imitation of the Greeks his handwriting imported new forms, including many unusual ligatures and letters that varied in size. Some of these features were taken up by the circle of his admirers, who included the head of the Roman Academy, Pomponio Leto, and, in a more modest way, Sanvito himself. He would also influence the style of the great Venetian calligrapher Tagliente, and to some extent colour the work of the later writing masters of the Renaissance. It was Ciriaco who introduced the feature of writing capital letters in coloured pigments and inks – greens, purples and yellows – a feature that both Felice Feliciano and Sanvito were to develop.

The humanists were not the norm in society throughout much of the fifteenth century; indeed, they were looked on with suspicion by the more conservative wing of the Church. In the mid-1460s in Rome they suffered a backlash. Pope Paul II dissolved the Roman Academy and accused its members of conspiring against his life; leading members were arrested. Pomponio Leto, its head and the greatest Latinist of the

age, was at that time in a Venetian prison on charges of seducing two of his young male pupils. He was handed over to the Pope, and he and his 'co-conspirators' were put to the rack. We have an extraordinary record from Bartolomeo Platina (the future first Prefect of the Vatican Library) of his clerical inquisitor sitting in an embroidered chair beside him as his limbs are being stretched, picking his nails with a knife and discussing with the torturer the merits of a jewel sent by his mistress.[59] All except Leto broke down under the treatment. He emerged, to the amazement of his friends, with a steady hand, his writing unaffected by the 'rough manicure' that he had endured.

Bartolomeo Sanvito, who was on the fringes of the academy, was not arrested and enjoyed a long and reasonably comfortable life. Though he continued writing manuscripts into his final years, his hand developed a small tremor from arthritis. By the 1470s the new invention of printing was affecting scribal commissions but Sanvito responded by writing lavishly laid-out books with which the printer could not compete – elaborate Eusebian Chronicles, books of inscriptions and writing in silver and gold on purple-stained vellum. He specialized in books written out completely in the italic hand. In his last years he created a new small book format for classical works, the octavo size – the size of an average sheet of paper folded into eight. He made a number of these books for his friend and patron from college days, Bernardo Bembo, a distinguished Venetian diplomat. In 1496 it would be a book written by Bembo's son Pietro, the *De Aetna* (a story of an expedition to Mount Etna in Sicily), which was amongst the earliest books* printed by the Venetian Aldus Manutius (1449–1515) in a roman typeface that would become the classic face of the sixteenth century. Later, Aldus would also issue the first printed book in an italic type (a Virgil from 1501). He confessed to Pietro when his book came out that he 'took the small size, the pocket book format, from your library, or rather that of your most kind father'.[60] And so even at the end of his life Sanvito's influence continued to flow over into the new medium of print; his work was amongst those that set the standard the new technology must match.

* It was the fifth.

The new pocket-sized book format that had evolved in his work was taken up enthusiastically and would cause the printed book to become ever more accessible and affordable, even down to the Penguins and Livres de Poche of our own day. It is doubtful, however, that he thought of himself as having this degree of influence; there is just a glimmer that he thought his work had significance – in his final years he began to sign his manuscripts, simply, with the initials BS, and the ivy-leaf decorative motif that he favoured.

Printing changes the game?

Just as Sanvito's career was beginning in Padua in the 1450s, several hundred kilometres to the north in Germany, in the strife-torn town of Mainz, events were unfolding which would have a dramatic and enduring impact: the 'ingenious discovery of imprinting and forming letters without any use of a pen'.* The earliest first-hand report for the invention of printing in Europe lies in a letter of 12 March 1455 written by Eneas Silvio, the future Pope Pius II, then a papal diplomat. In a letter to his friend Cardinal Juan de Carvajal, who has heard rumours of the new invention, Eneas writes: 'Of that extraordinary man seen in Frankfurt, nothing false has been written to me. I did not see complete Bibles but quinternions [twenty-page sections] of different books, written in extremely elegant and correct letters, without error, which your eminence could read without glasses.'[61] He goes on to say that between 158 and 180 copiies are being produced but that now, in March 1455, the run of copies is already sold out. He had first seen the examples the previous October in Frankfurt, at the time of the Frankfurt Fair – the forerunner of today's international book fair.

The extraordinary man was Johannes Gutenberg (*c.* 1398–1468), a native of Mainz, where his family had long-standing connections with the archiepiscopal mint. He himself had trained as a goldsmith and gem polisher. By 1455 he had been working on his new invention for at least fifteen years.

* From the colophon to the Mainz Psalter, 14 August 1457, by Fust and Shœffer.

From Enea's letter we can sense the sales patter that may have accompanied the first display of this new documentary form. Unlike writing from the human hand, the argument seems to go, this writing is elegant and correct throughout a book, each letter is as beautiful as the next, there is an almost superhuman endurance in this mechanical scribe. Errors can be checked for and eliminated before a book is even printed, so the text is exceptionally accurate, and this, together with the size of the letters (large by medieval standards), means that such a book is easy to read at a distance – appropriate for volumes designed as a lectern Bible, for use by private individuals or in an institutional setting where it could be read from in chapter house and refectory. The market for such books across religious communities could be considerable. There were 300 religious houses in Mainz alone at that date, and at the same time the local Benedictine houses, inspired by reforms in the monastery at Bursfeld, were growing in their appreciation of the need to have accurate, error-free texts. Gutenberg's Bible, bound in two volumes, offered not only accurate copies, but also identical ones in every detail, an unheard-of possibility. Christopher de Hamel, the Fellow Librarian at Corpus Christi College in Cambridge, has also pointed out that there was something of a revival of interest in large Bibles at the time.[62] Many Romanesque Bibles show signs of rebinding and repair in the mid-fifteenth century, and a number of spectacular new Bibles were commissioned in a large format. Mainz had its own example, the two-volume Great Bible of Mainz, written between April 1452 and July 1453.

At this point I find myself poised between two apparently contradictory statements. It is both hard to overestimate the impact of this one invention on the future shape of the written word, and at the same time I want to urge caution: it should not be overemphasized. From a long game point of view this is another moment in the unfolding story of writing and documents. It is confined to one culture, and even in that culture there have been other moments – we are living through one right now – that have had an equally earth-shaking impact, the equivalent of a paradigm shift. Furthermore, printing had its profoundest impact on the world of the book, but this is not the total sum of the

universe of writing. There were and are many kinds of written artefact left untouched: personal writings like the diary, the letter, the list and handwritten note; business papers and accounts; legal documents, and even, as we shall see, some particular kinds of books which would not be put into print for another 200 years.

Further, printing of various kinds had already been invented many centuries before. Early clay tablets are in fact impressed rather than written upon. The Cretan Phaistos disc from around 1600 BCE has its symbols stamped into the surface. The seals we see throughout the ancient world are a form of printed image. In China, from the tenth century onwards, the works of famous calligraphers were traced, coloured in and then transferred using off-printed pigment on to the surface of stone stelae, on which they were then engraved and repro-duced by taking rubbings from the carvings: the letters appear white on black.[63] Charms in the form of small printed scrolls are recorded both in China and as far back as 764 in Japan, when the Empress Shoktoku ordered a million miniature pagodas, each containing printed charms on a strip of paper 57 cm (22½ inches) long. Books were also being printed from wood blocks in China, Tibet, Korea and Japan.* The earliest surviv-ing securely dated book is from China, a copy of the *Diamond Sutra* dating from 868. It was found along with around 40,000 other scrolls and fragments in 1900 in a cave in north-western China. The scroll is 5 metres long and printed from seven blocks. Up to 1,000 impressions a day could be made from one block. Henri-Jean Martin quotes a figure of 600,000 works being listed in the bibliography of books published by this method in Japan before it opened its ports in 1867, 'a number greater than all the printed editions in any major European land of the time'.[64] He notes that the woodblock technique allowed for the easy integration of image and text on the same block. Such block printing was also being practised in Europe around the time of Gutenberg's invention.

Also in China, in 1045 CE, Bi-Sheng created a system for printing using movable type made from clay, but the sheer number of Chinese

* The evidence for block books in Europe seems to postdate the invention of printing with movable type.

characters needed hindered its adoption. In Korea in 1407, King Seycong commissioned the production of a system of printing using movable type which was realized in 1409. Later he would order the development of a new writing system. The Hankul alphabet of eighteen consonants and ten vowels was designed to replace Chinese characters for writing Korean, and though Hankul did not become widely used until the twentieth century it made the printing system much more practical.

Paper

The success of printing in Europe was also dependent on a number of parallel developments. Without a plentiful and cheap surface to print upon – paper – the invention would have stood little chance of taking off as it did. It was via the Arab world that knowledge of paper-making travelled to Europe from China, where it had originated around 105 CE. By the 790s paper was being made in Baghdad, and by 1120 it was being made in Spain, at Xàtiva. Doubts about its long-term permanence led Roger II of Sicily in 1145 to require all charters that had been copied on paper to be recopied on to vellum and the paper originals destroyed. In 1231 the emperor Frederick II, who also ruled Sicily, banned its use for all public acts. By this time paper was being made in France and Italy, where it found its principal European home.

The trade was concentrated in the early years around Fabriano in east-central Italy, an area famous for its fast-flowing and pure water and its metal forging industry. At Fabriano, the old system of grinding up hemp, linen, old rope and rags using millstones was transformed by the use of a camshaft to convert the rotary motion of a water mill into a levered action that could lift large mallets to hammer cloth into pulp. The mallets were faceted with the bosses and fittings for which the metal-working area was already known. Thin metal wire mesh was substituted for the vegetable fibres that had previously been used for making the moulds that paper-makers used to lift the raw pulp from the tub and drain it, prior to turning it out on to a pile. Interleaved with felts, paper was then pressed, individually sized with gelatine and hung out to dry. Pure water and a large supply of hemp or linen rags were

the essential raw materials for this trade. The required fibres were often found in the finer cloth used for undergarments. It is quite a thought when holding up an early piece of European paper: you are possibly inspecting a piece of recycled medieval underwear.

As time went on, printing presses engendered a vast demand for paper and rags grew in short supply. Towns developed laws that gave their local manufacturers the first pick of rags in their area; at one point people were even prohibited from being buried in clothes that could have been suitable for the paper-makers' trade.

Handling large quantities of paper would have been one of the logistical skills that Gutenberg needed to develop. By the end of the print run he would have had well over 100,000 pages of paper stacked in his workshop needing to be collated into his Bible, and then bound in two volumes for ease of handling.[65]

Gutenberg

Gutenberg began his experiments with printing in Strasbourg, where he lived in exile from Mainz from the early 1430s up to 1444. Though the printing of the Bible was certainly finished by the autumn of 1455, we suspect that from 1448 (when Gutenberg returned to Mainz and took out a loan, followed by another in 1450 and another in 1452) he was already engaged in finalizing his invention. Perhaps as early as 1452 he printed a series of indulgences. Certainly, in May that year the papal representative Nicholas of Cusa requested the Abbot of St Jakob's in Mainz to have 2,000 indulgences ready by the end of the month – a fairly tall order if they had to be handwritten; and two such printed indulgences by Gutenberg survive. Fragments of other early projects also exist: a book on the Sybilline prophesies about the fate of a nameless Holy Roman Emperor, a twenty-eight-page book on grammar by Donatus – a standard Latin textbook – and a calendar and pamphlet against the Turks, who had overrun Constantinople in 1453, finally extinguishing the Byzantine Empire.

Gutenberg's Bible has been acknowledged as a masterpiece. It is still one of the finest books ever printed. It also stands as a warning in

Fig. 26. Enlarged type from Gutenberg's *The 42-line Bible*, Mainz, 1455.
The original height of the type is about 4 mm.

this history, that other breakthrough moments just might happen with little notice.

Each volume of Gutenberg's Bible measures 405 x 295 mm (16 x 11½ inches). Though some sections produced during the earliest phase of the printing process have forty lines to the page, it soon settles to forty-two, arranged in two columns. Gaps are left for headings and initials to be added by hand, and some copies of an eight-page guide to this task, also printed by Gutenberg, remain. The text letters are large, 'such as that now used for the printing of Missals', wrote Ulrich Zell in 1499 (Fig. 26). A missal was a book used on the altar, to be read at a distance whilst standing. Each column is justified left and right, something scribes attempted, but it was much easier to do when printing, as each line of type could be assembled and then spaced out with hindsight, an impossibility for a scribe who must do it by eye in real time – one shot spacing!

The number of separate innovations that Gutenberg pioneered to produce this work are considerable. He must have found a way of casting large numbers of harmoniously proportioned letters; he found a means of setting them up, spacing the lines apart with 'leading' and clamping them (using wooden 'furniture' and screws) ready to print; he experimented with ink and paper to get just the right combination: the ink would be unusually sticky and the paper, he discovered, was better when slightly dampened. Then there was a press to build to hold the forme* of type, the 'carriage' that slid the forme and the paper in and

* The name for a block of type secured in a frame or 'chase'.

out from under the press, establishing the most efficient way to operate it, and handling the vast number of pages which resulted and which then must be collated into book form. There seem to have been new discoveries at every stage. Already, while at work on the Bible, it seems Gutenberg had started on a psalter which took the technology many steps further: printed coloured initials in red and blue, decorated capitals with filigree and two new typefaces.*

From calligraphy to printing: new discoveries about Gutenberg's invention

Up until 2001 the common assumption about Gutenberg's Bible was that its production followed the pattern of every book for the last few centuries up to the introduction of photo-typesetting in the 1950s. The type was made by cutting letters in relief and in reverse into a steel punch, using gravers, files and 'counterpunches' for some internal 'counters' of letters. The punch was then hardened and struck into a soft copper base. Once the copper base had been filed to the correct size, removing the bulge that resulting from the strike and obtaining the desired bearing of space to left and right, top and bottom, the hand-held mould could be assembled. A 'sort', or single piece of metal type, was cast from this mould using a mixture of molten lead, tin and antimony. The sort cooled almost immediately and the mould could be taken off and reassembled for the next casting, re-using the same copper base as the 'matrix'. One punch could thus be used to make a matrix on which innumerable identical pieces of type could be cast.

But in 2001 Paul Needham, the Librarian of the Scheide Library at Princeton University, with Blaise Agüera y Arcas, a computer scientist and physics graduate from the same university, announced the result of a study of Gutenberg's early types. The study had begun as an exercise in the bibliography of early printed books. By recognizing particular pieces of type from their unique markings (the result of damage during

* This book was published by Johann Fust with his partner Peter Schœffer in August 1457, after Fust's partnership with Gutenberg had been dissolved.

setting and breaking up blocks of type), the researchers had expected
to learn about early printing processes. Agüera y Arcas developed a
programme that would enable all the examples of a particular letter to
be compared with each other; it also filtered out irregularities resulting
from ink spread and smear, as well as over- or under-inking. But when
the results of the analysis came in they were hard to believe. Instead
of the images clustering around each other in groups relating to the
number of punches used, every single example of a piece of type on
a page appeared to be a uniquely cast letter; Japanese researchers have
subsequently found the same result. But in Agüera y Arcas's own words:
'It is the nature of the variability not its amount' that is important.[66]
The differences between letters are not the kind expected from damage.
The points of difference lay in the letters' construction: the angles of
letter parts, their placement and letter proportion. How could this be?

There was another mystery. By shining light through the paper and
photographing letters lit up from behind, sub-structures were revealed
within the letters: small ridges and overlappings. The bottom of the type
where it hits the page was not entirely level, as it should be if struck by
a single punch. The proposed solution to these two unexpected findings
is that Gutenberg had not invented the typical matrix for casting a font
of type, but something else. His type was cast perhaps in fine sand –
'Think of powdered sugar versus granular sugar,' says Needham.[67] The
mould was then broken up to extract the type; but the key difference
was in the way the image was struck into its matrix, whatever the mate-
rials used. The irregularities noted by the researchers could be explained

Fig. 27. The six pen strokes that make a gothic **n**.

if the letters were made out of a number of 'elemental' punches that were carefully imprinted into the mould to make up each single letter. As a calligrapher I find this a very natural thought: this is of course exactly how letters are written – they are composed of small groups of pen-strokes (Fig. 27). Each alphabet is made up of a carefully coordinated and limited sequence of proportionally related strokes, which the pen itself ensures are all related to each other as a result of the fixed width of its nib and the repetitive and systematic thinking about the strokes that the calligrapher employs. This is the kind of systematic thinking that may lie behind Gutenberg's process.

In the past, coins, seals and other stamps contained short strings of engraved letters, but Gutenberg's Bible presented a challenge on a completely different scale, for it contains more than 600 pages and nearly 2 million individual letters. And harmony must prevail over this entire field, for, as Lorenzo Ghiberti says, 'A script would not be beautiful unless the letters are proportionate in shape, size, position and order and in all other visible aspects in which the various parts can harmonise.'[68] Gutenberg's type has more than 290 characters in it and eighty-three ligatures, characters that are cast as joined. It would be a daunting task, never having done it before, to cut 373 characters, all the same height and related widths, with all the strokes being the same thickness according to their alignment. It might well strike the novice craftsperson that it would be much easier and perhaps more productive of unity to cut a smaller number of elemental strokes out of which all those letters could then be made; everything can then be automatically guaranteed to be equally weighted and of the same height. This is especially relevant since any differences would be particularly noticeable in the gothic *textura* letterform that was being used, which has many parallel lines. The method that was chosen builds upon existing skills – the calligrapher's hand and eye – in judging the number and placement of parts to make each individual mould. It does take an experienced eye to judge in real time exactly the intended width of a counter space, and how much overlap a stroke needs in order to bite and make a joint between a stem and a curve or a curve and another curve. It was thus, as the colophon to Gutenberg's *Catholicon* of 1460 puts it, that 'a wonderful

concord, proportion and measure of punches and formes' produced a book that many observers say looks more like handwriting than the uniform type we ourselves have been raised on.

The beauty of this discovery about Gutenberg's process is that it shows that the making of the first printed letters evolved out of the skills of the calligrapher, and the two arts – writing and printing – may have been joined in an organic process of development. The single punch for each letter was invented some time later.

The end of Gutenberg's life does not read happily. Bankrupted by the huge costs of developing his invention and by the money that he had to put up-front for both the type and the paper and vellum for his Bible project, Gutenberg surrendered his equipment to his financial backer, Johann Fust, just at the point where the Bible was finally printed. Fust went on to develop the business without Gutenberg's involvement, and was well placed to do so, for he already had a business on the side, dealing in block books and manuscripts, and he had good connections with the book trade in Paris. He tempted Peter Schœffer,* a Parisian calligrapher whom Gutenberg had recruited as an assistant, to set up business with him, and in 1457 Schœffer sealed the deal by marrying Fust's daughter. Fust died in 1466, Schœffer lived until 1503, and three of his four sons continued the line as printers, one of them as a specialist type caster. Gutenberg died in 1468, once more exiled from Mainz through civil strife during which he lost everything he possessed in that city. After the original 42-line Bible project he had engaged in a number of other printing ventures, seemingly both as printer and sometimes as adviser. The 36-line Bamberg Bible (1458–60) is probably one of the productions he oversaw. In 1465 Gutenberg was honoured by the Prince Archbishop of Mainz, a dubious though welcome recognition; it was the Archbishop's political machinations that had caused the city much suffering and his retainers continued to occupy Gutenberg's historic family home in Mainz. For his invention of printing, Gutenberg was raised to the lesser nobility, and given an annual pension in kind and a fresh suit of clothes

* It might be that Schœffer's experience was attractive to Fust not simply as a printer but perhaps as a maker of type?

per year. He died on 3 February 1468, St Blaise's Day. There is an irony here. Through his invention Gutenberg unlocked the voice of the mass of the people of Europe; and St Blaise is the patron of all those who are choking – his healing is that of the throat, that of the voice.

Gutenberg was buried in the Church of the Barefoot Friars in Mainz, of which no trace remains.

By the time of Gutenberg's death, printing was already on the move. The civil disturbances in Mainz of 1462 had made some of his early apprentices, and other aspiring printers, reconsider their positions, literally: they took to the roads. In 1464 Konrad Sweynheym and Arnold Pannartz set up their workshop in Subiaco, the Italian home of St Benedict. His hermitage had been in a cave above the town, and here he had established his first monastery. Subiaco was just 70 kilometres east of Rome, to which Sweynheym and Pannartz moved in 1467. Johann von Speyer and his brother Wendelin travelled from Mainz to Venice, where they were granted a brief monopoly on printing in 1468. By 1470 the printer Nicholas Jenson had originated the first recognizably modern roman type in Venice based on humanist hands, with capitals based on epigraphic letters and the lower-case letters adapted to blend with them. By 1480 there were presses across Europe, in thirty cities in Germany, fifty in Italy, nine in France, eight in Holland and Spain, five in Belgium and Switzerland, four in England and two in Bohemia. By 1500, sixty cities in Germany had printing presses, with fifty individual workshops in Strasbourg alone.

An early crisis

But all was not as it first seemed. As Andrew Pettegree has pointed out in his survey *The Book in the Renaissance* (2010),[69] the emphasis that scholars have placed on tracing the rapid expansion of printing has masked an early crisis. In the mid-1470s, in a phase that inevitably carries echoes for us today of the dot.com boom of the 1990s, enthusiasm for the new medium ran up hard against the reality of how money could be made from the business. The seats of learning, university towns, which had been the focus for the manuscript trade were not the places that could

sustain a lively printing industry. There were too few scholars there to buy even a modest print run of several hundred books, and no means of raising the large sums of capital that the printing trade required for its smooth operation, all so different from the one-man scribe or small atelier that the manuscript industry had been based upon.

Sweynheym and Pannartz closed down their business in Rome in 1473. There was a glut of books on the market and much of their stock was unsold. Pettegree relates how in Treviso, close to Venice, where printing had arrived in 1471, the eleven printers who at various times had worked in the town had all left by 1495, and no print shop would be established there for another ninety-five years.[70] In France just Paris, Lyon and Rouen sustained a continuous history of printing in the first forty years of the sixteenth century, and even in Germany the trade became consolidated in major cities. Gutenberg's personal story of increasing debt, which he had tried to finance with quick editions of single-sheet indulgences or popular calendars, was to be prophetic for the industry as a whole. New mechanisms of finance and distribution had to be evolved.

The late fifteenth century saw a rationalization of the industry which survived most strongly in the large trading cities of Europe, cities like Paris, Lyon, Antwerp, London, Basle, Augsburg, Nuremberg and Venice. These were the centres where the necessary business experience existed to develop the new industry. This was where financial backers could be found and here too were merchants who knew about distribution networks and the pan-European market. One of the advantages the trade had at the beginning was that Latin was still a common language amongst the professions from which many of the earliest buyers of books were drawn – lawyers, scholars, the nobility and the Church. So books in Latin had the potential to be supplied across the continent. Seventy-seven per cent of the 24,000 individual titles that we know were printed before 1500 were in this language.[71]

The other effect of this initial setback was that printers had to diversify their production to include the smaller, less expensive artefacts that Gutenberg had already experimented with. Books were costly. Gutenberg's Bible sold at twenty guilden for a paper copy and fifty for

one printed on vellum; this compares with the cost of a house built from stone in the city of Mainz at that time, which stood at between eighty and 100 guilden, and the annual wages of a master craftsman which stood at around twenty to forty guilden.[72] Less expensive artefacts enabled the printer to tap into the income of the middle classes: printed calendars noted the principal festivals of the year, almanacs contained a mixture of agricultural advice and astrological information, pilgrim cards and prayers that could be pasted into Books of Hours and pamphlets of all kinds made from single sheets of paper folded down into an eight- or sixteen-page booklet.

The Aldine type

The first successful, or clinching, design of a roman typeface originated in Venice with the type of Nicolas Jenson in 1470 (Fig. 28). Trained as a goldsmith in Tours, he visited Gutenberg in Frankfurt. It is possible he also designed type for the von Speyer brothers (Johann and Wendelin), who briefly held a monopoly on printing in Venice in the late 1460s. Jenson's type was a breakthrough, bringing his lower-case letters in line with the epigraphic capital that was now so popular by adapting the lower-case serif formation to the bracketed epigraphic form (though strangely his capitals remain crudely epigraphic in form). His model is unknown; this is the first recognizably modern roman type design.

Fig. 28. Enlarged letters from Nicholas Jenson's roman type
in a *Grammatici Veteres*, Venice, 1476.

Fig. 29. Enlarged type from Pietro Bembo's *De Aetna* printed by Aldus Manutius, Venice, 1496.

Fig. 30. Enlargement of the upper-case type used by Aldus Manutius in the *Hypnerotomachia Poliphili*, Venice, 1499.

Fig. 31. Francesco Griffo's second italic type made for Gershom Soncino's *Opere* of Petrarch, Fano, 1503.

The standard for the century ahead, however, in both roman and italic types, was set at the turn of the century by the printer scholar Aldus Manutius, known up to this point for his innovations in printing Greek. In 1496, as we learned earlier, he had published a small essay by Pietro Bembo, the son of Bartolomeo Sanvito's great friend Bernardo. The volume, *De Aetna*, was remarkable for the new face commissioned for it (Fig. 29). Of this type the book historian Harry Carter has written: 'The Roman fount that Aldus had made for Bembo's tract *De Aetna* was decisive in shaping the printers alphabet.' The small letters were made to conform with the epigraphic capitals that were paired with them by emphasizing 'long straight strokes and fine serifs and to harmonise in curvature with them... The balancing of the weight of capitals and lower case is helped by making the capitals line at the head with the undersides of the serifs of lower-case ascenders, not with their tops as Jenson's do. The letters look narrower than Jenson's, but in fact are a little wider, because the short ones are bigger (meaning taller), and the effect of narrowness makes them suitable for the octavo page.'[73]

These letters were in keeping with the more compressed and lighter-weight humanist minuscule (like Sanvito's) that was current in the Veneto in the last few decades of the fifteenth century. Slightly lighter and taller capitals would be added later (Fig. 30).[74]

In 1501 Manutius arranged to have cut the first italic typeface, which was soon his normal face for Latin or Italian text. Though using upright roman capitals, rather than the sloping capitals scribes had already devised for the script (they would come into type twenty years or so later), the 1501 octavo Virgil was typeset throughout in italic; it reflected a common practice amongst scribes to write entire manuscript books in cursive script – Sanvito had been doing this since the beginning of his career in the 1450s. Technically it was a challenge to print this letter-form. Italic letters are frequently joined to each other. Despite the use by Aldus of at least sixty-five ligatured letters, the printed letters inevitably looked further apart and more individually distinct than the written ones (Fig. 31). But this in turn helped establish a new visual aesthetic. Over the next several decades scribes themselves began to write italic letters with fewer joins when using the script in a formal context.

The punch-cutter for the italic type (and all else that Aldus produced) was Francesco Griffo from Bologna. When Aldus, the scholar/printer with connections, won privileges to copyright his use of these types, punch-cutter and printer fell out. Who owned the letterforms? There is an echo of how Francesco Griffo must have argued his case in the words of one of Aldus's competitors, Gerolamo Soncino of Fano, who used Griffo to help with his own productions after the break: '...he not only knows how to cut the form of letters called cursive or chancery, which neither does Aldo Romano nor others who cunningly have tried to adorn themselves with the plumes of others, but this very Messer Francesco first invented and designed, and it was he who cut all the fonts of letters from which the said Aldo ever printed, as well as the present font with a grace and beauty that speak for themselves.'[75] Francesco Griffo was a man with a grievance, and indeed right down to our day this issue of copyright and letter design is still a fraught one. The punch-cutter's contribution was vital.

Harry Carter wrote that 'much the best indication of the character of a face of type is the name of the person who cut it. Concentrated in that is all manner of information as to place and time, circumstances and relationships on which a history can build.'[76] For it is *in* that person (punch-cutter, calligrapher, drawer or writer) that the forces behind a form find focus, activation and whatever sense of coherence that they may have.

Gothic blackletter types and handwriting

Much emphasis has been placed on the development of roman upper-case, lower-case and italic hands – they are, after all, the predominant forms in use today. Until recently, however, the picture in German-speaking Europe was rather different. The gothic *textura* hand (and its cursive relatives) in which Gutenberg's Bible had been printed continued to hold sway. Roman and italic forms made some inroads into northern Europe when used in Latin texts, but in Germany, Austria, Switzerland, parts of Scandinavia, the Baltic and Finland, gothic blackletter types and handwriting were the usual forms in use for vernacular writings right

up to and into the twentieth century. Holland and Britain used gothic types into the eighteenth century. Today they continue to be used for areas of document production that represent authority or tradition – on banknotes, newspaper mastheads and legal documents, for example.

Gothic writing continued to develop in the centuries after the invention of printing. Regional variations of the Bastarda gothic cursive hand sprang up in Bohemia. From the early sixteenth century onwards, Fraktur, pointed or broken script, evolved out of the Germanic form of Bastarda (also called Schwabacher).*

Fraktur was destined to be one of the main letterforms in which German would be written and printed right down until the Second World War. It fell out of use only after it was banned by Hitler's Third Reich in favour of roman type. The official order, issued on 3 January 1941 under Martin Bormann's signature, stated that 'the gothic script consists of so-called Schwabacher-Jewish letters'. The real reason for the directive came in the decree's last line, which ordered that the first publications to introduce the change would be 'those newspapers and magazines that already have a foreign distribution or whose foreign circulation is desired'.[77] Fraktur was limiting access to German culture and propaganda in other 'occupied' countries of Europe.

In fraktur the pointed o shape of the more cursive Schwabacher is retained but often the first stroke in that letter is straightened and given an angled, though slightly more fluid foot – the curve is fractured and the form formalized. As in *textura*, the same can happen to a and d, diamond feet are restored to m and n, and the ascenders of letters can have the more formal endings (used in *textura*) of forked or pointed line finishings. The traditional explanation of fraktur's origin is that it evolved as early as 1507 in the calligraphy of Leonhard Wagner, a monk in the monastery of St Ulrich and St Afra in Augsburg. A silverpoint drawing of Leonard by Holbein exists: a somewhat serious-looking 'Friar Tuck' with an upturned nose. His writing was taken as the model for the type used by the Augsburg printer Anton Schönsperger for the *Gebetbuch*, an

* The name comes from the book, *Schwabacher Kasten*, where Bastarda first found a printed form in Nuremberg in 1524.

influential new prayer book commissioned by the Emperor Maximilian I and issued in 1514. Variants of the script were picked up in other books printed by Schönsperger. Neudörffer the Elder of Nuremberg produced a six-page exemplar of the script in 1519, which became popularized in later works. It even spread to England in the seventeenth century, where it became the hand favoured by legal clerks for formal headings; it was called 'German writing' in the writing manuals of the period.

In terms of letterform Germany alone amongst all the countries of Europe was relatively untouched by the new Italian handwriting. The politics of the Reformation did not favour their use. In a colophon to one of Luther's translations of the Bible printed by Hans Luft in Wittenberg in 1545, the explanation is given that whenever grace and comfort are discussed the capitals are in fraktur; roman capitals are used whenever the text deals with punishment and anger.[78] Germany's continuing importance in the history of the written word during this period lies in its being the cradle both of the new technology of the printing press and the Reformation which fed those presses with so many new kinds of texts.

Two letterform systems thus existed side by side in parts of northern Europe, and gothic forms are still employed in German-speaking areas today – though only at a fraction of the level of their previous usage. One reason for their enduring popularity, as implied above, is the unique role that texts printed in these forms played in the tumultuous period of the Reformation, a period during which the modern German language was forged.

CHAPTER 5

Turning the Page:
Reformation and Renewal

Fig. 32. Diagram of writing position with a quill pen. Woodcut from Sigismundo Fanti's writing manual *Theorica et practica de modo scribendi*, 1514, Venice. The image shows a left-handed scribe. Perhaps the engraver forgot to reverse the image.

In contrast to the contraction of the printing industry in the late fifteenth century, the early sixteenth saw an expansion of production and the creation of entirely new markets. At the core of this development lay the Reformation, a theological and intellectual awakening. The process of questioning religious authority and a new assertion of individual imagination, even the sense of feeling empowered to re-vision the way the world might be, had long had roots deep within humanist circles. But when on the eve of All Saints' Day, 31 October 1517, Martin Luther (1483–1546), an Augustinian friar and university theologian, posted ninety-five theses against indulgences on the door of the castle church in Wittenberg, a new movement for reform found focus within the Christian Church itself.

Wittenberg was a small town on the river Elbe in Germany, the seat of Frederick the Wise, the Elector of Saxony. The town had had a university since just 1502. Nailing the ninety-five theses to the church door was not an unusual way to publicize the fact that a debate was to be had in an academic town. But this spark lit a flame that spread right across Europe.

Luther's ninety-five theses were soon printed in Nuremberg, Basle and Leipzig, but it was the publication, in the following year, of his *Sermons on Grace and Indulgences* that launched him as a publishing phenomenon. The ever-wider distribution of Luther's views, through pamphlets, broadsides and even printed cartoons, meant that there was little hope that the debate could be confined to solely academic circles. As Luther's message became more widely spread, larger social changes became inevitable. Between 1518 and 1525 scholars have estimated there were as many as 3 million pamphlets (*Flugschriften* – flying writings) in circulation in Germany.[79]

The impact of these religious controversies on the political and social of life of Europe would be enormous. As Luther's movement for the reformation of the Church spread to Switzerland, Austria, France, and all the other countries of Europe, it complicated an already difficult situation between the French kings, the House of Habsburg and

the papacy. Educationally it energized new generations of authors and theologians as well as accelerating a movement towards greater literacy, so that the population at large might become better informed on religious questions. A market for books and pamphlets developed that was substantially different to that of the late fifteenth century, which had focused on previously issued works. Writers of the Reformation, on both sides of the issue, men such as Erasmus (1466–1536), Luther, Zwingli (1484–1531), and Calvin (1509–64),[80] wrote many new books; translations were required of them, and of their biblical source material, which was now rendered from Latin into the vernacular tongues of Europe. Luther's translation of the New Testament into German, which had taken him just eleven weeks to carry out and six months to print, was published in Wittenberg in 1522. It was reprinted on an almost monthly basis for the next two years. In the fifty years following the publication of Luther's Old Testament in the 1530s, it was reprinted 410 times. Hundreds of thousands of individual volumes were released to a new and growing population of readers.

The golden age of the writing manual

Luther was a tireless advocate of education. He urged town authorities to step into the gap created by the withdrawal of Catholic education from churches, monasteries and convents. He encouraged the use of Church assets to make new educational foundations. Single-class schools in villages, teaching the basic skills of reading and writing, were supplemented by tiered educational institutions in the towns. Knowledge of scripture, and an education in what it meant to lead a good life, were seen as fundamental to the success of the reform movement, so learning to read and write was encouraged both at a civic level and in the home. The fact that this trend coincided with an increasingly common perception, amongst the young and their parents, that literacy was now an important asset in business, further encouraged the development of these skills.

In England the Reformation also brought change. At the higher end of education the Universities of Oxford and Cambridge flourished, as

did the Inns of Court. Regionally, from the 1440s onwards, many wealthy merchants, clergy and yeomen had endowed local schools, paying the teachers' wages and sometimes the pupils' fees. But the dissolution of the monasteries and their schools in the late 1530s and the closure of chantry chapels, whose priests often doubled as schoolmasters, left the Crown with a sense of responsibility for education which was new. One consequence was an authorized grammar, drawn up at the request of King Henry VIII in 1540. It replaced all other such textbooks, whose use was now forbidden. Henry's textbook began with an ABC and then moved on to a simple catechism in Latin and English followed by a detailed grammar. It was the basis for school textbooks in England for the next 300 years.[81]

In France, less influenced by Protestantism at the time than by the humanism of the Italian Renaissance, new municipal grammar schools were established that taught the humanist curriculum. Studies included Latin and Greek grammar and the rediscovered works of such authors as Cicero, Virgil and Ovid.

However, the essence of education at the time was reading rather than writing, and this was to be so right up and into the nineteenth century. If writing was taught in the early years of schooling, it was only to a rudimentary level and only after the child had been taught how to read. In its polished form writing was considered a specialist subject, taught by teachers who travelled round and set up a class for a period of several months or maybe just weeks. Top-up classes could be taken at any point later in life.

The trendsetter for writing tuition in the sixteenth century was Italy, and it is here that the next change in the order of the written word would occur, the development of printed writing manuals. These manuals utilized the power of the press to make instruction in writing much more widely available, and it is to the hands in these first Italian copybooks that we owe the handwriting we use today.

The Italian calligraphers who wrote the new guides were drawn from amongst the scholars and scribes employed by the growing bureaucracies of the day. They worked in the papal writing office, or for city administrations such as that of the Doge and citizens of Venice. The

main focus of the writing instruction manuals they produced was the neat, careful, but serviceable writing they used in their letters and official documents, rather than the elaborate and formal bookhands that had been the staple of the manuscript book.

In the Middle Ages, a teacher of penmanship had little influence beyond his immediate contacts. Though Hugo Spechtshart, a schoolteacher from Reutlingen in Swabia, had written a guide to writing in verse, *Forme Scribendi*, in 1346, his manuscript exists in just two copies and appears never to have been widely disseminated. A popular author such as the Roman educationalist Quintilian, however, could hope for a wider circulation. Until the Renaissance his was the only text to deal with strategies for learning to write at any depth, and his prestige as a classical authority on both education and rhetoric gave his views wider currency. He gave no specific examples of letter shapes, preferring to leave the aesthetics to others. He focused instead on practical teaching methods, aimed at the children of the upper section of Roman society. He recommended children began their education in writing by playing with cut out letter-shapes:

> I quite approve...of a practice which has been devised to stimulate children to learn by giving them ivory letters to play with...As soon as the child has begun to know the shapes of various letters, it will be no bad thing to have them cut as accurately as possible upon a board, so that the pen may be guided along the grooves. Thus mistakes such as occur with wax tablets will be rendered impossible, for the pen will be confined between the edges of the letters and will be prevented from going astray. Further by increasing the frequency and speed with which they follow these fixed outlines we shall give steadiness to the fingers, and there will be no need to guide the child's hand with our own.[82]

In contrast to Quintilian's broad advice, the Renaissance writing manual was all about specifying particular letter-shapes, and because it was printed this form of instruction in handwriting could be widely distributed. These manuals represented a significant shift in the way a

writing style could be learned. As well as making writing as a craft more accessible, they initiated a movement that would replace local styles of writing, letterforms and address, with ones that were common across wider cultural milieux.

The earliest Renaissance manuals dealt only with capital letters. They circulated amongst artists, architects, mathematicians and other intellectuals; they were not aimed at the schoolman. Felice Feliciano's 1463 handwritten treatise on geometric proportions in Roman letterforms[83] fitted the capital alphabet into a rectangle within a square inscribed with a circle and diagonals. The letters are painted as if carved, with a V-shaped incision. Some are rather awkwardly shaped, with curves (as in **D** and **B**) not quite blending into the stems smoothly, other letters (**D** again, and **N**) appear very wide. The letters appear to be constructed with rule and compasses. This geometrical construction set an enduring interpretative framework, one which had deep resonance at this time, for musical or geometric proportions were thought to lie behind the physical structure of the universe itself.

The first printed book on the topic of capital letters was issued circa 1480 by Damiano da Moille, a scribe and illuminator, turned printer, from Parma. The plates in his book measure 6.5 by 6.5 cm (2½ by 2½ inches) and were, like all these early instruction books, made by carving letters in relief out of a woodblock. For a time this limited the amount of detail that could be put into small lettering, and most of the work reproduced in early books is large in scale. In 1509 Luca Pacioli, whom we met earlier as the father of modern accounting, but who was also the professor of mathematics at several Italian universities and a considerable geometrician, published his *De divina proportione (On divine proportions)* in Venice. The book (which had existed in manuscript form since 1497) looked at aspects of geometry in relation to architecture and solid forms, and also contained a section that discussed the construction of Roman capitals (Fig. 33).[84] Pacioli's thesis was that mathematics, including geometry, underlaid everything, including lettering. 'And let not scribes and illuminators complain if such necessity has brought to light the fact that the two essential lines, straight and curved, always suffice for all things that

Fig. 33. The letter **A** from Luca Pacioli's *De divina proportione*, Venice, 1509.

have to made in their art, for which reason I have made the square and circle before their eyes without their pen and pencil. Again, I do this that they may see quite clearly that everything comes from the discipline of mathematics.'[85]

De divina proportione gained a wide circulation, helped no doubt by the fact that the illustrations were based on drawings made by Leonardo da Vinci.* Whether Leonardo, a friend and student of Pacioli's, also made the drawings for the alphabet we do not know, but he certainly made drawings for the geometric solids.†

Following the success of *De divina proportione* a flood of popular manuals – dealing not only with capital letters but also with lower-case forms – began to reach the market. They were aimed less at the artist and architect and more at the growing population of literate young men who wanted to acquire a fashionable style of writing and advance themselves as secretaries, scholars and businessmen.[86] At the core of

* Leonardo illustrated the three manuscript copies prepared in 1497. The **M** logo used by the New York Metropolitan Museum of Art is taken from Pacioli's printed book.

† Leonardo's notebooks contain no drawings of letters, yet some finely painted examples are included in the scrolled motto of the Bembo family on the reverse of his portrait of Ginevra de'Benci (1479/80).

this second wave of manuals was the italic hand first developed by Niccolò Niccoli, but now appearing in the version written, one century later, in the papal chancery. The hand had by this time been christened *littera cancellaresca*, the chancery hand. It was not taught in the ordinary schools but it had become a mark of social and intellectual distinction. Ambitious young men, such as the young Michelangelo Buonarroti, had changed their writing style in order to adopt this new fashionable look. Michelangelo had been taught a regionalized form of gothic cursive, the *merchantescha*, at school in Florence. Some time between 1497 (when he was twenty years old) and 1502 he learned the new *cancellaresca* script which he used for the rest of his life.

A letter from the twenty-five-year-old painter Raphael to his uncle in Urbino from Florence in April 1508 shows he too had learned a graceful italic hand, more flowing than that of Michelangelo. With no printed manuals at that time to help them, both young men would have studied with a tutor who wrote out samples of the hand for them. Writing manuals can be seen as an extension of this practice. As one early author put it, 'since it was impossible to offer enough examples of my own hand to satisfy all, I have set myself to study this new invention of letters and to put them into print'.[87]

The demand for such books soon spread across Europe, stimulated by the use of italic in the correspondence of diplomats and scholars. In England italic was introduced to the court by Pietro Carmeliano, the Latin secretary to Henry VII (1457–1509). Henry VIII had all his children taught the italic hand. We have samples from the future King Edward VI (1537–53), whose handwriting aged eight is astonishingly well formed. Elizabeth I (1533–1603) was taught italic by her tutor Roger Ascham. She was the most skilled calligrapher of all the British monarchs; a handwritten prayer book in the British Library demonstrates her accomplishments.

The first book to describe the *cancellaresca* hand was printed in Venice in 1514. Sigismundo Fanti's *Theorica et practica de modo scribendi fabricandique omnes litterarum species* (The theory and practice of writing and making all kinds of letters, see fig. 32) set the pattern for those that followed. Not only did it look beyond capital letters to the roman

lower-case but it gave practical tips about materials and tools: papers, ink and the cutting of quills and reeds for different scripts,* the scribe's posture and penhold. Though the roman capitals in the book are depicted in large-format woodcuts, as are lower-case gothic letters, the printed book leaves blanks where the *cancellaresca* letters are supposed to appear. Presumably they were intended to be written in by hand, but no completed handwritten copy survives.

The first writing manual addressed to the general public appeared ten years after Fanti's *Theorica et practica*: this was *La Operina*, published in Rome in 1524 by Ludovico Vincente degli Arrighi, a writer of papal briefs who had recently lost his job and turned to printing. Arrighi's book, which was printed from woodblocks, illustrated *cancellaresca* at its true size, with letters between 2.5 mm and 3 mm high. It is a thirty-two-page masterpiece. Sixteen of those pages are devoted to instructions for the lower-case letters and just two to the capitals. The remainder give advice on joining letters and composition, and introduce us to the proverbs that will be the stock exercises of writing masters for the next 400 years: 'The blessed held a middle way'; 'Powerful indeed is a man to direct his own actions if he really knows himself.'[88] Previously, in the Middle Ages, the standard texts for writing practice had been taken from the Psalms.

Arrighi's method is to set out an oblong parallelogram, defined simply by a dot at each corner, and ask the writer to form each letter within this structure. In addition he divides the alphabet in two parts, a group of letters which begin with the writer making a short horizontal line 'which, reversed and turning upon itself' begins **a b c d f g h k l o q s x y** z. The other group, **i e m n p r t u j,** are all introduced with a slanting thin stroke (Fig. 34).† The style of italic, he wrote, had progressed, even from that prevailing at the turn of the century; it was

* For the rotunda style the nib does not need the point divided, a very short nib slit is used for humanistic minuscule, and the mercantile hand has a look that resembles an eagle's beak. For large letters he advocates pens made of metal or bone.

† Though Arrighi sometimes uses the modern shape of **v**, usually with a flourish for decorative purposes at the beginning of a word, his normal **v** is identical in form to **u**, as was the custom at the time.

Fig. 34. Arrighi's *La Operina*, woodblock print, Rome, 1524.

more uniform in shape across the alphabet, less ligatured and losing its association with the forms of gothic cursive that had been important to Niccolò Niccoli. There is some evidence that the book was brought out quickly in order to beat a rival to the honour of being first in the market. The rival was Giovanni Antonio Tagliente, who had arrived in Venice with his family in 1491 and had worked there ever since. Thirty-two years of teaching handwriting went into his book *Lo Presente* (1524), a virtuoso display of the writing master's art. Tagliente's style is more ornate than Arrighi's: the ligatures are occasionally extravagant and the interlaced capitals hard to read; there is an eastern influence in the book which is typically Venetian, and the use of multiple alternative letterforms

owes something to the hand of the antiquarian Cyriaco of Ancona. The book contains alphabets in Arabic, Greek and Hebrew. It also sets out a surprising variety of hands: several variations on the *cancellaresca*, *bollatica* (the hand used for papal Bulls), an imperial charter hand, and six mercantile hands. The mercantile hands were regional gothic cursives evolved by merchants and notaries in different trading cities such as Florence, Genoa and Venice. Tagliente also wrote books on mathematics, reading and a pattern book for lace-makers. He died in Venice in 1528, the same year that a serious outbreak of typhus hit the city.

Arrighi may have suffered a harsher fate. Having engaged in a frenetic spate of publishing (he printed twenty-seven titles, using types based on his own hand, between 1522 and 1524), his trail goes cold in Rome in 1527, the year the city was brutally sacked by the imperial forces of Charles V. Having grown tired of the constant demands of the Habsburg emperors, Pope Clement VII had sought to balance the imperial power's influence in Italy by forming an alliance between the Papal States, Italian cities and France. In 1527 the imperial army defeated the French, but when the army could not be paid it became mutinous and marched on Rome, determined to take the city and plunder it. They broke through the walls on 6 May, their 30,000 troops matched against a civil militia of just 4,000 and 168 of the Pope's Swiss Guards. The Guards were massacred on the steps of St Peter's, though they managed to hold back the troops for long enough for Clement to make his escape down a fortified corridor into the nearby Castel Sant'Angelo, once the mausoleum of the Roman Emperor Hadrian but now an impregnable castle. The imperial army ran riot. Sebastian Schertlin, who witnessed the events, wrote: 'We took Rome by storm, put over 6000 men to the sword, seized all that we could find in the churches and elsewhere, burned down a great part of the city, tearing and destroying all the copyists' work, all registers, letters and state documents.'[89] Citizens were tortured in the streets to reveal where they had hidden their wealth, and tombs were even broken open in the search for gold and jewellery. A city of 55,000 people was reduced by flight and murder to just 10,000. This was the effective end of the *Roman* Renaissance, the creative golden age of Michelangelo, Raphael and Bramante. From now on the atmosphere was sober.

A letter from Clement survives, written hastily on 6 June 1527 from Castel Sant'Angelo to the English Cardinal Wolsey. It shows that Clement too had learned to write an italic hand, but the letter shapes show signs of stress, with spiky long ascenders and descenders at varying degrees of slope. Henry VIII of England has asked for his marriage to Katherine of Aragon to be annulled, but she is aunt to Charles V, who holds the Pope's fate in his hands. Clement pleads the deplorable state he is in.[90]

It is thirteen years, following the sack of Rome, before we see another book from a Roman writing master. By then the city was rebuilt, and its population stood a little higher than it had before its ordeal. But the more restrained atmosphere of the 1530s and 40s affected the penmanship of Giovambattista Palatino. His portrait stares at us from the opening page of his *Libro Nuovo d'Impare a Scrivere Tutte Sorte Lettere* (A new book for learning to write all sorts of letters) of 1540. He sports a full beard, similar to that grown by Clement VII in mourning for the sack of the city. The author's praises are sung in a dedicatory sonnet. Palatino's *cancellaresca* has grown tall and thin; the oblong around which it is formed is now twice as high as the letter is wide and the letters appear compressed and pointed. Stanley Morison has described it as a 'crystallised and petrified' version of the free script of Arrighi and Tagliente, a reaction 'against too much licence in troubled times'.[91] He quotes James Wardrop writing of this more rigid framework: 'It was the old black letter formulae over again.'

One hundred and fifty years earlier, Petrarch and Salutati had triggered a reform in handwriting by reacting against the cramped gothic letters in the books they owned. Though beautiful, such letters were hard to read and stood awkwardly with the flowing classical language the humanists sought to revive. So Petrarch and Salutati experimented with a clear and legible hand, and these first shoots had led directly to the work of Poggio Bracciolini and Niccolò Niccoli and the full flowering of the humanist minuscule and italic *cancellaresca* hands. Now it seemed as if events had turned full circle, and the graceful italic was, in its turn, becoming formalized and stiff. Nonetheless the control that Palatino was able to demonstrate excited the admiration of his contemporaries, whilst setting them an almost impossible standard to aspire to.

In Palatino's *Libro Nuovo*, the tendency we saw in Tagliente's work, to introduce mercantile hands, becomes yet more marked. Arrighi too had introduced one such hand in his second book of 1524, *Il modo*. Palatino shows the vernacular mercantile hands of Milan, Rome, Venice, Florence, Sienna, Genoa and Bergamo, as well as the more formal scripts *Lettera Napolitana*, *Lettera Notaresca*, *Lettera Francese*, *Lettera Spagnola*, *Lettera Longobarda formata* (meaning formal) and *corrente* (which means cursive or flowing), and *Lettera Tedesca* (it means 'German' – he also includes an example of the Schwabacher hand). *Libro Nuovo* also contains Arabic, Indian, Syrian and Cyrillic scripts. The telling fact here, however, is that not only has every country its own style of writing (in handwriting this is still often the pattern today), but the merchant classes in each Italian city also had their own distinguishing forms. The late sixteenth century was the high-water mark for local variations; in future the wide distribution of printed writing manuals, and the popularity of the *cancellaresca* forms, would result in more uniform styles of writing across Europe.

Cresci's *Essemplare di Piu Sorti Lettere*: a legacy to handwriting

In 1560 the last of the great writing manuals was published in Rome by Giovan Francesco Cresci; it would prove the most influential of the sixteenth century (Fig. 35). Cresci set out a new way forward, both for roman capitals (he eschewed geometric drawing and favoured freehand) and for cursive writing. Born in Milan around 1535, Cresci was a 'scriptor' in the Vatican Library. In the year his book was published[92] he was appointed 'writer to the Sistine Chapel', where he made handwritten copies of missals, service and choir books. His book *Essemplare di Piu Sorti Lettere* (Models of more kinds of letters) would shape European (and even American) styles of handwriting right down into the early twentieth century. Cresci has been described as a conservative revolutionary.[93] Without actually naming him, he attacked Palatino's style of *cancellaresca* as 'a thing of points and angles', with narrow letters which made them hard to join; the pen was too broad and square and held at too steep an angle. The letters did not slope enough.

Fig. 35. *Cancellaresca Corrente*, from *Il Perfetto Scrittore*
by G. F. Cresci, Rome, 1570.

Cresci proposed a speedier, more practical hand for correspond-
ence and book-keeping (he was critical of mercantile hands also) with
slightly rounder letters, the narrower pen held at a flatter angle, the
letters leaning forwards (10–15 degrees rather than 5–8), and the invisible
oblong frame reduced in height. Certain letter forms were also modi-
fied in the name of greater speed: the round **r** was reintroduced in his
Corrente or cursive hand, **h** had an abbreviated foot to the first stem and
an inward curving bowl, **d** was rounded, the foot of capital **l** simplified,
the exit strokes from letters like **i**, **m**, **n** and **h** are curved rather than
sharply angled. The tops of the ascenders of letters such as **b**, **d** and **h**
were made with a looped circular movement that produced a blobbed
top. The book also showed examples of bills of exchange, not just well
intentioned *bon mots*, and Cresci cuts down on the numbers of alterna-
tive alphabets on display. He is pragmatic in his approach.

The scholar calligrapher Arthur Osley has described the effects of
these new letter forms on the craft of penmanship:

The physical effect of these changes was that rotating movements of
the hand tended to displace the reciprocal motions required for the
chancery italic. At the same time, the writer now stood further back

from the table, and manipulated his narrow pen (which required thinner ink) with more wrist movement. Instead of letting the pen do the work, as with the earlier italic, the writer had to have both a light touch…and a steady but flexible hand. From now on the obsession of Italian writing-masters is transferred from constructing the alphabet by geometry to acquiring this brand of manual agility.[94]

This presages a highly significant cultural shift over the next century. Partly because there is now the alternative of type and mechanical printing available for reproducing the main textual stream of European literature, handwriting is free to develop unencumbered by its more formal relative, the bookhand. At the same time, the quickening pace of economic expansion, fuelled by voyages to the Americas and the Far East, means that business – rather than government, religion or classical scholarship – is destined to become a principal area for the deployment of scribal skills and new forms of documentation.

Cresci's functional, speedy writing with a narrower pen nib answered the needs of his time, and his example was taken up by writing masters in France, Holland and England. The subtlety of his letterforms would be enhanced in the plates of their books by the new method of engraving on copper, which, like printing itself, originated in Germany. It gave a much crisper image to the letter: for the first time you could clearly see the detail of the individual letter formation in small sizes of writing. The first entire writing book to be engraved in Italy by this method was the *Essemplare Utile di Tutte le Sorti di L're Cancelleresche Correntissime* (Several models of all kinds of the regal current chancery hand) of Cresci's contemporary Giuliantonio Hercolani, printed in 1571/2, but the method had already been employed as early as 1538 by the great writing master of Nuremberg, Johann Neudörffer the Elder (1497–1563).* His book *Ein gute Ordnung* has continued to inspire calligraphers down to this day. Hermann Zapf, one of the leading type designers of the twentieth century, launched his career in letters by publishing a

* And also by eighteen-year-old Brussels calligrapher Clément Perret in his *Excercitatio alphabetica* of 1569.

book of engraved calligraphic examples, *Feder und Stichel*[95] inspired by the Nuremberg masters. Neudörffer's book, mostly displaying German gothic letterforms, was innovative, for it used semi-transparent paper for some of the plates, printing the letters on the obverse. This technique both enabled him to engrave the letter the right way round rather than reversed, and the copybook's owner to trace the letters through the reverse side of the paper. Hercolani also introduces a new device in his book, a page of ruled lines the height of the small letters; in between the lines are a series of dashes to indicate the height of ascenders and descenders. The lines are filled in with heavy cross-hatching so they can be used as a writing guide when laid behind thin paper.

In Spain it was the work of Francisco Luca (dates unknown) that set the pattern for the future. In his *Arte de Escrevire*, published in Toledo in 1571, Luca taught two principal hands: the mercantile *redondilla*, simplified, upright and round, and the *bastarda,* which was his version of a chancery hand. He measured the heights and widths of his letters, coincidentally following Arab precedent, using the width of the pen nib as a measure. His proportions are wider than the rectangle made of a double square that Palatino had used, and are closer to a three to two proportion between height and width. The letters are rounder, not so angled. 'The result is a handsome, legible letter, which was taught in Spain until at least the nineteenth century.'[96]

Michelangelo – a crisis for classicism?

But what of the greatest artist of them all: Michelangelo? Can we discern at this distance, through the well-attuned barometer of his artistic sensibility, the changing nature of the written word in the era of the High Renaissance? What was his response to the epigraphic capital and the new handwriting, and what was his sense of future possibilities for these forms?

In his slim but powerful book *Public Lettering: Script, Power, and Culture* (1980) the palaeographer Armando Petrucci points out that Michelangelo was, at the beginning of his life, very much a child of his times. As we know, he was sent to school in Florence to be trained for business.

At school he learned the common Florentine mercantile hand. At some point he taught himself the italic chancery script, which he came to write with exceptional energy and vigour. In his surviving letters and poems we can see the quill biting and digging into the page, as if he needs to feel the living contact between the tool and the surface in a dynamic and slightly aggressive relationship. The extended endings of his letters, such as the backwards curving tails of **p**, are a vigorous blend of curves and sudden angles, as if the pen were a chisel, and a chip would fly from the page at the end of a stroke. In contrast to earlier writers of italic, who used the hand in special instances alongside their everyday gothic cursive, Michelangelo uses this hand for all his writing needs. He annotates his paintings with it, uses it for letter-writing and carefully employs it in the fair copies of the sonnets he wrote in admiration of his friend Tommasso Cavalieri. In this respect he anticipates a time when scripts bred from italic will become the norm for handwriting across most of Europe.

In his sculpture Michelangelo's use of the epigraphic capital is infrequent – though when he does use it, he invariably does something original with its presentation. But the most striking feature in many works is its absence, even in circumstances where the context might suggest it was entirely appropriate, if not mandatory. Thus, the tomb of Pope Julius II in the Roman church of San Pietro in Vincoli has no inscription, nor does the Medici chapel in Florence's Basilica of San Lorenzo. The architecture of the Laurentian Library in Florence actually creates the perfect framing for lettering, so its absence there is all the more striking. It is as if a present-day artist had installed all the technology for a stunning multi-media presentation and then left the screen deliberately blank and the speakers silent. Petrucci argues that Michelangelo is probably unmoved by the roman stylistic tradition of imitating classical letters:

> A disinterest that enabled him to sense the growing contradiction between the schematic rigidity of the imitation classical epigraph, with its hard frames and immobile flatness, and the turbulent pathos to which he gave life in his sculpted forms and architecture. Rather, the use of another innovative architectural element must have

seemed to him far more expressive: blank epigraphy, emptied of its writing and reduced to a pure and simple plaque.[97]

Petrucci goes on to quote an observation from the French novelist and essayist Michel Butor, originally uttered in a different context but of relevance here: 'The absence of writing from a place which has been prepared for it becomes a nostalgia for a vanished state of things, and yet is also the expression of a void, an incapacity of our language, and thus an invitation to a new decoding, and to a new text.'[98]

It is the latter observation that seems true for Michelangelo. It is as if the classical tradition of letterforms had reached a hiatus. Inscriptions had become a part of the urban environment, integrated into buildings such as Alberti's Tempio Malatestiano in Rimini* and the façade of Sta. Maria Novella in Florence; they appear on the tombs of the Popes (of which the first using this style is that of Paul II from 1471). Jacopo Bellini (c. 1400–c. 1470) copied classical inscriptions into his sketchbooks. Classical lettering is found, besides many others, in the paintings of Mantegna, Perugino, Gentile, Ghirlandaio and Raphael. Where could things go now but in an utterly new direction, one before which Michelangelo falls silent? It is not just the pathos of his own life that the classical letter fails to express, but the disjuncture of the times, which are filled with brutally asymmetric forces. It is not just the wars and chaos of the immediate past, but all the religious upheaval, conflict and change that can be sensed in the centuries to come. Indeed, the challenge to work with letters in a new way, an *anti*-classical way, with values of high contrast and dynamic disharmonies which such times suggest, will not be taken up until the twentieth century. But it is as if Michelangelo has sensed something here. The confirmation of this – for me, at least – comes in his final work, the lettered block above the internal gate of the Porta Pia in Rome (Fig. 36). He was working on it when he died, aged eighty-eight, in 1564. It has a breathtaking boldness and dramatic abstracted design. The lettering is simply placed upon a block of travertine marble, no

* 'The only Renaissance lettering that I know which appears to be based on Republican prototypes.' Nicolete Gray, *A History of Lettering*, Phaidon, 1986, p. 133.

Fig. 36. Detail of the internal façade of the Porta Pia, Rome, built 1561–65.

edged moulding or frame to it. It is starkly massive, its solidity enhanced by the fact that it is poised above a thin swag that accentuates both the void beneath and the solidity of the white travertine block, punching into the space above, as if light was being separated from darkness. The letters are lightweight and almost monoline, skeletal forms that both complement and contrast with the simple chunky block they are carved upon. But for the surety of the block and the wide spacing of several words, they would be overwhelmed by the dense shadows surrounding it. The lettered block is bracketed by two volutes, large vortices that contrast with the square stone both in their circular form and the dynamism of their spiralling lines. The letters themselves are not innovative, but their presentation in this context is something entirely fresh. No one will have the courage to develop this stark prophetic simplicity until the early twentieth century.

Michelangelo's other small inscriptions – the lettered signature on his *Pietà* of 1499 in St Peter's Basilica, carved on the ribbon that holds the Virgin's cloak, and the setting for an inscription on the pediment he created for a statue of Marcus Aurelius in 1538 – indicate the direction his successors will follow. The lettering on the base of Marcus Aurelius's statue (now housed in Rome's Capitoline Museum) is placed upon a curved background. Bending the lines of lettering, placing them on illusionistic creations of cloth or shields, casting them in bronze, gilding them, infilling them with black pitch – these will be the stock in trade of

the baroque letter-carver. Such lettered monuments would incorporate the dead into the walls and aisles of churches across Italy and spread their marble pallor slowly northwards. But Michelangelo's last statement echoes down the succeeding centuries, it tears underground through a long dark tunnel towards the twentieth century, above ground, baroque and rococo letters trill: a flourish of silver trumpets.

At the sign of the Golden Compasses – printing in northern Europe

By the time of Michelangelo's death the printed book had over a century of history behind it. Successful printers in the mid-sixteenth century now had substantial capital backing and a pan-European distribution network.

In the third decade of the sixteenth century France overtook Italy as the main supplier of type to the printing houses of Europe. Indeed the type historian Henrik Vervliet has argued, 'A majority of today's text types, either Roman, Italic, Greek or Hebrew, derive directly or indirectly from type designs conceived or perfected in sixteenth-century France. They became a kind of European standard in the 1540s, towards the end of the reign of François I.'[99] It was King Francis I (1516–47), who invited Leonardo da Vinci to spend his last years at the royal court, who first sent French expeditions to India and to settle Canada (1541), and he was the first European monarch to reach an accommodation with Suleiman the Magnificent and the rising power of the Ottoman Empire. The centre of gravity in literature and the arts was shifting northwards.

The Parisian punch-cutter Simon de Colines (c. 1490–1546) was the first printer to introduce coherent roman and italic typefaces outside Italy. He was followed in this trend by his stepson Robert Estienne and the punch-cutter printer Antoine Augereau (1500–1534). Augereau came to an untimely end, strangled and burned for heresy on Christmas Eve 1534, but not before he had passed on his skills to the young Claude Garamont (1510–61), who, along with Robert Granjon (1513–90), would be amongst the most distinguished punch-cutters of the mid-sixteenth century (Fig. 37).

Simon de Colines's italic typefaces drew on both Griffo's Aldine italic and the later more formal style of Arrighi. Arrighi most likely created two types, the first strongly influenced by his own calligraphy and the second with less lengthy and curvacious ascenders and modest serifing – slightly more roman in feel. With Colines's introduction of both trends to French typography it fell first to Garamont and then to Granjon to unite them in a more legible and flowing style. But it was an Antwerp printer, François Guyot, who seems first to have deliberately conceived his roman and italic faces as one – to be used together rather than as separate bookfaces in their own right. The result is an italic that moves even more towards the roman, distinguished, as Harry Carter puts it, by a greater 'sobriety, width and rotundity'.[100]

Amongst the most successful of the new breed of northern European printers at this time was Christopher Plantin of Antwerp. He emerges vividly on to the pages of history because his business was carried on down into the nineteenth century by successive generations of the family. This meant that Plantin's archive survived. They include his business records, correspondence, accounts and even the type matrices and punches that he ordered from contemporaries – Claude Garamont and Robert Granjon amongst them. It was only in the 1950s that we came to realize the extent of the surviving collection, and it was a joyous time to be alive as a historian of type when the realization dawned that these carefully labelled packages containing type, punches and matrices

Fig. 37. Granjon's *gros-romain* (*c.* 16.5 point) type of 1566, in Livy's *History of Rome*, Frankfurt, 1568.

were the real thing – sixteenth-century originals from the hands of the masters themselves. Plantin's archive gives us a striking picture of the life of a printer a century after the technology had been invented.*

Born near Tours in France, around 1520, Christopher Plantin and his wife Jeanne settled in the booming port of Antwerp in 1548. Antwerp's rise as a trading centre, now the most successful north of the Alps, had been built upon a thriving textile industry and a growing trade in silver and spices as a result of the great Spanish and Portuguese voyages of exploration to the Americas and the Far East in the late fifteenth century.

By 1555 Plantin owned his own printing press. The trading network that he developed was the most extensive of his day. He sent books to booksellers in Scotland, England, Spain, France, Germany, Italy, Switzerland, Poland and Portugal, and his Hebrew Bible sold well in North Africa. In many French towns there were up to a dozen shops that his press supplied. Twice a year he sent several thousand books to the Frankfurt fair. They were transported, as most books were at that time, packed with straw in barrels. They travelled overland to Cologne and then by boat down the Rhine. In Frankfurt the company had a permanent store for unsold books, and there were also matrices of type kept there that Plantin had commissioned, probably for hiring out to other printers.

The business was a family affair. Frans Raphelengius, who married the eldest daughter Marguerite, was chief proofreader. He had been educated at Paris and taught in Cambridge; he knew both Latin and Greek and several Oriental languages. The second daughter, Martine, married Jan Moretus, company clerk and the business brain behind its operation. It was he who often travelled with Plantin to the Frankfurt fair. The daughters themselves ran a bookstall by the church of St Mary the Virgin during the Antwerp fairs, of which there were four a year. Another son-in-law, Gilles (Edigius) Bey, acted for a while as the press's agent in Paris. A cousin of Moretus was the permanent representative in Frankfurt.

* His home in Antwerp, the Plantin-Moretus Museum, is designated a World Heritage Site.

But the problems confronting printers in the mid-sixteenth century were no longer merely logistical. Books had certainly flooded on to the market, but with this increase in quantity other concerns had arrived. Secular and religious authorities were now wary of the press's power to influence a reading public.

Censorship

The history of censorship in book publishing is a complex one that varies not only from country to country but sometimes also between cities. Religious and secular authorities were threatened by the mass availability of texts. Current estimates are that by the turn of the fifteenth century there were between 15 and 20 million individual books in circulation. Until the 1470s most editions had run to between 300 and 400 copies. But in the early sixteenth century the numbers began to rise. In 1587 an agreement in England between compositors and the Stationers Company effectively identifies the upper limit: the maximum run for an edition was set at 1,500 copies. This was roughly equivalent to the number of sheets that could be printed (on both sides) in a single day. This represents an enormous change in production levels from the time when a single scribe could write a page or two of a large Bible per day. But whilst the opening decades of the sixteenth century saw many authorities trying to reassert control over what could be published, these restrictions had only minor effects on the physical make-up of books and none, in the short term, on the shape of letters and handwriting.

In 1515, at the fifth Lateran Council, Pope Leo X extended to the whole of Christendom a local provision of the ecclesiastical jurisdiction of Cologne, Mainz, Trier and Magdeburg that all authors must have prior permission on pain of excommunication. If you look inside any Roman Catholic prayer book today you will still see the Papal Imprimatur – the details of who gave permission to print it and when.

In France the Edict of Châteaubriant of 27 July 1551 required a specific form to be followed by printers so that the origin of a work could be traced. The edict ruled that:

It is forbidden to all printers to perform the exercise and status of impression except in good cities and orderly establishments accustomed to do this, and not in secret places. And it must be under a master printer whose name, domicile, and mark are put in the books thus printed by them, (with) the time of the said impression and the name of the author. The which master printer will answer to faults and errors that either by him or under his name and by his order will have been made and committed.[101]

Authorities sought to control the impact of the press in other ways also. In England Henry VIII granted royal monopolies to certain printers for the publication of particular genres of documents: only one printer could publish Bibles, or catechisms or books on common law.

Nevertheless, power to control a book at its point of origin had its limits, for the same book might be printed in a territory nearby that did not have identical regulations; a book banned in Paris could be imported from Lyons. So in the mid-1540s a new form of control was introduced. In certain cities it became an offence to *possess* prohibited books. Lists were produced, yearly, by the Universities of Paris and Louvain. Their example was followed by Venice in 1554. This latter list included the names of authors subject to a blanket ban on all their works. The Papal Index of prohibited books was introduced by Pope Paul IV in 1559,* and included named printers whose books, even if secular in nature, were prohibited on account of the printers' 'heretical' status.

The changing shape of the book

Fundamental changes to the physical nature of the book and the presentation of text had taken place in the course of the sixteenth century. Though Christopher Plantin still used the colour red in his liturgical books, most books were now printed in just black and white. Coloured text and illustrations were a thing of the past. Page sizes had shrunk, margins had been reduced and marginal glosses largely dropped. The

* And only finally abolished by Paul VI in 1967.

changes were made in the interests of technical simplicity and commercial viability – paper was the highest cost any printer had to bear. Title pages had been introduced giving the date of printing along with the names of the author and printer and the printer's mark. In the early days of printing this kind of information had appeared at the end of a book, as in the scribe's colophon or tailpiece. The extended length of book titles (they sometimes ran to long sentences) still showed that the rhetorical tradition of naming won out over typographic considerations of line length and easy word division.

The number of speciality letterforms used in the earliest typefaces was now vastly reduced, streamlining the typesetting process. The compositor, who set type, had to pick out each individual 'sort' of type from the case (called a fount or font of type) in front of him. The individual sorts were then placed in order in the typesetter's 'composing stick', which he held in one hand. Complete lines of type were transferred to the 'chase', a frame in which they were locked for printing. After each page was printed, the type block was broken apart and each sort redistributed back into its original pigeon-hole in the case of type. Capital letters were placed in the upper case and lower-case letters in the lower one. The more alternative letterforms there were to handle, the more complex and time-consuming the process became.

The pared-down presentation of the text on the printed page also allowed for faster reading and clearer lines of argument to be flagged up in the way the structure of the text was articulated. Verse numbers were introduced for the Bible and classical writings. Text, which had been printed in solid blocks, began to be divided into paragraphs. Because printing produced identical texts across an edition, new paraphernalia for reference evolved. Indexes with page references, footnotes, and agreed conventions for punctuation made printed books easier to consult.

Indexes were a significant introduction because they enabled books to be read in new ways. The most expansive botanical publication of the sixteenth century was a commentary on Dioscorides* by the Sienese

* Dioscorides (c. 40–90 CE) was a Greek physician and pharmacologist.

physician Pietro Andrea Matthioli. Matthioli's *Discorsi* was first published in 1544 and constantly updated as new plants were discovered in the Americas, Africa and the Far East. In the 1550s it had an index added so that one could consult the book not only according to the names of plants but from the basis of a medical problem and its solution.[102] The book thus became a practical resource for healing as well as a botanical encyclopaedia.

By the late sixteenth century the triumph of print was assured; the pulse of Europe's intellectual life flowed in its veins.

Handwriting Returns

201

Hearing that an Excellent Astronomer of my acquaintance had oftentimes measured the height of Clouds, I enquired of him, what height he had observ'd them to have & was answer'd that though he had measur'd 18 or 20, even of white Clouds in fair weather, yet he scarce observ'd any to be higher then tree quarters of a mile, & few of them he found to exceed half a mile.

Twenty shillings & somew above 3℔ of Sterling Allay being refin'd to a pound of Lead (w^ch weighs neer 4 times as much) weigh'd after the Operation ended but 4 ounces wanting a drachm.

A very Learned & fully credible acquaintance of mine inform'd me divers years agoe (& lately averr'd ye same thing to me) that in a place in Wiltshire (he nam'd he seen a Lyons of an Apletree graffed upon a Willow w^ch bore very faire fruite, but w^n he came to tast of ye Apple tho it seeming ripe enough yet it was almost insipid, & ye litle tast it had it seemed to have borrowd fro ye sap of ye stock not well assimilated or alterd: This Exp: is ye more considerable bec: it dos not only show upon how unpromissing stocks a Graff may prosper but that by Incision a Tree may be made to bare fruite y^t naturally bares none at all, at least if we may beleive husbandmen & others, who affirm y^t here in England ye Willow tree bares a kind of Blossome but noe fruite, & something J.A (I remember not,) ye same purpose is observ'd by virgil of ye same Tree in Italy.

About 3 months before ye late great Plague began in London (in the year 1665) there came to me a Patient of his to desire his advice for her Husband & ye D^r having enquired to aild him, she answer'd that his chief Distemper was a

Fig. 38. The chemist Robert Boyle's work book 21, entry 201-201, late 1660s.

Despite the arrival of printing, handwriting's role expanded in the sixteenth and seventeenth centuries. New forms of handwritten documents began to appear and scribal publication remained a feature of literary life into the early eighteenth century. Letterforms, both hand-written and printed, became simplified. Education in writing was more widely available. Books on how to conduct a correspondence made an appearance. European postal services developed. And finally, as part of the intellectual awakening that the Renaissance had stimulated, a new emphasis came to be placed upon collecting first-hand accounts of the observable world; handwriting served this need. Systematic note-taking and international correspondence underpinned the scientific revolution of the seventeenth century. Paradoxically, 150 years after the invention of printing, handwriting had never been so popular or widespread.

The *avvisi*: newsletters and newspapers

Handwritten pamphlets known as *avvisi* had begun to circulate in Venice and Rome in the mid-sixteenth century. They were compilations of news and gossip, the forerunners of the newspapers, produced by teams of copyists using information gleaned from the waiting rooms of ambassadors and the political networks that thrived in both cities. *Avvisi* were bought on the street as entertaining reading for ordinary citizens. The tone was often scurrilous. Paolo Alessandro Maffei, the eighteenth-century biographer of Pope Pius V, who tried to ban the *avvisi*, wrote:

> …on the one hand they always used the ploy of a vendetta and an uncontrolled vivacity of spirit, on the other, greed and gain played their part: but in everything malice is involved, coupled with lies, neither saying nor reporting what is true, but just enough to spread scandal and to ruin others, so as to find more readers for those unworthy sheets of paper and to reap greater profits from this ini-quitous trade.[103]

The handwritten *avvisi* were known in different parts of Europe as *gazette*, *raggualgli*, *nouvelles*, *courantes* and *Zeitungen*; they survived into the late seventeenth century.

In England news-sheets were tamer affairs. In the days of Queen Elizabeth I and her Stuart successors, nobles who were absent from court were kept informed of comings and goings by correspondents. By the 1630s this service had become professionalized and correspondents were charging for their services: John Porry received £20 a year from Lord Scudamore for his weekly letters in 1631–2.[104] Following the period of the Commonwealth, once the monarchy had been restored in 1660, newsletter distributors sometimes issued several hundred handwritten copies a week to a similar number of subscribers and charged between £3 and £6 per annum for a weekly subscription. For a time the first printed newspapers were sold alongside these handwritten newsletters and the *avvisi*.

Scribal publication in the age of print

Surprisingly, the handwritten manuscript book also survived well into the seventeenth century. In England 'metaphysical' poets such as John Donne (1572–1631), Andrew Marvell (1621–78) and Thomas Traherne (1636–74) wrote primarily for scribal publication. In the early eighteenth century, Alexander Pope even circulated a manuscript of his *Pastorals* (1709) in his own fine calligraphy. These handwritten publications could be profitable for the poet. Money came to an author, as it had since the days of Greece and Rome, from grateful patrons to whom a work was dedicated. Manuscripts allowed different dedications in different copies; a printed book just one.

The rush to print was still not an obvious choice for an author in the early seventeenth century; they were lucky to be paid by a printer for the use of their work. Most authors were simply given a specified number of free copies. They were expected to be writing not for profit but for some higher purpose, be that scholarly, religious, philosophical or political. They relied on private income or held public office. John Milton, Latin Secretary to the Commonwealth's Council of State, was paid just £5 for the rights to print his masterpiece *Paradise Lost* (1667),

and another £5 when the edition of 1,300 copies was sold out. Jonathan Swift had to be persuaded by Alexander Pope to accept any money for the publication of *Gulliver's Travels* (1726). Even as late as 1765 Voltaire was fulminating against 'the wretched species that writes for a living'.[105] The hazard of manuscript publication lay, as it had always done, in the possibility of errors creeping into the text. In 1677 Dryden complained in the preface to his printed *The State of Innocence*, essentially a stage adaptation of Milton's *Paradise Lost*, about 'many hundred copies of it being dispers'd abroad without my knowledge or consent: so that every one gathering new faults, it becomes at length a Libel against me'.* Those many hundreds of copies were all handwritten.

In London, records of parliamentary debates and other newsworthy announcements were published quickly in handwritten form. Considerable numbers of writers (sometimes up to fifty) could be mobilized at once, and by dictation news or copies of speeches (often just a page in length) were immediately made available. Scribes were also used for penning handwritten editions of polemical tracts that might get printers sued for libel. In the period after Queen Elizabeth I of England sanctioned the execution of her favourite, the Earl of Essex, on 25 February 1601, anonymous handwritten pamphlets were circulated protesting his death. In April 1601 an anonymous 'libel' on the same topic was forwarded to the Privy Council by the Mayor of London; it had been found dropped on the floor of the city's Exchange.[106] Leaving a copy in a public place was the usual way such handwritten protests were 'published'; they were also tied to the hands of well-known statues, nailed to the doors of the Inns of Courts or the House of Commons, even tied on to the door of the royal bedchamber. These acts of bravado (just like Luther's nailing of his ninety-five theses to the door of the church in Wittenberg) effectively made the work known, and copies might then be sought by others.

In a report to the House of Lords dated 1675, Charles II of England's fervently royalist Licenser of Publishing and Surveyor of the Press, Sir

* This discussion is in debt to Harold Love, *Scribal Publication in Seventeenth-Century England*, Oxford University Press, 1993.

Roger L'Estrange, makes clear that handwritten libels are still on sale alongside books in London's stationer shops. 'The Question of Libells, extends it selfe (I conceive) to manuscripts, as well as Prints; as being the more mischievous of the Two: for they are com(m)only so bitter, and dangerous, that not one of forty of them ever come to the Presse, and yet by the help of Transcripts, they are well nigh as Publique.'[107]

Postal services and letter-writing

The easy circulation of newsletters and newspapers had been made possible by steady improvements to postal services across Europe dating from the late fifteenth century. In 1476 Louis XI of France had established an equestrian post across his kingdom, with relay stations of fresh horses seven leagues apart.* Since 1489 the Taxis family from Bergamo had been carrying mail for the Emperor Frederick III from Italy up into Austria. From 1500 the service was extended into Belgium and the Low Countries. In 1516, the new Holy Roman Emperor, Charles V, permitted the von Taxis to carry private mail on a commercial basis as well as government correspondence. In response the family's postal routes expanded across Spain, Germany, Austria, Italy, Hungary and France. A letter from Brussels to Paris took between thirty-six and forty hours, Brussels to Rome just ten and half days.[108]

The royal mail in Britain had been a continual drain on royal resources. In 1635 steps were made to remedy the situation. Private letters could now be included with the mail for a fee. The fee was set at 2d for up to 80 miles, 4d for 80–140 miles, 6d beyond that and 8d to Scotland. The cost to the royal purse of the post before these changes was estimated at £3,400 a year; if the average charge per letter was 3d then carriage of 270,000 private letters a year would cover the cost.

It was not the most efficient system: all letters had to be sent to London first for sorting,† and only a single folded sheet of paper could

* An old French league was 3.248 kilometres or 2.018 miles.
† The trip to London could add a considerable expense, because charges were made by the distance the letter was carried rather than the miles that divided the postal and delivery addresses.

be carried. Letters were held up to a candle if they were suspected of containing additional sheets and they were charged double on delivery. Postal charges were worked out before dispatch from London and written on to the packet, which was also date-stamped. The sums due were entered into a Letter Book against the name of the local postmaster, who had to collect the revenue on delivery.

Sending all letters via London had an unintended consequence. During the period of the Commonwealth, John Thurloe, Cromwell's Secretary of State, took advantage of the arrangement to open a secret room next door to the General Letter Office in Bishopsgate where mail could be opened and copied, handwriting forged, and seals duplicated. The work was done between 11 p.m. and 3 a.m. to 4 a.m. the next morning.[109] Elizabeth I's intelligence operation, run by Sir Francis Walsingham, was known to have employed similar black arts, but now the practice was institutionalized within the postal service. A specially equipped room was maintained at the headquarters of the Post Office until at least the nineteenth century.

In 1657 Cromwell established the General Post Office, one organization for the whole of the British Isles, an act confirmed in 1660 by the newly restored monarchy. It was pressure of trade that had led to the post's expansion; more and more people wanted to use it, and between 1650 and 1714 the number of employees in its service quadrupled.[110]

At about this time individual European cities established their own postal services. In 1653 Renouard de Villayer organized the *Petite Poste* in Paris. Letter boxes were set up on the street, and for a standard fee of one sol letters were delivered anywhere in the city that same day. The receipts for the postal fee were attached to the packet before posting, the precursor of the modern postage stamp. Though copied in many other cities, this particular service lost money and was short-lived. One particularly inventive rival attempted sabotage by posting live mice into the boxes.

By 1680 London also gained an additional postal system, the penny post: for a penny a time messengers would collect and deliver letters. Messengers called at Receiving Houses (of which there were up to 500 across the city) every hour and guaranteed to return with a reply to a

message in just two hours – the equivalent of our 'biking it'. Correspondence as a habit grew: in 1698, 792,000 letters passed through London's penny post and an additional 77,530 were sent into the country.[111]

The painted evidence

The physical form that correspondence took in the seventeenth century, and the domestic settings in which letters were composed and read, is beautifully illustrated in the many works made by Dutch genre painters on this theme from the 1630s onwards. The choice of subject is extraordinary in itself, men and women (but mostly women) reading and writing letters. Painting has moved from the world of the gods, the great and the good, to depict ordinary lives in domestic interiors, from the world of high drama and action to suspended moments of concentration. Thought is palpable as Vermeer's 'woman in a yellow dress' looks up from her writing (Fig. 1, p. vi), and as his 'woman in a blue coat' stands, pregnant, by an open window, a large map on the wall behind her, catching the light on the letter she reads. Nearly one fifth of Vermeer's small output is pictures of women reading or writing letters.

Vermeer's own hand was a gothic cursive until just before his death at the age of forty-three, when it changes to larger roman forms, as if laying claim to a greater status. On other documents, such as a loan he guarantees with his wife in 1655, his signature is small and unpretentious. His wife, thought to be the model for a number of his letter paintings, signs the same document with calm, skilled calligraphy and an elaborately flourished initial. It is clear that she took considerable pride in her penmanship (Fig. 39).[112]

Fig. 39. The signatures of Johannes Vermeer and his wife Catharina, 1655.

Fig. 40. *Notary in his Office*, by Job Adriaenszoon Berckheyde, 1672.

Job Berckheyde's *Lawyer or Notary in His Office with a Peasant Client* of 1672 depicts a professional environment (Fig. 40). There are a lot more documents around. Bundles of letters were conveyed (and sometimes stored) in closely fitting woollen bags, and eight such bags hang upon the wall along with several other paper bundles. The letter rack has a double row of pigeon-holes. There is a bookcase. Many leather-bound books line the walls and lie on shelves along with a scatter of smaller documents.

A comparison with Holbein's portrait of the thirty-four-year-old Hanseatic merchant Georg Giese in London in 1532 makes it clear that the materials used in letter-writing have changed little over the past century and a half. Quill pens (goose is the most popular) and iron gall ink, sealing wax and pewter inkwells lie close to hand. By the seventeenth century, however, paper was more commonly used than parchment; vellum was now usually restricted to the lawyer's office. The paper sheets in Dutch genre painting measure a little larger than the standard sizes of paper we use today. Often written on a bifolium, a folded sheet,

the letter could be folded into at least three sections across, enabling one end of the message to be tucked around into the other to form an envelope. The address was written on the outside of the packet. Paper could be folded more easily than vellum, and it was thinner, so the size of the folded packets has decreased from those in the Giese portrait. The tapes and parchment ties we see hanging on the wall of his workplace are for re-use on bulky vellum documents.* Georg Giese's workplace is homely, a covered table, battens tacked to the wall to act as letter racks, just two elaborately carved shelves with ledgers – measures, currency and a scale, all finely crafted. One senses a more leisured age.

Everything about the art of letter-writing was celebrated in the Netherlands; penmanship was held in high esteem. The economic historian and biographer of Vermeer John Michael Montias has examined the inventories of seventeenth-century homes in Delft and found many examples of sheets of calligraphy (or *schoonscrift*, beautiful writing) being exhibited alongside paintings in people's homes.[113] In 1617, when the Dutch writing master Jan van der Velde sent his son a copy of *Spieghel der Schrijfkonste*, his most celebrated book, he told him he should be able to ask 100 guilders for it, or 3–4 guilders per page if the book was broken up into individual sheets (of which there were 100). The annual wages of a carpenter or master bricklayer at the time was 250 guilders.[114] Fine writing could be an expensive commodity as well as a beguiling accomplishment.

Towards the English round hand

It was Dutch writing masters who were the leading influence on European handwriting in the early seventeenth century. The Dutch Republic, formed from the seven northern provinces of the Low Countries that broke away from the Spanish Netherlands in 1588, was now a growing commercial and political power. The harsh rule of the Spanish in the southern part of the country had only served to increase the cultural vitality of the north, to which the intellectual and financial elite had

* Presumably they are kept to be recycled on further correspondence.

fled. The tradition of well-known writing masters from the region went back at least as far as Mercator (b. 1512), who made the maps and globes that Plantin had stocked in his Antwerp shop (alongside books and fine wines – he was selling a lifestyle). In 1540 Mercator had produced a succinct writing manual, really as an assistance to those who made maps, a growing profession in what was becoming a great maritime nation. Mercator advocated the italic hand over the gothic cursive as being both more legible in confined spaces and capable of being flourished in areas of a map that were inevitably still blank. Other masters from the period included Clement Perret, whose first writing manual was published in 1569 when he was just eighteen years old; his second was printed by Plantin in 1571. Jocundus Hondius's *Theatrum artis scribendi*, a compilation of writing masters' works, was published in 1593; it included work by his sister Jacquemine, Caspar Becq and his daughter, Maria Strick of Delft. Also included was the hand of an assistant to Becq whose star was the brightest of all, Jan van der Velde. We have met him already – sending pages from his writing book to his son; the book he had sent was his masterwork, his fourth book, the *Spieghel der Schrijfkonste* of 1605. It was reprinted several times and translated into both French and Latin. His command of hand is striking and steady. For writing the fluently curved flourishes and knotwork for which he was famous he advocated the lightest of penholds and the stiffest of quills, soaked for a while in the ink beforehand to soften the nib.

Several of these masters, Mercator and Hondius for example, spent extended stays in London, to which the French Huguenot John de Beauchesne had fled in 1565. It was he who produced the first English writing manual, *A Booke containing divers sortes of hands,* with John Bales in 1570.*

Simplicity and practicality were the qualities writing masters espoused at the dawn of the seventeenth century. Yet still the script for daily business in all the countries of northern Europe at the time was

* Mention must be made of another Huguenot refugee, Ester Inglis, whose family found refuge in Edinburgh. Renowned for her miniature books, she numbered Elizabeth I amongst her patrons.

various forms of gothic cursive. Jan van der Velde identified four that were current in the Low Countries.

> The first can be compared with the style that the French call *ronde*. It is of square proportions and tranquil aspect and constitutes the basis of the other styles since students always begin with this style when learning to write...the three other styles are called current or expedi-tive. The first is upright, the other two inclined, one forward and one backwards. These two styles are influenced by German writing. The first of these current scripts, the most perfectly formed and surely the most handsome, is used by solicitors, lawyers and secretaries to write letters patent, petitions, contracts and receipts. As for the other two they are suitable for merchants and copyists who have to take notes in a hurry or transcribe dictated texts.[115]

The *ronde*, as van der Velde says, was the principal formal hand used in France. It had a life in formal documents right into the early twentieth century and its forms still lie behind contemporary French handwriting. But it had two companion or rival scripts. One, *coulée*, was formed from a mixture of the small-sized version of the *ronde* called *financière* and the simplified shapes of the *Italienne bastarde*. The second rival was the *bastarde Italienne* itself, which had been developed out of Cresci's italic and popularized by the papal scribe Lucas Materot, whose crisply printed *Les Œuvres de Lucas Materot* were published in Avignon in 1608. Materot's *bastarde Italienne* (Fig. 41) proved influential in England, eventually evolv-ing into the English round hand, which became the predominant hand in Europe and North America in the late seventeenth and eighteenth centuries. The hand was taken on by Jan van der Velde in his reissued *Spieghel der Schrijfkonste* of 1609. There are traces of a similar stripped-down aesthetic in the Roman hand of the Englishman Martin Billingsley in his 1618 *The Pen's Excellencie or the Secretaries Delight*. It can also be found, described as *bastarde Italienne*, in Richard Gething's *Chirographia* of 1645. His pupil Peter Gery's version, in *Gerii viri in arte scriptoria* of 1667, is beautifully straightforward. Another student of Gething's, Thomas Topham, seems to have taught the hand to his student John

Fig. 41. The *bastarde italienne* hand, forerunner of English round hand,
from *Les Œuvres de Lucas Materot*, Avignon, 1608.

Ayres, for it appears in the latter's *A Tutor to Penmanship or the Writing Master* of 1697/8. By the early eighteenth century the received wisdom was that Ayres himself was responsible for the introduction of the hand. The penman John More, in his *Specimens of penmanship* of 1716, writes: 'The late Colonel Ayres (a disciple of Mr Topham) introduced the bastard Italian hand amongst us, which by the best masters has been admitted, naturalised, and improved.' It is not surprising that Ayres attracted this legend to himself – he was a larger than life character alternately called 'the Major' or 'Colonel' as a result of his work with the City Bands, and had started life as a footman. Like many penmen of the age he was fiercely assertive of the merits of his profession. He ran his own school at 'The Hand and The Pen' near St Paul's churchyard, and Samuel Pepys, a collector of handwriting manuals and samples of calligraphy, held him in high regard.

In reality the introduction of the English round hand was a cooperative effort, a matter of common agreement between masters of the time that this simple script answered the needs of an age where swift and accurate written records had become crucial to many enterprises. Other penmen who assisted in shaping the script included Charles Snell

(*The Penman's Treasury Open'd*, 1694) and George Shelley (*Natural Writing*, 1709). The writing master and engraver George Bickham (1684–1758) helped popularize the hand through *The Universal Penman,* published in parts between 1733 and 1741; the work contained his own engravings of the work of twenty-five contemporary English writing masters in 210 plates (Fig. 42).

That at any rate is the 'official' history. One has to wonder, however, as one examines the ordinary writing of the period in letters and note-books, as we shall later in this chapter, to what extent the penmen of the era were really trend-setting or following the crowd. The handwriting of many intellectuals of the period, Isaac Newton and Robert Boyle for instance, shows tendencies to simplification – perhaps as a consequence of the immense amount of writing they were doing. It seems unlikely that they had learned a simple style but rather such a style had evolved in their writing, perhaps from necessity. Charles II of England, a prolific correspondent, and his brother the Duke of York, the future James II, also show the use of simplified letter forms in their personal correspondence: Charles, neat, spacious and flowing, and James, large and angular, in one's face, completely filling the page right up to its edge.

Judged by the standards of our own time, writing masters could be strikingly condescending. The simplified Italian hand, which was the origin of English round hand, had begun the century, as Martin Billingsley makes clear in *The Pen's Excellencie, or the Secretaries Delight* (1618), as a script for women. The roman hand 'is conceived to be the easiest hand that is written with Pen and taught in the shortest time', he wrote,

Fig. 42. English round hand, George Bickham's
The Universal Penman, London, 1733–41.

'therefore it is usually taught to women, for as much as they (having not the patience to take any great paines, besides phantasticall and humorsome) must be taught that which they instantly learne'.[116] Billingsley for all his 'phantasticall' comments was ahead of his time: he was at least arguing that women *should* be taught to write.

The awkward fact that a handwriting supposedly for women was also providing the model for the new commercial hand led to attempts to distinguish more markedly between the 'feminine' Italian and the 'plain, strong and neat writing…obtained among Men of *Business*; with whom all *affected* Flourishes, and quaint Devices of Birds and Bull-Beggars, are as much avoided, as Capering and Cutting in ordinary Walking'.[117] As time wore on the Italian hand narrowed to the very slim shapes we see in Bickham's manual. The round hand expanded in letter width. In John Ayer's *The Tutor of Penmanship* (1697/8), the diagram of related letter-shapes* at the end of the book shows letters made about fifteen nib widths high and twelve wide. The size of nib for this script was chosen to reflect the desired width of the stem of a letter.

Texts from the late seventeenth and early eighteenth centuries show how the thick and thin strokes in this hand were obtained. The common perception today is that they were achieved by using a pointed nib and applying pressure, but this was not so for most of the seventeenth and eighteenth centuries. Certainly pointed nibs and pressure were used for some scripts in the period, and for elements in particular letters and flourished shapes and in particular for swash italic capitals, for small sizes of writing (less than 1.5 mm high)† and when writing needed to be quickly done. But for the *bastarde Italienne* and round hands, in the late seventeenth and early eighteenth century, the nib was cut square but with the nib slit placed over to one side rather than centrally. Jean-Baptiste Alais de Beaulieu's *L'Art d'Ecrire* (first printed in Paris in 1680) shows the thumb side of the nib with a considerably wider part of the nib than the finger side (Fig. 43). When making a letter the thin upstroke

* Large letters are superimposed upon each other but without the underlying grid that will become a commonplace in eighteenth-century writing manuals.

† This trend towards the use of a very fine pointed pen is already noticeable in *Les Œuvres de Lucas Materot* from 1608.

Fig. 43. Enlargement of diagram in the margins of plate 20
from Alais de Beaulieu's *L'Art d'Ecrire*, Paris, 1680.

is produced by rocking on to the corner of the larger (and hence stiffer) 'thumb' side of the nib and making a thin line extending up to the right. When the nib comes to the top stroke of the letter the whole width of the nib is placed down upon the page to make a thick descending line. In this way the squared-off foot to letter stems was obtained – as a normal function of using a broad-edged pen. Alais demonstrates the technique with a diagram showing the pen in action writing the lower-case letters **n** and **u**. He also explains that though the letters might look as though they join to each other actually they don't, they are separate, but the finishing stroke of the letter is simply allowed to run on and the stem of the next letter comes down on top of it. They overlap rather than join.

The growth of literacy

The many different styles of letterform in use were an obstacle to the more widespread acquisition of literacy. To be literate then was to be literate in certain fields that were at first geographically and then professionally circumscribed. Different professions had different requirements; the form expected of legal documents, always the most conservative and resistant to change, required that legal clerks still had to learn specific forms of gothic cursive and formal blackletter. They also had to learn how to prepare and write on vellum, something that the ordinary businessman no longer needed to know. Literacy meant different things in different settings.

Figures for literacy are notoriously difficult to establish before the modern era; the problem is what do you measure? Scholars have focused mostly on documents such as marriage registers, wills or oaths of loyalty that substantial proportions of a population are required to sign. These can supply an optimistic baseline level of ability but one simply does not know if the writer's skill is more generalized than the ability to sign their name. One must also recognize that literacy can change over time. Like a second language learned at school by twentieth-century children which can grow rusty if left unpractised, so too with handwriting, which might actually peak in early years and then, for lack of use, shrink to the ability to make one's mark. Measurements based upon

signature collection certainly underestimate female literacy, for they focus on typically male domains, oaths of allegiance for instance. The rates of advance in literacy across Europe are also patchy, and sometimes (as in Spain from the second half of the sixteenth century to the mid-eighteenth) even regressive.[118] Progress is not steady, and political developments can be disruptive: in the early seventeenth century, the Thirty Years War (1618–48) between Catholic and Protestant forces devastated much of central Europe. When combined with the effects of plague, areas of Germany and Bohemia saw the population level fall by between 30 and 60 per cent.[119] There was also a long economic depression in many parts of Europe from 1690 to 1730. Areas of eastern Europe did not see any improvement until the twentieth century. Then again, different sections of the population can have quite different degrees of skill. It is difficult to compare like with like. In Caen studies of a 1666 municipal census, which counted only fluent signatures with linked letters, reveal that 90 per cent of the city's prestigious textile workers could write. The figures were 60 per cent for tailors and shoemakers, 55 per cent for bakers, 40 per cent for stonemasons and carpenters, 25 per cent for weavers and 12 per cent for day labourers and porters. Figures for Elizabethan England show that literacy amongst the gentry was the normal state of affairs, and by 1600 writing ability amongst tradesmen and craftsmen nationally stood at about 50 per cent.[120] But to truly understand this data we need comparable figures for different cities and slices through the same professions in the same city over time, as well as over the lifetime of individuals.

Nonetheless a few broad trends are visible. From the late seventeenth century literacy increases in many centres of population in Europe, and particularly so in the second half of the eighteenth century, though in England there is evidence that it slows down towards the very end of the century as the Industrial Revolution gathers pace.[121] The gap between men and women slightly narrows. In one survey of French marriage registers, during the measured period from 1686 to 1690, 29 per cent of men and 14 per cent of women can sign registers; the figures rise to 47 per cent of men and 27 per cent for women from 1786 to 1798, and a century later they stand at 75 per cent and 61 per cent respectively.[122]

For England we have on record Thomas More's assertion in his *Apology* of 1533 that six out of ten Englishmen could read.[123] But how many went on to write? Taking the balance of evidence from a number of documents that required signatures, David Cressey has national illiteracy figures at the beginning of Elizabeth I's reign for the population as a whole at 80 per cent for men and 95 per cent for women. This compares with figures of 80 per cent and 90 per cent around the time of the Civil War, and by the end of the Stuart period (1714) the figures are 55 per cent of men being unable to sign their name and 75 per cent of women. From 1754 onwards all brides and grooms in Britain had to sign the official marriage register. From this evidence we can see by the mid-eighteenth century that just 40 per cent of men and 60 per cent of women are unable to sign.[124] This represents a 40 per cent increase in signatures for men and 30 per cent increase for women over the course of 100 years, up to the mid-eighteenth century.

The geographical distribution of figures is also significant. Figures for England, using signatures required from all males over eighteen subscribing to an oath to uphold 'the true reformed protestant religion' from 1642, lead us to believe that at least 60 per cent of the male population in towns could sign their names. In the countryside around London about 40 per cent of males could do so, and this figure goes down to 30 per cent in the further reaches of the kingdom.

It is really not until the modern era, however, that figures are detailed enough to be usefully comparable across regions, countries, socio-economic and gendered categories. It is perhaps more instructive to look at what people did with the skills they acquired.

Letter-writing

Printed guidebooks to letter composition make their appearance in France from the 1550s and are soon translated into Dutch and English, offering model letters for correspondents to follow. The most successful seventeenth-century manual was Jean Puget de la Serre's *Le Secrétaire à la mode* of 1630, which was reprinted at least thirty times. In England the earliest manuals were titled with aplomb: *The Enemy of Idleness* (1568) by

William Fulwood, Abraham Fleming's *A Panoply of Epistles* (1576) and Angel Day's *The English Secretorie* (1586).

As the seventeenth century wore on, the kind of letters people wrote was widening. Jean Puget's *Le Secrétaire à la mode*[125] supplied examples of letters requesting employment, protection, offering advice or assistance, letters to counter false rumours, and to solicit pardon. There were also letters of congratulations, expressions of gratitude or condolence; the last fifth of his book is devoted to love letters. Other manuals, such as B. Hakvoord's *Alegemeene zendbrieven*, published in Rotterdam in 1696, were more prosaic: letters for collecting rent, IOUs, contracts, testimonials, prenuptial agreements and even poetic greetings to be sent on the major festivals of the year. Some manuals in the seventeenth century began consciously to print model correspondence as a form of entertainment. Sequences of letters began to tell stories. Pierre de la Chambre's *Verscheyden Brieven, bequaem in de Schoolen te gebruycken* (Different Letter Samples, for use in schools), printed in Haarlem (in French and Dutch) in 1648, satirizes the painful experience of a parent who has sent a son away to school. The last letter in the volume is from the schoolmaster demanding payment of the school fees.

Though manuals were undoubtedly helpful in teaching the basic skills of how to draft a letter, so was advice from closer to home, from correspondence within the family. Susan Whyman has shown how for a number of families this was how the children really learned their letter-writing skills.[126] The diarist John Evelyn (1620–1706), who at the age of fifteen had put himself 'to the Writing Schoole for a Moneth or two' because his father 'was extreamely displeased at my Writing so ill a Character',[127] schooled several generations of his family in their writing style through the correspondence he had with them. Through research in local archives Whyman has shown that this was true also of merchant families in Hull, Newcastle, Derby, Manchester and Kirkham in Lancashire. Children's letters were collected by anxious parents who knew this skill was important, not only to their family cohesion but to getting on in the world. Fine examples of their children's letters were shared with friends and lovingly annotated. On the back of a letter of verses from his son Jack, Evelyn scrawled, 'Jack was but 12 years when he writ this.'[128]

A culture of observation and annotation

As we saw at the time of the Renaissance, movements in the human spirit, the subtle influence of imagination and new experience can often provide motivation for changes both in letter-shapes and textual content. As the palaeographer James Wardrop observed, scripts 'get that way', 'not from any prepotency in themselves but because of the purpose underlying them; because (to reduce it to its simplest terms) people and things, in all ages, were set against a specific intellectual, social, and economic background; because men (sic) pursued this or that ideal, or illusion, or appetite, and made or unmade themselves in the process. Thence the student may be led to the conclusion – a trite enough conclusion, but one often missed – that the ultimate value of paleography (the study of ancient writing), as of any humane study whatsoever, lies in just what it has to tell us about people and things.'[129] The broader significance attached to handwriting in the late sixteenth and seventeenth centuries across many aspects of European culture signals a new attention to the value of first-hand experience, its documentation and communication. In reality this was an emphasis that had been growing ever since the dark days of the Black Death, and the birth of humanism. At that time it had led to new developments in literature, theology, an appreciation of the classical world, art and architecture; now it was to lead to a scientific revolution and an age of 'enlightenment'.

Back in 1543 an anatomist from Padua, Andreas Vesalius (1514–64) had published a ground-breaking work, *De corporis fabrica* (On the fabric of the human body). The detailed woodcuts of anatomical dissections that the book contained set new standards for the accurate depiction of the human body. The reason for their accuracy was that Vesalius had undertaken the dissections himself and made notes and drawings as he went along. This was a radical break with the past. The normal procedure at the time was that a barber surgeon did dissections to the instructions of a physician, who followed the procedures set out in the writings of Galen (129–217 CE), the Roman physician who was still an undisputed medical authority – even for da Vinci in his unpublished dissections of a few decades earlier. Vesalius's personal observations revealed that

Galen's writings were deficient in many respects.[130] He also uncovered the fact that Galen had never examined human corpses, only those of the Barbary ape; dissecting humans, it turns out, had been illegal in the Rome of his time.

In a similar fashion, direct observation radically changed the world of medical botany. In 1530 Otto Brunfels had published *Herbarum vivae icones* (Living portraits of plants). The 260 woodcuts the book contained were made by Hans Weiditz, a pupil of Albrecht Dürer. The woodcuts were freshly observed from living plants rather than copied from drawings in earlier works. Weiditz reproduced the insect damage on leaves and even drooping and withered flowers. So accurate were the drawings, now reproduced in woodcut, and distributed widely, that it made it possible for botanists to come to agreement, for the first time, about what plants were being depicted. A common terminology for plants, where local names differed across Europe, was now possible.

Careful observation and annotation were linked to other new discoveries. Galileo Galilei relied on direct observation to confirm what both the Polish priest-astronomer Copernicus and the German Johannes Kepler knew, that the earth was a planet in orbit around the sun. In proving the theory Galileo made use of lenses and a telescope, heavily inked notebooks and drawings in which he recorded his observations. In January 1610 he observed moons circling Jupiter. The fact that another heavenly body had objects orbiting around it was the *coup de grâce* for the Ptolemaic understanding of the cosmos, which was geocentric, meaning that all the heavenly bodies were thought to circle around the earth. Though Galileo later felt compelled to renounce his views by the Inquisition, which held that they challenged biblical teaching, Galileo's letter of 1615 to Christina de' Medici sets out the point at issue. 'I think that in discussions of physical problems we ought to begin not from the authority of scriptural passages, but from sense experiences and necessary demonstrations.'[131] Tellingly his letter to Christina circulated only in manuscript form for the first twenty years of its public existence. In England the philosopher statesman Francis Bacon (1561–1626) also argued for knowledge of the world to be derived from reasoning based on experience and observation. Henceforth, new universities,

such as that at Leiden in Holland, founded in 1575 by William, Prince of Orange, would have not only lecture halls and libraries but also dissecting theatres, botanical gardens, laboratories, observatories and museums. The authority of book learning was, in this respect, diminishing. Whilst at the opening of the Renaissance to be learned meant assembling a library of all known classical works, the Bible and its principal commentaries and absorbing them, this was no longer sufficient. The world had been shown to have dimensions unknown to these earlier authorities.

Underpinning the new sciences of medicine, botany, astronomy and geography was the culture of direct observation, demonstration and experiment, *and at the heart of this approach is the methodically kept handwritten record* – the scholar's note- and sketchbooks. Handwritten records were no longer simply a tool of the state or counting-house; now their pages became the anvil on which individual experience of the material world was forged into intelligible form. These discoveries were then communicated to others, in the first instance, not through books but by correspondence – often in Latin.

The collation and coordination of different points of view through handwritten documentation, via correspondence, through public meetings and readings and the making of minuted copies of decisions lay behind many significant achievements of this time. Careful documentation was on the ascendancy; it made wider cooperation, and geographically distributed projects possible. In Britain the King James Bible, published in 1611, drew together up to forty scholars, at the King's command, in a collaborative work of scholarship. Much telling language and phraseology that has become common English usage was forged by these means. In 1623 William Shakespeare's fellow actors and good friends John Heminge and Henry Condell undertook the production of the first folio edition of Shakespeare's work, carefully compiling and comparing the resources they could muster. Fair handwritten copies, prompt copies, earlier printed quarto editions and Shakespeare's own 'foul copies' – his original manuscript version – thus became the first definitive edition of his plays.

The list of the different kinds of copies used to compile Shakespeare's

first folio edition surely points to the existence in countless workplaces, families and communities of a wide range of manuscript sources, personal diaries and commonplace books, small handwritten instruction manuals made for local use that have perhaps never seen the light of day. Within the English Benedictine community of monks and nuns, who had lived in exile since Henry VIII's dissolution of the monasteries, a particular treasure was the many handwritten manuscripts of their greatest seventeenth-century spiritual director, the Welsh monk, Dom Augustine Baker (1575–1641). These writings comprised over 100 books in manuscript form, but are still only known today through a heavily edited and systematized compilation, *Sancta Sophia,* published in 1657.[132] The original manuscript works from the early seventeenth century are only now being published.[133]

Handwriting and the scientific age

Carefully compiled handwritten documentation leveraged many of the developments that made the seventeenth century one of the most formative periods in European history, but it was nothing pretty to look at. These commonplace documents were generally not in the fine hands of the writing masters but in more serviceable scripts modified by speed and the constant rehearsal that encourages a personal quality in writing to emerge. Such papers can look humdrum; their significance is easily missed.

Described as looking like a prop from a Harry Potter film, just such a battered, 500-page manuscript full of closely written text was shown to a valuer at an unidentified house in Hampshire in January 2006. It had been produced by the owner as an afterthought. The valuer had his coat on and was about to leave. The book had been kept amongst old playbills and other papers in a box at the back of a cupboard for the last fifty years. Speaking to the newspapers later, Felix Pryor, the manuscript consultant for Bonhams auctioneers, said, 'The first page I saw was headed "President Sir Christopher Wren in the chair," and I knew I was looking at the vanished minutes of the Royal Society…Then there were all these names: Wren, Leibniz, Aubrey, Evelyn, Newton. Then I

began to recognise the handwriting of Robert Hooke. It was a magical moment.'*

The Royal Society of London was the world's first fellowship-based academy of science. In its own words, 'it promoted the new philosophy of learning by experiment, observation and international correspondence'. It had grown out of informal meetings and correspondence between friends, beginning in the late 1640s. They met once a week to observe experiments and discuss the results. *Nullius in verba* was the Society's motto – 'Take no one's word for it'. With the restoration of the monarchy in 1660 they decided to formally constitute themselves and received their Royal Charter two years later, in 1662.

The Society was dedicated to sharing knowledge; overseas visitors were welcomed into their meetings. The Society's secretary, Henry Oldenburgh (originally from Bremen), acted as a clearing-house for letters coming in from scientists across Europe. He forwarded Newton's letters to Leibniz in Germany and let him know of the reactions to his letters at meetings, and then solicited his response. Extracts from the letters received were published in the Society's *Philosophical Transactions*, in effect one of the earliest peer-reviewed journals.

For historians of writing the seventeenth century has often been an era to move quickly over. Perhaps we are embarrassed by the impossible posturing of the writing masters, those self-important characters that Isaac Disraeli would dismiss as Vive la Plume men. Everything seems to be flourished and insubstantial. But in the documents and notebooks of the new scientists, chemists and philosophers of the Royal Society and their correspondents we can see the first handwriting that is recognizably modern. The modest looped cursive of Descartes, the flowing hand of the astronomer Edmund Halley, and Boyle the chemist, and Newton's hand, look as if they might have been written any time in the last century; but not always so. Sometimes they revert; this is still a time when writing is in 'transition'. Robert Boyle's (1627–91) handwriting is

* The *Guardian*, 9 February 2006. See also R. Adams and L. Jardine, 'The Return of the Hooke Folio', *Notes and Records of the Royal Society*, 2006, 60, pp. 235–9, published online 8 September 2006. Accessed 10 February 2010.

particularly variable over the course of his life. On one particular page of his notebook No. 21 (Fig. 38, p. 154), we can see a functional and flowing hand at the top of the page (entry 201) and then a complete contrast beneath, a stiffer flourished hand that reminds one of Billingsley.[134] In the margin to the left of the passage, where the change occurs he has written the word 'Transcribed'. It appears that the act of transcription has made him socially self-conscious again; he feels he has to put on a bit of a show – this is his careful writing.

Born on 4 January 1643, Newton grew up in Lincolnshire. Neither of his parents knew how to read and write – his father died shortly before the boy was born. Aged twelve he was sent away to school in Grantham. He bought a small notebook with a vellum cover with two and a half pence his mother had given him. Inside, in microscopic writing, he penned *Isacus Newton hunc librum possidet* – 'he possesses this book' and then his first notes:

> ... Instruments of drawing.
> Pens made of Raven quils
> thick & smooth paper
> & light coulored blew paper
> fine parchment
> a flat thin bras ruler
> a paire of compasses
> a wing
> & sundry plummetts
> & pestells to draw withall

He soon graduates to tables of the sun's altitude through the year, copies of model correspondence and the invention of a code based on sounds. He takes the book to Cambridge when he goes up to study there in 1661. When space in the notebook runs out he buys another, 90 by 140 mm (3½ x 5½ inches), covered in leather; in this small book his revolutionary ideas on optics and momentum first see light of day. Four of his Cambridge notebooks survive.

There is something about the notebook, filled with tiny writing, rather like the artist's sketchbook, which is freeing. It is almost as if at this period of European history it was necessary for certain kinds of writing to now divest themselves of pretensions. Francis Bacon had urged that the first necessity of any scientific endeavour was to clear the mind of distortions that could cloud one's judgment. He named four, that of the tribe, the den, the marketplace and the theatre. In other words we must purge ourselves of all that smacks of social conformity, the ivory tower, of over-selling an idea, or oneself (by a kind of theatrical posturing) in order to see clearly. So too in handwriting – this new kind of exploration was best carried out away from the world of fine writing, the ruled page, the classical idyll; it needed to use materials and forms that themselves enabled the provisional, the unknown, the second thought to be welcomed not grudgingly, as imperfections or cancellations, but as part of the process of writing itself. I am reminded of a parallel context noted by Susan Bernofsky when she comments on the origins of the microscripts of the modernist writer Robert Walser (1878–1956). His writing had become blocked and his hand psychosomatically cramped, 'and so he adopted a radically new approach to his writing, abandoning the pen with its long and daunting calligraphic history for the lowly pencil, an instrument for children and by filling up page after page with crabbed writing so small it defied legibility, he broke radically from the aesthetic ideal of the elegantly inscribed page he had pursued' and his work was reanimated. The mid-seventeenth century is the moment when many in Europe also deliberately break with the aesthetics of the well-written page; perhaps this is why the lettering historian has always found the period difficult to write about. It is not simply that the printed book has now assumed responsibility for carrying forward the formal stream of knowledge with all the demands on legible form that that role generates, but rather that some forms of handwriting come to serve a different concept. Imperfection, lack of knowledge, the obscure are now areas for exploration, and these moments of doubt and tentative discovery must be served as well as our shining moments of certainty. How ironic for a period in history named the Enlightenment that outside the writing masters' manuals and the certitudes of the counting-houses and

lawyer's office writing actually lowers itself, becomes homely, a trifle careworn – the only way, as Ovid tells us in his *Metamorphoses*, to safely entertain the gods unawares.*

The modern look of Newton's writing comes from its on-running momentum, which itself comes from freely flowing thought. Again I am reminded of Walser. Writing in the *New York Review of Books* for 2 November 2000, the South African playwright J. M. Coetzee highlighted a 'gain' for Walser's 'pencil method'. 'Walser needed to get a steady, rhythmic hand movement going before he could slip into a frame of mind in which reverie, composition, and the flow of the writing tool became much the same thing. In a piece entitled "Pencil Sketch" dating from 1926–1927, he mentions the "unique bliss" that the pencil method allowed him. "It calms me down and cheers me up," he said elsewhere. Walser's texts are driven neither by logic nor by narrative but by moods, fancies, and associations: in temperament he is less a thinker or storyteller than an essayist. The pencil and the self-invented stenographic script [it was based on German *Kurrentschrift*] allowed the purposeful, uninterrupted, yet dreamy hand movement that had become indispensable to his creative mood.' Writing and thought itself were flowing into fresh channels.

There is perhaps something else about the Royal Society and the culture it represents that encourages the trend to simplicity in written forms. In 1667 Bishop Sprat, the Society's first historian, discusses the members' use of language. He writes they had

> a constant Resolution, to reject all the amplifications, digressions, and swellings of style: to return back to the primitive purity, and short-ness, when men deliver'd so many *things*, almost in an equal number of *words*. They have exacted from all their members, a close, naked, natural way of speaking; positive expressions; clear senses; a native easiness: bringing all things as near the Mathematical plainness, as they can: and preferring the language of Artizans, Countrymen, and Merchants, before that, of Wits, or Scholars.[135]

* See the final section of Ovid's *Metamorphoses* and his description of Philemon and Baucis.

The credible face of business

Whilst the Royal Society encouraged plain writing and speaking, other British institutions were developing more exact standards for the use of the written word in business. Arithmetic and book-keeping had been taught alongside writing and letter structure as long ago as the sixteenth century by teachers such as Luca Pacioli (1446–1517) and Johann Neudörffer the Elder (1497–1563). But the new private schools that sprang up to supply clerks and accountants to the shops, offices, warehouses and counting-houses of a now flourishing mercantile nation could be sizeable establishments. One of the most successful private writing and accounting Academies of the period was that of Thomas Watts at Little Tower Street in London, employing four masters, one full-time teacher of French and several part-time teachers. Such schools ran their own boarding-houses and courses of study extended for several years. High standards of legibility and accuracy were demanded from clerks. The chief resource of the man who would raise capital and enter business was trust. The credible face of the business lay in its books. As William Leekey wrote in *A Discourse on the Use of the Pen* (1766), 'writing should be performed in the single *Operation*; for when after *Touches* are made, that *Letter* so *assisted* is not *wrote*, but *drawn*, *painted*, or *patch'd* and that additional *Assistance* takes away the *very* Propriety of *Writing*'. Accounts should 'be kept fair and clean to a Scruple', 'without Blots, Razures, or Interlineations'.[136] One of the claims to fame that penmen now advanced was that they made a contribution to the nation's wealth and overseas adventures. In George Bickham's *The British Monarchy* (1743), a representation in maps, pictures and prose of the extent of the territory belonging to the King of Great Britain, we find 'All those Countries, Islands, Forts and Settlements which are in the Round-Hand character, belong to the King'.[137] Penmanship was leveraging an empire.

A particularly good example of just such a contribution to the national wealth was that made by the officers and clerks of the British East India Company. Set up by Royal Charter on 31 December 1600, by the late seventeenth century the Company's trade with India was organized from Surat on the west coast and Fort St George on the Coromandel

Coast, on the eastern side of the sub-continent, with many sub-centres reporting to them. In 1675, the same year that Newton made his first appearance in person at the Royal Society, a new administrator, Streynsham Master, was sent out to Fort St George. He was charged with 'regulating and methodising' these trading posts or 'factories'. In Miles Ogborn's engaging book *Indian Ink*,[138] he shows us how this company's attention to record-keeping helped it handle complex operations. The great danger for the Company had always been that individual officers out on post in India would use their position as a base for unauthorized personal trading rather than devoting themselves to the Company's interests. The Company sought to prevent this by a carefully structured process of recording – and closely monitoring – all its transactions and decision-making activities. This was the careful observation and methodical note-keeping of the scientist applied to business.

The Company had sent out printed orders to their officers in 1667, laying down how business was to be conducted, but these had fallen into disuse. The system that Streynsham Master put in place established procedures and physical spaces that ensured the Company's interests were upheld. Eventually the Company was so well organized that it managed to maintain duplicate archives in both India and London, enabling its trading posts to expand and grow over two centuries into a powerful commercial and political force that would exert a decisive influence on the history of the Indian sub-continent.

At the heart of the day-to-day operations in India were the Company meetings and their associated Consultation Book. Master required meetings to be held twice a week on a Monday and Thursday, commencing at eight in the morning. Only specific office-holders were allowed to attend and none of the latter could be debarred without approval being obtained from London, and even then only according to strict conditions. All decisions were to be taken through free and open debate and then voted upon; discussions were recorded in the Consultation Book even if no decisions had been reached; dissenting opinion was also recorded and then, crucially, all members of the council were required to sign each entry or amendment to confirm it was an authentic record. In this way the written record made the entire group responsible for the conduct

of business and no one person could dominate. Copies of Consultation Books from sub-factories were sent up the hierarchy for scrutiny, and copies of them all were sent annually to London, also signed by all council members. The Consultation Book itself was also required to be kept on public view and no 'Company Marchants, Factors, Writers & Apprentizes' were to be 'debarred or kept from the sight of Our Bookes and affaires'. For, as the Company's London officers phrased it when censuring an employee in 1662, 'faire and honest dealings need not Shunn the light'. The Consultation Book was used in training, to pass on accumulated wisdom and precedent. Ownership of the books was vested in the Company, and they were always to be kept in the writing office, a special room which was another of Master's innovations. All work had to be undertaken in the office, where the Chief also had a desk. It imposed discipline on the clerks, who were no longer permitted to conduct business in their private chambers. All books and accounts had to be kept in this room and never leave it.

In late seventeenth-century London Samuel Pepys, Secretary to the Navy Board, was engaged in a similar overhaul of the documentary procedures of the Royal Navy. He required journals to be kept by ship's captains and an entry book for all orders issued or received at sea to be maintained. On return to London all journals and order books were to be returned to him for scrutiny. When in foreign ports, ship's captains and consuls were obliged to provide regular posts about proceedings with abstracts from their journals. Pepys's purpose was to acquire 'thorough knowledge of the condition, services and proceedings of all and every ship employed on foreign service'.[139]

The modern sociologist Anthony Gibbons has called this activity of interlocking material and social processes *structuration*, a word for describing the way the activity of doing something, the thing done and the institution itself are all mutually constitutive – interdependent. Each helps create the other.

The consideration paid to structuring the decision-making process and its related documentation illustrates a significant characteristic of the world of the written word in the seventeenth century. Documents of all kinds, in academic and civil society, were now increasingly important

to how European societies functioned. The detail of how documents worked, and the parts they are constructed from, was becoming a matter for close attention. A cluster of new questions surrounds written documents by the end of the seventeenth century; mostly they focus on questions of identity. How can we ensure that documents are what they purport to be? How can we guarantee accurate and effective record-keeping? Who wrote this document and when? What rights attach to that authorship?

There are echoes here of the questions being asked by the philosopher and scientist. Newton and his fellow scientists sought answers to operations in the natural world; they wanted to know how the universe worked. Philosophers such as Locke and Hobbes posed questions about individual human beings, their identity and rights: in relation to property, their own person, and the state. In the area of the natural sciences the composition of things, their working parts and order were studied through newly constructed microscopes; Robert Hooke's *Micrographia or some physiological descriptions of minute bodies made by magnifying glasses* (the first publication of the Royal Society) was issued in 1665. Analytical thinking was part of the climate of the times and it was being applied to writing and its uses.

CHAPTER 7

Putting the World of the
Written Word in Order

Ludovicus Simonneau Aurel: sculr: 1695.

Fig. 44. Lower-case romans on large-scale grid, engraved by Louis Simonneau, 1695.

Just as attention was turning to the careful composition of documentation in correspondence, in scientific discourse and in trading relations and business, so the status and composition of historical documents was also to come under a new and searching scrutiny.

In 1675, the same year that Streynsham Master set sail for India, the Dutch Jesuit scholar Daniel van Papenbroek (1628–1714) published the second volume of the *Acta Sanctorum* (Lives of the saints) that would occupy him for much of his life. The project had been the brainchild of Papenbroek's fellow Jesuits Heribert Rosweyde (1569–1629) and his assistant Jean Bolland (1596–1665), from whom the scholars took their name 'the Bollandists'. They would publish a complete 'Lives' of all the Christian saints. By combing European monastic libraries they amassed a large number of such 'Lives'. They wrote a preface for each which included a note about the author and the historical value of the writings they had collected. The project was far bigger than could be accomplished in one lifetime; it ran on until 1915. Papenbroek was part of the third generation of scholars to be involved in the project.

The historical assessment of source material that these scholars engaged in led Papenbroek to include some prefatory material to his second volume about how to distinguish spurious from genuine documents. Daniel van Papenbroek was one of the founders of the modern method of historical criticism, which assesses the composition of texts and the contribution made to them by various sources. When applied to Christian scripture in the late nineteenth century this work would have considerable impact, but for now the effect was a heightened level of attention to the materiality of the document – what today we might think of as its archaeology: seals, styles of writing, use of language.

In the course of the preface to this second volume Papenbroek expressed an opinion that a charter, reputedly from the Merovingian King Dagobert I to the monks of St Denis and dating to 646, was a forgery. This document was the title deed that established the monks' right to their abbey. Many of the lands of French Benedictine

monasteries were held by title of similar deeds, so there was widespread consternation. The newly reformed Benedictine congregation of St Maur numbered many scholars amongst its members, and they asked Dom Jean Mabillon (1632–1707) to look at Papenbroek's claims. Rather than write an immediate rebuttal, Mabillon decided to mount a defence based upon scholarly and scientific principles. After six years of intensive study he published the result, a six-volume work, *De re diplomatica*. It dealt not only with the charter in question (which Mabillon agreed was a forgery, whilst authenticating all the others that Papenbroek had brought into question), but, more significantly, Mabillon discussed the much wider question of what he called *res diplomatica* – things diplomatic. Diplomatic means pertaining to Diplomas, another word for medieval charters. In so doing he brought the subject of the historical study of documents into being.

Mabillon's own definition of *res diplomatica* was that it involved studying the age, language, material and writing style of any historical document and its associated attachments (seal, signatures, superscriptions – even erasures). A twentieth-century expert on the subject, the gutsy, chain-smoking Irish Canadian Prefect of the Vatican Library Fr Leonard Boyle (1923–99), summed the topic up as the who, what, when, where and why of a document.[140]

Mabillon's work clarified the different kinds of charters that were issued, proving that royal charters had been promulgated from an early date. He also examined the materials used to write upon, the inks and letterforms that scribes employed. The second volume examined the language that these documents used, the different parts of charters, their styles of dating and their seals. Book III focused on the charters that Papenbroek had called into question; Book IV listed the residencies of the kings of France where charters were drawn up. Book V presented engraved illustrations of different styles of ancient handwriting, and Book VI contained the annotated texts of over 200 documents considered to be genuine examples. It was a tour de force.

Papenbroek's letter of congratulation to Mabillon on his achievement bears quoting:

It is true that I felt at first some pain in reading your book, where I saw myself refuted in so unanswerable a manner; but finally the utility and beauty of so precious a work soon overcame my weakness, and, full of joy at seeing the truth in its clearest light, I invited my companion to come and share the admiration with which I felt myself filled. Therefore, have no hesitation, whenever occasion shall arise, in saying publically that I have come over completely to your way of thinking. I beg for your affection. I am not a man of learning, but one who desires to learn.

Mabillon replied to Papenbroek that his magnanimous letter was the greater human achievement, more praiseworthy than anything he himself had written.[141]

Mabillon's work stimulated his younger *confrère*, Bernard de Montfaucon (1655–1741), to produce a similar treatise on Greek writing. His *Paleographica graeca* of 1708 remained the standard work on the subject for the next two centuries and introduced the term 'palaeography' to describe the academic study of ancient writing and book production. As Thierry Ruinart, the editor of the posthumous 1709 edition of *De re diplomatica*, remarked, Mabillon's work had an impact on scholars in France, Germany, Spain, Italy and England. In the eyes of his contemporaries Mabillon had shown that the history of writing was a science, and it had a story that could be traced.

Yet Mabillon's work contained a flaw, revealed five years after his death. In his account of different styles of handwriting he had assumed that the many scripts we see appearing towards the end of the Roman period had been brought into the Empire by the different waves of barbarian invaders who had precipitated its collapse. In 1712 the true picture emerged. Marquis Scipione Maffei in Verona had initiated a search for the lost books of the city's cathedral library – books of the late classical period that had been seen at the time of the Renaissance but then misplaced. It was early morning when the news was brought to him that the books had been found, and so great was his excitement that he ran through the streets to the cathedral still dressed in his nightshirt. The books had been discovered on the top of a large cupboard,

where they had been placed to save them from flooding, and then been forgotten. When Maffei examined these early volumes he realized that the variety of scripts that had puzzled Mabillon arose by natural variation from the standard roman capital and lower-case cursives; they had not arisen independently among the barbarian tribes but by a long and patient evolutionary process from earlier Roman writing. This was the Darwinian moment for written forms. European scripts could now be seen not only to have a chronology but to have evolved one from another; there was a continuous evolutionary line that ran unbroken from the time of the Greeks and Romans down to Maffei's own time. Palaeographers also learned an invaluable lesson. Henceforth *all* the evidence must be consulted before an opinion was expressed. Mabillon, despite having travelled to Italy, had not gathered enough evidence for the late Roman period.

Scientific letter design – *romain du roi*

With hindsight 1675 was a seminal year for the history of writing in the seventeenth century. As Streynsham Master set sail for India and Papenbroek published his second volume of the *Acta Sanctorum*, in Paris a small commission was formed to look at modern crafts. The commission was the result of an initiative taken by Jean-Baptiste Colbert (1619–83), finance minister to Louis XIV of France. He had been charged with improving the economic welfare of the kingdom. Colbert had begun with a reform of the taxation system, then turned to consider the improvement of French industry. In 1675 he ordered the Académie des Sciences, which Louis had founded at Colbert's suggestion nine years earlier, to study craft techniques in order to improve them by the application of new scientific understandings.

France already had a distinguished history as far as the origination of fine type was concerned. A succession of skilled punch-cutters in the mid-sixteenth century had propelled the country into a pre-eminent position. But now things had changed. French type design had become stultified and imitative. By the mid-seventeenth century it was Dutch designers like Christoffel van Dijck (1601–70) who were the most highly

regarded by their contemporaries. Certainly the English printer and royal hydrographer Joseph Moxon thought so. In his *Mechanick Exercises on the Whole Art of Printing* (1683–4) he waxes lyrical: 'the late made Dutch-Letters are so generally, and indeed most deservedly accounted the best…the commodious Fatness they have beyond other Letters, which easing the eye in the Reading, renders them more Legible; As also the true placing of their Fats and Leans, with the sweet driving them into one another.'[142]

In France, now ruled over by the 'Sun King', Louis XIV, magnificence and ceremony had become one of the means by which royal power was projected. Despite Louis's stuffy stipulation that only handwritten manuscripts were acceptable for his personal library at Versailles, a fresh look at the visual quality of French typography was in order.

The Académie des Sciences finally began its work on type in 1693 by setting up a commission to study printed letterform, 'since it is the art that records all others'.* It collected good examples of letters from calligraphers, typographers and historians – including, it would seem, from Joseph Moxon and from Dom Jean Mabillon, who had dedicated his *De re diplomatica* to Colbert. The Academy's commission then compared the samples and decided to follow two guiding principles in drawing up a new model for typeforms: first, to accept that a geometric method would be used in the letters' construction, and, secondly, to render the shapes consistent with one another. The first principle marked a significant modification to the rationale for roman letter design up to this point. The traditional approach, as expressed by Moxon, was that letters must approximate geometric figures, as modified by *'the course and progress of the pen'*.[143] This is the crucial phrase that is missing from the Academy's statement. Right from the time Gutenberg had made his first printing types the pen's influence had remained unmistakable. Even the most obtuse speculations by Renaissance artists about the geometrical construction of roman capitals nonetheless took calligraphed inscriptional models as their basis rather than pure geometry – hence their complexity. The Academy's proposal broke this relationship between

* It began its work at last in January 1693.

shape and the geometry of the pen and substituted a more radical one of rule and compass, and in so doing they opened up a whole new set of possibilities for the roman alphabet.

The geometry of the pen is a simple one: let us imagine a vertical line like the letter **I**. When I write with a broad-edged nib the edges of the **I** are set at a fixed distance apart according to how wide my pen nib is. The left-hand corner of the nib defines the left-hand edge of the letter and the right-hand corner does the same for the other side. Because my nib is rigid this distance and alignment never varies, and when I use my pen the left- and right-hand edge of the stroke are made simultaneously. But if I now draw the edges of the letter separately with a single point, such as a pencil, which the geometric method requires, then there is no longer any physical feature holding the edges in a fixed relationship, I can move my pencil in and out as I please. The fixed geometrical relationship between the left edge of a letter's stem and the right-hand edge is now fluid. There are many subtle changes in form encouraged by breaking the pen-based rationale. It is, for instance, easier to write with a pen when the broad edge of the nib is slightly slanted in relation to the line one is writing (Fig. 45). In circular letters this has the effect of giving the counter of the letter (the inside space) a slight tilt. And if one looks at nearly all examples of lower case **o**'s up to this point in time (and all letters with curves **a**, **b**, **c**, **d**, **e**, **f**, **g**, **h**, **j**, **m**, **n**, **p**, **q**, **s**, **t**, **u**), this slight slant

Fig. 45. I wrote with a pen on tracing paper directly over enlargements of Aldus's *De Aetna* type with no touching up or modifications. The thick and thin parts that result from the natural slant of the pen nib give the rationale for the placements of thick and thins in early forms of type.

and consequently stressed and potentially unbalanced letter, body mass or weight is there in varying degrees.

Intuitively we think of letters as subject to gravitational forces: a **P** with too large a bowl feels as if it is about to fall over. If we were to use Newton's language, the quantity of body or mass in a letter, and its distribution around a form, seems to set up an implicit velocity, movement and force within the letter. Thus an **e** might appear to be likely to roll over backwards or topple forwards; a letter can feel top-heavy and thus unstable, or solid and immovable. Our sensing of these stresses has played a part in the way our eyes and hands have shaped letters over the centuries, methodically applying the inherent geometry of the pen's broad-edged nib to arrive at intuitive harmoniously weighted and balanced forms. Dispensing with the pen means that a new rationale, or set of constancies, for these relationships must now be found, for remember, the Academy's second principle was 'to render the shapes consistent with one another', which meant harmonious and balanced and not arbitrary or random.

The members of the commission achieved a rationale for a new set of forms by constructing the letters on a grid (Fig. 44, p. 186). For certain capital letters the grid was drawn of squares. Engraved examples of the alphabet by Louis Simonneau were published from 1695 to 1716.

The French Academy's commission also broke new ground by proposing a third design to be added to the roman upper- and lower-case, an italic whose letters were a sloping roman rather than the usual form with low springing arches based on the Italian chancery hand. In this case, however, the break with calligraphy was not so complete, for it seems the work of the writing master Jean-Baptiste Alais (d. 1689) provided the original model. Further back in time Cresci had begun experimentation in this direction in his *Il Perfetto Scrittore* (1570). He shows five plates, printed white on black, displaying a remarkably graceful romanized italic, with alternative forms in **o** and **g** that have an upright axis.

The Academy's research influenced the shapes of *romain du roi* (or King's Roman).[144] This face, designed for the exclusive use of the *Imprimerie Royale*, makes its first appearance in 1702 in a luxurious book cataloguing

the medals issued to commemorate events during the reign of Louis XIV. The type was a work in progress for a number of years, with successive inputs from Philippe Grandjean and others.[145] In the mid-eighteenth century the printer and theoretician Pierre-Simon Fournier (1712–68) liked to emphasize the impracticality of these earlier mathematical designs, but the explorations that the Academy had started did mark a new point of departure for roman typographic forms. Curved letters acquired an upright rather than a tilted axis and a greater contrast between thick and thin strokes characterized all letters; serifs had minimal bracketing, particularly on the capitals. Type designed on these principles thus had a more dazzling, sharper appearance on the page. In truth the manuals of the writing masters, engraved on copper plates, which the committee consulted would have suggested a similar aesthetic.* But this was a new departure for type-cast letters, and the more upright axis to letters such as **e**, **o**, **c**, **d**, **b**, etc. was a key change; the trend would reach its full fruition in France and Italy in the last decades of the eighteenth century in the work of Firmin Didot and Giambattista Bodoni. Their type designs became more rigorously geometric, had high contrast between thick and thin strokes and were built from more uniform and seemingly interchangeable parts.

Pierre-Simon Fournier picked up on one further recommendation of the commission, made by the Carmelite friar Père Sébastien Truchet. Truchet was an inveterate builder of machines and had designed the water supply system to Louis's new gardens at Versailles. He suggested that type should be produced to standard measurements. He recommended using the French silversmith's measure of the *Ligne*, or 'line', one twelfth of a twelfth of an official inch, with a further subdivision

* This style of capital letter was also anticipated in inscriptions on coinage. Both the Dutch and English medals for the Peace of Breda (1667) show similar weighting, as do the letterforms on several generations of English coinage, going back to the introduction of roman capitals at the time of Mary Tudor, 1553–8. It could be argued that the form is a development of engraving techniques where a simple line across the bottom of the letter stem is easier to form than a subtly bracketed one. A map from *c.* 1680, *Nova Totius Terram Orbis Tabula* by Gerard Valk from Amsterdam, now in the collection of the British Library, also shows highly contrasted roman capital letters in its titling (so contrasted in this case that it reminds one of the nineteenth-century type of Didot and Bodoni).

of twelfths below that (*c.* 0.188mm).[146] He further proposed that differ-
ent sizes of type should be cast in geometrical increments, to make one
interlocking system.[147] Individual punch-cutters and type-founders most
likely had their own private systems already, but Truchet was suggesting
a common measurement that could be shared.[148] In 1742 Fournier became
the first type-founder to advocate the standard measure of the typo-
graphic 'point', including a table of standardized type measurements in
his *Modèles des Caractères*. It was based on one seventy-second of an inch
– derived from 12 lines each divided into 6 points. François-Ambroise
Didot (father to Firmin), would develop the system further, settling on a
standard French inch in 1783. A little over a century later the system had
been adapted for metric use in France and Germany, and for the slightly
smaller British inch by the Anglo-American type-founding industry. This
point system is the reason that early computer printers and monitors
worked to seventy-two dots and pixels per inch.

The Académie des Sciences's approach, using careful measurement,
drawing instruments, compasses and the grid, spoke of the new scien-
tific age. This was a rational view of type for an Enlightened Age.

The author and the text

As the seventeenth century progressed, the last substantial, yet still unre-
solved, issue within the order of the written word was who owned the
rights to a piece of writing: was it the booksellers, the printer or the
original author? It seems astonishing, but 250 years after the invention
of printing an author still did not automatically have a right to the text
he or she had written.

In England in 1695 the Licensing Act was allowed to lapse, and
although there were still plenty of means by which the press could be
regulated (laws of blasphemy and seditious libel, and taxation of printed
matter), prior permission to publish was no longer required. In 1709 'An
Act for the Encouragement of Learning' or the Copyright Act, as we
know it today (printed entirely in gothic blackletter with every noun,
and many other words of 'substance' capitalized), introduced a new
system. [149] The emphasis, as the original name of the act suggests, had

shifted from control towards the benefit of educating a reading public. High book prices were to be controlled, and copies of every published book must be deposited in the King's Library and libraries at Oxford and Cambridge so that they were available to the public.

For the first time an author's right to their own work was upheld by the act. The rights were limited to a period of fourteen years, but if the author was still alive at the end of that period one's rights could be renewed for a further fourteen (provided the book had been registered at Stationers' Hall). For books already in print by 1709 booksellers were given a further twenty-one years of printing rights.

For more than a century pressures for change had been building within the publishing trade, both in England and on the continent. From the authors' perspective, an unjust system of rewards had arisen as printers obtained exclusive rights to print the author's writings from authorities in different domains. In the era before printing, anyone who obtained a book had been free to make a copy of it. An author's reward had come in the form of a gift from a patron whose artistic circle the writer graced; it had not come from the sale of books. Because there was a human limit to the scale on which handwritten copies of books could be produced (books took weeks and often many months to create), it was recognized that the person who copied a book had invested considerable amounts of their own labour in it, for which they in turn should be recompensed. But when books could be typeset and 100 copies produced in the same time as it might have taken to write a single volume, and all 100 copies of the printed edition could be sold to the benefit of the printer, the respective rewards to the printer and to the book's original author became incommensurate with the labour involved. Book production, which had proceeded in a common spirit of shared intellectual endeavour for centuries, had now become an area for significant commercial exploitation by one of the parties in the chain of production. Authors were not happy but neither were printers. Their books were subject to piracy.

A printer's investment in a new work could be undermined by a rival taking a copy of his book and printing a cheap edition themselves. The original book, which would have taken considerable time to edit, design

and typeset, was now simply imitated line by line. Using cheaper paper and with less expensive printing, these pirated editions undercut the market. Printers responded by demanding exclusive rights to individual titles. But who was it that could grant these rights? Initially this was a power that was taken on by religious and secular authorities. Yet pirated editions did not respect borders: what was licensed in France could legitimately be printed in the Low Countries and imported. The situation was fraught: authors and booksellers got caught in the conflicts of loyalty; printers became locked in rivalry. Furthermore, authors resented the lack of control over the presentation and marketing of their work. Since booksellers had the right to publish any manuscript they obtained, some authors found themselves in impossible situations. In the seventeenth century the French comic dramatist Molière, for instance, found that the text for his play *Les Précieuses ridicules* (first performed in 1659) had been obtained by the bookseller Ribou and published without his consent. The bookseller went so far as to obtain a privilege that legally forbade the author from publishing the play. Molière could only overturn this by going to court himself.

Eventually publishers and booksellers came round to the opinion that if their permission to print was to hold good they must themselves uphold the authors' right to the ultimate ownership of their own text. The author (rather than a variety of secular or religious authorities) was then able to transfer their rights to the publisher for a specific period, and in this way publishers could possess an exclusive right. Booksellers and publishers emerged from this period, paradoxically, as champions of the rights of the very same authors they had once ruthlessly exploited.

In Britain, as the year 1731 approached, the date when – twenty-one years after the original act of Queen Anne – previously published work would come out of copyright, publishers and booksellers began to lobby for an extension of their rights. The works of Milton, Shakespeare and others had been steady money-earners, and publishers who had 'owned' the rights to them were now about to lose out. At each turn in a thirty-year-long flurry of legal cases which now ensued, the claims of publishers and booksellers to extend their privileges were delayed or refuted. During this period, 'the Battle of the Booksellers' as it came

to be known, three characters in the guise of an author criss-crossed the legal landscape searching for affirmation. In the process the idea of what it meant to be an author underwent a subtle but substantive development. The Hack, depicted in so many of the cartoons of the period, working by candlelight in some Grub Street garret, wrote for a living, often for the many journals and magazines that had sprung up in London following the deregulation of the press. The man of letters, with a private income or public position saw writing, in contrast to the Hack, as a liberal pursuit; Milton and Marvell had been such figures, working as employees of the government whilst they penned their poetic works. The third figure, argued for by the compiler of the first English Dictionary, Samuel Johnson, and his supporters, was the writer as a creative and original force. In 1751, in the columns of the periodical *The Rambler*, Johnson had argued, in an article headed 'Petty Writers are not to be despised', that it was in conceiving the phrasing and formulation of concepts, 'an uncommon train of images and contexts of events', that the writer's originality lay.[150]

When the case of the publisher *Tonson v. Collins* came to court in 1761–2, Johnson's argument for the originality of the author was taken up by the Vinerian Professor of English Law at Oxford, William Blackstone (1723–80). Blackstone, who was arguing the publishers' case for the author's right to a perpetual copyright, gave the argument a solid grounding by reference to the writings of the philosopher John Locke. In his *Two Treatises of Government* of 1690 (part 2, c.5), Locke had argued that since 'every man has a property in his own person' (a person owns themselves), they must also own their labour and the fruit of their labour. Locke had in addition argued that the natural foundation of a right to property lay in bettering nature in invention (mind) or labour (body). The originality of a written work, Blackstone believed, made it the subject of invention and the labour lay in its composition.

Ultimately Blackstone's position formed just part of the classic compromise that ensued when the issue came to a head in *Donaldson v. Becket* – heard on appeal before the House of Lords on 22 February 1774. Donaldson, an Edinburgh bookseller who specialized in cheap reprints of classic authors, had opened a London shop in 1763, undercutting

London prices by between 30 and 50 per cent. He naturally disputed the perpetual right to copyright which some publishers were still trying to maintain; all previously outstanding cases were now rolled into this final appeal. At that time the House of Lords (acting as a supreme court) heard cases on a different basis than is usual today: the judges presented their case to the whole House, which then debated and voted on the outcome. The debate and subsequent vote recognized the author's right to copyright, but also that it must be balanced against the public's right to have access to that knowledge. Authors would indeed have a right to their work but only for a certain time, after which the work would pass into the public domain. In this way ideas could freely circulate but the writer's right to a livelihood was respected. This was the compromise that had in fact been suggested by the original 1709 act; now it was definitively established in case law. But from the contest of ideas the author had emerged as more than a labourer with rights to the fruit of their labour, more than a copyist or paid flatterer, but as an original thinker, a creative 'genius', capable of the unique expression of ideas and sentiments. A work carried the impress of an author's imagination. This was the main point upon which French copyright law would also rest when introduced by a succession of royal decrees in the late 1770s.

Handwriting and individuality

In terms of handwriting the individual had been making tentative appearances on the stage for much of the last century. The abandonment of what the Scottish calligrapher David Browne had called 'sumptuous writing', in his *Calligraphia*, printed in St Andrews in 1622, for 'the incongruitie, or irregularitie of common or current writ, because it is both cheape and hastilie done', had led in his view to 'a Brazen Time for the small number of expert Writers, by whom it pleaseth GOD even to keepe (as it were) some spunke of life in fayre Writing'.[151] But the corollary had been the emergence of hands that were less tutored and conforming – more personal. In addition Tamara Plackins Thornton has argued in *Handwriting in America: a Cultural History* that there was a significant shift in public perceptions of handwriting in Britain once

printing was released in 1695 from the constraints of the 1662 Licensing Act.[152] Once printing presses had spread across the landscape of Britain in the early eighteenth century and printed material finally became ubiquitous in daily life, the very regularity (in visual terms) of the printed page meant that by contrast handwriting came to be seen as containing individual differences that simply had not been recognized before.

The first time that individual differences in handwriting are acknowledged in a legal context in Britain appears to be in 1726, when the English jurist Geoffrey Gilbert asserted, in a treatise on legal evidence, that 'men are distinguished by their handwriting as much as by their faces, for it is very seldom that the shape of their letters agree any more than the shape of their bodies'.[153] He goes on to state that for this reason forged writing can be told apart from the genuine article, and the implication was that handwriting could now be accepted as evidence of identity in a court of law. Up until this point it was not thought that individual examples of handwriting were sufficiently distinct to be told apart, other than in broad categories of social class or gender. Witnesses would swear to a sample of handwriting being theirs (or not) but there was no sense that this could be proved in a technical sense. Yet recognition of the absolute uniqueness of handwriting before the law had some way to go. For the next half-century witnesses attesting to the identity of the person responsible for a piece of writing were expected to have seen that person write. The witness could have watched them write any document, at any time in the past (sixty-five years ago in one case), but they had to have observed them pen in hand; they then brought that experience to the document before them. Exceptionally proof of forgery came from a different spelling of a name and more rarely still from the different shape of initial letters. The first witness statement, from the records of the Old Bailey in London, where the witness identifies a hand and supports his assertion by stating that he had previously seen that person write is from 16 January 1729, when William Hales and Thomas Kinnersley (a clergyman) were indicted for forging a Note for £1,260, payable to Samuel Edwards, Esq.[154]

Handwriting and character

Graphology, the 'science' involved in the study of human character through analysis of a person's handwriting, gained ground in this period. Manuscripts in the hands of famous persons were noteworthy in Roman times. Pliny the Elder (23–79 CE) remarks that he himself had seen documents in the handwriting of the reformers Tiberius and Gaius Gracchus in the possession of the poet Pomponius Secundus (the manuscripts would have then been nearly 200 years old), and 'as for the handwriting of Cicero, Augustus and Virgil, we frequently see them at the present day'.[155] Suetonius, in his *Lives of the Twelve Caesars*, comments on the handwriting of several emperors – that Augustus never liked to divide his words between lines but wrote the remaining letters beneath the word and drew a loop around them,[156] and that Nero (some of whose pocket books and sheets of papyrus Suetonius himself owned) used frequent crossings out and interlinings when composing his poetry.[157] But there is virtually no evidence of such interest in the Middle Ages except for the odd added inscription that makes an attribution to a manuscript or drawing – 'In the hand of St Dunstan' adds a fourteenth-century reader to the drawing of Christ as Wisdom in Bodleian Ms Auct.F.4.32, also known as the tenth-century 'St Dunstan Class book'.

The first text in modern European history to focus on character in handwriting would appear to be a treatise, *How to tell the nature and quality of a writer from a letter* (1622), by the Bolognese doctor of philosophy and medicine Camillo Baldi.[158] Though a founding reference point for modern graphologists, this book was largely unknown until the late nineteenth century, when it was discovered by the French graphologist the Abbé Michon. Yet certainly, by the first decades of the eighteenth century, a connection was being made between a good writing hand, deportment and character. In George Bickham's handwriting manual *The Universal Penman*, issued to subscribers between 1733 and 1741, he encourages the reader to 'give to writing what we admire in Fine Gentlemen; an Easiness of Gesture, and disengag'd Air, which is imperceptibly caught from frequently conversing with the Polite and Well-bred'.

Over half a century earlier the philosopher and mathematician Gottfried Leibniz (1646–1716) had written, 'handwriting also nearly always expresses, in one way or another, a natural temperament, unless it be that of a writing master, whose writing lacks spontantaneity, but sometimes even then'.[159] The Swiss physiognomist Johann Kaspar Lavater (1741–1801) made this connection explicit in his widely read *Physiognomic Fragments*,[160] published 1775–8. In the second edition he added a chapter on 'Character in Handwriting'; Goethe wrote an introduction. But Lavater failed to provide any practical method of analysis. His argument, though, was clear: it is 'highly probable, that each of us has his own handwriting, individual and inimitable'. And, he asks, 'is it possible, that this incontestable diversity of writing should not be founded on the real difference of moral character'?[161]

It is not until the twentieth century that the full potential of writing, signatures and mark-making as an expressive and personal graphic act will be realized.

The Coming of Industry

Fig. 46. Handwritten cartouche on a vellum map drawn by the surveyor G. Hutson, 1788.
The gothic, roman and sloped italic hand numbered amongst the usual hands taught
by writing masters in the eighteenth century.

The mid-eighteenth century was the moment in European history when sensibility and feeling are discovered alongside the pre-existing instincts for rationalism and scientific progress. In the previous century writing had been subjected to a rigorous analysis of its organization, history, structure, ownership and character. But the tone is now different. Typefaces evolve with more subtle shapes and finely contrasted thicks and thins. The pointed pen, which is much more sensitive to variations in pressure from the writer's hand, gradually supersedes the edged pen as the most popular writing tool. By the late eighteenth and early nineteenth centuries there is an excess of feeling in the air: this is the age of the romantics, the American and French revolutions, and wars that rage across Europe.

A spirit of improvement

The essence of the Zeitgeist of the first part of the eighteenth century is a spirit of improvement. On the continent this spirit was exemplified by the success of the *Encyclopédie*, whose articles ranged from agricultural topics to history and the new sciences. Under the editorship of Denis Diderot, in collaboration with Jean Le Rond d'Alembert, the most brilliant scholars of the age were commissioned to write articles. The Encyclopaedia eventually amounted to eleven volumes, with a further ten of illustrations. The scientific, philosophical and technical articles that it contained defined the age, and the work was reprinted in ever more accessible formats in France, Italy, Switzerland and Spain.

In Britain, the printer John Baskerville (1707–75),[162] in a similar spirit of improvement, re-examined every aspect of the printing process to produce some of the last great examples of printing from the pre-industrial age. He had begun his career as a writing master and carver of inscriptions. When he moved to Birmingham in 1726, a city he would remain in for the rest of his life, he was moving to a town that was already running to a different rhythm. Baskerville's early biographer

William Hutton writes of how he himself was struck on arriving in Birmingham in 1741 by the special spirit of the town: 'I was surprised at the place but more so by the people; they were a species I had never seen: They possessed a vivacity I had never beheld: I had been among dreamers, but now I saw men awake: Their very step along the street showed alacrity; Every man seemed to know and prosecute his own affairs: The town was large and full of inhabitants, and these inhabitants were full of industry.' In the one portrait we have of Baskerville, painted by James Millar in 1774, he too displays a similar alertness of character. Seated in a red-backed chair in a green coat with golden brocade, big buttons, simple stock and ruffed cuffs, his head held slightly on one side, he lightly clasps his hands in front of him: the fingers are long, the pose self-confident, judicious, the beady eyes amused.

Around the time of his father's death in 1738, Baskerville took up one of Birmingham's most popular trades, japanning, or the coating of metal panels, frames and artefacts with paints and varnishes. In 1742 he patented machinery for rolling and grinding metal plates or veneers. It was not until the early 1750s that he took up printing. But with years of working in the japanning trade behind him (in fact he never entirely gave it up), and the trained eye of a writing master, he now had all the skills necessary to reappraise the different material and operations that printing involves. In the preface to an edition of Milton, produced for the bookseller Tonson in 1759, Baskerville shared his thoughts on his aims. 'Having been an early admirer of the beauty of letters, I became insensibly desirous of contributing to the perfection of them. I formed to myself Ideas of greater accuracy than had yet appeared, and have endeavored to produce a *Sett* of *Types* according to which I conceive to be their true proportion...The improvement in the Manufacture of the *Paper*, the *Colour*, and the *Firmness* of the *Ink* were not overlooked: nor did the accuracy of the workmanship in general pass unregarded.' Baskerville knew how to exert significant control over his materials. He re-machined the iron plates of his press so they sat more correctly in alignment. He designed new letter shapes (Fig. 47) influenced by the work of writing masters, such as George Shelley, and perhaps his French Canon hand. Baskerville's personal recipe for printer's ink was

Andriam ex Perinthia
atque uſum pro ſuis.

Fig. 47. Enlargement of Baskerville's *great primer* roman type (*c.* 18 point).
Taken from *The Comedies of Terence*, Birmingham, 1772.

made from lampblack (there was a plentiful supply in Birmingham) and boiled linseed oil, to which some rosin had been added to impart a soft sheen. It was kept three years before use and gave a dense and glossy black of a depth not attained by any other printer. In order to get a smoother paper surface for the crisp printed image that he wanted, he worked with James Whatman the Elder to obtain a laid paper.* It was made using a very fine-grained mould of wire mesh laid on top of the original mould to eliminate its texture of wires and watermark. He ran the sheets through heated copper rollers after printing, glazing the surface and drying the ink. This 'hot press' process is reminiscent of the way japanning is fired on to a surface at the conclusion of its manufacture.

Baskerville's books, in particular his Virgil of 1757 and the Bible of 1763, which he printed once he had become printer to the University of Cambridge, stand out as some of the best printing ever done in Britain. The inking is controlled and even, the composition is spacious, the margins wide, and his fine judgment of space extends to the design of the letters themselves. A close look at the French Canon type specimen, printed by his widow Sarah in 1777, reveals his sensitivity to the weighting around curves (capital **B** and **D** for instance, where the weight is ever so slightly dropped towards the bottom of the bowl) and the smooth junctions between the stem and the arch of lower case **n** and its related forms creates a flowing internal counter. This polished smoothness was one of the principal features copied by Baskerville's early imitators,

* The paper was made at Whatman's Turkey Mill, near Maidstone in Kent.

along with the heightened contrast between thick and thin lines.* Bask-erville records that for a number of years, as he was developing his art, he was a daily user of microscopes,[163] though much of the punch-cutting and presswork seems to have been by his trusty assistant John Handy. Of his books, his French contemporary the type-founder Pierre-Simon Fournier wrote: 'There is no denying these are the most beautiful things of their kind seen up to now.'[164] The books are sensuous in every detail. The effect is different from the types of his nearest English rival William Caslon (1692–1766).

Caslon, who had grown up in Shropshire, had begun life as a gunsmith and metal chaser. From his works in London's Chiswell Street he issued types following a less contrasted Dutch model; his were the most popular types of the day. Caslon's types (several generations of the family followed him in the business) were solid yet spacious – famil-iar and reliable. He was the first Englishman to cast his own type and they have proved durable, revived in both the nineteenth and twentieth centuries.

The Aldine letters, which we first saw in Bembo's *De Aetna* (1495), and which had been introduced to France by Simon de Colines and shaped in turn by Claude Garamont, Robert Granjon and others, had been taken up by the Dutch in the late sixteenth century. Punch-cutters such as Christoffel van Dijck (1601–72) and the Hungarian (but Dutch resident) Nicolas Kis (1650–1702) gave the letters a more robust (and in Kis's case more compressed) character. The slightly weightier appearance of late seventeenth-century typefaces served to play up the contrast with Baskerville's approach both towards type design and to the design of the book as a whole. But, in reality, as the typographic scholar Beatrice Warde has written, 'Baskerville was only the first to admit into the type foundry a type that had been clamouring outside its door for at least half a century.'[165] On coins and medals, monumental inscriptions, and painted lettering as well as within the engraved plates of the writing masters manuals, we see letterforms being worked out with pen, brush and engraving tools that have similar sharper contrasts of light and

* See Fry's Baskerville, cut by Isaac Moore (1763).

dark within the lines of a letter and smoother contours. In a sense the continuity with the past is even more radical that Warde suggested: it could be argued that it goes back to the manuscript age. Sharply made lettering was a tradition that was never actually lost to those who made letters by hand – including the punch-cutters themselves. It was lost in certain possibilities for their reproduction (in wood blocks and inexpert printing). Once copperplate engraving became a thriving medium we see sharply reproduced forms that even enhance the contrast between thick and thin letter parts, for the copper engraving process can produce the thinnest hair line. We see this effect in writing manuals from at least 150 years before Baskerville's time. The influential 1608 writing book of Lucas Materot has startling clarity. In addition, in the writing manuals of Jan van der Velde,[166] John Ayers,[167] Charles Snell,[168] George Shelley[169] and others we see written roman forms developed specifically by writing masters themselves and quite distinct in proportion and construction from those appearing in the type of the period. As a writing master himself Baskerville knew (and undoubtedly practised) this long-standing tradition of 'brightly' written and engraved romans. He had sample pages of writing manuals displayed in frames around his house. It would seem that Baskerville's typographic innovations were aimed at re-engineering the printing process so that this inspiration could be carried into print. We might think printing a conservative medium for not having embraced these forms earlier, but technically there were a number of developments needed to make it possible. Baskerville's knowledge of varnishes and metal-working, and his positioning within a network of enterprising craftsmen all looking to improve their manufacturing processes, meant that the time and conditions for this innovation had finally come right.[170]

Baskerville's attention to every aspect of his work, letters, ink, paper, press, and accurate and careful workmanship, was both of his time and ahead of his time. Soon the art of printing would be overtaken by the helter-skelter of the Industrial Revolution, its division of labour, impressive economies of scale, and speeded-up production lines, but once the dust settles it is Baskerville's approach, his craftsmanship and his view of the work in the round, that will resonate in the twentieth century. The

next figure of a similar stature in the world of British printing will be William Morris (1834–96). Baskerville and Morris frame the period we are about to discuss.

Shaping the text – the novel

The list of publications that Baskerville issued over the course of his lifetime as a printer is solidly non-fiction or religious – just three poetic works are exceptions. Conspicuous by its absence is the novel. Baskerville professed only to be interested in 'serious' work, but his London business partner, the printer and bookseller Robert Dodsley, was not so shy of the new genre. In 1759 he and his brother James oversaw the publication of the first two volumes of one of the most unusual books, typographically speaking, of the whole eighteenth century, the Rabelaisian comic novel *Tristram Shandy* by Lawrence Sterne, a Church of England clergyman. The eighteenth-century novel, as it developed, posed new challenges in visualizing the text.

The novel as a genre had found a growing audience in Georgian England. Though its parentage lies in the literatures of France and Spain, with François Rabelais's (1494–1553) *Gargantua* series (1532–64) and Miguel de Cervantes's (1547–1616) two-part comic narrative *Don Quixote* (1605 and 1615), its deeper roots lie in the pages of medieval chivalric romance, classical satire – like Apuleius's *The Golden Ass** – and dreamy myth. As such its visible form was always somewhat loose, even exploratory; fantasy gambolled in its margins. In Britain, following the publication of Daniel Defoe's *Robinson Crusoe* in 1719 and Jonathan Swift's satirical *Gulliver's Travels* of 1726, the genre moved from fictional 'lives' into an epistolary form – an exchange of letters between the principal characters. Samuel Richardson's *Pamela* of 1740 launched this genre of literature. The previous year Richardson had been commissioned by commercial booksellers John Osborn and Charles Rivington to write a manual on letter-writing; *Letters Written to and for Particular Friends, on the Most Important Occasions*, was eventually published in 1741. Amongst

* Lucius Apuleius, *c*. 125–180 CE.

the model letters in the volume that Richardson had written there was one for a servant girl, under pressure from an amorous master, and it was this that gave him the idea for the novel, which he wrote in two months flat. *Pamela* traced the fictional correspondence of the servant girl as she struggles to preserve her honour; her ultimate reward for virtue preserved is a happy and upwardly mobile marriage.

The novels of Defoe, Swift and Richardson all met with success. *Crusoe* and *Gulliver* have never been out of print since. *Pamela* (printed by the Dodsley brothers) was translated into all the major European languages of the time. When published in parts such novels became affordable to a wide class of readers. Richardson was a canny marketeer of his own writings: he published sequels, sold the books with fans and other memorabilia, and in later editions filled out 'missing' passages.

Richardson's second novel *Clarissa* (1748) and his last, *The History of Sir Charles Grandison* (1753–4), also follow the epistolary form. The letter format allowed an author to explore the insights and feelings of his principal characters; this was the beginning of the psychological novel. So popular was the letter-writing device that by the 1770s, 70 per cent of English novels were written in this form.[171]

None of these early novels, however, developed the visible language of literature as far as Sterne's *Tristram Shandy*. Sterne flouted normal sentence construction, he undermined the plot's development and celebrated a multiplicity of thoughts rather than a uniform direction and flow. His book uses many graphic devices to move the material forward. Rather than commas and full stops, frequent dashes ('ellipsis' as they were then called,[172] though today we use this term for '…') indicate the 'sudden interruptions and oscillations of thought and feeling' of his hero.[173]

Like Baskerville, Sterne sought control over every aspect of his book's creation. He wrote to the publisher about the format, the quality of the paper, the choice of type and layout. At one point *Tristram Shandy* includes a complete page printed black, at another the chaotic images of a tipped-in marbled sheet of paper. Asterisks, blank spaces and a pointing hand supplement the punctuation. One quarter page is simply completely covered in dashes, another with squiggling lines representing

the development of the plot of the novel thus far. The text uses italic, roman and gothic typefaces: 'Italics, for example, enact the actor's emphasis – the raised voice, the confidential whisper, or the wink; while capitals and gothic letters supply heavier emphasis for a moral reflection, a scholarly reference, or a tear. Asterisks and blank spaces similarly provoke our active response, and lead us to ask what they stand for, or to supply something for ourselves, whether correctly or not we often don't quite know...'[174] Never previously had a novel been quite so adventurous in its typography.

The besetting typographic problem for the novel at the time was how to punctuate direct speech. Until the 1780s, though a little later in France, this kind of punctuation had no settled form. In *Robinson Crusoe* Defoe had used a solution that goes back to Roman times – name headings (as in a play) – but he also employs different categories of type. Man Friday speaks in italics, Crusoe in roman. In France, though *guillemets* (« »), angled quotation marks, had been developed from late medieval practice by the punch-cutter Guillaume Le Bé (1525–98) circa 1546, the use of the dash in France to indicate changes in speaker crept into the language in the 1760s – most likely from practices noted in Richardson's novels.[175] The convention of separating out speech by different characters on to different lines was not widely accepted until the nineteenth century.

The novel engaged the reading public in a way that no other literature had since the religious controversies of the sixteenth century; some have held it responsible for a 'reading revolution' in the later part of the eighteenth. A German visitor to Paris at the time recorded: 'Everyone is reading...Everyone, but women in particular, is carrying a book around in their pockets. People read while riding in carriages or taking walks; they read at the Theatre during the interval, in cafes, even when bathing. Women, children, journeymen and apprentices read in shops. On Sundays people read while seated at the front of their houses; lackeys read on their back seats, coachmen up on their boxes, and soldiers keeping guard.'[176]

Correspondence

Whilst the epistolary novel as a format faded in popularity in the last decade of the eighteenth century, letter-writing itself was assuming ever greater importance for society at large. Families displaced by the Industrial Revolution could stay in touch if they had learned to write. For some their correspondence became a means of reflecting upon their changing fortunes, for others it became an effective support for political action.

As Susan Whyman has shown in her book *The Pen and the People: English Letter Writers 1660–1800* (2009), in the late eighteenth century it was not only the middle classes who wrote but farmers, wheelwrights and domestic servants. Classes of people not previously thought to have engaged in letter-writing activity *did* write, and gained strength from the opportunity it gave them to weave the events of their lives into a narrative that brought meaning and encouragement in changing times.[177] Jedediah Strutt of Derby (1726–97), the improver of the stocking frame, is one manufacturer whose correspondence Whyman studied. He badgered his five children to write him letters for the sake of their own improvement. His own lack of a broad education in a country school meant that he remained uneasy in 'polite society' throughout his life. Nonetheless letter-writing served him well. For seven years he sustained a long-distance courtship with his future wife Elizabeth, a housekeeper to a non-conformist minister in London. Elizabeth's confident but phonetically spelled replies show how much harder it was for a woman to acquire a continuing education in this period when most left school in their early teens and had no further opportunities for learning. But, for all that, she and Jedediah quote Shakespeare and Milton to each other and the sentiments they express are partly informed by the new 'sensitivity' and 'feeling' found in the novels of the period. In addition Jedediah's letter-writing becomes a significant part of his own reflection on the transition he was making from a rural wheelwright to a powerful factory owner.

In the turbulent years following the French Revolution in 1789, when the emergent sensibility towards individual feeling and rights had been transformed into cooperative action in the name of reform, writing

also found a place in the political awakening of a broad mass of people including artisans, tradespeople and shopworkers. Corresponding societies of working men were founded across Britain to debate parliamentary reform and correspond with like-minded groups. In March 1792 the London Corresponding Society began to communicate with a group in Sheffield; other societies already existed in Manchester and Derby. The members contributed a penny a week to the Society's funds to pay for paper and postage. The aim was to discuss, clarify and propagate ideas, and to organize the committed membership who attended weekly society meetings. The movement spread rapidly, to the alarm of the authorities, who might well have recalled the effective action of American Committees of Correspondence in organizing resistance to British colonial authority in the mid-1770s; they had become the seedbed for revolutionary action.

In 1793, following the execution of the French King the previous year and the ensuing terror in Paris, the resistance to reform stiffened. In 1794 the authorities moved against the Corresponding Societies, arresting their leadership. Thomas Hardy, a shoemaker and the founding secretary of the London Society, was arrested. The arresting officers (a King's Messenger, two Bow Street runners and the private secretary to the Home Secretary) ransacked the house and gathered up four large silk handkerchiefs of letters and a corn sack of leaflets, manuscripts and pamphlets. At his trial Hardy was acquitted; he had been prosecuted for high treason, a capital offence, and the chairman of the jury fainted on giving the 'not guilty' verdict. Hardy was drawn through the streets in triumph by his supporters. But a few years later, in 1799, the Corresponding Societies, the first mass political agitation conducted and organized through correspondence, were banned and the movement for reform passed into other hands.

Back in the box

At about this same time a new, more conservative, approach to the teaching of handwriting makes an appearance. Efforts are made to exert greater control over the body and mind of the writer and paradoxically

this postpones the moment when students come to write useful and meaningful communications.

The American John Jenkins's (1755–1822) 'plain and easy system' in his *Art of Writing* (1791) reduced the elements of round hand to six basic motions of the pen. Breaking the letters down into parts, and then reassembling them out of these pieces of movement, becomes a commonplace in early nineteenth-century writing manuals; the method is reminiscent of mechanical operations on the factory floor. It also recalls the approach to letterform that was taken in the type designs of the contemporary Parisian printer Firmin Didot and the Italian Giambattista Bodoni – the latter certainly thought of his types as composed of interchangeable parts.[178] The result was that much of the handwriting of those trained to write in the early nineteenth century is less individual in character than those of the preceding century.

Jenkins also pays considerable attention to the correct sitting position and to furniture. He prepares a dialogue for students to learn, a catechism of writing. They recite, by question and answer, the names of elementary strokes, how they are to be shaped, and the proportion of the letters; a stem is one sixth of the overall width of the 'measure' (given by the letter **n**). The student was supposed to spend five to six minutes several times a day just practising correct penhold and posture. Writing letters commenced once these basic shapes and rules were learned by heart. Many nineteenth-century writing manuals give similarly detailed written guidance about letterform and posture.

A further difference between eighteenth- and nineteenth-century penmanship is speed. The title of James Henry Lewis's *The Flying Pen* of 1806 says it all. The pen is scarcely lifted from the page; more loops and greater continuity of line characterize the writing. The correspondence between Maria Edgeworth, pioneer of the historical novel, and her admirer Sir Walter Scott shows their writing to be continuously connected throughout a word, almost monoline and drawn out horizontally like a telegraph wire from post to post. The pressure of the pen is light, the nib, pointed and thin. Lewis, 'a smart Cockney' (Sir Walter Scott's description),[179] advocated a new writing action, which includes movements from the shoulder and not only the hand. The subtitle of his

book, *A New and Universal Method of Teaching the Art of Writing, by a System of Lines and Angles*, presented the theory in suitable scientific disguise. The hand held the pen between the first finger and thumb, but the hand was turned over, the wrist was almost flat, the hand rested lightly on the little finger alone; later on teachers would recommend resting on the nails of the third and fourth fingers (as did Jenkins). The system was popularized by Joseph Carstairs, who taught from rooms in London's fashionable West End. A series of stinging affidavits sworn before the Mayor of London in 1816, following publication of Carstairs's book two year earlier (also called *The Flying Pen*), attest to Lewis's grievance at his rival's success. They also allow us to trace exactly how Carstairs taught himself. Originally a tailor from Sunderland, he learned from James Mowat, a teacher from Edinburgh, who in his turn had learned from the itinerant writing master Charles Lister, who had himself been a pupil of Lewis (all three men submit their affidavits). Carstairs's system eventually faded out in Britain but, modified by the American Benjamin Franklin Foster, it went on to have a considerable influence in Europe and the United States. By the 1830s, 2 million of Foster's copybooks were printed, and the text was translated into French and German.

The principle of free movement from the shoulder, which was the first stage of the movement exercise Carstairs taught, is well worth trying. All along it had in fact been the basis of the Dutch method of 'striking' or flourishing.* Carstairs advocated practice every day with letters at least four inches high on two-foot-square sheets of paper; he encouraged the hand to move to all areas of the page, literally from one corner to another and for the writer to produce chains of letters swinging down and across the page. It is surprising to discover the degree of control that is possible when one goes through some of Carstairs's

* 'To strike or (as 'tis called) to flourish after the Dutch manner, the Penman should keep his Arm quite detached from his body, and capable of being moved or swung about at Pleasure, or otherwise his striking will be stiff, and lose that Freedom which is its peculiar Grace'…'and the two fingers the hand rests on are elevated a bit so nothing may touch'. A. Serle, *The Art of Writing*, G. Keith, 1782, p. 59. And 'the centre of motion in striking, is at the shoulder'. H. Dean, *Dean's Recently Improved Analytical Guide to the Art of Penmanship*, 1808.

exercises. But there is a curious sidelight on this approach as practised in the early nineteenth century, which originates with Lewis. For all the freedom that such penmanship appears to demonstrate, success in this kind of movement depends upon building a firm platform of stressed muscles and fixed limbs within the writer's body, from which movement can be organized. The free shoulder movement is only possible by making the trunk of the body rigid and the writing hand relatively immobile, even as the arm moves the hand and pen about the surface. To encourage this stability Lewis, Carstairs and Foster all advocated the use of bindings (Fig. 48), elaborate ribbons that tied the hand in the correct position on to the pen; writers might also be tied to their chairs to ensure correct posture. None of this binding is actually necessary, but something about this use of restraint chimed with the times and its struggles to control the body and perhaps the power of writing itself. In the world of women's fashion the waist was 'freed into its natural shape' with whalebone stays and laced corsets. Shirts and collars would soon be stiff and starched. And not so far into the future handwriting 'drill' would soon be executed to the beat of metronomes. The cultural

POSITION OF THE HAND & PEN.

Fig. 48. The Talantograph, a fold-out (pl. 3) in Benjamin Franklin Foster's *Practical Penmanship being a development of the Carstairian system*, Albany, 1832.

historian Tamara Plakins Thornton has commented that writing is now conceptualized as 'the triumph of the student's will over his body...All told pedagogy promised a good deal more than training in a particular skill. Its real product was not handwriting but men, men of a type compatible with a new social order.'[180]

The impact of the Industrial Revolution

Though the long-term consequences were going to be incalculable in the first few decades of the Industrial Revolution there was little impact on the written word. Certainly one thing the Industrial Revolution did *not* depend on in these early years was an increase in the general population's ability to read and write. In the 1790s and early 1800s, in the Midlands and northern England, regions that lay at the heart of the new coal-mining, iron-smelting and cotton-spinning and weaving industries, literacy rates actually fell back during the decades when the first phase of the Industrial Revolution was at its height.[181] The impact of industrialization was particularly hard on children; some of the earliest factories were staffed almost exclusively by unpaid child apprentices brought in from parish poorhouses. The work was gruelling. It was not until 1819 that children's work hours were reduced by Act of Parliament to a maximum of seventy-two hours a week. Some manufacturers and charitable associations set up evening schools, but many children were simply too tired to attend. Figures for the Lancashire market town of Chorley in the 1790s show that barely one-sixth of the Sunday school children took the evening writing class one day a week.[182] Sunday schools themselves confined their activities to learning to read. A Manchester parson who appeared before the Factory Commission in 1833 said that many people who contributed to the schools objected to the pupils being taught to write. The evangelical Hannah More noted of her Mendip Charity schools, 'I allow of no writing. My object is not to teach dogmas and opinions, but to form the lower class to habits of industry and virtue.'[183]

Mechanical interventions

Nonetheless, pressures on those who were already literate were increasing. As early as the mid-seventeenth century, experiments into the use of stencils for making multiple copies of handwritten documents had been made in France by the Dutch mathematician and astronomer Christiaan Huygens (1629–96) and at the Royal Society in London by Hooke and Wren.[184] Huygens, a founding member of the French Académie Royale des Sciences, etched writing through a thin metal plate which was then printed by using a rolling press. From the first half of the seventeenth century, stencilled letters and notation seem also to have been used in large liturgical books in France and Germany, for monograms, even calling cards.[185] Single letter stencils for public lettering would become a commonplace from the mid-eighteenth century onwards. But Huygens's written stencils were never followed up – they were a one-off development, as was the first typewriter patented in 1714. Its inventor, the Englishman Henry Mill, described it as 'an artificial machine or method for the impressing or transcribing of letters, singly or progressively one after another, as in writing, whereby all writing whatsoever may be engrossed in paper or parchment so neat and exact as not to be distinguished from print'. But no drawings of the machine exist, and though at his death 'some printing letters and utilities for printing' were among his effects, we do not actually know if a working machine was ever built.*

In 1780 James Watt (1736–1819), the perfector of the steam engine, patented a letter-copying device. His machine consisted of an iron screw letterpress that clamped the documents between two metal plates, and a double roller like a laundry mangle that pressed documents against each other for copying. He also developed a portable wooden box-like press. The principle was the same in each case: within a day of the document

* Mill was the chief surveyor for the New River Company, responsible for bringing fresh water from Chadwell Springs, in Hertfordshire, to London. See lot 80 from the second day of the auction. S. Paterson, *A Catalogue of the genuine household furniture, philosophical and mathematical instruments, various improvements in mechanics, implements in arts and trades, plate, watches, books, sundry curiosities and other effects of Henry Mill…sold by auction…April* 18th 1771.

being written, a dampened piece of tissue paper was pressed against the original; the tissue picked up a reversed impression of the writing but since the paper was semi-transparent it could be read the right way round through the paper from the other side. This was one of the secret techniques that had been employed in the hidden room next door to the General Postal Office in London since the mid-1600s, but now it was publicly available and mechanically obtained. Letterpress books were made for sale, filled with pre-bound blank tissue paper on which to receive the copies. In America, George Washington and Thomas Jefferson all used screw-press letter-copying devices supplied by Watt's company, and Benjamin Franklin took three of them to Paris when he was posted there in 1781 as minister of the United States. Jefferson also experimented with a polygraph machine, a device that produces a piece of writing simultaneously with the creation of the original. The writer's pen had its motions transferred by levers to another pen that wrote alongside it on a separate piece of paper; these engines never worked adequately, needing frequent adjustments, and failed to catch on.

The bane of all eighteenth-century writers' lives was the quill pen. Quills are delightfully flexible tools to write with but they require

Fig. 49. The shape of a cut quill with the narrow-bladed quill knife.
The cutting edge of the knife is beveled on one side to enable it
to make the necessary scooping cuts.

careful trimming and maintenance; they are not so suited to quantities of writing that must be produced in a hurry (Fig. 49). Around 1810 fine crow quills for architectural drawing were sold for 9 shillings a hundred, turkey quills for the lawyer's office (they were hard and durable) were priced at 7 shillings, domestic geese at 15, whilst swan quills and goose quills from the Hudson Bay could fetch up to 63 shillings for a hundred – these were high-grade instruments.[186] Most quills, however, were so unreliable that they were considered disposable. In 1807, writers to the English exchequer were allowed 100–300 pens a quarter, or up to three a day. In a presentation at the Royal Society, on pen manufacture, presented in 1835 by the chemist Michael Faraday (1791–1867), he calculated that amongst the population in general, scarcely one pen in three was retrimmed, the rest were simply thrown away.[187] The quantity of quills that was imported to Britain in the late eighteenth and early nineteenth centuries was astonishing. Even in the 1830s, by which time metal nibs had begun to be manufactured, Britain imported nearly 20 million goose quills a year from Russia, Poland and the Hudson Bay;* this is besides the 8 million geese plucked for the domestic market (these figures are for 1812).[188] In the East End of London, where the quills were prepared for use by being soaked in water, heated then scraped (to remove the greasy coating) in a process called dutching, a quill-cutter could cut up to 1,200 quills a day. One manufacturer in Shoe Lane cut up to 6 million pens a year.

In 1804 the locksmith and pioneer of machine tooling Joseph Bramah took out a patent for a quill-cutter. His clip and punch mechanism allowed one quill barrel to have six nibs cut from it. The nibs were sold as portable pens that could be carried in a small box and fitted into a nib holder; 60,000 of these pen nibs were manufactured weekly. They were the precursor to the industrially manufactured steel nib that was

* Imports to London of goose and swan quills from the Hudson Bay began in December 1774. Hudson Bay Company returns show the trade rose from 58,000 quills in 1799 to peak at 1,259,000 in 1837. Up to the early 1890s an average of half a million quills were imported from this region annually. Quills continued to be sent by the company until 1912. C. S. Houston, T. Ball, M. Houston, *Eighteenth-Century Naturalists of the Hudson Bay*, McGill-Queens, 2003, pp. 197–8.

soon to be stamped out in the millions and which revolutionized the writing experience for the general population. They no longer had to struggle with a spluttering quill that quickly blunted or split and must be mended.

Metal nibs had been in use to a limited extent since Roman times, and craftsmen had experimented with pens made from bronze, brass, copper, silver and gold. By the early eighteenth century steel nibs had made an appearance. Richard North writes to his sister on 8 March 1701, 'You will hardly tell by what you see that I write with a steel pen. It is a device come out of France, of which the original was very good, and wrote very well; but this is but a copy, ill made. When they get the knack of making them exactly, I do not doubt but the Government of the Goose Quill is near an end, for none that can have these will use others.' France does seem to have had the lead in this area. The nuns at Port Royal, just south-west of Paris, made copper pens. The poet Alexander Pope mentions pens of gold and steel made by one Bertrand.

The industrial manufacture of steel nibs in Britain was begun in 1819 by James Perry of Manchester; his company moved to London in 1824. Perry overcame the problem of rigidity in a metal pen by introducing side slits and apertures into the nib. By 1835 Perry's company was manufacturing 100,000 nibs weekly, or 5,200,000 annually. Gillots of Birmingham, with 300 employees, was using forty tons of steel a year. With one ton of steel producing a million pens, that is around 80 million nibs a year, they went to offices and classrooms all over the world, from South America to India.[189] Suprisingly, though, despite the greater reliability of the metal pen, the 'Government of the Goose Quill' only gradually loosened its grip; as late as 1898 one company supplied an order of 2 million quills to London's India Office.

The 'modern' typeface

Whereas in handwriting the English round hand was now the predominant script for business throughout Europe, in typography the picture was rather different. Following the death of John Baskerville in 1775, the centre for creative innovation in typographic design passed (temporarily)

back to France. In 1783, the year that the American War of Independence was brought to a conclusion by the Treaty of Versailles, a young Parisian punch-cutter was working on a new design for a roman typeface.

Firmin Didot (1764–1836) came from a family of printers. His father and grandfather were both in the business, as was his elder brother Pierre. Firmin's type took its inspiration from two sources, the geometrical constructions of the *romain du roi* (and the work of those French punch-cutters that had been influenced by it) and the typefaces developed by John Baskerville. Baskerville's reputation on the continent was higher than in Britain; his work was in sympathy with a trend towards contrasted weight in typefaces such as those of Johann Michael Fleischmann (1701–68), working in the mid-eighteenth century at the Enschedé foundry in Haarlem. But his type and printing techniques had struck a particular chord in France: the apparent modernity of the forms and the evident craftsmanship of his work were appealing and the appeal was epitomized by the fact that the dramatist politician Beaumarchais bought all of Baskerville's printing equipment after his death. He used it to print a fine edition of the complete works of Voltaire, the archetypal voice of the French enlightenment.

Firmin Didot's type, issued in 1784, was the first in a series of designs that would push the contrast between thick and thin within a lettershape to a new extreme (Fig. 50). He had, in effect, invented what used to be called the 'modern' face, a letter with a vertical axis that ran through the complete alphabet. The type had lengthened ascenders and descenders, and relatively heavy stems in comparison to the wafer-thin serifs that crossed the stems at right angles with no brackets. It was a visually rigorous exercise of minimalist construction.

Didot's letters have sometimes been presented as marking a definite break with the logic of the pen, and favouring instead the drawn or geometrically constructed letters of the *romain du roi*, but the argument is only partially true. His italics were modelled on a pen-written letter. Where he does follow the *romain du roi* tradition is in his treatment of his serifed romans. Pierre-Simon Fournier had already noted, in his *Manuale* of 1764, 'an alteration has lately been made in the case of capital letters, whose angles have been squared to give an effect of lightness,

venis, et cæco carpitur ign
virtus animo, multusque re
os : hærent infixi pectore vι
1ec placidam membris dat c

Fig. 50. Firmin Didot's roman as it appeared in Virgil, *Opera*,
printed by his brother Pierre in Paris, 1791.

whereas they were formerly somewhat concave, which gave the letters
a heavier appearance. The same thing has been done to all the angles of
the lowercase letters.'[190] In other words the fashion in France, some time
before 1764, had already moved towards unbracketed serifs and Didot
continued this practise.* But what makes Didot's serifs appear so fresh
is not only the lack of any waisting in the stems of letters but also the
high contrast in weight which Baskerville's types had inspired; the thin
lines are very thin indeed. This marked contrast between thick and thin
initiated in typeforms by Baskerville and which Didot followed, was, as
we saw earlier, itself inspired by the writing masters' work with edged
and pointed pens (and their experience of working with engravings of
such forms). Indeed, as Didot's close competitor, the Italian typogra-
pher and printer Giambattista Bodoni (1740–1813), writes in the preface
to his posthumously published *Manuale Tipografico* of 1818, sharpness of
definition, neatness and finish are desirable in letters, they reflect 'the
beautiful contrast as between light and shade which comes naturally
from any writing done with a well-cut pen held properly in the hand'.

Like Firmin Didot, Bodoni would run the modern face through
many finely tuned variations.

* Apart from evidence mentioned in an earlier chapter, there is also other English
evidence. Plate 7 in George Shelley's *Alphabets in all hands* (1710?) has unbracketed hairline
serifs on all his lower-case romans. In addition James Mosley shows a photograph of an
original eighteenth-century Caslon punch for a four-line pica **m** with unbracketed serifs
in his blog 'Recasting Caslon Old Face' at http://typefoundry.blogspot.com/2009/01/
recasting-caslon-old-face.html.

Having looked to the types of Pierre-Simon Fournier for his early inspiration, Bodoni eventually created a narrower 'modern' letter to rival that of Didot. His *Manuale Tipografico* revealed Bodoni to have been a perfectionist. He believed a printer should have type in every size imaginable, even in gradations that were hardly visible. The 538 pages of type specimens in this two-volume work show the vast number of letters he cut in order to achieve his vision. There are twenty-two different sizes of type shown, and within each size there are innumerable variant cuttings of weight, letter width and x-height. When the British agricultural reformer Arthur Young visited Bodoni in 1789 at the Ducal Press in Parma, he recorded that he held up to 30,000 punches and matrices that he himself had created.*

Letters on display

The final development for letters in the late eighteenth and early nineteenth centuries was the development of type specifically for advertising.

From the early days of the Industrial Revolution advertising had become a necessity: a broad mass of people had to be persuaded to buy and consume goods beyond their daily requirements, and there was an excess of products available. In the early days typographers had set posters and handbills in the largest size of book type available, and these early advertisements had been laid out like books, with paragraphs and substantial blocks of text. By 1803, however, thanks to the joint work of Saint-Leger Didot, his English brother-in-law John Gamble and the stationers Henry and Sealy Fourdrinier, a paper-making machine had been developed in England.† Paper became available at a cheaper price and in much larger sizes. The old mills typically produced 60–100lb of paper a day but the new machine could produce up to 1,000lb, a tenfold increase.[191] This factor, together with the development of the iron press (1799), which allowed a more even pressure when printing over

* An inventory made by his widow in 1840 lists 25,491 punches and 50,283 matrices.

† Originally invented by Nicolas-Louis Robert in 1789 for the paper works at Essonnes run by Pierre-François Didot – Saint-Leger's father and brother to Firmin.

wider areas, created an opportunity for using larger sizes of posters and eye-catching printing types.

Already, circa 1765, Caslon's apprentice Thomas Cottrell (d. 1785) had created the first type that was clearly not intended for use in books but rather in advertising, a 'proscription or posting letter of great bulk and dimension'.[192] This twelve-line pica letter stood about two inches or five centimetres high. It was Cottrell's apprentice Robert Thorne of the Fan Street Foundry who pioneered the even greater bulk of the fat face. This 'extreme' face where the stem might be one third as wide as the letter height began to make an appearance in type from 1803 onwards. The design was a development of an already existing form based on the structural proportions of English vernacular lettering of the eighteenth century. These were painted and drawn letters of generous width, with, for instance, a projecting lower arm to the **E**, a very round **C**, and an upright axis to **O** and other curved letters, as in Baskerville's type. In the hands of sign-writers, letter-carvers and others working in wood, metal and ceramics this lettering had grown in scale and impact as the century progressed.[193] The fat face form is created by pushing these letters to an extreme until, like the politicians in a Regency cartoon, they become a colourful parody of themselves.

The sheer amount of black these letters contain draws one's eye towards them – they clamour for attention (Fig. 51). The larger sizes were cut as brass letters, while others were cut in wood and then cast as type in moulds made from beds of sand. The invention in America of the mechanical router in 1827 would ultimately lead to the manufacture of large wooden type itself becoming a viable proposition.

The small amount of space left for the letter's counters in a fat face forced the maker to simplify the contour of the letter with the same abrupt changes of angle between serif and stem that had, by now, been suggested by the work of Didot and Bodoni. The success of the 'extreme' face as a display type also encouraged the revival of a weighty gothic blackletter for similar uses. That this development happened in Britain rather than elsewhere should be no surprise. This was the first country in Europe where the commercial pressures created by the Industrial Revolution came to bear.

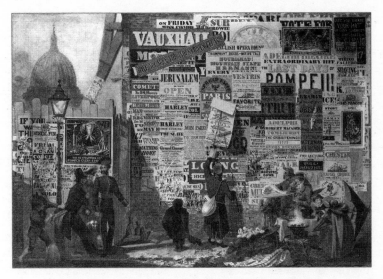

Fig. 51. *The Poster Man*, John Parry, 1835. The multi-talented
Parry made the painting as a gift for his wife. It contains many
witty references to his own history as a performer.

Ornamental types, of a more decorative character, had been taken
up in a serious way in the recent past by the Frenchman Pierre-Simon
Fournier. He had also introduced large sizes of letters with a fine inner
white line* that acted as a highlight to the letter, in imitation of carved
and gilded forms. He created letters composed of filigree and panelled
shapes and floral motifs, and he revived the use of typographical orna-
ments. The world of the pre-revolutionary French salon, the gleaming
rococo, the paintings of Boucher (1703–70) and Fragonard (1732–1806),
was drawn into the books that used Fournier's types. They were the
first, in the eighteenth century, to create a sense of freedom of form
around letterforms.[194] Though many aspects of his work would have
only a brief-lived impact because of the revolutionary times ahead – he
had nonetheless opened a Pandora's box, and henceforth anything was

* Technically known as two-line or inline letters, they were commonplace in engraved
lettering; a fine example appears in an etching, 'The Colonies Reduced' (1767), in J. Almon,
The Political Register and London Museum Vol. 3, London, 1768, p. 321. See http://www.loc.
gov/pictures/resource/ppmsca.31019/.

possible – new inspirations could be brought from far afield to the world of type, and once the stern times of the end of the century were past, this part of his legacy blossomed.

The other great revival of the late eighteenth century was the letter with no serifs at all, the stoic sans-serif, the ancient Roman republican letterform. This monoline block letter would eventually eclipse all its rivals and become one of the most popular choices for new type designs in the twentieth century. Its beginnings are modest. Sans-serif forms had always been a part of the folk memory of the lettering craftsman. In England they were carved into Elizabethan pulpits and domestic furniture, ran along Jacobean balustrades and were cast into the iron tombstones of the last of the Sussex iron masters.

On a grand tour through Europe in 1763, George Dance the Younger (1741–1825), son of George Dance the Elder (1695–1768), Surveyor for the City of London, made drawings of the sans-serif lettering that ran around the architrave of the ruined Roman Tempio della Sibilla at Tivoli outside Rome. The temple dates from the first century BCE. The type historian James Mosley, who has made a special study of the origins of the sans-serif letter in type,[195] has shown how some years later, when George Dance the Younger had followed in his father's footsteps as Surveyor for the City of London, his young apprentice, John Soane, made careful copies of these drawings. Later Soane adopted a sans-serif letter for use in the inscriptions he suggested in plans for the design of 'A British Senate House', exhibited at the Royal Academy in 1779, and also for the Bank of England and the House of Lords. Having pressed the letters into service on his architectural drawings, this practice seems to have spread to other architects and so into popular culture.

Strange though it may seem to us, these letterforms, though known to come from ancient Roman sources, came to be called Egyptian letters by the public. Napoleon's conquest of Egypt had brought that country's ancient heritage back into European consciousness. Buildings in Egyptian style appeared in European cities. The first in London were the offices of the *Courier* in the Strand, built in 1804. In August 1805 the *European Magazine* included a comment on the strange letters now appearing on the streets of London; the writer is unconvinced of their appeal:

'I find it convenient to no classes except the house painters, who must gain considerably by repainting so great a portion of the metropolis, and who can apply apprentices to so simple a letter, where abler and more expensive workmen were necessary heretofore…the warmest advocates of these letters cannot but allow, that they are clumsy in the extreme, and devoid of a single beauty to recommend them, or any thing whatever, except their antiquity.' So, as James Mosley observes, by 1805 'Egyptian letters were happening in the streets of London, being plastered over shops and on walls by signwriters, and they were astonishing the public, who had never seen letters like them and were not sure they wanted to'.[196] Was this a fad or something type-founders should take seriously? It would not be until c. 1819 that William Caslon IV would cast the first British sans-serif type, and not until the 1830s that a wider choice of sans-serif faces would come to the market – issued by Vincent Figgins and William Thorowgood (Thorne's successor at the Fann Street Foundry). Figgins (1830) called his type a sans-serif. Thorowgood (1832) called his a grotesque (from the Italian *grottesco* meaning of the grotto or cave), and both terms remain in use today. Thorowgood's grotesque was the first commercial type to have sans-serif lower-case letters as well as capitals.

The type that we know as 'Egyptian' today is rather different from the ancient Roman republican sans-serif letter. Rather it is a slab-serifed form whose earliest known appearance is currently on a lottery bill from 1810; these letters are woodcuts rather than set as type.* Wood-engraved lottery bills display some of the most adventurous lettering to have survived from the period.

All the fun of the fair

Following the end of the Napoleonic wars in 1815, Europe was open to travellers once more. Horizons were expanded, new sources of inspiration sought. Though the economic climate remained harsh for a number

* This was a discovery of the calligraphy and type historian Justin Howes, documented after his untimely death by James Mosley in his blogged article *The Nymph and the Grot*, an update. http://typefoundry.blogspot.com/2007/01/nymph-and-grot-update.html.

of years, the grand tour was revived for the wealthy. On the banqueting tables of the Prince Regent in Brighton, the Russian Tsar in St Petersburg and those of the Rothschilds in Paris, the fabulous iced confectionery centrepieces created by the French chef Antonin Carême now glittered in the shape of Egyptian monuments, classical temples, rustic cottages and Tuscan ruins. Letter shapes too were reinvented in a similar profusion of eye-catching ancient and rustic disguises.

The slab-serif letter (see Fig. 51, top right, 'VOTE FOR') finally made a centre-stage appearance in the type catalogue of Vincent Figgins, circa 1817. He called it 'Antique'. Dating the cornucopia of new letterforms that appears in the first half of the nineteenth century is problematic. The first known example of a letter that will come to be called Ionic – a slab-serif with added brackets from the slab into the stem, is on Thomas Telford's Waterloo Bridge (1815) in cast iron at Betws-y-Coed in Wales. There soon followed a shaded version from Vincent Figgins of the same date. The foundry of Blake and Stephenson introduced an outline Ionic form in 1833. Caslon's foundry introduced the first solid Ionic in 1842, and lower-case letters followed one year later. Yet in all likelihood, as the history of the sans-serif highlights, the letter would perhaps have made its first appearance in a sign-written form predating the Waterloo Bridge inscription by some years.

The year 1817 saw the arrival of Tuscan faces in type-cast form, with complex bifurcating serifs. There are echoes of Fournier's ornamental types here but this shape has a Roman precedent in the fourth century, in inscriptions such as that on the tomb of Pope Damasus (c. 305–84), carved by his friend the scribe and calligrapher Furius Dionysius Filocalus. To the nineteenth-century type designer the Tuscan's branched terminals suggested foliage, and this form became one of the most ornamental letters of the period.

The Italian types of Caslon and Livermore, issued from 1825 onwards, take another look back at classical precedent. We know them today from their descendants (somewhat confusingly called French Clarendon types), which appear as the letters seen on WANTED posters in the American West. They show the reversal in weighting that produces thin stems but heavy horizontals last seen in Roman rustic letters. Similar

letters were reappearing on the freshly excavated walls of Pompeii and Herculaneum, which had been rediscovered in 1748 and thereafter became a popular stop on the grand tour.

Perhaps the last great success of the period, structurally a direct descendant of the Ionic, but conceived for a rather specific application, was the Clarendon type cut by Benjamin Fox and issued in 1845 by Robert Besley. Besley, a future Lord Mayor of London, was joint proprietor of the Fann Street Foundry. The foundry had issued a succession of letters with prominent and weighty serifs. The Clarendon was a slightly narrowed yet lightened form of the Ionic. 'One of the great successes of British type designs', says James Mosley,[197] for at last a display letter was also made suitable as a type for use in books alongside a related roman. Bodoni's 'Ducale' specimen from his *Manuale* of 1818 shows type in a range of three weights, one of which is bold, yet the graphic reasoning behind the Clarendon's design, given in a Fann Street Foundry specimen book, suggests this is an independent development:

> The most **useful Founts** that a Printer can have in his Office are the **CLARENDONS**: they make a **striking Word** or **Line** either in a **Hand Bill** or a **Title Page,** and do not overwhelm the other lines: they have been made **with great care,** so that while they are **distinct** and **striking** they possess a **graceful outline,** avoiding on the one hand, the **clumsy inelegance** of the **Antique** or **Egyptian Character,** and on the other, the appearance of an **ordinary Roman Letter thickened by long use.'**[198]

Besley's 'bold' was an immediate success, enormously popular and widely copied. It could of course be used in headings, but now, as the type specimen itself suggested, it is also employed for what the type historian Michael Twyman has called 'non-linear reading' or accented text. Bold type could be used to highlight words within the text and speed one's absorption of the information the text block contained.

One wonders why there had been no bold bookface up to now. Of course in the manuscript age many sizes and weights of lettering had been used. Before *c.* 1100 the hierarchy of meanings within a text was

usually indicated by the use of different scripts entirely; headings or key words were highlighted by being written in capital letters (majuscule scripts) like roman capitals, uncials and rustics. After 1100 the places where we might use bold in a text today (for headings, key words and endings) were often written with the same pen and letterform as the main text but with a differently coloured ink, often red, blue or gold. As colour was gradually dropped from printed texts so this level of distinction vanished, to be replaced by the use of italics.* Later capitals and small capitals were also used, as was a gothic blackletter. In legal documents right down into the nineteenth century keywords were still written in larger bolder writing – sometimes in a formal fraktur letter – and it is this practice, together with those adopted by educators to cue information in complex tables, that is the nearest contemporary parallel to the introduction of bold letters within text blocks in the 1840s.[199] Already, with the introduction of the extreme faces for advertisements, the prose in posters and handbills was being written in a more abbreviated style so that it could be separated out line by line; now text blocks themselves were being typographically enhanced.

In the mid-nineteenth century a new note is introduced, a revival of Caslon's 'old' face, used in publications of the Chiswick Press, indicating a more moderate climate, a society now at ease with itself and its past. This atmosphere is encapsulated in Alexander Phemister's work for the Scottish type foundry of Miller and Richard. Their specimen of 1860 shows a series of 'old' faces, designed and cut by Phemister, still with the vertical axis of the 'moderns' in the circular letters but with slanted serifs and without strongly contrasted shading within strokes. The letters have a light, bright impression on the page. The **a** is wide like Baskerville's and the **c** and **e** have a lovely momentum from the forward-driving curve of their lower half; the letters are generously spaced. Phemister would emigrate the following year to the United States. There he produced 'Franklin Old Face', a version of his Miller and Richard's design but now made for a new world – Dickinson's type foundry in Boston, the town where he made his home.

* Introduced for this use by Robert Estienne and others in France from *c.* 1520.

*

The end of the century's story is now in two parts. The multiplication of documents in business and personal correspondence threatens to become overwhelming. On the other hand a new sensitivity has been aroused. Nostalgia for a pre-industrial world of romance, heroic individuality and handwork hovers, hauntingly, on the smoke-stained air.

The Industrial Age

Fig. 52. As printing entered the industrial age, in England legal clerks continued to write in gothic hands on parchment documents. This mortgage in favour of the father of the poet Percy Bysshe Shelley and his widow, Mary Wollstonecraft Shelley, was drawn up in 1845.

We stand now on the edge of a second great age of transformation – one in which we still travel. Universal primary education vastly increases the number of literate persons – from countries who have a few hundreds of thousands of people who can write we now have millions of people. The range of written artefacts expands in quantity and in kind.

The relentless press

Since the earliest days of printing the mechanics of the printing press had remained little changed. Engravings that show presses at work from the fifteenth to the eighteenth centuries are virtually identical; the workplace becomes slightly more opulent, the number of presses increases – as does the number of compositors at work at the cases of type in the background – but the design of the press remains the same. Then, in 1799 the first all-iron press, using a system of compound levers, was developed by Lord Stanhope and his engineer Robert Walker. From then on changes are introduced at an ever-brisker pace. A high-speed steam-powered press, invented by Friedrich Koenig (1774–1833) and the watchmaker Andreas Bauer (1783–1860), was put into use on 29 November 1814 at *The Times* in London. The number of impressions that these machines were capable of producing per hour increased through the use of polygonal rotary presses from 1,100 in 1814 to 12,000 by 1848.

In the late 1840s efficient circular rotary presses were invented. Two men, quite independently of each other, worked on the rotary principle – Richard March Hoe (1812–86) in New York and Hippolyte Auguste Marinoni (1823–1904) in Paris. Hoe's system used wedges and screws to keep the type in place, but Marinoni used stereotyping (a name invented by Firmin Didot). Flexible moulds were made of typeset pages using papier-mâché 'flong'; these moulds could be bent, and curved metal castings made to be fitted to the rotary bed of the press. By 1869 circular rotary machines at the London *Times,* now printing on rolls of paper

rather than single sheets,* could make 12,000 copies of the paper in an hour. In 1895 *The Times* introduced a new press that not only printed 24,000 copies of an entire twelve-page newspaper in an hour, but also folded them as well.[200]

In this fast-paced environment it was increasingly hard for the compositor to keep pace with the demands of the press. In the final years of the eighteenth century compositors at *The Times* had experimented with a typeface that used syllables and not just single letters of type.† But the breakthrough that saw the entire process of printing completely mechanized was the invention in the United States of machines that enabled operators using keyboards to select and cast type on a machine's own matrices as they simultaneously composed the text. At the command of the typesetter, using a keyboard, hot metal was poured on to type matrices which, in the case of the Linotype machine developed by Ottmar Mergenthaler (1854–99) in 1884–6, were combined to produce a single slug of type per line. The rival Monotype process, developed by Tolbert Lanston (1844–1913) between 1885 and 1897, cast the type in the usual individually discrete forms, or 'sorts', allowing slightly more subtle spacing between letters. The type was melted down after use and the type-metal recycled.

It was not just newspapers that were benefiting from increased speeds of production and larger editions. By the mid-nineteenth century documents of all kinds had begun to proliferate, and advertisements in particular. In December 1861, a little before Christmas, William Smith, the manager of the New Adelphi Theatre in London's Strand, recorded a walk across the city from Elephant and Castle station, south of the river Thames, to the Smithfield Club's annual Cattle Show, which lay to the north-east. He had conceived a plan for that day; perhaps he was already working on his book *Advertising When? Where? How?* (1863).

* A paper tax, paid by the sheet, had prevented the use of rolls of paper until 1861 when the tax was abolished.

† This 'logographic' method had been invented in 1778 by Henry Johnson. The patent was bought by John Walter, who founded *The Universal Register*, later *The Times*, where logographic printing was used until 1792.

During the walk Smith accepted every piece of free publicity he was offered along the way; by the end of the day he had collected 250 hand-bills, books and pamphlets. He estimated that if only half the number of people (20,000) following the same route through London that day had accepted half the number of items offered them, then, in the course of nine hours, 2,300,000 pieces of advertising had been distributed.[201] By now, William Smith reveals, advertising methods included not only handbills and sandwich-board men, but stunts (men throwing handfuls of leaflets into the air outside railway stations), painted clothing, and elaborately made items (paper cuts, cards and adhesive stickers), folio cards for shop windows, six-sheet posters and larger. 'Within the last two or three years,' he writes, 'not a side of a house, railway-arch, or hoard-ing in any public thoroughfare (even the chimneys have not escaped), but is covered with posters and bills of all descriptions, from the modest single sheet to the unblushing, self-asserting, eight and twenty'.[202] He continues, 'In France it is by no means uncommon for a single advertiser to take the whole side of a house, on which his advertisement is painted in letters several feet long.' This is a different age from the previous era. Smith describes how in 'Seventeen Hundred and Half Asleep', as he calls the previous century, posts divided the pavement from the roadway along Fleet Street and the Strand. It was on these posts (from 1745 or thereabouts) that theatre bills were stuck, and this was the beginning of regular London bill-posting.[203]

William Smith himself put the success of advertising down to 'a cheap press, circulating all over the kingdom, the paper duty-free, the price of advertisements within the reach of all, and but few, even down to the very errand-boy, I am glad to say, who cannot read'.[204] A critical mass of readers had been reached.

Nonetheless England and Wales lagged behind many European countries in educational reform. At a time when universal elementary education was already being instituted in France, as part of the revolu-tion's social reforms, a movement to provide such education in Britain was defeated in the House of Lords in 1807. In the debate in the House, Lord Giddy, the President of the Royal Society, argued that 'educat-ing the labouring classes of the poor' would be found 'prejudicial to

their morals and happiness; it would teach them to despise their lot in life, instead of making them good servants in agriculture, and other labourious employments…instead of teaching them subordination, it would render them factious and refractory, as was evident in the manufacturing counties'.[205] In 1839 and again in 1843 several proposals for ratepayer-funded education fell to rivalry between Anglicans and non-conformists over who would run the schools. In Prussia, the leader in educational reform, school attendance in 1864 was assessed at 85 per cent.[206] It was not until the Education Act of 1870 that a nationwide network of elementary education was created. In the 1880s education to the age of ten was made compulsory, and in 1891 it was made free.

The biggest change in nineteenth-century education, over that of the eighteenth, was that writing was finally given equal stress to reading: 'henceforth any child who attended primary school could not only decipher a text but also hold a pen and write at least a few words'.[207] By 1900 census figures for France, England and Germany show illiteracy at just 10 per cent, at 12 per cent in Belgium, 22 per cent in the Austro-Hungarian Empire (where figures vary greatly across ethnic groups), and at 50 per cent in Russia shortly after 1900.

The population itself was also growing. In Britain it grew by 66 per cent between 1850 and 1900, and by the same figure in the Austro-Hungarian Empire; in Germany it grew by 96 per cent in the same period. Whereas in 1800 there had been just twenty-two cities in Europe that held more than 100,000 inhabitants, in 1850 there were forty-seven and by 1914 there were 182.[208] All these expansions – in population, education and commercial advertising – would lead to a proliferation of documentary material.

'Chemical printing'

As the century advanced, printing technology continued to develop. Now it was discoveries of new chemical processes that proved significant rather than simple mechanical improvements. Lithography, or 'chemical printing' as it was called by its inventor Aloys Senefelder (1771–1834), was the most groundbreaking innovation in the opening years

of the nineteenth century. Senefelder discovered that if he wrote with the greasy compound on a porous stone like limestone which was then wetted, printer's ink would stick to the marks made by the crayon but would be repelled from the surface that was saturated with water – for oil and water do not mix.*

Senefelder published the results of his life's work in *A Complete Course in Lithography*, which was printed in several languages between 1818 and 1819. Senefelder's invention multiplied the kind of materials that could be printed: handwriting and drawing could be reproduced directly rather than having to be engraved. And so it also opened up to printing those scripts (like Arabic, Urdu and Persian) that had until that point proved too complex to print (they had much overlapping and joining of letters and alternative letter shapes).†

Lithographic printing using colour was also possible. Chromolithography used separate stones to print individual colours (as with woodblock printing). Refinements to the process in the mid-nineteenth century by French artist Jules Chéret (1836–1932) made lithographed posters glow with colour, as well as giving them a transparency of ink and subtlety of line never seen before. Chéret's own work for the theatres and packaging of the Belle Époque, together with the hand-drawn and lettered posters of Toulouse-Lautrec (1864–1901), are amongst the most memorable lithographed lettered images of the nineteenth century. Printed lettering could now be more organic in shape and responsive to its setting, as it had been in the manuscript book.

By the mid-nineteenth century lithography had also made possible the printing of inexpensive maps.

* The process was eventually refined: once an image had been drawn on the stone, the stone was washed in an aqueous solution of gum arabic and weak nitric acid. The layer of gum and salts that this laid down within the stone meant that these areas continued to attract water into the stone whenever it was wetted.

† Newspapers in Pakistan and some parts of India continued to be printed lithographically from photographically transferred handwritten masters right down into the 1990s.

The penny post

The early nineteenth century saw two crucial developments in the infrastructure that supported communication with the written word: the building of new transport systems and the introduction of the penny post.

The Stockton to Darlington Railway was opened in 1825, and was the first line to carry fare-paying passengers. In 1829 Stephenson's *Rocket* began running from Liverpool to Manchester at unheard-of speeds – up to thirty miles an hour. Railway fever had begun. Within twenty-five years tracks had been laid across Europe, North and South America, in Australia, India and Egypt.

By cutting the time and cost of carrying letters the railways speeded the introduction of the penny post – a uniform postal rate of a penny throughout the United Kingdom that had been argued for by Rowland Hill (1795–1879) in a pamphlet, *Post office reform: its importance and practicability*, published in 1837.[209] The radical nature of his idea becomes clear if we compare his proposed charge of 1d, however far a letter was sent within the United Kingdom, to those levelled prior to 1840. In the 1830s the cost of sending a letter up to fifteen miles distance was 4d, and for 300–400 miles it was 1s 1d.

Though Hill's argument was backed at every turn by facts and figures, his underlying motivation for the reform was humanitarian. He was a Benthamite. He believed, following Jeremy Bentham (himself inspired by the chemist and natural philosopher Joseph Priestley (1733–1804) – a friend of Hill's father), in the greatest happiness for the greatest number of people. In his 1837 pamphlet he also portrays the Post Office as a 'powerful engine of civilization, capable of performing a distinguished part in the great National work of Education'.[210]

A standard charge of a penny was introduced to the British postal service in October 1840. Within a year the volume of letters carried by the Royal Mail rose from 79 million to 169 million a year; within twenty years it had tripled. It took twenty-three years, though, before the Post Office actually went into profit. The concept of an inexpensive uniform postal rate soon spread. Within a decade it had been adopted by many major European countries (though Brazil was the first, in 1843). In 1874

an International or General Postal Union was adopted, as a result of the Treaty of Berne. Uniform flat rates to mail a letter anywhere in the world were established, with postal authorities giving equal care to foreign and domestic mail. Each country of origin was to keep the income that international postage generated.

Split nibs

During the early years of the nineteenth century the systems of penmanship operating in Europe and the USA began to move in different directions. The introduction of the more disciplined penmanship of Carstairs and his followers in the harsh and anxious times that followed 1815 had seen the individualism nascent in British handwriting put back in its box. But in America the social and political system was now quite different following the revolutionary war, and penmanship was free of the constraints that affected Britain. There were more than 100 writing masters in the United States in the first half of the nineteenth century teaching and publishing their own systems[211] – it seemed that vitality in writing had moved across the Atlantic. It was in the United States that what we might loosely think of as romantic penmanship flourished. The prophet of the new movement was a young man born in 1800 near Poughkeepsie, New York. At school he so excelled in penmanship that he was enlisted to teach his fellow pupils when he was just twelve years of age. His name was Platt Rogers Spencer.

At the age of ten, Spencer (1800–1864) had moved with his widowed mother to unsettled country in north-eastern Ohio. Already fascinated by writing but lacking paper, he wrote on whatever nature could provide: on birch bark, snow, sand and scraps of leather from the local cobbler. His penmanship was profoundly affected by this experience. He had looked to nature for what was beautiful and had found pleasure in its colour and variety; he described the essential shape behind his letters as a gently sloping oval, like the pebbles found on a lake shore. The looped length of ascenders and descenders should, he felt, vary in size – for all things natural did. The thin line traced by the quill or metal pen should also, now and then, be enlivened by the contrasting tone of thicker

shading, made by applying pressure to the nib. Unlike the English round hand, this shading could be varied at will, whilst most of the letters were written with a thin flowing line. And as for the writing action itself, like Carstairs Spencer encouraged a relaxed gesture engaging a variety of muscle movements involving the whole arm, as well as wrist and hand. The hand rested on the nails of the third and fourth finger.

It was only when Spencer was forty-eight that a former pupil encouraged him to publish his work – up to this point all his teaching had been by personal example on handwritten slips of paper which he gave to his students. The encouraging pupil was Victor M. Rice, superintendent of schools for Buffalo and later of the whole of New York State. Spencer's first manual consisted of printed writing slips contained in an envelope. Within two years he was able to relocate the family from the log cabin where they had lived to a more substantial house, and a pattern was established of classes for budding penmen who travelled from across the States to work with him in the cabin in the winter and teaching tours of many cities in the summer. His writing scheme was adopted by Bryant and Stratton's Mercantile Colleges, which had been established in Cleveland, Ohio, in 1852 and soon spread to New York City, Albany, Buffalo, Philadelphia, Detroit and Chicago. By the 1860s it was influencing penmanship right across the United States.

The corporations

Bound together now by the railway network, an efficient postal system, and the new steam-powered ocean-going ships with iron hulls and screw propellers (as well as increasingly by the telegraph, of which more later) from the 1840s onwards it became possible to build industrial organizations (and bureaucracies) of a size and complexity never before seen. The sheer scale and geographically distributed nature of these organizations stimulated the development of new forms of management; within such companies formal systems of written communication became increasingly important. It was the railroads that took the lead. The real-time activity of a railroad, with its high volume of traffic, allowed much less margin for error in operation.

In the early years of the Industrial Revolution the management of many companies had been undertaken in much the same way as they had in the craftsman's workshop. Apart from small advances in accounting practices and simple record-keeping, word-of-mouth was still sufficient for daily operations. But in 1841, following a series of disastrous collisions in the United States (on the Western Railroad running between Worcester and West Stockbridge in Massachusetts), the American railroads began to adopt lines of management and methods of written communication that were more strictly controlled.[212]

By the 1880s 'systematic management', employing regular flows of written information up and down an organization in the forms of reports, orders, timetables and operational manuals, had spread to other kinds of business. Yet companies were realizing that growth had *not* brought them the increase in profits that they had expected, for an increase in size does not automatically yield economies of scale – it is as likely to bring chaos if the nature of the business is not grasped and managed well. New lines of communication were instituted that ran *across* the firm; statistical reporting was encapsulated in tables, graphs and reports, and typical acts of communication within a company, such as ordering stationery or other supplies, now had forms to be filled in. Oral communication within companies became formalized in managerial meetings that also had to be documented.* Written communication was being employed systematically to overcome the disadvantages that larger operational size and complexity could bring. With it, though, came a certain depersonalization. As the company built its own in-house store of wisdom in handbooks and manuals, and required its employees to be accountable to paper-based procedures, the lower managers and craftsmen who had been the repository of much knowledge found authority, initiative and power draining away. So too did the office clerk, whose accomplishment in careful penmanship had once been a source of pride and a testament to the company's probity.

* Although the telephone was invented in 1876 and installed in many workplaces soon after, it did not fulfil the requirement to document activity, for it neither built an institutional memory that enabled efficiencies to be made nor guaranteed that action had been taken and responsibilities discharged.

The 1870s saw a rash of new technologies aiming to make the clerk's work more efficient.

New machines for writing

Remington's typewriter was released in 1872. Leaving aside Henry Mill's patent for a writing machine from 1714 and the inventor Pellegrino Turri's typewriter (1808) for his lover – a blind contessa – a considerable number of inventors had tried their hand at such machines by the mid-nineteenth century. The first machine to go into commercial production (1870) came from Denmark; the Reverend Rasmus Malling-Hansen's ball-shaped typewriter was one of the most beautiful writing machines to have been invented. It looked like a small brass globe or enlarged dandelion head made of buttons and pistons one could press.[213] Hansen was a pastor who ran Copenhagen's Royal Institute for the deaf and dumb – his vision was to enable his charges to speak through their fingers. The machines continued in use into the early 1900s. When the German philosopher Friedrich Nietzsche (1844–1900) found his eyesight was failing he acquired a Hansen Ball to enable him to continue writing.

Remington's 1872 machine became the standard every other manufacturer had to compete with. It had begun life in Milwaukee, Wisconsin, as the brainchild of three men, Christopher Scholes (1819–90), a newspaper editor, and his friends and associates Samuel Soule and Carlos Gliddens. Initially Scholes and Soules had been working on a machine to number lottery tickets and pages, and it was Gliddens, a local lawyer and amateur inventor who suggested it could be applied to writing with letters also. They sold their first machine to a school for training telegraphists before the patent was sold to E. Remington Ltd, the rifle and sewing machine manufacturer in Ilion, New York. Remington's No. 1 machine was produced sitting on a cast-iron sewing machine base with gilded and painted panelling to appeal to the women typists who it was anticipated would use it. It was women, finally benefiting from the improvements in education, who were moving into office work in increasing numbers, unsettling the penmen's male preserve.

Central to the effectiveness of the typewriter were the increase in

the speed with which a document could be written (about 150 words a minute as opposed to thirty) and the ability to produce multiple 'carbon' copies. Though carbon paper had been invented in 1804 by Ralph Wedgwood, cousin to the potter Josiah, its original use had been conceived as a device to help the blind write; it eliminated the need to dip the pen in an inkwell – a pointed stylus was all that was necessary. But with the introduction of the typewriter the potential for carbon paper to produce multiple copies was quickly realized. It became possible to type up to ten copies at a time using special one-sided carbon sheets.

The typewriter's famous Qwerty keyboard was also developed by Scholes and his associates, but, as Professor Koichi Yasuoka of Kyoto University has shown, its layout is more happenstance than the product of a single rigorous logic.[214] Certainly some account was taken of the need to stop the mechanical arms of the typewriter jamming when frequently occurring letters were placed close to each other, but personal whim, and the need to be different from other copyrighted designs, also contributed to the keyboard's layout. Typewriter terminology has since entered the everyday language of word-processing; backspace, (carriage) return, shift key, tab all originated with descriptions of the mechanical operation of the machine. The letters on these early machines looked like type, a cross between slab-seriffed Egyptians and the popular Clarendon face.

Around 1876 effective machines for stencilling were introduced. Amongst the more exotic was Thomas Edison's 'Autographic Press and Electric Pen', which sliced small dashes into a paper master as the copyist wrote; ink was then squeezed through the stencil, which was held secure in a small press. The wet-cell batteries that powered the pen were open baths of sulphuric acid, which had to be kept topped up by the secretary.

The makers of the 'Mimeograph', another form of stencil press, claimed it could print up to 1,500 copies from a single master. Another method of reproduction was the gelatin or spirit duplicator. The premise here was that an inked original was kept dampened either by floating on top of a gelatin base or by being wiped with spirit before each printing, The hectograph, which used gelatin and aniline inks, came on to the market in 1876. In the late 1880s it became possible to type stencils as well as to hand-write them, a much clearer and less messy process.

Several document-copying machines that used light-sensitive paper were also developed. By the 1870s the 'blue print' used for copying large plans and drawings was in regular use. An original drawing in black Indian ink, made on waxed or semi-transparent paper, was placed over light-sensitive paper which, when exposed, left blue markings where the paper's surface had been covered by the original ink drawing. The Photostat machine (c. 1907) was a breakthrough, for this was a device that could copy anything without the need for special preparations at the time of writing. With a Photostat one could take images of originals and print them on to rolls of photosensitive paper; the first print was always a negative image, white on black, but it could be re-photographed to reverse the tones.

Paper

Paper manufacturers only managed to keep up with the demand from growing businesses, the needs of advertisers and faster printing methods by diversifying from cotton and linen fibres into alternative esparto grass and wood pulp. When the wood-pulp method was first discovered in the late 1840s (simultaneously in Germany and Canada) the fibres were broken down by mechanical means, but in the 1870s a chemical method was introduced using both sulphurous acids and salts. There were hidden penalties to this process which are only now becoming apparent, for it left the paper acidic, a fact accentuated by changes in the way paper had been sized from 1840 onwards. A chemical formulae of alum and rosin was frequently substituted for gelatin sizing. Unfortunately the two substances produce sulphuric acid in reaction to each other, and as the sizing was done in the pulping tub the acid was distributed throughout the paper and not just on its surface. Henry-Jean Martin tells us that out of the 2 million books published after 1875 held by the Bibliothèque Nationale de France, 75,000 have been permanently lost to decay, 580,000 are in danger in the short term and 600,000 will be at risk soon.[215] The chemicals left in the paper by its manufacture turn paper brittle; it literally crumbles to dust. This process of decay is affecting newspapers, music, maps and documents, and the potential loss is truly catastrophic. One estimate

suggests that 80 million books alone in the United States are vulnerable and 12 million of them are 'unique titles needing high-priority preservation'.[216] Several generations of records and literature could simply be wiped out without a massive conservation effort; work began several decades ago using microfilm and continues today with digitization – though it too has its own conservation problems.

Muscular writing

By the late 1870s, Spencerian script, largely confined to the United States, sat less happily within an industrial setting. Whilst Spencer's script had originally offered a contemplative regard for natural form – which he had described as 'taking penmanship quite out of the circle of the arts merely mechanical' – the clerks who used handwriting within the industrial system were coming to be seen as just another cog within the machine, mere 'pen-pushers' and 'quill-drivers'. The approach to teaching penmanship was changing. Teaching methods in America following the Civil War increasingly emphasized penmanship as a physical discipline. Penmanship lessons were renamed 'handwriting drill'. Classes of pupils picked up their pens in unison to called-out 'commands'. All the students wrote the same words at the same time. Some manuals recommended that students make the elements (or parts of a letter) to the beat of a class metronome. 'You count for each movement; you require the most absolute promptitude and obedience; you transform the class into a machine, in which every right hand is moved absolutely at the direction of your count from left to right.'[217]

In Britain the pressure for change was also building, stimulated by the sheer quantity of paperwork that modern business practice involved. Demand rose for even simpler forms of cursive writing. By the century's end English round hand became the preserve of 'Ornamental' penmanship. The main casualty of the rush of business was – as in print – the fine line. Faster and more legible writing could be fashioned, it was argued, from unshaded monoline forms written without any of the variations in pressure that had long preserved the thick and thin contrast in the pen-strokes of English round hand.

In 1865 in Britain the Vere Foster Copy Books introduced a simple hand for the times; printed by lithograph, this was an unfussy script, easily joined and with scarcely any contrast between thick and thin. Foster (1819–1900) was an Irishman, born in Copenhagen, educated at Eton and Oxford; he had become a British diplomat until the Irish famine of 1848 led him to retire early from the Foreign Service to devote his life to bettering the lot of his fellow countrymen. Believing the only immediate remedy to the terrible poverty afflicting Ireland was emigration, his handwriting scheme was designed to help the emigrant find work in the USA and beyond, as well as to increase educational standards at home. Foster, no writing master himself, consulted widely in Britain, the USA and on the continent. He made his letters more upright – the fashion had been for a steep slope from the vertical of around 15 degrees – and he eliminated the thin upstroke and thick downstroke of the round hand entirely. Hairline strokes in writing were a particular *bête noire* for the British Foreign Secretary and then Prime Minister Lord Palmerston (a relative of Foster's who had suggested the scheme). When asked to give his endorsement, Palmerston struck through lines he thought too thin in the copy he was shown, prior to giving his consent. Vere Foster's Copy Books became popular across Britain and in North America. By the late 1880s newspaper reports say they were selling 3 million copies annually.[218] Renamed the Civil Service hand (from 1870 there was a handwriting test to enter the service), they proved so durable that they continued in use in Britain well into the 1960s.

Meanwhile on the spacious plains of America a new 'muscular penmanship' was taking shape, advocating whole arm movement for every aspect of writing. Austin Norman Palmer (1860–1927) was a direct descendant of the Spencerian school, taught by George A. Gaskell (1844–85) in Manchester, New Hampshire, where he had paid for his early education by sweeping the classroom floor. Gaskell had been a member of Spencer's 'Log Cabin Seminary'. In the authentic Spencerian tradition – that of Platt Roger himself – penmen had felt free to develop their own style; this Gaskell had done and, in turn, Palmer would also do. Like Vere Foster's writing scheme, he would eliminate the contrast between thick and thin strokes in writing.

By now, as Tamara Plakins Thornton points out in her book *Hand-writing in America*, penmanship, once so closely identified with the male world of business, was facing an identity crisis, for the business world itself was changing. As corporations grew, their employees were losing their powers of autonomy and initiative, promotion prospects were limited, and following the introduction of the typewriter modern women were entering the office place. Thornton sees the new penmanship of the end of the century, Palmer's penmanship, as a reassertion of male muscularity. It 'joins the many phenomena,' she writes, 'from the cycling craze to Susa marches, identified by the historian John Higham as symptomatic of the 1890s mania for masculine vigour and activity. That mania has in turn been linked with a crisis of gender identity that first arose in the same decade.'[219]

Palmer rejected will power and character formation, or any 'philosophical line of thought' in the development of good writing, for the simple power of repetitive movement to shape the letters. The arm was held fixed, writing came from the shoulder, practice sessions began with movement drills and the pen was kept in constant motion even between strokes when the pen should circle in the air; the writing must become unquestioning, an automatic unthinking mechanical response.

Palmer's system, developed in the 1880s, took off after the publication of the first of many books, *Palmer's Guide to Business Writing*, in 1894. By 1928 three-quarters of all American schoolchildren were learning by his methods.

The telegraph

In the 1860s another strand was woven into the fabric of the Victorian communication system – the telegraph. This was the first system to rival writing in the long-distance transmission of information. An overland connection was established from the east to west coasts of the United States in 1861. In 1866 the first commercially viable cable was laid across the Atlantic Ocean.

From *tele* (far) and *graphein* (writing), the meaning of the word goes back to the Greeks. The historian Polybius describes a system in 150 BC;

two torches can be used to indicate the position of a letter in a five by five square. Complex messages could be sent optically over a considerable distance. Ships had long signalled using flags; the first instructions on signalling in the Royal Navy date back to those issued by the Duke of York, the future James II, in 1673. Optical telegraphy, using towers with signalling arms and pivoting shutters, was developed by both the French and the British during the Napoleonic wars. With towers every 30 kilometres (20 miles) and using telescopes, messages could be sent from the Admiralty buildings on the banks of the Thames in London to the Royal Navy's Portsmouth base in just five minutes. It was a great improvement on the linked chain of fire beacons that had warned of the approach of the Spanish Armada in 1588.

Experiments had begun with electrical telegraphy in the 1830s. It was the electrical nature of the system that in the long term would prove significant, laying the basis for the global systems of communication we enjoy today. Carl Freidrich Gauss (1777–1855) and Wilhelm Weber (1804–91) built the first line for regular communication; just 1 kilometre long, it connected the observatory at Göttingen with the nearby Institute for Physics. In 1837 William Fothergill Cooke (1806–79) and Charles Wheatstone (1802–75) patented a system in England. They installed the first 13½ miles of cable for the Great Western Railway in 1839; the cable ran alongside the track between Paddington and West Drayton stations and eventually extended to Bristol.

Also in 1837, Samuel Morse (1791–1872) and his assistant Alfred Vail (1807–59) patented an electric telegraph system in the United States. The code that Morse developed would eventually become the standard method for communication, and was simplicity itself; by depressing a lever to complete a circuit a series of short dots or longer 'dashes' (the time it would have taken to make three dots) could be used to represent the letters of the alphabet. Initially the machines printed the code out on strips of paper, but soon operators realized they could read the message simply from the sounds that the machines made.

During the 1870s the telegraph network expanded further. A connection from Britain to India was established in 1870 and to Australia in 1872. A complete encirclement of the globe was finally made in 1902 with the

laying of a Pacific cable. Meanwhile in 1896 the young Italian Guglielmo Marconi (1874–1937) had begun experiments with radio telegraphy. In 1901 a message was successfully sent across the Atlantic from Poldhu, on the Lizard peninsula in Cornwall, to Signal Hill in St John's, Newfoundland.

So by the late Victorian period a combination of national postal and telegram services connected by railroads, ocean liners and cables had become a global system of communication – some would say a forerunner to the internet. By the early 1900s a message travelling from New Zealand to Britain, which once took seven or eight weeks to make the voyage, could be sent via telegraph through the undersea Pacific cable to Canada, then by an overland route to Halifax, Novia Scotia, where it was transmitted across the Atlantic to London; it arrived in a matter of minutes in the central telegraph room of the British Post Office. Situated in the shadow of St Paul's Cathedral, the building, whose construction had begun in 1874, had vast galleries arranged by region and linked by five miles of pneumatic message tube; this centre processed all the telegrams sent in and through the country. By the late 1920s it was handling over 1.5 million telegrams a week.

Storage

Whilst the quantity of written and printed material continued to expand, the storage systems for office paperwork had remained largely unchanged since the late Middle Ages. Early photographs of nineteenth-century offices show pigeon-holes bulging with papers and desks covered with apparently chaotic piles of documents. To accommodate this overflow of paper, desks were made with more compartments. Abraham Lincoln's desk in Springfield, Illinois, had no fewer than forty pigeon-holes and ten tall thin compartments ranged along its back like a kitchen dresser. The 'Wooten Cabinet Secretary', patented in 1874, was the ultimate in 70s office furniture: it had wings that could open on either side of the main desk containing eighty additional pigeon-holes – one proud owner was the industrial magnate John D. Rockefeller.

Clerks, who mostly still worked standing at upright desks, tried to keep tabs on incoming letters by pasting them into books or folding

them into pigeon-holes. Then in the 1870s the box file and the flat file were invented. Flat files could be built into large chests of drawers, and letters filed unfolded and without the need to abstract them. But there were still some inconveniences: to find a letter one had to lift the entire pile out of the drawer and sort through it. If drawers were too full the papers were easily caught, torn or crumpled as they were opened and closed.

The man who finally brought order to this decades-long nightmare was a librarian, Melvil Dewey. In a spirit of tidiness and economy Dewey had shortened his name from Melville to Melvil because he thought the final 'le' a waste of space (he is also responsible for the American spelling of 'thru'). Melvil Dewey's obsessive-compulsive nature, a problem to himself and those around him, was nonetheless gainfully employed in devising a system for storing documents with the minimum waste of space; the filing cabinet with hanging files was his invention and first appeared in the catalogue of his company the Library Bureau in 1900.[220]

The library problem

Books too were proliferating. The accessibility of books in a library of substantial size had been a problem since classical antiquity. In the library of Alexandria, founded around 295 BCE, the first director, Zenodotos, had arranged its 490,000 scrolls in categories originally derived from Aristotle. Rooms and shelf space were allocated to each topic, and within topics the scrolls were arranged in alphabetical order. Callimachus of Cyrene supplied a catalogue. It was based upon his *Pinakes*, a list of Greek authors and their works in 120 volumes divided into categories of prose and poetry. Using tables of authors and their works from the *Pinakes* he then cross-referenced the works to a shelf list. This system of arrangement by designating a specific room or shelf for particular works would continue right down into the nineteenth century. In London, when the library in the British Museum first opened its doors on 15 January 1759 its books were arranged as they had been in the libraries of the two founding collections, that of Sir Robert Cotton and the Earls of Oxford. Cotton's library had had shelves topped by the busts of different Roman

emperors – calling to mind the statues of Roman authors in the library Asinius Pollio built in Rome in 27 BCE. The Lindisfarne Gospels, which had formed part of Cotton's bequest to the Museum, were catalogued then, and still are, as Cotton MS Nero D, iv, meaning that the manuscript could be found in the bookcase crowned with Nero's portrait, shelf D, fourth book along.

Clearly finding a book in a library building as vast as those that a significant collection now required was going to be problematic, not only because of the number of books it contained but also because the lack of distinguishing features in larger buildings made precise navigation much more difficult. In some ways the problem of finding a book at this point in history was rather like finding your way around a city before there were specific road names and house numbers – you steered by local landmarks. In fifteenth century London, Caxton's press advertised itself as 'in Westminster, in the almonry' at 'the sign of the Red pale' (a heraldic sign of a red stripe on a white shield). Directions to specific places were finally made easier in Britain by the Stamp Act of 1769, which required every house in particular streets in a town or city to be given a number. The library problem was eventually resolved in 1876 by a similar numerical solution – and it was also Melvil Dewey who came up with the answer. It was the work that made his name and fortune. Dewey's decimal system took its underlying structure from an influential classification of human knowledge first developed by the English polymath Francis Bacon (1561–1626) and imposed upon it ten basic categories. The subsequent subdivision of classes eventually led to a unique designation for each book (once letters for authors or titles were added), which gave the system an appealing simplicity. As the library grew or changed, no re-cataloguing was necessary other than to add new books into the system.

The music of handwriting: a revelation

Many of the changes that the written word witnessed in the nineteenth century had been the result of improvements in technology and its better organization at an institutional level, leading in turn to better printing,

transport and communication systems, and more methodical office procedures and library systems. Education too had been reformed and handwriting schemes organized for use in public and business schools; one-to-one tuition with a writing master became less common. Amidst the many pressures towards uniformity that these changes created, the identity of the individual writer and their personal relationship to their own handwriting was a point of tension. A search for the personal and 'authentic' in handwriting became inevitable when the nineteenth century saw the rise of the Romantic movement, which valued individual experience and feeling with effects on music, literature, art and architecture. Yet it was slow to affect teaching methods or handwriting systems (with the exception of Spencerian). Rather the yearning for individual liberty and originality revealed itself towards handwriting in a new reading of the meaning that the lines carried. Handwriting came to be understood as the product of a flow of energy that poured forth from the unknown depths of nature, revealing the hidden qualities of unique human beings.

It was in the late sixteenth century that people had begun to collect signatures and writings from their friends; the trend seems to have begun in universities in Germany and the Low Countries. These 'Books of Friends' (*alba amicorum*), sometimes made from blank sheets, sometimes interleaved into printed books, were a testament to one's connections. They are reminiscent of the personal prayers written into Books of Hours that were solicited from courtiers and royalty in England during the time of the early Tudors. But now the writing is more extensive and secular. 'Books of Friends' enclosed letters of recommendation from teachers and classmates, and also drawings, heraldry and, later, items such as locks of hair and pressed plants. Charles I of England was a particularly avid collector. Today's guest books are perhaps the closest modern parallel.

But by the end of the eighteenth century, in Europe and North America, autographic manuscripts were being sought for an additional reason: they were understood to carry an aura of personal presence. In 1788, as William Blake issued the first of his relief etchings to incorporate

writing (*All Religions are One* and the twenty plates for *There is No Natural Religion*), just five minutes' walk away from Blake's Poland Street home, at his shop in Rupert Street, John Thane (1748–1818) published his *British Autography, a collection of the Facsimiles of Royal and Illustrious Personages with their Authentic Portraits*. Thane, a major dealer in coins, drawings and prints, showed the portraits of 269 persons above examples of their handwriting and signatures, as if this too was a portrait of the famous person. In the German-speaking world, parallel developments were taking place; literature too was being read in a new way – as a window on to the inner spirit of the author. 'Where it is worth the trouble,' wrote the philosopher Johann Gottfried Herder in 1778, 'this *living* reading, this divination into the soul of the author, is the *sole* mode of reading, and the most profound means of self development.'[221]

A reaction to the rationalism of the age of Enlightenment was setting in – Rousseau had been its harbinger: overlooked aspects of human experience were re-examined. 'Nature' was no longer seen as passive material to be dissected and pulled apart but animate, a nurturing yet awesome force. Landscapes, previously ignored as unsophisticated wilderness – the highlands and islands of Scotland, the mountains of Wales, the Rhine valley and the Swiss Alps – had become 'destinations'. The musical genius of Beethoven, Berlioz, Brahms, Rossini were being celebrated. 'Music reveals to man an unknown realm,' wrote E. T. A. Hoffman, the composer and writer who was a contemporary of Beethoven, 'a world quite separate from the outer sensual world surrounding him. A world in which he leaves behind all feelings circumscribed by intellect in order to embrace the inexpressible.'[222]

Handwriting was now re-envisioned as part of this larger cultural shift. Handwriting too was a landscape re-enchanted. And it was the signature – its wildest, most personal and least calculated outrush – that was most admired (Fig. 53).

It is difficult to know exactly when signatures became the focus for serious study and admiration, but it was probably in the earliest years of the nineteenth century. When Lavater's work (p. 202) was translated in 1806 by Dr Jacques-Louis Moreau, a professor at the Paris medical school, Moreau expanded the section on handwriting. From an English

author, John Holt Schooling, writing in 1892, we gather 'from M. Moreau's observations that graphology was seriously practiced by a few men, starting from the year 1806'.[223]

In 1812, in Paris, the Belgian translator of Lavater's work, Edouard Hocquart, publishes *L'Art de juger de l'esprit et du caractère des hommes et des femmes, sur leur écriture* (*The Art of Judging the Mind and Character of Men and Women from their Handwriting*). It is the first substantial work since Lavater's publication in the 1770s to deal with the subject, and it is illustrated by the signatures of twenty-four famous men and women.

Fig. 53. Napoleon's evolving signature. Plate originally published in John Schooling, *Handwriting and Expression*, 1892.

The Englishman Sir Thomas Phillips (1792–1872) claimed that it was he who was the first collector of autographs* – beginning soon after being sent to school at Harrow in 1807. At his death his collection was so large that it took up to fifty years to disperse. Yet William Upcott (1779–1845), bookseller and librarian of the London Institute, must have begun collecting at about the same time, if not earlier – he had a head start, having already been left a collection of letters from his father's correspondence. His residence in Islington became known as 'autograph cottage', filled as it was with manuscripts, prints and drawings; on his death 32,000 autograph manuscripts were sold, which reside today in the Bodleian and British Museums. American collectors built similarly large collections. William B. Sprague (1795–1876) of Albany, New York, had over 30,000 autographic manuscripts in his collection. He had begun collecting in 1814 with a letter in the hand of George Washington, given to him by his employers, Major and Mrs Lawrence Lewis; Mrs Lewis had been Washington's adopted daughter.

In 1816 Hocquart had published the second edition of his book, making an important change to the analysis of mind that the book enshrined. Instead of the traditional four humours, suggested by Lavater, Hocquart now proposed just two qualities, 'energy and imagination'. With energy and imagination an individual could *feel* and *experience* the consequences of their condition and they could act anew; these were the forces that empowered the romantic vision. It was for instance the *feelings* and *acts of imagination* caused by the great landscapes of the Alps that made them romantic, their elevating loftiness, their terrifying depths.[224] It was the feelings also that Beethoven's music set up that made *it* romantic: 'Beethoven's music sets in the machinery of awe, of fear, of terror, of pain, and awakens that infinite yearning which is the essence of romanticism,' wrote E. T. A. Hoffmann when reviewing a performance of the fifth symphony in 1810 for the *General Musical Review* of Leipzig.[225]

* Coincidentally a note to such effect appears in the *Corsair* for 28 September 1839, immediately below the news of the first telegraph in operation between Paddington and West Drayton.

With handwriting envisioned as the product of energy and imagination then, as the journalist Thomas Byerley writes in 1823 'a man [using a pen] acts unconsciously, as the current of his blood impels him; and there, at all times, nature flows unrestrained and free'.[226] A mature handwriting has come to be perceived as unique, something over which the person themselves now lacks control in an important respect. There can be no deception, only a revelation of character. Such written gestures, in Hocquart's words, 'carry the imprint of truth', for they pour forth from nature itself and its unknowable depth within each of us.

The first record in London to include a sale of autographs (meaning personal papers as well as signatures) can be found in the 1820 catalogue of Thomas Thorpe, one of the many booksellers along the Strand. By the 1830s his catalogues have regular notices of such items, and at least one New York paper is recording that autograph collection and inspection is all the rage.* But it is not until the mid-1870s that handwriting and character receives a respectable cloaking of science.

In 1875, after nearly thirty years of interest in the subject, the Abbé Jean-Hippolyte Michon (1806–81) published his *Système de graphologie*[227] in Paris, followed in 1878 by *Méthode pratique de graphologie*.[228] Whilst the Swiss physiognomist Lavater had written about the relationship between character, handwriting and gesture in the later part of the eighteenth century, he had never come up with any systematic analysis. But Michon, having been disappointed in his championing of modernism in the Roman Catholic Church, turned to handwriting analysis as a new field of 'scientific' endeavour. He it was who first coined the term 'graphology' and rediscovered the lost seventeenth-century work of Camillo Baldi in a translation by Petrus Vellius in the medical school at Montpellier in 1875. He wanted to elevate graphology 'from the level of intuitive guesswork or foolish divination to a rational basis of careful examination and comparison of actual data'.[229] For all his empiricism,

* In September 1829 the *New York Mirror* reported: 'there is indeed a sort of rage for the inspection and accumulation of autographs, and those who have a high opinion of their own acuteness pretend that they can form a just opinion of a person's character from such an examination.' *New York Mirror*, 7:10 (12 September 1829), 75.

he nonetheless expressed the underlying premise of his theories in thoroughly romantic terms: 'When the child, the adolescent or the adult who has been instructed in calligraphy, enters into spontaneous and free life and wants to express his thoughts and feelings towards other people quickly, without effort, without study, without being concerned in the least about forming the letters well or badly, he instinctively abandons his habits of calligraphy and shifts to a writing with unique characteristics...'[230]

It is interesting that it is here, in spontaneous handwriting rather than in fully developed calligraphy (as in the Orient), that a nineteenth-century European intellectual expects to find an authentic expression of individuality. This development will make gestural movement a field for exploration by European and North American artists in the following century.

In the meantime graphological gestures were subjected to a rigorous analysis by Michon's follower Jules Crépieux-Jamin (1859–1940), whose book *L'écriture et le caractère* was published in 1888. In the words of his English translator, John Holt Schooling, Crépieux-Jamin's work emphasized 'the relative value of graphological signs as contrasted with the absolute significance which used to be given to them'.[231] Nonetheless his table of 180 'General and Particular Graphologic Signs' contains some fairly specific guidance, even though the accompanying note commends the reader to the spirit of the analysis rather than seeing it as an absolute code (Fig. 54).[232] Of signatures he writes: followed by a dot – prudence; followed by a line accompanied by a dot – distrust; with a straight line underneath – pride of name; with a curved line underneath – self-complacence; with a flourished stroke from right to left – defensiveness (his illustration on page 88 is of Emile Zola's signature). His work was translated into Danish, Italian and English, but it was in the German-speaking world that it had its greatest impact and it is from there that the next generation of European graphologists would come.

Back in England in the 1830s the attitude to handwriting was rather different. The contrast between the English and French legal systems is revealing. Far from accepting expert comparisons of script as in France

| Graphologic Sign. | Ordinary Significance. | Significance more specially relating to a state of personal— | | Accompanying and Accessory Significance. |
		Superiority.	Inferiority.	
Dots—				
varying in emphasis	Animation			
placed very high	Religious spirit			Mysticism (?)
placed in advance of the letter	Spontaneity			Initiative faculty, vivacity.
placed behind the letter	Want of ardour			
very slight	Delicacy	Delicacy	Weakness	Timidity.
emphasized	Materiality			Firmness.
placed after the signature	Prudence	Prudence	Distrust	
placed frequently where not needed	Constraint in breathing, obesity			
placed where not needed, but light and scattered (fig. 126)	Constraint in breathing			Asthma, shortness of breath.
placed where not needed at the commencement of sentences	Hesitation			A fastidious choice of words.
Mis-use—				
of notes of exclamation, of interrogation, of suspension	Exaggeratio	Enthusiasm	Want of judgment	Imagination, exaltation, madness.
Frequent underlining	Exaggeration	Enthusiasm	Want of judgment	Imagination, exaltation, madness.
Margins—				
absent	Want of taste			Economy.
regular	Taste			
at both sides of the writing	Delicate taste			Artistic feeling.
Signature—				
with no addition (fig. 30)	Simplicity	Pride	Insignificance	

Fig. 54. Section of table in John Schooling, *Handwriting and Expression*, 1892.

(the country was after all the home of Mabillon as well as of graphology), in the English courts the evidence of 'experts' was frequently discounted. The prevailing opinion was best summed up by Justice John Taylor Coleridge (nephew of the poet) in a landmark judgment of 1836 still referenced in cases today. In his judgment on *Doe v. Suckermore* he wrote: 'The test of genuineness ought to be the resemblance, not to the formation of letters in some other specimen or specimens, but to the general character of writing, which is impressed on it as the involuntary and unconscious result of constitution, habit, or other permanent cause, and is therefore itself permanent. And we best acquire a knowledge of this character, by seeing the individual writing at times when his manner of writing is not in question, or by engaging with him in correspondence; either supposition giving reason to believe that he writes at the time, not constrainedly, but in his natural manner.'[233] This form of proof may seem counter-intuitive to us today, who tend to think of writing as a primarily visual phenomenon – the marks on the page. Handwriting is being understood as craftsmanship, as the product of a performance.

But here the judgment was that we would be able to identify someone's writing, their 'work', if we have seen them *at* work; our impression of their writing is thus formed by watching how they approached the task. In watching someone write we tie together aspects of letter shape, ink

flow, joins between forms, with the moment-by-moment adjustments that we always witness a writer making as they write. First, as they settle to the task, choosing and arranging the paper, checking the pen nib, dipping it into the ink, hurriedly or with absorbed concentration, and then watching how the writer makes that initial contact with the page and gets the ink to flow. The task is like sawing a plank of wood. The experience of the craftsman unfolds with a particular rhythm of pressures and adjustments, of sounds and variations of speed between up and down strokes, with confidence or nervousness – all of this is taken in by the person who watches. A constant stream of minute adjustments characterizes the performance of any skilled movement.[234] The English legal judgment speaks from craftsman to craftsperson. And perhaps this mindset is one of the contributing reasons to why the English response to the depersonalization with which the Industrial Revolution threatened the world of the printed and handwritten word was a response primarily made at the level of craftsmanship. It was by renewing engagement with the making process at a deeper level that people in the British Isles formulated their own response to the many changes the nineteenth century wrought on the world of the written word.

Revolutions – in Art and Print

Fig. 55. Wooden type for poster printing. Edward Johnston's
London Underground Railway type with roundel logo.

In London, on the evening of 15 November 1888, a talk on 'Letterpress Printing and Illustration' was presented at the New Gallery, 121 Regent Street. The speaker was Emery Walker, the owner of a photographic engraving company. The event formed part of a programme coinciding with the first exhibition of the Arts and Crafts Exhibition Society. The gallery had opened earlier that year, showing the works of Pre-Raphaelite artists. On this evening, lit by electric light, it stayed open until 11 p.m. so that people could enjoy the show. Oscar Wilde was present at the lecture and wrote next morning in the *Pall Mall Gazette*:

> Nothing could have been better than Mr. Emery Walker's lecture... A series of most interesting specimens of old printed books and manuscripts were displayed on the screen by means of the magic lantern, and Mr. Walker's explanations were as clear and simple as his suggestions were admirable...he pointed out the intimate connection between printing and handwriting.

Walker's professional involvement with photography meant that he had been able to photograph enlarged examples of early typography and focus on the detail of their design. For some of his illustrations he had drawn on the library of his friend William Morris.

The book beautiful

Morris (1834–96), one of the founding influences of the British Arts and Crafts movement, had taken an interest in writing and illuminating since his student days at Oxford, where he had begun a lifelong practice of writing out manuscript books. His philosophy of life was influenced by John Ruskin (1819–1900) and Thomas Carlyle (1795–1881), who were the mouthpieces for a movement which, from its first beginnings, had harboured serious misgivings about the impact of industrialization on Britain. They objected not only to the 'ravaging' of the countryside, the

growth of industrial cities and miserable conditions of work, but to the way the division of labour was affecting 'man' himself.

> We have much studied and much perfected, of late, the great civilized invention of the division of labour; only we give it a false name. It is not, truly speaking, the labour that is divided; but the men: – Divided into segments of men – broken into small fragments and crumbs of life; so that all the little piece of intelligence that is left in a man is not enough to make a pin, or a nail, but exhausts itself in making the point of a pin or the head of a nail.[235]

Ruskin felt that a person could no longer exercise his full humanity at work – head, heart and hand together. In the industrialized system work was no longer a calling to fulfil one's nature, a vocation (or so they idealized), since conditions now made it impossible for the individual workers to follow their own conscience in the work they undertook. The labourer had become a factory 'hand', deprived of responsibility and the opportunity to exercise his full natural intelligence. For Morris the making of a book by hand was a statement that joy in labour was worth pursuing for its own sake; here was a creative process that reunited designing and making in one revolutionary act – however nostalgic its forms might appear.

By the late 1870s Morris's calligraphy had achieved a remarkable standard. His early efforts had been guided by the copybook he owned containing original editions of such Renaissance masterpieces as Arrighi's *Operina* and *Il modo tempore le penne*, Tagliente's *Lo presente* and Sigismundo Fanti's *Thesauro de Scrittori*. During his 1888 talk Walker showed a page of Arrighi's work, and Wilde records that this sample of italic calligraphy was greeted by a spontaneous round of applause. Walker's message was that it was time to re-evaluate book production and design, for, in Morris's words, 'a work of utility might also be a work of art, if we cared to make it so'. Walker's slides emphasized that the standards of early book production were such as they were because they were still connected to a living tradition of handwritten books whose calligraphy generated 'ever living and fluent prototypes'[236] for the development of new letterforms.

Walker's lecture proved to be a turning point. On the walk home from Central London to Hammersmith, enthused by all he had seen and heard, Morris turned to Walker and said, 'We must make a type.' From this small beginning stemmed the Kelmscott Press. Morris's involvement with the world of printing would last until his death eight years later in 1896. When the Hammersmith-based press finally closed its doors in 1898 it had published fifty-three titles in sixty-nine printed volumes.

The first type designed for the Kelmscott Press was 'the Golden Type'. It was created by drawing from photographic enlargements (five times actual size) of fifteenth-century Venetian printing. Morris had bought two books to study in detail, a *Pliny* of 1476 printed by Nicolas Jenson, and Leonard of Arezzo's *Historia Fiorentina*, printed by Jacobus Rubeus, also in 1476 in Venice.[237] Later enlargements of types from both books also provided the model for the type designed for the Doves Press, established in 1900 by Emery Walker and T. J. Cobden-Sanderson.[238] The Doves Press's minimalist, rational typography, cleanly set with spacious margins, confirmed that book production was set on a new course for the twentieth century. Cobden-Sanderson's aim was to produce books that were beautiful 'by the simple arrangement of the whole Book, as a whole, with due regard to its parts and to the emphasis of its capital divisions rather than by the addition and splendour of applied ornament'.[239] Beauty came from the type itself and its arrangement, an approach subsequently adopted by many in the private press movement during the early twentieth century. By contrast Morris's books, which had crowded pages and heavy marginal decoration, had little stylistic impact beyond his own time. But together the Kelmscott and Doves presses were responsible for establishing a new tradition of fine private press editions which was highly influential in the English- and German-speaking worlds down to the beginning of the Second World War.

A calligraphic revival

For calligraphers the implication of the stance Walker outlined in his 1888 lecture was daunting. 'It is the function of the calligrapher to revive and restore the craft of the Printer to its original purity of intention and

accomplishment. The Printer must at the same time be a Calligrapher, or in touch with him,' wrote Walker's partner T. J. Cobden-Sanderson.[240] But where were those calligraphers to come from? Other than Morris, the last calligrapher in Britain to be involved seriously with the design of type was John Baskerville of Birmingham in the eighteenth century.

The few calligraphers who existed in England in the late nineteenth century were not well suited to taking up Emery Walker's challenge; on the whole they looked backwards to the medieval world. By the mid-nineteenth century A. W. N. Pugin's publication of a *Glossary of Ecclesiastical Ornament* (1844) had substantially changed the kind of ornamental lettering that engaged the public's interest. Men like Owen Jones and Henry Shaw, stimulated by the rise of interest in all things gothic, reproduced hand-drawn letters in imitation of medieval manuscripts. Ruskin was an avid collector of medieval initials: 'cut up missal last night – hard work' he recorded in his journal for 3 January 1853.[241] In the early 1860s Messers W. & G. Audsley published their *Guide to the Art of Illuminating and Missal Painting*. 'Owing to the rapidly increasing love for the beautiful art of Illumination, and the devotion with which it is being studied throughout the length and breadth of our land, no apology is required for the appearance of this littler volume,' they stated in the Preface. By the 1890s the book was in its nineteenth edition.

Edward Johnston

What Emery Walker could not have known on that dark evening in November 1888 was that less than a mile away from the lecture hall, at 25 Regents Park Road, lived a sixteen-year-old boy who had been educated entirely at home, of apparently fragile health and inclined more to the sciences than the arts. He would become the man to answer Walker's call for a revival in the art of calligraphy, and he *would* have a dramatic effect on many aspects of the written word in the twentieth century.

For his sixteenth birthday, on 11 February that year, Edward Johnston had been given the Reverend William Loftie's *Lessons in the Art of Illuminating* by his mother.[242] Her intention was to encourage the creative streak in her son that had revealed itself in the form of sensitive drawings

and small illustrated books, made for his much-loved sister Ada. These books included poems written by Edward, and paintings of cats dining on lobster, and Rackhamesque faeries in battle. Aided by his birthday present, Edward now embarked on a new venture, the making of illuminated texts as gifts for family and friends. He called them his 'scriggles' and 'parchments'.

Both Edward and his brother Miles went on to study medicine at Edinburgh, but Edward found the course tough going. In 1898, following advice from the family that he would find the demands on his health too great if he continued his studies to be a doctor, it was with a sense of relief and excitement that he resolved to follow his own instincts and 'go in for art'.

On 4 April 1898 Johnston arrived in London from Edinburgh to make a new start. He was to spend the summer taking a journey with a cousin across the United States to Canada before settling down to his new life in the autumn; he had three weeks to prepare for the great expedition. Scarcely had he got off the overnight train and arrived at his lodgings in Bloomsbury than he was introduced to Harry Cowlishaw, an architect who was also one of the best of the new breed of illuminators. 'Lethaby is the man you want,' he replied, when Johnston asked for his advice on how to progress his career, and immediately arranged for the two of them to call on him. W. R. Lethaby was a notable architect and the new principal of the Central School of Arts and Crafts. 'What branch of art do you intend to go in for?' he asked Johnston. Johnston thought he ought to go to an art school and learn to draw. 'Lethaby leaned back in his chair and closed his eyes,' wrote Johnston's daughter later. '"Learning to draw! Learning to draw! Thousands of young men and women – learning to draw!" He urged Johnston to give up these vague ideas and specialize in a line of his own, a craft for instance – he suggested bookbinding or silversmithing.'[243] Next day Johnston called on Lethaby for a second time to show him the 'parchments' he had been making. 'You will do very beautiful work if you stick to it,' Lethaby pronounced, and there and then commissioned Johnston to illuminate a manuscript for him. What Johnston did not know was that for ten years now, ever since Walker's original lecture of 1888, the Arts and Crafts movement had

been waiting for someone such as him. Lethaby, with typical prescience, had recognized that he had finally found his man.

When Johnston next called, to present the finished commission – 'Over the sea our galleys went' from Browning's *Paracelsus* – just before he left on that summer's journey to the Pacific north-west, Lethaby was delighted. And he had a surprise for Johnston. He was starting a class in illumination next autumn at the Central School. 'If all's well, I shall put you in charge of it.' Johnston was bowled over: he had been hoping simply to join the class, not to lead it. He objected that he 'knew nothing'. 'That is for the hirer to judge,' was Lethaby's reply.

On Johnston's return from North America in the autumn of 1898 he began to make a serious study of manuscripts in the British Museum. The class, for administrative reasons, was delayed by a year, and in early October, again thanks to Lethaby, Johnston was shown around the Museum's manuscript collection by Sydney Cockerell, who had been William Morris's secretary. At dinner in Richmond he showed Johnston Morris's calligraphy, his printed books and the manuscripts he had looked at. This gave Johnston's work direction; as he looked at the flow of styles down the ages he came to realize there was a central core, 'a golden thread', as the contemporary calligrapher Sheila Waters has called it. Here was a stream of influences down which he was floating, and if he stuck to the central channel of this tradition he could not go wrong; all that he did or looked at would contribute to the present. His great discovery, after an age where handwriting had been largely made using pens with pointed nibs, was that the square-edged pen was responsible for the design of nearly all the shapes that ran down the central channel of letterforms from Roman times to the Renaissance. This pen naturally made the thick and thin parts of a letter as it was moved around a letter shape; there was no pressure on the nib involved and no filling in; the correct shading arrived naturally, in the traditional places as the nib wrote. For Johnston it was a revelation.

During the autumn of 1898 and the spring of 1899 Johnston came to understand some crucial technical relationships that no western calligrapher had articulated before with such clarity. Weight in a letter's shape, where the thicks and thins are distributed around its form, is determined

by the angle at which the pen's nib is held to the line on which the letters are arranged. A flat pen angle, approaching zero, gives thin horizontals and thick vertical strokes. A slanted pen takes weight away from the verticals and as the slant increases the nib starts adding more and more weight to the horizontals. By changing the angle Johnston could come close to reproducing the different varieties of penmanship that he was studying, from roman and rustic capitals to insular half-uncial and italic scripts (Fig. 56).

The amount of weight in a letter could be roughly measured by the number of times the width of the nib went into the height of the letter. This proportion was also vital to recapturing the look of a letter, for a heavy-weight letter tended to have sharp contrasts between thick and thin and inside counter shapes that were angular, light-weight letters tended to have smoother curves and gentler transitions from thick to thin parts. Having understood the formative characteristics of letter weight and pen angle, Johnston then came to appreciate that within the

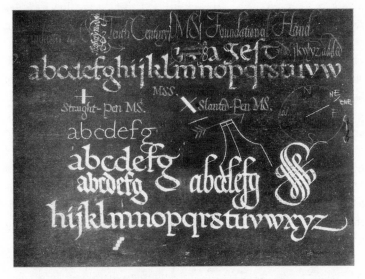

Fig. 56. Johnston developed blackboard demonstrations when teaching large classes at the Royal College of Art. Here we see a variety of hands demonstrated in a lecture on 4 October 1926.

tradition's central core the alphabet was not seen as an unrelated collection of twenty-six completely different forms, but these letters had been understood as a system of *related forms* with certain constancies running through different families of letter shapes. For instance the particular curve of an **O** was reflected in most of the other curved letters. The lead-in strokes to letters shared a common method of introduction. His interest was shifting inexorably from illumination to penmanship.

Johnston would in fact spend the rest of his life articulating how the formal qualities of the pen's broad-edged nib could be used to describe, relate, suggest and generate letterforms. He came to have an almost mystical understanding of the philosophy that lay behind his forms. The generative aspects of weight, angle and form were paired with his 'essential qualities' of Sharpness (meaning explicit form), Unity and Freedom, which Johnston read back into a Trinitarian reflection on the original unity underlying creation (Fig. 57).

When Lethaby became Professor of Design at the Royal College of Art, Johnston added classes at the college to those he already ran at the Central School and so his ideas spread. They had a particular resonance in Germany, where his handbook, commissioned by Lethaby for his

Fig. 57. Johnston's crisp calligraphy with a quill pen (1923), notice the curled spring inside the pen made so that it can hold more ink.

series on technical and artistic crafts, was translated into German in 1909 by his student Anna Simons. This handbook, *Writing & Illuminating, & Lettering* of 1906, carried Johnston's teaching beyond the small circle of people he could teach directly. One of the unique aspects of the book was that it used photographic plates – produced with the help and advice of the now ubiquitous Emery Walker. This was perhaps the first time in the history of western writing that ordinary students of penmanship could see accurate reproductions of a full sequence of historical manuscript writing in one place.

Photography made possible a calligraphic revival with historical roots, just as it had also enabled Morris to pioneer the redesign of a typeface (and office workers, at the end of the nineteenth century, to discover new ways of copying documents). This alliance between photography and calligraphy was significant: no longer spread through the medium of woodcuts, rubbings, drawings and engravings – all of which introduced their own shading to the forms – original works were now widely accessible for accurate comparison and study.

Writing & Illuminating, & Lettering proved a formative book because it was the first to cover the whole field of the lettering arts. With calligraphy at its core it nonetheless showed how an understanding of calligraphic form, and Johnston's own method of study and analysis, could be transferred into illumination, printing, engraving and the cutting of letters in stone. In effect Johnston had relocated where the knowledge about letters was held. Having been fragmented across a number of professions (the palaeographer, sign-writer, clerk and notary, teacher, printer, the stone-carver, engraver, penman and architect), it was now brought together within the covers of one book. When placed in the creative context of the art school, as it was by Johnston's teaching at the Royal College of Art, this unified vision of previously isolated elements triggered a resurgence of interest in writing, illuminating and lettering as a subject. *Writing & Illuminating, & Lettering* has remained continuously in print ever since 1906, though we should note that *Formal Penmanship and other Papers*, which expressed Johnston's most developed understanding of penmanship, was published only posthumously, as late as 1971.

Having begun his teaching career employing as his basic instructional hand William Morris's favourite script, the insular half-uncial as seen in the Lindisfarne Gospels, around 1908 Johnston made a switch to a new 'foundational hand'. He chose as his calligraphic model the writing of the tenth-century English scribe who had written *The Ramsey Psalter* (BL Ms Harley 2904), a manuscript shown to him years before by Sydney Cockerell. In searching for a lower-case that resembled the standard of legibility that type had set, Johnston could have looked at fifteenth-century Italian manuscripts, or at those of the twelfth, but he chose the Anglo-Saxon Carolingian forms because the letters were more straightforward to write, closely related to each other in shape and requiring less manipulation of the pen angle when writing. The simplicity of this particular hand should not be surprising, for, as we have seen, it was developed in England from continental exemplars just after the Danish invasions and during a period of enthusiastic monastic renewal, when a considerable number of people were rediscovering how to write and make books.

Johnston and handwriting reform

Johnston's basic method for lessons in the foundations of calligraphy was also influential in the area of handwriting reform. Though he himself had a lifelong reluctance to prescribe any particular kind of writing, he wrote a report for the London County Council in 1906. His approach seems wildly impractical until we remember he was self-educated; he recommended retracing the evolution of the roman letterform, starting with capitals on wax tablets and following their transformation into lower-case forms, then, using a broad-edged pen – either quills, metal nibs or fountain pens – trying to write a basic print script that could mature into a running hand. He recommended that students worked from photographic copybooks rather than books that were engraved, as this showed the writing more directly. His ideas were not sympathetically received, but in 1911 and again in 1913 he spoke to audiences of parents and teachers on 'Teaching Handwriting as Penmanship' and in that same year – and probably much to his surprise – the LCC announced the adoption of a handwriting system they called 'print script'.

Johnston's basic ideas had been picked up by the new educationalists who were coming to understand the child in a different way. Educational theorists were beginning to reconceptualize children as human beings undergoing a developmental process, rather than regarding them as 'little adults' who must be quickly instilled with adult virtues. According to this view, children could not be expected to form adult handwriting, since their neuro-muscular and cognitive development was not yet complete. Handwriting was seen as providing a means of expression for emerging individuality, rather than as a physical exercise in conformity. It was in this developmental context that Johnston's ideas were looked upon more favourably. In essence he was recommending that the child retrace the evolutionary path of European letterforms in their own development as writers. In the new LCC system learners began with simply written capitals and moved on to individually written lower-case roman letterforms. Over time the child was expected to find ways of joining up these letters and then their unique script would emerge. The most interesting scheme, and the one closest to Johnston's own recommendations, was started in Leicester, where Johnston had himself given a series of lectures at the art school between 1902 and 1907 and where he had met local Inspectors of Education to discuss concerns over handwriting reform as early as 1907. The Leicester inspectors called their system 'manuscript writing' rather than 'print script'. Those students who learned via the Leicester system progressed gradually to the use of edged pens and natural joins over time, with no sudden switch to a cursive style of writing.

'Manuscript writing' was popularized in the United States following the arrival of Marjorie Wise from England to take up a post to teach handwriting instruction at Teachers College, Columbia University, in 1922.* The underlying arguments that she and others put forward for the scheme was that it was easy to teach and to learn. Not only were the simple shapes suited to the limited physiological development of the

* By 1926 she was back in England on the staff of Dartington Hall School. Her book *On the Technique of Manuscript Writing* was published in New York by Charles Scribner's Sons in 1924.

child, but it removed the necessity for arduous exercises in the elements of handwriting drill before a child could learn to form the letters; children could express themselves the moment they began to learn to write. Furthermore, the letters a child learned were clearly related to the shapes of the letters that the child was seeing in their reading classes; up to now the copperplate forms that children had learned to write looked quite different to the letter shapes children were learning to read in printed books. Stress was laid in the classroom on real tasks: children learned to write the day's date and record the weather, to order seeds for the classroom's window box, to make notices of all kinds. Manuscript writing, as Thornton succinctly puts it, had reconceived handwriting 'as a means "to tell" rather than a motor habit'. This was a completely new approach and one which is still highly influential.

Johnston and Gill: a tale of two sans-serifs

In 1913 Johnston moved his young family out of London. They settled in Ditchling, Sussex, where his student Eric Gill had established a stone-carving workshop that would prove to be the seedbed for a revival of fine letter-carving in Britain. Then in 1915 he and Gill were approached by Frank Pick of the London Electric Railway with a request for them to produce a new type for the London Underground. Gill soon dropped out and Johnston took the job over. He already had considerable experience with type, having worked from 1911 onwards designing an italic, blackletter and Greek type for use by Count Kessler's Cranach Press in Germany, and he had also designed an alphabet of capitals and many initials for T. J. Cobden-Sanderson's Doves Press. But now he was asked to design a block letter type which should combine 'the bold simplicity of the authentic lettering of the finest periods and yet belong unmistakably to the twentieth century'.[244] This was Edward Johnston's third major contribution to lettering in the twentieth century, after the calligraphic revival and the reform of handwriting. Johnston relished the challenge: it spoke to his love of lettering and interest in technical matters. His innovation was to reintroduce the systematic proportions of roman imperial capitals in the upper-case. In the lower-case, in his own words 'to combine

the greatest weight or mass with the greatest clearance of lettershape. The lowercase o is the key letter. It is circular and has a counter [internal space] twice its stem width (giving approx ideal mass and clearance).'[245] All the letters were then designed with this key relationship in mind. Johnston also reworked the London Underground logo, replacing the previous solid circle and bar design with the familiar bulls-eye logo, integrating the proportions of the symbol with the lettering on its blue plaque. Johnston's design struck a chord with the public and influenced a parallel movement towards sans-serif letters in Germany, but there were legal restrictions on the wider use of his London Underground font. Sensing an opening for a more widely available font, Stanley Morison, the type director for the Monotype Corporation, commissioned Eric Gill to come up with his version of a similar face. The resulting typeface, Gill Sans, was drawn in 1927 but not fully available until 1930. As Gill himself says in a letter to Johnston, its virtues owed everything to his earlier design, but Gill made subtle changes to quite a few letters: in the capitals the S and E became more symmetrical, the A's cross bar higher (so the internal spaces become less equivalent), the G's cross bar lower (so making the letter feel more open). The most significant change, however, was his introduction of a sans-serif italic, actually a sloped and slightly narrowed version of the roman lower-case with a radical simplification of the form in the way the bowl of b, d, p and q meet the stem. Today this type is the public face of the BBC. As Phil Baines, the Professor of Typography at Central Saint Martins, has written, Gill Sans has 'entered the nation's visual consciousness, becoming for the whole of Britain what Johnston (Sans) is for its capital city'.[246]

Morison's type revivals

The late nineteenth century had seen the development of machine type-setting using the Linotype and Monotype processes. The rivalry between the two companies was intense. One way in which they competed was by producing new designs of type for their different machines. Since the late nineteenth century, the invention of the pantographic engraving machine by the American type designer and inventor Linn Boyd Benton

in 1884 had opened up the design of types to those who could draw but not necessarily cut a punch themselves. Benton's machine could also condense, expand or slope a design. Operators worked from large-scale drawings of letters (up to one foot high). The new accessibility of this process encouraged Stanley Morison to pursue a programme of type revivals at Monotype, revisiting the great masterworks of the past and producing new versions of the classics; Garamond (1922) had already been produced before his arrival in 1923, and it was followed by Baskerville (1923), Fournier (1925) and Bembo (1929). Sensitive to criticism that he was not sponsoring new designs, types were also commissioned from contemporary designers, beginning with Eric Gill's Perpetua (1925–9).

Morison's most famous new design was Times New Roman. Elaborate technical and optical research lay behind its production: it had to be clear to read, economical of space and up to the demanding requirements of newspaper production. It went into use at *The Times* on 3 October 1932 and remains one of the most popular and versatile faces in use today.

The revival of lettering and typography as a vital means of communication in the twentieth century was not a matter left to English hands alone. During the closing years of the nineteenth century and the early years of the twentieth different groups across the continent of Europe would also play their part, and among the most significant were a new wave of artists from southern Europe, who were as different in character from Emery Walker, Morris and Johnston as it would be possible to imagine. They would provide a new kind of scaffolding for lettering in terms of line and space that would enable it to move out of the world of the book and into that of the poster and modern commercial art.

Out of the box: the Futurists

On a windy spring day in Venice, 27 April 1910, a group of young artists stormed to the top of the campanile above St Mark's Square. Shouting their manifesto to the crowds that gathered below, they threw out handfuls of the 200,000 leaflets they had prepared. Venice could rot, and Venice and its museums and libraries could moulder and sink into

slime! Burn the gondolas, for this was a new age; they were the Futurists and they proclaimed this the age of the machine, of revolution, youth, power and speed. The Futurist manifesto had first been published in an Italian newspaper more than a year earlier. Then on 20 February 1909 it had been printed on the front page of *Le Figaro* in Paris. The Futurists excelled at these interventionist actions, which generated new kinds of publicity. The movement was symptomatic of a generation that wanted to break with the past. Of typography, Filippo Marinetti, the movement's founder, wrote: 'I am against what is known as the harmony of setting. When necessary, we shall use three or four columns to a page and twenty different typefaces. We shall represent *hasty perceptions* in *italic* and express a **scream** in **bold** type.'[247] Marinetti demonstrated what he meant with sound poetry set on pages that broke with the sequential flow of type, pages where words collide, punctuation disappears or is replaced with mathematical or musical symbols. Letters, words and onomatopoeic sounds (cuhrrrrr – a passing car) are formed of type with hand-drawn lettering that contrasts in weight, style and size forming a dynamic web of reportage. Text races towards the edge of the page, up steep inclines, then, tilting, falls down head over heels. Marinetti was aiming for a new form of visual language, a clashing abbreviated poetry formed of sound and symbol. His typographic compositions, along with those of fellow Futurists, often rather loosely cohering as visual structures in their earliest manifestations, gained a sustained existence, a viability beyond the experimental, when they were combined with new developments in structuring pictorial space. This later advance was happening chiefly in France. Here a new way of constructing and reading visual planes in paintings would make the integration of different layers and alignments of images, text and photography not only attractive but usable in the everyday world.

Cubism

In the first decade of the twentieth century a new space for letters opens suddenly and inspirationally in France – as if we had rushed into the sunlight after a long journey through the dark. It appears first in the work

of Georges Braque (1882–1963), an artist locked in a dialogue – some-
times a duel – with his collaborator Pablo Picasso (1881–1973). Braque
and Picasso, Picasso and Braque, their work of this period somewhat
dismissively described by Henri Matisse (to the critic Louis Vauxcelles)
as like a series of cubes, one stacked on top of another, introduced a
paradigm shift in the visual language of word and image. Cubism
– Matisse's witticism stuck – broke through into a world of multiple
perspectives, grid-like and partially abstracted forms, and new ways of
combining text and image in the same picture space.* In their earliest
phase the Cubists were highly analytic in the way they reorganized the
space, the contour and volume of the subjects they depicted – seated
individuals, landscapes, table tops, still lives; their work was never purely
abstract. Between 1908 and 1911 they made a series of three technical
breakthroughs that enabled their new space to become more elaborately
articulated. The first move in this direction is seen in Braque's paintings
from the summer of 1908, which he spent in L'Estaque, Paul Cézanne's
old stamping-ground near Marseille. He had been profoundly affected
by the Cézanne exhibitions of 1907 that had followed the artist's death in
the previous year. The *passage*, a way of keeping an apparently enclosed
space open – a partially painted roof, field, wall – so that line, surface and
adjacent spaces could mutually enliven and connect with each other,
allowed space to become integrated across a painting. In Chinese and
Japanese calligraphy activated space and the concept of 'flying white'
(un-inked paper opening up within a character stroke) was used for
a parallel effect integrating the character with the space within and
around it. The Cubists' inspiration had come specifically from the June
1907 exhibition of seventy-nine Cézanne watercolours which, Picasso
noted, appeared paradoxically unfinished but possessed of an 'intrinsic
completeness'.[248] The *passage* showed, for those who would care to
look, how images and space, and ultimately letters and the page, might
find a more dynamic relationship with each other in the future. Letters

* I am following the account in John Richardson's *A Life of Picasso*, Vol. 2, Random House
1996, p. 101. He talks of the word being put into circulation by Louis Vauxcelles, who
attributed it to Matisse. Matisse had drawn a series of little cubes for him to depict the
structure of Braque's L'Estaque paintings.

naturally have spaces in between and within themselves, so a development that showed how such spaces might be activated, brought freshly alive, within western painting was of considerable significance for the way letters might be arranged in the future.

The second innovation dated from the summer of 1910, when first Braque and then Picasso adopted the orthogonal grid as a way of organizing their work. Grids had been used by artists since time immemorial for squaring up a surface in order to enlarge a drawing, but this was not technically necessary in the Cubists' paintings; Braque introduced it as a way of helping him adjust the tension, rhythm and structure of a composition, and Picasso followed his example. The grid, sometimes represented as a series of disjunctures of colour and line or suggested alignments running right across a canvas, sometimes abbreviated to a shorthand of T-shapes that appear like a wire-framed armature glimpsed through fabric, was, as John Richardson writes in his *A Life of Picasso*, 'appropriated by Mondrian, when he came to Paris in 1911, as well as by van Doesburg and Malevich, and would soon become a modernist trademark'. It would also become a staple of twentieth-century graphic design.

In the spring of 1911 the third innovation, and the final piece of the puzzle, fell into place. On his return from a visit to his parents in Le Havre, where Braque liked to spend evenings in the harbour-side bars playing the accordion, singing and dancing, he painted a picture of a guitar player – 'Le Portugais' – seated in front of a café window. Using stencils, Braque, who had once trained as a painter and decorator (lettering was considered part of the trade), dropped in a number of typographic elements as if they were floating in space, perhaps reflected in the window glass. **DBAL** appears top right, with & and 10,40 below and **CO** to top left. In a nod and a wink game of one-upmanship Picasso then began to leave cryptic references to his new mistress, Eva, on his canvases. Soon both artists were incorporating into their works painted fragments of advertisements, bottle labels and brand names, which they pulled apart into fragments and rearranged. Then, in a development that came to be known as synthetic cubism, they introduced an increasingly wide range of different real-life elements in their paintings: collaged

paper, mastheads from newspapers, headlines, calling cards, cigarette wrappers and advertisements chosen purely for their typographic texture and outline.

The Cubists' use of painted or collaged letters was a radical break with the past and suggested new possibilities. From Roman times down to the present, written forms had usually appeared in a classically structured setting: they were symmetrical, balanced with harmonious proportions and graduated steps of increase in scale or weight. But the new visual language that Picasso and Braque were introducing shattered that orthodoxy. Three and a half centuries earlier, in the dramatic abstracted design of the lettered block above the internal gate of the Porta Pia in Rome, Michelangelo had suggested that there were ways of presenting letters in an *anti*-classical way. But at the end of a long life and in an era when the classical had been so newly reintroduced, he was in no position to take further steps away from prevailing aesthetic orthodoxy, had he even wanted to. In the early twentieth century, however, Picasso and Braque also sensed that classicism no longer spoke to their experience, or to that of the society in which they lived. In France in particular the fabric of the country had been repeatedly blasted apart and pieced together again as a result of successive conflicts running from the Revolution of 1789–99, through the Napoleonic era, the Revolution of 1848, the Second Republic (1848–52), the Second Empire (1852–70), down to the Franco-Prussian War of 1870–71 (during which Paris itself was besieged) and the bloody events of the Paris Commune. Their world was not one of balance and harmony but of rupture, revolution, multiple points of view and high contrasts. This is what their new art represented, along with the urban landscape and the café society that these artists knew.

It was exactly in these same years 1907 to 1911 that the musical world also experienced a similar classical rupture – the development of Schoenberg's atonal compositions. In his case, atonality was set against the destabilization of the multinational Habsburg Empire, of which he was a citizen. Nationalist tensions, which were pulling the Empire apart, would culminate in the assassination of Archduke Franz Ferdinand in the summer of 1914. The First World War that descended on Europe in July and August

of that year would change everything. At its end 15 million Europeans were dead and another 20 million wounded; the Austro-Hungarian and Ottoman Empires were dismantled. In 1917 the Russian Revolution was triggered, in part by the additional pressures the war had placed on an already dysfunctional and tottering system.

The newly structured visual language discovered by Picasso and Braque would resonate throughout this period. It was of greater long-term significance than the calligrams of their friend Guillaume Apollinaire, who impulsively volunteered for service on the western front and died, weakened by his experiences, in the influenza outbreak of 1918. Apollinaire's poems in the shape of an image – falling rain, a watch face – have precedents in the figured poems of Lewis Carroll in the nineteenth century, and those of Robert Herrick and George Herbert in the seventeenth. The tradition goes back even further: there is similar work by Ennius (239–169 BC) and Virgil (70–19 BC) during the Roman period, and by Arator (sixth century AD) and Venantius Fortunatus (c. AD 530–600) in late antiquity. 'Shape poetry' can also be found in ancient Greece and within the Arabic tradition – it was not a creation of the modernists.

On the other hand the typographic experiments of the Symbolist poet Stéphane Mallarmé, which anticipate later 'concrete' poetry, go further. His last poem, written in 1897, was only finally published (posthumously) in the form in which he had intended it to appear in 1914. *Un Coup de Dés Jamais N'Abolira Le Hasard* (A Dice Throw At Any Time Never Will Abolish Chance) was not only a work of literature but also – indivisibly – a work of art in its own right. The poem was printed in eleven double-page openings, each opening acting as a single (yet sequential) canvas on which the type was arranged. Mallarmé had created a kind of musical score to read from.[249] In the English-speaking world this was a prototype (not surpassed) for the work of the English Vorticists, and their publication *Blast!* (1914 and 1915), and for the ranged layout of poetry on the page by T. S. Eliot and the Welsh poet David Jones. It may also have prepared the ground for the readiness with which typography was embraced in experimental artworks from 1914 onwards.

Dadaists, Constructivists, the Bauhaus

During the war years significant stylistic developments emerged, in a number of different European countries, that would enable designers to orchestrate this new typographic language with greater sophistication. Before Italy's entry in to the war in May 1915, the Italian painter Carlo Carrà (1881–1966) continued his Futurist experiments in collage and book typography.[250] A collage such as his *Interventionist Demonstration* of 1914 is as densely packed as any book page, but now the cuttings swirl out from a central point on the canvas (the word Italia). His final Futurist production was a typeset book, *Guerrapittura* (War Painting) of 1915. The cover is printed in the stencilled letterforms Picasso and Braque made famous, but the interior reveals a layout that utilizes contrasts in space amongst the textual elements, as well as contrasting sizes of type, and columns of type held together by brackets and overlaid directional lines. Pages were coming to have focal points around which the text was arranged (hanging in space in groups as it were) rather than frames which were filled up with text from top to bottom.

As different as chalk and cheese from the Italian Futurists and their glorification of war and machine progress were the Dadaists, a movement formed in Zurich in 1916. Revolted by the slaughter of the First World War, Dada artists (mostly exiles from their own war-torn countries) sought to expose the hypocrisy and apparent futility of current social and commercial conventions. They worked with poetry, in theatre and the graphic arts. They played ironic word and image games. Using a photomontage technique based on the Cubists' *papiers collés*, they appropriated material from newspapers and magazines that subverted the self-satisfied tone of contemporary culture. Whilst the Futurists had invented sound words based on warfare and machinery, the Dadaists chose to splice word fragments together that were deliberately nonsensical or infantile. Photomontage emerged as a technique in Dadaist circles in Berlin between 1918 and 1919. It was a significant development because in, for instance, the work of Czech-born Raoul Hausmann (1886–1971), one of its leading proponents, we see for the first time how type and photographic material could be combined within one image

– something we accept today as a normal part of our visual language.

Significant developments were also taking place in Russia, where, following the Bolshevik revolution in 1917, the visual language of contemporary art – a particular form of Russian Cubo-Futurism – became yoked to a broad message of cultural and political change. Modern art, which broke with earlier conventions of depiction, was seen as a particularly suitable vehicle – or set of techniques – for this revolutionary effort.

Such artists as Aristarkh Lentulov (1882–1943), who studied in Paris in 1910–11, together with other members of the so-called 'Knave of Diamonds' group, had shocked the Russian public in 1910 with their blend of European influences (Cézanne) and Russian primitivism. Following Lentulov's 1913 exhibition in Moscow, many Russian painters experimented with Cubism. Amongst them was Kazimir Malevich (1878–1935), an artist from the Ukraine (though born of Polish parents). It was he who pioneered the Cubo-Futurist style – soon to be famous because of its application to the painting of Agitprop trains sent out into the countryside during the first phase of the revolution – bringing news and educational material to the masses. But by 1915 Malevich had created another world of visual possibilities with his painting of a stark black square on a white ground that he showed in the last Futurist exhibition '1.10' from December 1915 to January 1916. He gave the name Suprematism to this new art, which he also termed 'non-object' based or abstract painting. He attempted to convey feeling through simple, roughly painted forms – geometric shapes: rectangles, parallelograms, circles and lines.

Malevich would become an influential teacher – ousting Chagall from the directorship of the Art Academy in Vitebsk. From here his 'new and direct representation of the world of feeling' was picked up by colleagues and admirers who saw the possibility of using it to add another dimension to typographic arrangements. In the absence of traditional symmetrical page layout, geometric shapes – squares, circles, bars and lines – can provide useful additional elements from which visual rhythms can be built across a layout. This can help structure the way we read the page – what we feel about it and how our eyes travel around its spaces.

Amongst the artists that Malevich influenced were Alexandr Rodchenko and Lazar Markovich Lissitzky (better known as El Lissitzky), both of whom emerged as powerful graphic artists following the Russian revolution of March 1917.

Rodchenko (1891–1956) was one of a group of Russian painters to abandon 'pure art' in 1921 to concentrate on applying their skills to the construction of the new society – they became known as the Constructivists. Rodchenko took to typography. He understood the crucial role played by text in effective communication, so for some of his work – such as advertisements for the state store Mosselprom – he employed the poet Vladimir Mayakovsky as his copy-writer. Rodchenko and Mayakovsky produced terse and memorable phrasing: 'Nigde krome kak v Mosselprome' (Nowhere else but in Mosselprom) was one of Mayakovsky's favourites. This approach fused with the graphic requirements of asymmetric typography – shorter lines – that was emerging in designs for posters, product packaging, books and films. Mostly the products that Rodchenko and Mayakovsky worked on were very down to earth: advertising for light bulbs sold by the state store Gum (1923), cigarette advertisements for Chervonet (1923), sweet wrappers, and (Rodchenko on his own) packaging designs for Zebra biscuits. But through this work the visual language of avant-garde art entered the vocabulary of propagandist and commercial art.

El Lissitzky (1890–1941) came under Malevich's influence whilst working as Professor of Architecture at the Vitebsk art school. This led him to incorporate typographical elements into his paintings and then to become involved in poster and book design (Fig. 58). Having studied engineering in Darmstadt before the First World War, once the war was over Lissitzky returned to Berlin. The city had become a centre of cultural experimentation and there, for a number of years in the early 1920s, Lissitzky was the channel by which Russian Constructivist influences moved west and came into personal contact with members of other European art movements. This was how a visual language that had begun with Picasso and Braque returned to western Europe with an application to contemporary graphic design, using text and images in a commercial or propagandist setting.

Fig. 58. El Lissitsky, book cover, *Architecture at Vkhutemas*, 1927. Vkhutemas was the Higher State Artistic-Technical Workshop in Moscow and, like the Bauhaus, an important centre of artistic and pedagogical innovation.

The Bauhaus, the premier innovative art school of the period, is where all these influences finally converged. Reincarnated from the old Weimar School of Arts and Crafts, from 1919 onwards the Bauhaus was under the leadership of the young architect and designer Walter Gropius. It was in the process of putting together the school's design programmes over a number of years that many of the new principles of modernist art found focus and a practical outcome. The school aimed to break down the barrier between crafts and the fine arts. Gropius believed that artists should also work with industry, so the school taught painting, sculpture, theatre work, and then added to them architecture, graphic design, industrial and interior design. Bauhaus teaching in art and design laid the foundations for the structure of an education in these subjects that we still follow today.

It was a visit to a 1923 Bauhaus show that inspired the twenty-three-year-old Jan Tschichold from Leipzig to follow a career in typographic design. In a series of articles and books, published from 1928 onwards, he codified much of what had been developed in the cross-fertilization between modern art movements and graphic design in the early years of the twentieth century. He has been both praised for his perspicacity and blamed for defining the subject too early ever since.

Originally Tschichold had trained as a calligrapher and taught calligraphy in Leipzig. As a young teenager he pored over Edward Johnston's *Writing & Illuminating, & Lettering*, and *Ornamental Lettering* by Rudolf von Larisch from Vienna. At the Leipzig Academy for the Graphic Arts and the Book Production Trade he was introduced to the work of the writing masters Palatino, Tagliente, and Jan van der Velde. In the Master Printers' Federation Library he studied incunabula and the type specimens of Pierre-Simon Fournier. But now, following the 1923 show, Tschichold threw himself into the hyper-dramatic language of modernist typography. Soon he was meeting and befriending Lissitzky, van Doesburg, Schwitters, the photographer Man Ray and the other great exponent of photo-montage, John Heartfield. He distilled the essence of what he was learning from his engagement with modernism in *Die neue Typographie* (The New Typography), published in 1928. 'It was, in a very literal sense, epoch-making,' wrote the British typographic historian Ruari Mclean, 'for it was the first publication in any language to attempt to lay down principles of typographic design which could be applied to the whole printing trade, embracing jobbing, advertising and journals, as well as books.' This, the most groundbreaking book on typography in the twentieth century, remained untranslated into English until 1995.

Asymmetric typography

Tschichold later regretted what he felt were his youthful enthusiasms; he was too absolute, he thought, about the use of sans-serif letters, too determined that asymmetric typography was the only way to do things. His doubts were triggered by his arrest for 'Cultural Bolshevism' in 1933.

He came to identify the militant spirit in his own writings with the same spirit of intolerance he experienced during six weeks of detention by the Nazis. As soon as was possible after his release, Tschichold and his family emigrated to Switzerland. In later years he became an articulate spokesman for the values of classicism and following the Second World War spent several years in England, where he was charged with the redesign of all of Penguin Books' paperback list.

Many of the Bauhaus staff left Germany following the school's closure in 1933. But wherever they went and whoever they taught, under their guidance modern typographic language grew in sophistication. Adopting principles from gestalt and perceptual psychology that had been introduced into the Bauhaus curriculum by the Hungarian Moholy-Nagy, a simplified style whose axioms were that 'form followed function' and 'less is more' flourished in the post-war period. Sophisticated grid systems enabled practitioners of what came to be called the 'Swiss style' to balance and prioritize the value, size, shape, texture and grouping of the increased number of elements – graphic, typographic, photographic, illustrative and diagrammatic – that the modern page often had to cope with.

At the same time the flexibility of these grid-based systems in terms of placement and scale also enabled designers to take advantage of the new visual experiences of life in the twentieth century: aerial perspective from tall buildings or from aeroplanes gave one an ability to look down on things and to visualize them in terms of rotation and strong perspective; motion pictures reinforced the possibility of seeing the page as a space where things might be partially on or off screen and understood as a dynamic setting for movements rather than a passively 'composed' framing; travel by train, tram and automobile, especially in cities, had introduced people to blurred movement and ever-changing perspectives; electric light had brought a different understanding of the shadow, of colour at night and light against black. Many of these phenomena had been included in design work in some form in the past but now they were intensified, and as their influence spread into typography, photography and other visual arts the traditional balanced arrangement of the book began to look tame and less contemporary by comparison.

Lyrical writing – Larisch and Koch

On the continent of Europe new ways of arranging type on the page for posters, book covers and commercial jobbing printing had drawn inspiration from Cubism, Futurism and Constructivism, in a creative alliance between art, state propaganda and commercial advertising. The letters that they used were anonymous, stencilled or sans-serif. But it was a different stream of artistic influences that flowed into the world of the continental calligrapher. In Britain the arts and crafts revival had been a significant shaping influence; in Germany too Morris's works were read and studied, but crucially there were two other strands in play. The Jugendstil (or German Art Nouveau movement) was particularly influential in Vienna, the capital of the Austro-Hungarian Empire. The second significant influence, from 1909 onwards, was German Expressionism. These influences transformed calligraphy in the German-speaking world in a different way to the historically oriented and analytic British tradition, though, after 1910 (when Johnston's book was translated into German), the British influence was also felt.

In Germany calligraphy began to emerge as 'art'. A new kind of calligraphic mark pushes forwards into the consciousness of Germanic calligraphers in the first two decades of the twentieth century. It is urgent, emotionally charged, felt, a line that carried traces of more primitive origins and which echoes also the rough collisions and atonal harmonies found in Schoenberg's music. Western calligraphy too was making an alliance with contemporary artforms, a move that had not been seen so directly since the Renaissance over 400 years earlier. The line was seen to have a new kind of personal expressiveness; like the graphologists' signatures or natural gestural handwriting, it apparently spoke of emotional and psychological depth.

Two lettering artists, Rudolf von Larisch (1856–1934) in Vienna and Rudolf Koch (1876–1934) in Offenbach near Frankfurt, stand out as key influences. They, along with Johnston, determined the shape of European calligraphy for the majority of the twentieth century. Placed beside Johnston and Koch, von Larisch appears the most worldly-wise. 'Larisch was the old type of Austrian gentleman,' wrote his friend Siegmund

Forst, 'raised in a multinational monarchic empire – liberal, tactful and broadminded.' He worked as a civil servant in the archives of the Austrian Chancellery in a job that he disliked. Whilst his main home was in Vienna, he had a house in the country on the Danube, and there he could indulge his love of sailing and canoes. His other great love was music. As secretary to Wiener Singakademie (the Vienna Singers Academy) he would have had dealings with Gustav Mahler and Richard Strauss, both of whom conducted their own works for the choir. So it is not surprising that Larisch's theories on lettering emphasized writing as a performance, with rhythm as an important feature. For this reason he advocated the use of block letters, so popular in Secessionist art, for this form could be stripped of historical associations and the awkward stresses of edged penmanship, which can interrupt the flow of the writer.

Larisch's students began by writing with primitive tools: wood, reeds, cork and glass pens. On the strength of his book *Über Zierschriften im Dienste der Kunst* (About Ornamental Letters in the Service of Art) of 1899 – a survey of Jugendstil lettering – Larisch was appointed as an instructor at Vienna's Kunstgewerbeschule, the school for applied arts. His students worked in a variety of materials, including lettering in glass and woven carpets. Larisch's main textbook, *Unterricht in Ornamentaler Schrift* (Teaching Ornamental Lettering), was published in 1904. Through the work of his long-lived student Friedrich Neugebauer, who ran annual summer schools in his mountain home near Salzburg into the 1980s, Larisch's insights have spread as far as the present generation of calligraphers in the United States.

Rudolf Koch was a very different character from Larisch; he had an intensity few calligraphers, even today, could match. He would transform German calligraphy and show how its historic forms could become vivid means of expression. Although he did not know it at the time, by reinvigorating traditional gothic forms during an era of resurgent German nationalism, Koch was playing with fire. It is only now, at some distance from Germany's traumatic experience of two world wars, that we can see that Koch also achieved something remarkable – in his hands, in the early twentieth century, western calligraphy and

art conjoined. In practice he made a link between the calligraphic line and that of the German Expressionists – indeed, in a modest way, he went even further. Knowing some of his most famous compositions, the cruciform Sermon on the Mount of 1921, the black block of his revelation of St John, it is hard to believe he had *not* seen photographs of Malevich's work from the 1:10 Last Futurist exhibition in Moscow. This could be why he moved towards the calligraphic panel rather than the book from 1920 onwards. His tapestries too blend influences from the Secessionist Oskar Kokoschka's lettering (clearly the inspiration for Koch's Neuland typeface) with the blocked bars that we see in the work of the Russian Constructivists of the period.

Koch taught himself calligraphy from studying old typeforms in books and newspapers. Like Johnston he had independently realized that the broad-edged pen had formed the letters he had studied; in fact the tradition of using the broad-edged nib had never died out in Germany to the same extent as it had in Britain due to the continued use of gothic letterforms. But he had also looked at manuscripts and particularly at the woodcut letters in the block books from just before Gutenberg's time, and here he had found 'an uninterrupted, almost passionate, change of forms, the avoidance of any geometrical regularity which we so love in Roman lettering, the different locations of the angles of the heads and feet, the rising and falling movements of the basic strokes, none of this can be accomplished with a simple stroke of the pen…'[251] This blend of diversity in unity was the key to his work.

Fig. 59. 'Lord have mercy upon me.' Rudolf Koch thought of this calligraphy (*c.* 1921) as an 'unrestrained revelation' of his 'inner feelings'.

When Koch's calligraphy moves out on to broadsheets like the simple presentation of 'Lord have mercy on me' (Fig. 59) or the pithy woodcut 'Kiss my arse', this calligraphy now embodies the expressive potential of the written line. For several centuries the graphologist and the autograph collector have been fascinated by this association. Now the expressive mark, the art of the line, had come home to western calligraphy. 'Lettermaking in every form gives me the purest and greatest pleasure,' wrote Koch, 'and on numberless occasions in my life it has been to me what a song is to the singer, painting to the painter, a shout to the joyous and a sigh to the afflicted – to me it is the happiest and most perfect expression of my life.'

But Koch was unfortunate with the times he lived in. Whilst the German Expressionists, who had inspired him, found their work labelled degenerate art, and the works of Ernst Barlach, who Koch particularly admired, were ignominiously withdrawn from public display, his own work with letterforms, however Expressionist they might be in their inspiration (Fig. 60), tapped into historical roots that the Nazis began to ruthlessly exploit for their own nationalist political agenda. In 1933, the year Hitler came to power, Koch found himself lauded in the press

Fig. 60. 'What doth it profit a man…' Rudolf Koch, linocut, 1920.

and heaped with honours. He was awarded a Gold Medal at the Milan Triennale; he became honorary President of the German Office for Religious Art of the German Evangelical Church; a special double issue of *Archiv für Buchgewerbe* celebrated 'Rudolf Koch and his circle'; and in January 1934 a fifty-six-page article on Koch and his Werkstatt appeared in the book collectors' journal *Philobiblon*. But hard choices lay ahead, for the Lutheran Church, to which the fiercely religious Koch belonged, was readying itself to oppose the National Socialists' transformation of the country.

Koch's own church, the Friedenskirche in Offenbach am Main, where he had been a parish councillor, would become part of the breakaway group known as the Confessing Churches, established by Pastor Niemöller in the Barmen Declaration of May 1934. Koch's own pastor and friend would be the chairman of the group.[252] These churches would become virtually the only organized centre of resistance to the National Socialists within Germany. In March 1934, however, Koch had fallen ill with a blood disease that would hasten his death.

In the last twelve years of his life Koch had pioneered another way forward in his work as a calligraphic artist. In 1921, not content to work alone, he established an atelier, the *Offenbacher Werkstatt*. In the same year, 1921, Eric Gill had established a community of craftspeople at Ditchling in England – a group that had grown out of his association with Edward Johnston and which came to include the lettering artist and poet David Jones. So now in Germany Koch attracted some of the leading letterers of the next generation in the German-speaking world – artists who, forced into exile by the Nazi persecutions, would eventually spread Koch's approach to a number of other countries including Britain, Switzerland, Israel and the United States.

Berthold Wolpe, one of the principal Werkstatt members (he had been born in Offenbach in 1905 and joined in 1924), lost his job as Head of Lettering at the Frankfurt Kunstgewerbeschule in 1935. 'As you are Non-Aryan,' read the letter from the Reichskulturkammer (Chamber of German Culture), 'and as such do not possess the necessary reliability to create and spread German cultural values, I forbid you to further practise your profession as a graphic designer.' Wolpe left Germany for

Britain, his passage eased by a special appeal from the printer Francis Meynell to the British prime minister Stanley Baldwin. Wolpe went on to a successful career in British publishing: he became Faber and Faber's in-house cover designer and a teacher of lettering at the City and Guilds of London Art School. The techniques he had learned in the Werkstatt helped shape the look of the letters he used, compact, weighty forms. His most famous typeface, Albertus, was directly descended from his experiments with engraving letters in metal. You can see it used today on the street nameplates throughout the City of London.

Fritz Kredel (1900–1973), a gifted wood engraver and Koch's collaborator on *Das Zeichenbuch* and *Das Blumenbuch* (1929–30), emigrated to the United States in 1938. He and his family settled in New York City, where he taught at Cooper Union. He went on to a distinguished career in illustration, working with Eleanor Roosevelt on her children's book *Christmas* and designing a woodcut of the presidential seal for the inauguration of President John F. Kennedy.

Blackletter and National Socialism

The pages of the German calligraphy magazine *Die Zeitgemäße Schrift* now show a long downward spiral; this will be the death song for gothic letterforms in northern Europe. Certificates for Nazi youth work turn up designed with drilled rows of gothic letters, blond-haired Hitler youth in dark shirts with the single runic letter 'sig' on their sleeve and brown shirts with swastika armbands sit at Johnstonian writing boards with pictures of the Führer on the wall in the background. For the Olympic Games of 1936 'good lettering and letterforms' were taken as 'truly expressive' of the nation's creative genius. Dr Theodor Lewald, president of the organizing committee, proclaimed that it 'eminently fitted to promote understanding of German ways and German character among other nations'.[253]

The new forms of gothic type favoured by the regime – such as Tannenburg, Element, Gotenburg, Deutschland and National – were stripped of Koch's 'passionate, change of forms' and reduced to picket-fence uniformity – as if the very life was draining out of them. The

German typographer Yvonne Schwemer-Scheddin has described them as 'numb typefaces' and 'brutal soldierly stylizations of form'. 'This aesthetic ideologising of black-letter,' she writes, 'was the death blow – the end of fraktur as a creative expression of the self.' And all this is so ironic, for if you look back beyond the dividing line of the Protestant Reformation and the loyalties it engendered, it is to the compressed Carolingian minuscule of southern England and northern France that we must look for the origin of gothic letterforms – not Germany. The one original script truly shaped by German history, though France and Italy can also claim involvement, is the early rounded and lyrical Carolingian minuscule – the script that was written in the palaces of Aachen and Regensburg in the time of Karl der Große, Charlemagne – this script gathered together the essence of the roman minuscule and passed it on to the medieval and Renaissance scribe.

So long the giants in Europe of the black and white graphic line, now all was changed and winter falls on this part of the giant's garden.
Looking back from mid-century as the Second World War approaches, one can only marvel at the energy unleashed around the appearance and arrangement of written words in the century's first forty years. It is as if, after experiencing a sense of being overwhelmed by written material in the final decades of the nineteenth century, now there has been a great striving of the senses towards new ways of embodying them as a personally felt expression.

CHAPTER II

Alternative Dreams

Fig. 61. With the release of the Apple Macintosh in January 1984 the first stage of the computer's transformation from a calculating device into a machine for writing had been achieved.

For a war that was so dramatic in its consequences, that in six years saw over 60 million people killed, a continent divided, the arrival of nuclear weapons and the horror of the Holocaust, it is perhaps surprising that there were no dramatic changes for handwriting in Europe immediately following the Second World War. The early 1950s in Britain did see a small-scale revival of interest in italic handwriting – the country was looking towards a new Elizabethan age. And in the English-speaking world this would prove to be a last hurrah for a disciplined approach towards handwriting for several generations. But the really big story for writing in the second half of the twentieth century, as big as that of Gutenberg's in the fifteenth, was the arrival of the digital. Computers, which in mid-century had been seen as gigantic calculating machines and employed as the great code-breakers of the Second World War, came to be reconceptualized as a medium for communication. They became a new writing tool in succession to the printing press, the typewriter and the quill pen. Type was now also to be transformed into a digital medium. To follow the story of how this breakthrough came about (before we return once more to the story of the handwritten letter) we must stray into unfamiliar territory and cross, for a while, from the domain of the arts into that of science.

New writing machines

In the United States, as the war drew towards an end in the summer of 1945, Vannevar Bush, the scientist who had coordinated America's wartime research network of over 6,000 scientists, turned to consider the future. He had overseen the beginnings of the Manhattan project, which had led to the development of nuclear weapons, and he wanted now to work on a non-destructive endeavour. In the July 1945 issue of the *Atlantic Monthly* he identified a great new task, the augmentation of human memory and intelligence through the use of a variety of new technologies. This vision would provide one of the conceptual building

blocks that would lead to the personal computers we use today. One of the devices he dreamed up to harness these technologies was a desk with a transparent top. He called it the Memex.

If you owned a Memex it would hold all your records, books and communications on microfiche in such a way that they could be consulted through the transparent screen at speed and with considerable flexibility. New documents could be photographed by the desk or a micro-camera attached to one's forehead. The beauty of the Memex lay in its organization: you would be able to track connections across texts and subjects. This was an idea similar to the medieval glossed text, Origen's *Hexapla* and Eusebius's Chronicles and Canon Tables, but in 3D, on steroids and at high speed.

Though Bush's vision was just a thought experiment, it inspired a number of followers. Out in the Far East Douglas Englebart, a radar operative in the US Navy, came upon a popular presentation of Bush's ideas in a copy of *Life* magazine. Englebart was most struck by the thinking behind the futuristic invention and eventually made it the goal of his lifelong work at ARC (Augmentation Research Center), a lab which he established at the Stanford Research Institute.

A mathematical theory of communication

Two key developments lay behind the success of the project envisaged at ARC: a fundamental shift (over a long period of years) in the way mathematics was applied to human thought, and the development of a new substrate for writing upon – the screen.

Though we can go back to Descartes to find philosophers who believed that mathematics and geometry might provide for a kind of thinking that was pure and precise, it was George Boole, a young mathematician from Lincoln, who put flesh on the idea. In 1833, when he was just seventeen years old, he had what he described as a mystical experience. Whilst walking through a meadow he became convinced that his vocation in life was to explain the logic of human thought in symbolic or algebraic form. It was Boole's lifetime of thinking that was picked up by the first computer scientists in the middle of the twentieth century.

In the 1930s Claude Shannon, an electrical engineer at the Massachusetts Institute of Technology (MIT),* used Boolean logic to provide the wiring patterns of the electrical circuits in a calculating machine. In 1948 Shannon published a paper that would lead to the crossover of Boolean logic and mathematical thinking into a theory of communication. 'A Mathematical Theory of Communication' dealt with aspects of signalling using the telegraph, but as one of the early commentators on the paper noted, 'This is a theory so general that one does not need to say what kind of symbols are being considered – whether written letters or words, or musical notes, or spoken words, or symphonic music, or pictures. The theory is deep enough so that the relationships it reveals indiscriminately apply to all these and to other forms of communication.'[254]

Scientists, such as Shannon, were reaching towards the conclusion that if machines could calculate then they might also be made to 'think' symbolically, and since communication itself relies on manipulating the same symbolic structures as thinking – this too could be mathematically and mechanically modelled in all its variations and media. Here was the necessary blend of theoretical and practical elements to underpin the full range of digital technologies we know today.

The screen, light and electricity as writing medium

The second step forward in creating a new digital medium was the development of the screen as a new writing surface. Actually seeing a screen, attached to a computer, glowing with dots that were constantly refreshed and thus able to be manipulated and rearranged must have been one of the physical experiences that prepared researchers to understand that a computer could have graphical potential. The first computer to have such a screen appears to be the Electronic Delay Storage Automatic Calculator (EDSAC) built for Cambridge University in England in 1949. Three cathode ray tubes were built into the interface, the screens monitored the content of the computer's registers and memory; this was amongst the first computers to use a memory to store its programmes.

* And incidentally Vannevar Bush's PhD student.

But the screen truly came of age, in its earliest large-scale application as a computer interface, in the mid-1950s when it was used in the SAGE (Semi-Automatic Ground Environment) of the US Air Force's radar defence system. During the Battle of Britain the problem of coordinating all the information arriving from radar stations around Britain was solved by the creation of the operations room, where symbols of aircraft formations were pushed around a large map table by women of the Royal Air Force using long poles, commanding officers watched from a nearby platform and could scramble squadrons as needed. SAGE coordinated all this information for the US Air Force electronically. The visual display units at SAGE showed the positions of objects picked up by radar. Individual operators could use a light pen – they called it a 'light-gun' – that touched the screen to identify targets for tracking. This was the point at which the screen had become an interactive graphical interface and a whole new substrate for displaying and working with information had emerged.

Today visual display screens continue to develop both in size and clarity and also in portability. Their advantage lies in the ephemeral nature of light; the light source, unlike ink or pigment, must be constantly refreshed and thus can be instantly changed, images can move, or be erased with ease, an ironic advantage considering the effort mankind expended over centuries to make writing endure. No medium had existed since the wax tablet of Roman times that could be so instantly modified.

The role played by light in the history of writing has been a long and deeply symbolic one. Medieval illuminators strove to bring jewelled intensity to their pages through the use of colour and highly polished gold leaf. We can imagine how the gold flashed and flickered in the candlelight of a cathedral's dark interior, giving the lettering and pictures life and animation; light was a metaphor for knowledge and knowledge was considered divine in origin. So in mosaics and stained-glass windows, in enamelwork and on the glazed geometric and calligraphic tilework of mosques and palaces, light was made to play upon the word. In the twentieth century light moved on to our streets; neon and animated displays lit up city centres and theatre districts, and on the movie screen the titles of films were often ingenious displays of letter-shapes and pictures in transformation and movement; animation had also arrived.

*

The keyboard also made a contribution to the new medium. Keyboards were used to punch the holes in the cards and paper tapes used in programming computers, and, perhaps more significantly, specialist typewriters were being employed as printers. An electro-mechanical typewriter for the telegraph, a 'teletype', first put to commercial use in 1910, was employed as a printer on Colossus 2, a code-breaking computer built by the British in 1943–4. The Harvard Mark 1 computer, built during the same years, used a Flexowriter for a similar purpose. The 'Flexo' was an electro-mechanical typewriter controlled by punched tape. Its commercial use was as an electronic letter-writer. What both these printing systems had in common was that they worked using electronic commands. The command was instigated either by the operator pressing a key or by its input via punched tape or down a telegraph cable. The commands, a development of Morse code originally used by the telegraph, employed a series of five-bit patterns to stand for each letter or symbol. These patterns were created in a series by turning an electrical circuit on or off. These electronic codes provided a natural bridge into a language that the computer could read, and once used for outputting material it was only a short step to realizing that these same devices could be used to input text as well. The electronic codes eventually became standardized and expanded.

In 1963 the American Standards Institute introduced a seven-bit American Standard Code for Information Interchange (ASCII), and in 1987 Unicode, a new sixteen-bit system, was established by researchers at Xerox and the computer company Apple that would be multi-lingual in approach. Today Unicode has electronic/binary codes for most of the world's writing systems, ancient and modern; even Egyptian hiero-glyphics has its Unicode set.

The knowledge work environment

At the Augmentation Research Center (ARC) at Stanford University, Englebart focused on how to make the inputting, manipulation and outputting of information, using computers, an easier task. He was in

effect building a complex new instrument for working with information of all kinds. Englebart saw the convenience of using screens and keyboards (including chorded key sets and the first 'mouse'). He and his co-workers developed text-handling capabilities for the screen including drag and drop. They set up facilities for searching indexes of keywords, and introduced the capability of linking different pieces of text together across documents. Englebart was also convinced that the ability to work collaboratively should be a feature of what he called his 'knowledge work' environment, so the system developed at ARC also allowed multiple users at different sites to work on the same document simultaneously, whilst connected by the telephone line.

On the afternoon of 9 December 1968 at the fall Joint Computer Conference held in the San Francisco Convention Center, Englebart's oN-Line System environment (NLS) was shown to the public for the first time.* The event, which has since been given the name 'The Mother of All Demonstrations' because it showed so much of what we now take as commonplace, amazed the many computer scientists that had assembled to view it. The demonstration, funded by Robert Taylor of ARPA (Advanced Research Projects Agency) of the US Department for Defence, finally alerted people to the potential significance of this work. Until that moment, Taylor recalled at the 40th anniversary conference of the demonstration, ARC had been at the bottom of the pecking order. People just did not get the idea.[255]

Englebart had a vision of what could be done with computing that was ahead of his time. His knowledge work environment was envisioned as a tool, as complex to play as any musical instrument. He, and those who thought like him, expected that over the years people would develop new ways of thinking and approaching problems by using and developing these tools, and that as a result twenty-first century humanity would be as different in its thought patterns as sixteenth-century humanity had been from earlier generations following the invention of printing. In many ways this is a vision that has yet to be fully implemented; the

* It can be watched online at http://www.youtube.com/watch?v=JflgzSoTMOs.

technology, some would argue, has become distracted from serious goals by its function as entertainment.*

Unluckily for Englebart, his funding was soon to dry up, and within two years of his demonstration a new research lab with almost unlimited money drew many of his team away from ARC to PARC, the Palo Alto Research Center of the Xerox Corporation. It was here that the first networked personal computer was developed with prominent text-handling capabilities.

The development of the Alto – the first desktop networked computer

Xerox established PARC in late June 1970. It was the second research establishment it had founded; the other, at Webster, near Rochester, New York, the company's headquarters, focused upon Xerography and imaging research. PARC's role was to expand business opportunities by first merging digital technologies with the corporation's existing strengths in imaging and marking technologies, and then building 'a system architecture that would facilitate Xerox's development of information systems for business use'.[256] This lab thus straddled the divide: it was a scientific and technological research centre but its expertise was in documentation and copying issues and this was where the team from ARC came in.

One of the first people recruited to PARC in the summer of 1970 was Robert Taylor, its new director; he had worked previously as head of the Information Processing Techniques Office of ARPA (Advanced Research Projects Agency), he had funded Englebart and now he recruited a number of his co-workers to PARC. Taylor had a longstanding interest in communications.

The other hiring that proved of key significance was that of a young jazz-playing computer scientist whom ARPA had also funded. Alan Kay,

* See the talk by Alan Kay at the 40th anniversary conference for the 'Mother of All Demonstrations', Stanford Research Institute, 2008. http://www.sri.com/engelbart-event-video.html.

originally trained as a microbiologist, had been introduced to computers whilst serving in the US Air Force. Whilst reading for his PhD at the University of Utah, he saw Ivan Sutherland's work on Sketchpad; a pioneering 3D graphical application for computers that was a spin-off from work that had been done for SAGE, it was interactive, using a light-pen as a pointing device to drag, rotate and join drawn lines. This inspired Kay to design FLEX (though he never actually implemented it), his own version of an on-screen interactive graphical user interface using a concept he called windows.

But Kay's vision of the potential for computing was soon to be given a dramatic twist. In 1968 he paid a visit to Seymour Papert at MIT's Artificial Intelligence Laboratory. There he saw children from eight to twelve years old working with the LOGO programming language with unexpected ease.* Papert had studied with the Swiss developmental psychologist Jean Piaget (1896–1980) and had built his work around Piaget's analysis of the sequence through which human cognitive capacity unfolds. He had then adjusted the programming method so that it could work at these various levels of a child's development. This shifted Kay's understanding about the kind of relationship that humans could build with computers. Kay suddenly saw their potential as a more intimate medium. His main realization was that here was not just a new substrate, the screen, but a whole new medium, one that could be accessible to anyone and fashioned to whatever ends an individual chose to direct it; this medium could not only handle information and assist with problem-solving but it might empower us to discover for ourselves exciting new ways of being in the world.

In the plane on the way home from MIT Kay sketched out what his new computer might look like: it needed to be small, portable like a book, affordable and easy to use. Later he built models of it in cardboard, confident that in a few years' time computing power would have developed to such an extent that this concept would be realizable. At PARC the research agenda was relatively unconstrained; people were hired

* Children were using LOGO to build their own applications that wrote poetry, did maths and translated into Latin.

more for their research record than for a specific project. So Kay took the opportunity to develop his vision further; he called it Dynabook, a conscious proclamation that he thought the arrival of the new medium was as significant as the introduction of a new means of printing, reading and writing.

To run the Dynabook, Kay and one of his team developed a new programming language which they called Smalltalk. It was designed to be simple, understandable by a child; indeed over four years it was tested on 250 children (from six to fifteen years old) and just fifty adults. They were encouraged to work with Smalltalk and devise applications for their own use – these came to include programmes for painting, keeping home accounts, playing music, information storage, teaching and games.

Thus two streams of influence, the one flowing from Bush via Englebart and his fellow 'knowledge workers', the other flowing via Sutherland and Kay through a filter of playful exploration and intimate creativity, came to be fused in work at PARC. These understandings were then built into a few 'temporary' Dynabooks. They called this computer the Alto. Following Kays's experiments with Smalltalk, the Alto supported 'interactive text editing for document and programme preparation, support for the programme development process, experimenting with real time animation and music generation, and operation of a number of experimental office information systems'.[257] By the second half of the seventies the Alto was up and running: there were nearly 1,000 in regular use, not only at PARC, where it was used by researchers and secretaries, but also at a number of universities, the US Senate and Congress and even the White House – all gifted by Xerox. A brave new world was dawning. The main way in which the Alto came to be used in most of these settings, despite its many functions, was for handling text, design and communications.

Fumbling the future

But within Xerox there was a struggle under way. The idea of the personal computer was still in its infancy; there was not yet a clear role for it in business, and though Xerox scientists at PARC had now invented many of

the key pieces of the future computing environment, and had installed it as a working system within its own workplaces – the corporation's executives back over on the East Coast of the USA could not see how any of this was of benefit to a company whose business was photocopiers. Just as centuries earlier Gutenberg, through bankruptcy, had lost control of his original invention and it went on to be developed by others, so the Alto, whilst representing the future, was soon hit by serious problems in its own backyard that would ultimately deprive its inventors of the rewards they might have gone on to reap.

There was no one watershed moment when the Alto failed to be exploited; it happened for a number of reasons. New Japanese photocopy companies, Canon and Minolta, had entered the field, and Xerox had their eye on them, not on their own scientists' inventions. The main problem was that the managers of the company back on the East Coast just did not understand how this equipment could be used, and they were out of sympathy with their own researchers at PARC, whom they viewed with suspicion – they thought them arrogant and insolent, they wore jeans and sandals to work. When the Alto was demonstrated in 1977 at Xerox's World Conference, held that year in Boca Raton in Florida, there were disturbing signs of what was to come. A team from PARC had pulled out all the stops to set up a realistic, working 'office of the future' – they hoped this would lead to a commitment to go into production. During the afternoon session Xerox managers and their wives were shown the new equipment.

> 'The reactions we saw in the wives,' said Chuck Geschke, who showed them around, 'was what we had hoped to see in the men. What was remarkable was that almost to a couple, the man would stand back and be very sceptical and reserved, and the wives, many of whom had been secretaries, got enthralled by moving around the mouse, seeing the graphics on the screen and using the colour printer. The men had no background, really, to grasp the significance of it. I would look out and see bright enthusiasm in the eyes of the women, and the men just asking in a stand-offish way, 'Oh, can it do that?'[258]

When PARC researchers did a study of how many of the company's senior management actually used their new office network, it was just 5 per cent. The final factor counting against the Alto was its size: Xerox was used to selling big machines, to business and government, that used lots of toner and paper, the major source of Xerox's income – how could something that small and orientated to the personal user make money? It was apparent that no serious resources were going to come the Alto's way.

The final act came in the winter of 1979. On a mid-November day, Steve Jobs, the pushy, perfectionist, co-founder of Apple, finally had his arm twisted to make a long-delayed visit to PARC. What he saw blew him away; he later recalled this moment in an interview…

…they showed me really three things. But I was so blinded by the first one I didn't even really see the other two. One of the things they showed me was object orienting programming. They showed me that but I didn't even see that. The other one they showed me was a networked computer system…they had over a hundred Alto computers all networked using email etc., etc., I didn't even see that. I was so blinded by the first thing they showed me which was the graphical user interface. I thought it was the best thing I'd ever seen in my life…Within, you know, ten minutes it was obvious to me that all computers would work like this some day.[259]

A few weeks later Steve was back with his entire programming team. Adele Goldberg, one of the Smalltalk development team, remembered the visit. She was asked by the head of the science centre at PARC to demonstrate the system, 'and I said no way. I had a big argument with these Xerox executives telling them that they were about to give away the kitchen sink and I said that I would only do it if I were ordered to do it cause then of course it would be their responsibility, and that's what they did'.[260] Apple had gained access to PARC by allowing Xerox to buy $1m of its stock and gifting some itself. The look and the feel of the Alto was subsequently built into all the Apple computers that followed, and it's there today on its newest products. A few years later, much to

Steve Jobs's annoyance, Microsoft also adopted windows, the mouse and the graphical user interface. When asked to explain himself, Bill Gates, alone in a room with ten Apple executives, is reported to have replied to Jobs, 'Well, Steve, I think there's more than one way of looking at it. I think it's more like we both had this rich neighbor named Xerox and I broke into his house to steal the TV set and found out that you had already stolen it.'[261]

Although Xerox went on to develop its ill-fated, because too expensive, Star computer, many researchers had had enough. Charles Simonyi, the Hungarian developer of the Bravo text-editor for the Alto, was recruited into Microsoft, where he led the team that developed Microsoft Word; at least ten other researchers followed him. Alan Kay moved to Atari and then to Apple. The man who developed the Ethernet, Bob Metcalfe, left to set up his own local networks company, 3Com; today the Ethernet port is built into every computer. John Warnock, whose 'interpress' graphics language for controlling printers was languishing neglected, also left and with fellow PARC researcher Charles Geschenke he founded Adobe, where the postscript language was developed to do what 'interpress' had already achieved. Larry Tessler, part of the Alto's development team, moved to Apple, rising eventually to be one of its vice-presidents.

From counting to writing machines

Though in the Alto we saw the first networked personal computer biased towards the production of text rather than calculation, the Alto was more than the pen, press and typewriter combined – an entirely new context for reading and writing had been developed. With its graphical user interface and its associated technologies of email, Ethernet, file sharing and bulk storage, this kind of machine did not simply create written documents, it could also act as a library, a search facility and a postal service at the same time. It created a whole new ecology in which the documents it produced could be placed and used. Gone were the days of the separate library building, the filing cabinet, the office spike – the Alto could manage all this information under one roof. Information passed through it in any number of specific forms,

as accounts, advertisements, letters, novels, sets of drawings and plans; it also handled photographs, sound and moving pictures. But whereas previously this range of materials and the activities associated with it would have been handled by different professions in separate buildings spread across town – the architect's office, the accountant, the publisher, the design studio, the museum, the classroom, the records office – now it was all here, potentially in front of the ordinary user. For the first time computer makers and users were challenged to think not simply about how to give access to all this information but about the material relationships amongst and between it all. How does a sheet of accounts relate to the plan of the building that the accounts cost; are there new ways of representing this? Are there previously undiscovered relationships between material, people and products that we had not realized before?

The Alto thus represented not only a new tool for designing, printing and distributing documents but it also created a huge virtual umbrella for activities of many kinds that fused elements of the office, the home, the performance space, the marketplace and library with a referenced filing system, a stage, a postal service and a helpful multi-skilled secretariat. Documents and text came to be kept within a context that was far more dynamic than the storage drawers of a vertical filing cabinet.

There is an ancient literary and cultural parallel to this – just a germ of a connection without the far-reaching and interconnected strands that give today's technology such leverage and yet pointing to the power the technology may have to fashion a new identity for those who use it. The imperial Roman creation of the public library situated within the great Roman baths had also, you may recall, seen culture, entertainment, business and education coming together in a powerful fusion under one roof. In the baths of Caracalla in Rome there were gymnasiums, reading spaces, rooms for talks, a performance space, the baths themselves, dining facilities and separate Greek and Latin libraries; all paid for by the state. It has been argued that the bath culture of ancient Rome was the one shared public institution that bound its far-flung citizens together and helped to forge a sense of cultural unity from Spain to the Middle East and North Africa to Hadrian's wall; in some ways these

bath houses were far more effective in developing the idea of what it meant to be a citizen of Rome than either its politics or its army.

Digital letters

The digital storage of letterform designs was initiated in Germany in 1965, when Dr Rudolf Hell invented 'Digiset', the first process to digitally assemble typefaces. The technology arrived in the midst of a period of revolutionary change in printing methods. In the late 1940s, photo-typesetting had been developed in the USA and France. Master drawings were reproduced as negatives on a photographically produced matrix. Light was shone through the matrix to project an image on to photo-sensitive material from which a printing surface could be made. Consequently by the 1960s much printing was done from lithographic plates. Different sizes of type were produced by optics. Because letters no longer had a type body they could be spaced in more versatile ways. There were disadvantages too. Small-sized letters need more space inside them to read easily. Shrinking them by optics did not achieve this. Also, with no ink-spread from an impression, typefaces designed for letterpress printing appeared thin. Letters had to be redesigned for photocomposition. The direct mechanical link between type and image had been broken, and this, as the type scholar Richard Southall has written, 'called into question all the conceptual and dimensional frameworks on which five hundred years of received wisdom about type and typography had been built'.[262] Whilst the commercial life of photocomposition was short, perhaps just a few decades, during this time a new generation of type designers were trained. They learned to transcribe designs for one technology to another. Later many of these same designers would work a similar transformation for type into digital and numerically encoded designs.

Hermann Zapf was one of the first to work with digital technology; between 1973 and 1992 he designed five faces for Hell's machine. By 1977 Zapf was also thinking of ways in which computers could support typographic layout. He travelled from Germany to teach the first course on the subject at the Rochester Institute of Technology that same summer, and also founded Design Processing International Incorporated (DPI)

that year. Though the New York-based company had little commercial success, its business premise was interesting. They intended to develop programmes for typographic structures, based on modular units that could be used by non-specialists – office workers and secretaries. In April 1985, Zapf presented the concept to Apple in Cupertino.

In 1973, designing letters for the Digiset machine had meant that Hermann Zapf and his wife Gudrun had to work, without a monitor, colouring in thousands of squares in white paint on pre-printed black raster sheets. But technical progress came quickly. In 1974 Peter Karow of the typefounders URW in Hamburg developed the 'Ikarus' type design system, which converted drawings into digital outlines using spline curve representations.[*] This meant that a letter's image could be saved as data that mapped its outline, rather than recording each individual pixel. This was a less memory-intensive way of storing a shape and one that allowed it to be scaled up and down, rotated, reflected, and skewed with ease. A similar principle lay behind the much richer 'Metafont' programme developed from 1977 onwards by Donald Knuth, Professor of Computing at Stanford, famous for his work on algorithms.[†] Knuth had been frustrated that the mathematical textbooks he used could no longer be typeset (a highly skilled sub-species of typographic design) because the old experts were retiring, and he resolved to apply his own expertise to the problem, both of setting the text and designing new symbols.

Different variations on splines lie behind all the modelling software for type in use today. They are also used in Adobe Illustrator, which grew out of the software developed for editing fonts on screen at Adobe in the late 1980s.[‡] In 1981, Bitstream of Cambridge, Massachusetts, became the first independent digital type foundry. The early 1980s were crucial years for the intersection of typography and computing.

[*] Complex mathematical functions that can be used to model curves.
[†] 'Metafont was not merely a kind of representation for existing letter forms, but a computer language for describing letterform that allowed many variations to be produced from a single program written in this language.' Sumner Stone, personal communication, 26 May 2010.
[‡] Sumner Stone, personal communication, 26 May 2010. Stone was the first Director of Typography at Adobe.

Dropping out of and into calligraphy

Apple's adoption of the graphical user interface for the Mac in 1984 was a step towards establishing an enhanced visual experience on the screen. Like the Alto, the first Mac had a choice of typefaces. So from 1984 onwards some traditions from the paper world began to be honoured. When we look closely it was the indirect influence of Morris, Johnston and their disciples that encouraged this process. In a commencement address at Stanford University in 2005, Steve Jobs recalled a chance event during his student days at Reed College, in Portland, Oregon:

> Reed College at that time offered perhaps the best calligraphy instruction in the country. Throughout the campus every poster, every label on every drawer, was beautifully hand calligraphed. Because I had dropped out and didn't have to take the normal classes, I decided to take a calligraphy class to learn how to do this. I learned about serif and san serif typefaces, about varying the amount of space between different letter combinations, about what makes great typography great. It was beautiful, historical, artistically subtle in a way that science can't capture, and I found it fascinating.
>
> None of this had even a hope of any practical application in my life. But ten years later, when we were designing the first Macintosh computer, it all came back to me. And we designed it all into the Mac. It was the first computer with beautiful typography. If I had never dropped in on that single course in college, the Mac would have never had multiple typefaces or proportionally spaced fonts. And since Windows just copied the Mac, its likely that no personal computer would have them.*

In fact the early typefaces on the Mac were not that sophisticated; the medium was still at an early stage and Jobs was not the only person working on the problem. But what was crucial was that a *choice* of

* To watch the speech see http://www.youtube.com/watch?v=D1R-jKKp3NA. Accessed 28 July 2010.

typeface was present, and that they were proportionally spaced and the platform was open to the development of design and layout tools.

The founder of the calligraphy programme at Reed where Jobs had studied was Lloyd Reynolds, a quietly charismatic English literature teacher (Fig. 62). Reynolds wrote an exquisite self-taught italic hand, and like many in the arts community of the Pacific North-west, he was heavily influenced by Asian art and philosophy. This came out constantly in his teaching. He was the first western calligrapher to take seriously the quality of *chi* in writing, a concept crucial for an understanding of Chinese calligraphy and painting. He translated the term as 'rhythmic vitality' or 'life movement'. Importantly he also taught the graphic arts, book design, printmaking and typography. Having taught himself from Johnston's *Writing & Illuminating, & Lettering*, he saw the world of the written word as a whole. Type, calligraphy and letter-carving were all facets of one subject, which had a deep cultural, spiritual and philosophical background, conveyed in its aesthetic forms and material practices; and Reynolds communicated his passion and insight to his students. Quite unknown to himself Reynolds was doing something greater yet:

Fig. 62. Lloyd Reynolds in the 1960s.

he was one of the channels through which the western manuscript tradition was flowing into the digital age. In addition to Jobs, who had learned from Reynolds's successor, Robert Palladino, Sumner Stone, the first director of typography at Adobe, was a student of Reynolds himself, as was Chuck Bigelow, an early designer of digital type. But Reynolds passed away in 1978, just before any of these threads and their significance were apparent.

Making the link at Adobe

In 1984 the calligrapher and typographer Sumner Stone was appointed Director of Typography at Adobe. Initially he pioneered a somewhat lonely trail as he sought to bring good typography to the personal computer. But his achievement was substantial – even if today he feels that by the time he left he had failed to convince the corporation of the value of the historical perspective he introduced.[263] To help him in the task he founded a Type Advisory Board, comprising Jack Stauffacher (legendary proprietor of the Greenwood Press in San Francisco); Alvin Eisenman (head of graphic design at Yale); Max Caflisch (Swiss typographer and educator); Lance Hidy (a book and poster designer, and artist); Stephen Harvard (type designer, book designer and Vice President of the Stinehour Press), and Roger Black (magazine and newspaper designer). The board met twice a year, with guest members in attendance too.

Most significantly, Stone hired type designers and commissioned new faces, carefully ensuring that a series of classics picked up on older traditions. The Adobe Originals programme even went so far as to highlight three stylistic peaks in letterform development from *before* Gutenberg: there was a monoline Greek-inspired form, 'Lithos' (the designer looked at the Priene inscription mentioned in Chapter 2); the first careful attempt to translate the letters from Trajan's column into a type, 'Trajan'; and 'Charlemagne', which, despite the name, took its inspiration from versal[264] capitals in the late Anglo-Saxon *Benedictional* of St Aethelwold, which Johnston had originally used as a guide to making letters with compound pen-strokes. Unusually, these three, drawn by Carol Twombly, were capitals-only faces. During Stone's period as

director, which ran up to 1990, the foundations of Adobe's collection of types were laid.

At the same time Stone and his advisory board saw that many of the new users of their software had little background in letterform and type, and so they made it part of their mission in these early years to educate their new customers. They produced a magazine, *Colophon*. Its second issue, announcing developments in PostScript, proclaimed: 'It's April 1986, one year ago hardly anybody had heard the phrase "Desk top publishing"...' The key innovations were two-fold. First, Apple's introduction of the graphical user interface with WYSIWYG ('what you see is what you get') pioneered on the Alto; and second, Adobe's PostScript printing language, which itself revolutionized digital typographic standards, allowing much finer detailing of forms. The real unlocking of typography on the personal computer thus came with the introduction of the LaserWriter* and its resident Adobe fonts.

At the same time that this work was going on, the design press was celebrating the kind of punchy personal typography emerging from *Émigré*, a magazine established by Zuzana Licko and her husband Rudy Vanderlaans in 1984† – the year the Mac was launched. From 1989 into the early 90s, experimental work from art schools such as Cranbrook and CalArts also caused a stir. Certainly, as Sumner Stone has observed,[265] experimentation with type in an art school context had been long overdue, and at least it showed future designers that lettering and type could have some kind of conceptual basis.

Whilst postmodernism was in full flood across other areas of design, it was never as strong an influence on the graphic arts. Nonetheless, as a reaction to the cool logic of the international Swiss style, images and type were now being layered, collaged, arbitrarily combined, tilted and pixelated in work for commercial publicity. Historically, however, these experiments proved too tied to the limitations of a still-emerging technology to sustain themselves. Rather, it now seems (as far as the

* Developed by Gary Starkweather for Xerox. He worked on the first fully functional system at PARC in 1971.
† Licko's digital fonts foundry of the same name was established in 1985.

long-term future of the medium was concerned) that it was the work going on at Adobe and other digital type houses with an informed historical perspective that had the greater impact, for they preserved a precious degree of continuity from pre-digital to post-digital documents, both in print and on screen, and this was going to prove critical for the wide uptake of the digital medium.

Adobe's development of PostScript in 1983 was highly significant. It was a programming language that gives a very accurate description of what a *paper* page looks like. As a page description language, used in the first instance to control printed output and later also representations on screen, it was explicitly mediating between the forms seen in a paper-based document and those of the new electronic sphere. Furthermore, it worked across platforms, with both Apple and Microsoft products. With the introduction of the pdf, a portable document format, in 1993, Adobe went one step further. On top of the underlying page-imaging model from PostScript was layered a way of describing an entire document's architecture. The document could have interactive navigational features, hyperlinks and the like. Documents could be randomly accessed – straight to page 54 rather than in strict sequence – they also gained interactive areas (as in forms), and they could be marked-up in various ways by readers. Security features to protect documents from unauthorized changes were also introduced. Together these innovations enabled digital documents to effectively challenge the place of a surprising number of previously paper-only artefacts: official forms of all kinds could go on-line; the book and newspaper, with their different typographical traditions, could search out new but still paper-related formats (presented on-line on the newly expanding World Wide Web); electronic documents could now be annotated like typed or handwritten manuscripts. Without introducing at least some correspondence between the look and feel of the old (paper) and the new (on screen) worlds in terms of fonts and layout and function, this migration from paper into the digital medium simply would not have happened. The genres would have become unrecognizable and thus confusing and inoperable. With no apparent visual order or connection to recognizable types of document, it would have been unclear just how the new medium could be useful.

Thus we have a paradox: preserving an apparently traditional element – limited typographic conventions, letterforms and layouts – has proved key to unlocking transformative change in the digital sphere. But, once there, documents gained additional properties. They could be changed, archived, searched and shared in new ways. They also lost some features, such as the physical procedures that ensured privacy, security or their material authenticity (locked cabinets, keys, passes, printing techniques and papers that were hard to match).

Emergent writing

Amongst all this flurry of investment in technology one might ask what of humble pen and paper? Whilst calligraphy and lettering had been developing as an artform in the 1950s and 1960s, and the 1970s saw a distinct calligraphic revival, with new societies for western calligraphy being formed in Europe and North America, handwriting tuition in schools within the English-speaking world was becoming a less strict discipline. New educational theories were gaining ground. At the centre of these new ideas was the work on cognitive development by the Swiss psychologist Jean Piaget (1896–1980), the same man who had influenced Seymour Papert's LOGO programming language and the design work of Alan Kay at PARC on Smalltalk and the Alto. Now, inspired by Piaget's theories, educationalists such as the New Zealander Marie Clay were observing the behaviour of children in the classroom and realizing that writing skills were something that children (in literate households) had begun to engage with at a much earlier stage than first expected. Children saw letters in storybooks, when out shopping, in the home environment. They played at writing in their own drawings. They could understand that certain things were signs for other things. Signs could be repeated, and have direction; a child would point at scribbles and announce 'it says …'

Piaget's theories stressed that children learn in an interactive way, and the richer these interactions and the more skilfully supported, the more successful the learning will be. Behaviour could be modelled and learned from other adults and children. There was a certain amount of

trust building amongst educationalists that children wanted to learn, especially if placed in an environment that was rich in opportunities to engage with new skills (the same philosophy guided the design of the Alto and Apple's computer interface). The 'emergent writing and reading school' in the English-speaking world suggested that both these subjects were best learned together, rather than in the traditional order of reading first, then writing.

The idea that teachers should be more flexible and adaptive in their teaching was reinforced by the now common understanding that handwriting reflected personality; to establish too strong a model for students to follow in older age groups risked cramping them. Creative writing exercises rather than the writing process became a more insistent theme. In England, a report into English Language education by Sir Alan Bullock, 'A Language for Life', in 1975, contained a brief appendix on handwriting. It noted that 12 per cent of six-year-olds now had no time spent in class on teaching handwriting (in a traditional sense) and that this rose to 20 per cent for nine-year-olds.*

From the 1960s onwards, technical obstacles to engaging with writing from an early age were being lifted. Educational furniture came in a greater range of sizes and configurations. Cheap pens had begun to be available for classroom use. Though inexpensive fountain pens had been available since the 1930s, fountain pens with cheap replaceable nibs of different sizes and styles were only finally accepted into classrooms in the 1960s.

The other big innovation was the ballpoint pen. In 1931 the Hungarian László Bíró had first shown his new design for a pen. He patented it in 1938. As a journalist he had noticed that printer's ink dried quickly and without smudging and he wondered if a viscous ink might work equally well for writing. With his chemist brother Georg he invented a pen with a hard metal ball held in a socket. Licensed to the Royal Air Force (the pens worked well at high altitude, where fountain pens flooded), they

* A. Bullock, *A Language for Life*, Her Majesty's Stationery Office, 1975, Annex B, pp. 184–6. http://www.educationengland.org.uk/documents/bullock/bullock11.html, accessed 17 April 2012.

finally came on to the mass market from the mid-1940s. But it was not until the 1970s that they were commonly accepted for writing classes in schools.

Fibre tip pens made from felt had been around for lettering and poster work since the early 1950s. Fibre-based 'marker' pens are now the most popular pen for early writing after the pencil. They need to be held in a slightly more upright position than the traditional pen, but as Rosemary Sassoon points out in *Handwriting of the Twentieth Century* (2007), penhold has *always* been changing in response to tools, materials and fashion.[266] Sassoon has pointed out how unusual handwriting policy in Britain has been in comparison to other countries. In many (the USA, Canada and France), copperplate styles, first introduced in the nineteenth century, continued to hold sway for much of the twentieth century. In Britain, even with its different education systems in England and Wales, and Scotland, there has been little regulation attached to handwriting. Individual schools have been left to devise their own policies and teach the scheme (sometimes in-house) that they think appropriate – this remained the case even after the introduction of a National Curriculum in 1988.

The European system that contrasted most strongly with that of Britain was the French, where one national style of handwriting was (and continues to be) taught throughout the school system – in much the same way as it had been for the last three generations. Education in writing was continuous from pre-school at three years old (98 per cent of French children now attend) until nine. The philosophy behind the system was well understood by teachers and there is an extensive range of research and support material to back them up. Handwriting was understood to be a more difficult task than reading; it was both creatively and physically challenging, and it was prepared for across the curriculum by fostering a culture of *Graphisme*. In subjects such as Music, Art and Physical Education, exercises build control over arm and hand through gestural movement, throwing and catching games, dance, drawing in scribbling rhythms, zigzag and circular, emphasizing fluidity of movement.[267] The cursive hand used is rather more ornamental than British writing; it descends from the *Ronde*, originally a cursive adaptation of

a seventeenth-century calligraphic, square-nibbed, gothic cursive, but influenced by the passage of time and the pointed pen towards a more copperplate appearance.

When Rosemary Sassoon surveyed European writing towards the end of the twentieth century she noted:

> ...the real surprise that emerged from the handwriting of this new generation of students. Whether they have been taught to adhere closely to a national model – the French traditional cursive, the German modern cursive or the Swedish italic, for example – it does not make much difference. A proportion of teenagers seem to disregard any trace of their taught model and develop a round personal writing almost indistinguishable from their British peers. It seems that soon it will no longer be so easy to tell the nationality of a writer.[268]

Sassoon was at a loss as to know why this was so; clearly some 'have found that their national model teaches a traditional style of writing that is inappropriate for their needs'. She speculates on whether the more upright penhold modern pens require is encouraging writing to move in this direction, or is there a more global youth culture influencing the trend?

Traces of 'underground' characteristics in writing had been found by Frances Brown in her 1981–2 survey – features that seemed to be shared by certain groups but had never been taught in any writing scheme (hollow circular dots above an **i**, for instance). They were signs of individual children finding their own style. But far from the schoolyard now, a new generation of young writers were about to do just that in their own spectacular and completely unanticipated way – the graffiti writing movement was upon us.

Letters of protest

However inconvenient and sometimes unattractive it may seem, from the late 60s onwards graffiti writing became one of the most innovative events for letterform design that the roman alphabet has experienced for

many centuries. But we should be clear, because it is an astonishing fact, that this movement arises from the world of literate children and young adults, an unsuspected outcome of decades of hard work to achieve widespread literacy. In some ways it was proof of much of the thinking behind the emergent writing movement – that given the tools young people *will* pick them up and use them to write the messages they want to write. And as if emphasizing how young mankind's use of writing still is, this is the first time in our history that a much younger group of people – children of school age – have had the means and confidence to start developing their own graphic expression of writing rather than following the methods their elders had inducted them into.

During the 1970s and 80s, from its origins in Philadelphia in the late 1960s, graffiti (or 'writing' as those closely involved called it) spread across the buildings and subway systems of New York, Los Angeles and Chicago, then Amsterdam, Madrid, Paris, London and Berlin. These were of course the very same years that the computer revolution unrolled from the back yards of Silicon Valley. At the same moment that countercultural elements within white middle-class society migrated on-line, drawn to the new frontier of cyberspace, urban youth from marginalized areas of society reconfigured public spaces through a graphic revolution rooted in the utterly human (and non-technological) physical act of writing. Nothing could seem more different from the products of the temples of Hi Tech than the riot of graffiti in the parking lot.

'Graffiti writing' was linked to an alternative youth culture and the soon-to-be musical scene of hip-hop. The movement took three features inherent in writing – its ability to name things, the physical pleasure and aliveness of embodied movement, and writing's innate sense of risk (it's a performance that can all go wrong in an instant) – and elevated them into a new way of being, of hanging out and gaining respect from one's peers.

Amongst the earliest writers were Darryl McCray – 'Cornbread' – and his friend 'Kool Earl' in Philadelphia. 'Cornbread' was a nickname that McCray had picked up in a juvenile institution in the late 1960s. Speaking in an interview for the hip-hop website HHUK.com, Cornbread explained how it had all begun for him.

When I got out I met this girl in school named Cynthia. I used to like Cynthia a lot. I would walk her home from school every day 'cause I was trying to be her boyfriend. I started writing 'Cornbread loves Cynthia' all over the neighbourhood. She didn't know Cornbread and I were the same person, she just knew me as Darryl. It played on my mind 'cause Cornbread seemed to get more attention from her than I did. One day many months later, she saw 'Cornbread loves Cynthia' written on my school book and she realized who I was.*

The relationship was short-lived, but Cornbread now began simply signing his name. He really hit the news, he said, when his friend Cornelius was shot dead.

People crowded around shouting 'Corn got shot, Corn is dead!' When the press got to the scene, they heard this and thought it was me. After that I knew I had to do something bizarre or my name would be buried with that guy. That's when I broke into Philadelphia Zoo and spray-painted 'Cornbread Lives' on an elephant. I didn't stop there. I wrote on cop cars, paddy wagons, 30 storey skyscrapers, even on the side of the Jackson 5's private jet. I stopped writing on walls when I was 17 years old.

That was 1972. The new movement was partly fuelled by attention from the black and establishment press; as Cornbread's activities were reported, more people had the idea of making a name for themselves. Writing spread to New York, where the *New York Times* did its first article on the phenomenon in July 1971, featuring a young writer from Washington Heights. 'Taki 183 spawns Pen Pals' ran the headline. Taki was short for Demetrius, and 183 stood for the street he lived on. In fact he was imitating another local teenager, 'Julio 204', who had begun tagging the neigbourhood twenty blocks to the north. What made Taki different is that he travelled around all five boroughs from Kennedy airport and

* This and the following quotation are from an interview with David Cano which appears on http://ukhh.com/elements/graffiti/cornbread/index.html, sourced 14 June 2010.

out to New Jersey, up-state New York and Connecticut. Once graduated from high school, he became a messenger boy for a high-end cosmetics company. He used their boxes to hide his hand as he wrote on buildings and lamp-posts around town. When confronted by the *New York Times* reporter about the $300,000 a year cost to the Metropolitan Transport Authority for removing graffiti, Taki commented: 'I pay my taxes too and it doesn't harm anyone. Why do they go after the little guy? Why not the campaign organizations that put stickers all over the subway at election time?'*

It's a revealing comment. Before Taki started, there were already multiple genres of text invading public space and private property; Taki saw himself matching the political campaigner's tactics. The graffiti movement developed following a time of political activism in which, it could be argued, the handwritten public notice had taken on a different urgency and a sense of rebellion. From the mid- to the late 60s, first with the civil rights movement, then the anti-Vietnam war demonstrations and student protests in the USA and Europe, the handwritten placard and banner were constantly featured by media documenting the protests (Fig. 63). These urgently produced, spur-of-the-moment writings used whatever materials were to hand: magic marker, poster paints, chalk and chalk boards, board fences and brick walls – and clothing; even the marine's flak vest could be written on. The purpose of this writing was to change things; it was marked by indignation and protest. In his 1976 article 'Kool Killer or the insurrection of Signs', Jean Baudrillard makes a connection also to the urban riots of 1966–70. Graffiti was an offensive, he argued, a symbolic destruction of a social relationship, territorializing space and combating anonymity. Certainly the young writers on the New York City subway found the illegality and notoriety of their train 'bombings' attractive, and they felt famous as they watched their names go by.†

* Taki 183 can be found at http://taki183.net/.

† *Watching My Name Go By* is the British title of the earliest publication on subway art – conceived by Mervyn Kurlansky, a founder of the design group Pentagram, who was struck by the phenomenon on a visit to New York in September 1972. This photo-essay put together by Kurlansky and Jon Naar was accompanied by a piece written by Norman Mailer. It was issued in the USA as *The Faith of Graffiti*, Praeger, 1974.

Fig. 63. Parking lot wall, off Market Street, San Francisco, 1991.

Subway art was New York's original contribution to the 'writing' movement. To begin with, it was made mostly by kids returning from school as they exited the subway car; later, particular locations were hit for the way they would be noticed. Just as the highest spot in a neighbourhood might get tagged, so the front of the train and a particular side might get special attention. In the early 1970s things developed fast. Lee 163 was the first to join his letters together, something that would promote a more cursive style of writing. Barbara 62 and Eva 62 (Barbara is mentioned in the *Times* article of '71) were the first to outline their names. Super Kool 223 was the first to surround a tag with clouds like the speech bubble in comics. In late 1972, Phase2, Lee's cousin, invented the softie or bubble letter. All these innovations made the letters capable of greater graphic development. Tags were enlarged, and when crews of writers began breaking into rail yards they could take time to develop more eye-catching 'signatures'. The discovery that the nozzles on different cans were interchangeable and that wide spray nozzles were available meant they could go on to paint whole trains top to bottom.

Just as photography was so helpful in the early days of the twentieth-century calligraphic revival, so it played a crucial role here also. Initially

it allowed writers to circulate evidence of their 'hits'. But when the film *Style Wars* came out in 1983 and the book *Subway Art* followed in 1984, it allowed the work to be studied in more detail and it spread wider. Amok, a writer in Berlin, where graffiti writing arrived in 1983–4, reported that: 'The bomb really hit with the book *Subway Art*, all of a sudden most of our questioning, such as how to work on a wall or if outlines come first and then the fill-in, were answered…from this moment it spread like wildfire.'[269] Whilst this early photography gave a limited exposure to the work, the fanzines of the early 1990s spread it much more widely and had another effect: local styles began to disappear or go global. People no longer learned from the great writers in their own neighbourhoods. Graffiti writing had spread into the culture in general; it was on clothing and in advertisements and some artists had successfully crossed genre: their art world was that of the gallery.

At its purest, graffiti writing remains the 'tag'; it asserts the presence and skill of one writer to another. Like early cuneiform or hieroglyphics, this writing deals in names. In graffiti, writing somehow got back in touch with its roots, asserting the power of presence, display and personhood and a renewed excitement in the activity of writing itself. Writing has always been an art of risk, because, to borrow a phrase from Lorca's essay on the art of *Duende*, '[It] needs a living body to interpret [it], since these are forms that are born and die endlessly and raise their contours in the exact moment.'[270] So, like a line of music or an arc of dance or spoken poetry, writing can at any moment fall into chaos or hesitation and its flow become completely undone. But if carried through to success it operates on a body 'like wind on sand…and at each moment it moves the arms with gestures which have always been the mothers of dance'.[271]

Graffiti 'writing' has gone on to become a world-wide movement. Today the Far East and Latin America, particularly Brazil (where paint rollers have made a mark), continue to bring new ideas into the field. The phenomenon has become part of the visual experience, *and practice*, of millions of people. As the phenomena grew and as younger generations found their feet socially and politically, graffiti has also become a political force.

The electronic web

In the same years that the graffiti movement was fanning out from its first urban footholds, a new electronic medium of communication was coming to birth. Email had already been many years in development. Back in the early 1960s when the only computers were large time-sharing mainframes, users had found ways of leaving messages for each other on the same machine. Each user had their own file on the mainframe and short messages could be left there with only the owner being able to view them – the message was a hack into their file. In 1972 Ray Tomlinson, a researcher at Bolt, Beranek and Newman, the company that had the contract from the US Department of Defence to set up an interlinked system of computers known as the Arpanet, wrote a short programme in two parts, one part to send mail and one to receive it. He also created the standard email address system we know today, using the @ symbol to separate the user from the host name. By luck his own workplace had two large mainframe computers sitting next to each other in the lab and curiosity got the better of him; he wrote a further programme to send a mail between the two computers – it worked; he had simply thought it a 'neat idea' to try.

The Arpanet had been set up a few years earlier in 1969, by ARPA (Advanced Research Projects Agency), funded by the US Department of Defence. This was the same agency that funded some of Englebart's work, and the man in charge of the initiative at the time was Robert Taylor, future director of Xerox PARC. The idea behind the scheme was to economize by sharing resources (software and data) from one computer to another down leased telephone lines. The network opened with four participating partners or 'nodes' in October 1969 and rapidly expanded.

In the fall of 1972, as a new File Transfer Protocol was being worked on at one of the nodes (MIT), it was decided to piggyback Tomlinson's programme for mail on to the new software. Rapid growth of the Arpanet meant that email, which had already developed on many different computer systems in many forms but for purely local use, now became a highly convenient communication tool across the Arpanet's

distributed sites. By the end of 1973 a report from ARPA concluded that email comprised nearly 75 per cent of the traffic that the Arpanet carried.[272] The popularity of email was a complete surprise.

In an article on 'Applications of Information Networks' in 1978, Joseph Licklider and Albert Vezza describe the advantages that the mail system offered:

> ...in an Arpanet message, one could write tersely and type imperfectly, even to an older person in a superior position and even to a person one did not know very well, and the recipient took no offense. The formality and perfection that most people expect in a typed letter did not become associated with networked messages probably because the network was so much faster, so much more like the telephone ... Among the advantages of the network message services over the telephone were the fact that one could proceed immediately to the point without having to engage in small talk first, that the message services produced a preservable record, and that the sender and receiver did not have to be available at the same time.[273]

The internet, the linked system of telephone lines or satellite connections down which data files and email flowed, had no single point of origin. In one sense it was simply the successor to the global system of communications that began with interconnected postal services, railways, steamships and telegraph at the beginning of the twentieth century. By the 1960s dreamers had begun to imagine a new global network built around computers. In a seminal paper, 'Man Computer Symbiosis', written in 1961, the psychologist Joseph Licklider (1915–90) envisioned a network of 'thinking centres', 'connected to one another by wide-band communication lines and to individual users by leased wire services'. By 1963 Licklider's interests in human computer interaction had led him to be recruited by ARPA to head their 'Information Processing Techniques Office (IPTO). In mails to his staff Licklider imagined what he called an 'Intergalactic Computer Network' where data could be accessed from any point. Licklider (Lick to friends) was one of the key people responsible for creating an awareness of 'The Computer as

a Communication Device',[274] the title of a paper he co-authored with Robert Taylor in 1968. Taylor succeeded Licklider as director of IPTO and he worked to make such a network a reality; he had been forcefully struck by the three computers he had in his office each linking into a different local network but each unable to speak to each other, clearly a waste of energy and resources.[275]

Work to establish connectivity between all the various networks working with email had begun back in 1972, when the InterNetwork Working Group was established. In 1973 several of its members developed an open architecture Transmission Control Protocol (TCP) which they put forward as a new standard that was eventually adopted by the Arpanet in 1983. It became the most used programme for facilitating electronic links between computers. Gradually different local networks began to connect to the larger groups, forming one interlinked global community. Compuserve, a commercial email system, was linked to the wider community in 1989. In 1990 ARPA transferred control over the running of the non-military aspects of the net to the National Science Foundation. In January 1993 the connection to the internet of the online community The WELL (Whole Earth 'Lectronic Link) went live.

By the 1990s, just before the development of the World Wide Web, the achievements of the internet, electronic mail and the desktop computer with a graphical user interface and printer attached were already considerable. Together they were revolutionizing the production and storage of documents of all kinds; they were being developed for teleworking and conferencing, task coordination, powerful modelling and simulation, data collection and manipulation, news services, computer-based education, office work, design work, print production, community news and, in Vannevar Bush's now quaint phrase, the 'augmentation' of the human intellect – spell-check, search and find capabilities, remembering. But from 6 August 1991, when Tim Berners-Lee and a team at CERN* (the European Particle Physics laboratory on the Swiss-French border near Geneva) released a Hypertext Transfer Protocol (HTTP), which

* A name originally derived from the now superseded *Conseil Européen pour la Recherche Nucléaire*, who created the Lab.

they had been working on for the previous two years, the medium of the digital document began yet another transformation.

The concept we now call the web formed gradually, by accretion, from conversations, half-formed thoughts, personal experiments, and thinking about the best way to handle the daily tasks Berners-Lee was engaged in during the course of his work at CERN. In explaining his vision he wrote:

> The fundamental principle behind the web was that once someone somewhere made available a document, data base, graphic, sound, video, or screen at some stage in an interactive dialogue, it should be accessible (subject to authorization of course) by anyone, with any type of computer, in any country. And it should be possible to make a reference – a link – to that thing, so others can find it.[276]

Technically there were three parts to the implementation of this concept. Each document or selected piece of information was given a unique address that would enable a computer to find it – the universal resource identifier or locator (URI or URL), the equivalent of its shelf mark in the library. Secondly, the hypertext transfer protocol (HTTP) that Berners-Lee developed functioned as the equivalent of a request slip to a librarian to go and retrieve the requested material. Thirdly, he developed a new standard for describing what the text should look like on the screen – technically this is called a mark-up language. The term derives from the old paper-based system where editors or publishers marked-up an author's original manuscript ready for printing, noting down on the page all the information that a compositor would need to set the type, i.e. type size and style, paragraphs, page breaks, high-lighting which words needed underlining or setting in capitals or italics. Hypertext Mark-up Language (HTML) does this for web pages.

The beauty of Berners-Lee's system was that it allowed links to be made between documents in a non-hierarchical way; 'anything could potentially be connected to anything',[277] almost as human intuition itself makes very free associations between experiences. It was also

decentralized; no one needed to ask anyone else's permission before they made a link or put a page up on the web.

In the first three years of its use the web grew exponentially, by a factor of 10 each year. From the summer of 1991, when Berners-Lee began tracking the figures, the average number of daily hits grew from 100 a day, to 1,000 in the summer of 1992, to 10,000 in 1993. On 30 April 1993 CERN announced that the World Wide Web would be available for anyone to use free of charge. The eventual global uptake of the World Wide Web seemed assured.

The Material Artefact

Fig. 64. Demonstration of freely written roman capitals from a calligraphy workshop held by the American calligrapher David Mekelburg, The Old Meeting House, Ditchling, Sussex, England, 1998.

By the mid-1990s a new research agenda had made an appearance at Xerox PARC. Though the digital age was breaking over us, it was now that useful insights began to emerge into the way paper documents worked. Sometimes it is not until you think you are losing it that you realize the value of something you had. PARC, on its hot sunny Californian hillside, was always a place with a fairly free-flowing research focus. Now, in a 'happenstantial' way, a grouping of researchers had begun to form around the study of 'documents' and they were provoking new insights. The group included computer scientists, anthropologists, and others interested in sociology, history, typography, philosophy, linguistics and calligraphy. Documents had become a concern within Xerox because in analysing where the corporation had made its mistakes with the Alto some analysts felt the corporation had tied itself too closely to one specific piece of technology, the photocopier, and this had obscured their wider interests. They saw the need to develop a concept for the company that was non-technologically specific. A focus on documents seemed to provide an answer; 'Xerox: the Document Company' was born. But what was a document?

Documents at work

Amongst those working at PARC was the anthropologist Lucy Suchman, leader of the Work Practises and Technology group. She explained her work at the time to inquiring colleagues by pointing to one of the advertisements for a laptop that was appearing in all the magazines. It showed a paper napkin inscribed with notes at the top of the page, a table with two businessmen and a laptop between them on the bottom. Beneath the napkin it read, 'Why do this', then below the scene with the laptop, 'When you can do this?' Suchman suggested taking that question seriously: why might you want to use a paper napkin as a writing medium given the opportunity to use a computer? There are indeed some advantages. The napkin is readily available in a variety of locations,

it has a number of writing surfaces, is easily transported, discreetly used, simply disposed of, and it's free. It is a very handy artefact. The thinking here was that unless one could describe and understand how useful were such simple things, like the paper napkin, it would be difficult to think about systems to handle more complex documents. Suchman's commitment was to 'taking the specificities of each medium seriously, their particular possibilities, and how might they co-exist in generative and useful ways rather than assuming a linear progression wherein each medium that came along will displace the one before'. [278]

Indeed we have only to walk down the high street to see this vision as a reality. My local bank carries out its banking function through a seamless array of technologies that date from different moments in the past and range from materials as varied as the incised lettering in the stonework outside to the still useful but dated fax machine within. Behind the counter clerks are using pens of every description, rubber stamps and ink pads, keypads, carbon paper, printed paper, mobile phones, fountain pens and computer screens, and somewhere out in cyberspace clients are also conducting their banking remotely. Written documents exist in many forms and they work together to provide the substance of the banking experience.

Our graphic culture is diverse, unfolding through all the possibilities that the materials and technologies, the social, political and economic facts allow at any one time, constantly reconfiguring itself – and delicately balanced.

One study at PARC undertaken by Suchman and her group in these years highlighted just how finely tuned the make-up of documents can be; they looked at a regional airport. For many hours a day, activity in the ground operations room was monitored. Researchers watched the flow of documents, paper and electronic, timetables and luggage tags, and observed the movements, behaviours and conversations of the staff involved. Then some months into the programme the building was torn down as part of a scheduled reconstruction programme and the same people were observed doing the same job in the new location. For some reason, the documentation had changed. Yet the people were the same, their schedule was the same, even the landing and departure times of

the aircraft were the same. What had changed were the chairs. In the old operations room, chairs had wheels. People could swivel and scoot across the room to check a colleague's screen or look out of a window to see a hidden part of the tarmac. But now chairs were fixed in rows, as in a lecture theatre. Unable to see a colleague's screen or out of the window, new safety procedures had had to be introduced. An innovation in the architecture of the seating arrangements had caused much of the paperwork and procedures surrounding the working of this part of the airport to change.

Findings like these showed that written documents exist, like animals or plants, within a delicately balanced ecosystem. If you change one aspect of an environment the whole balance may change – and the documentation with it. Even the positioning of a computer on a desk can change the way an office works. What hope have we then of avoiding large-scale disruption when paper systems move over to being digitized?

Whilst documents are fashioned in particular places reflecting particular geographies of work, available technologies and social interactions, many aspects of the work that documents do may remain invisible to the casual observer. In the 1990s, when a photocopying company (it shall remain nameless) was developing a copying machine that printed, collated and bound copies to book printing standards, they built it so that instructions could be sent to the machine and its operator directly via email. Direct human interaction was cut out. This was supposed to save time and effort. They were shocked to discover, in experimental trials, that the amount of documentation surrounding the printing of an item now increased five-fold. They had failed to take into account that the human behaviour of actually walking to the copy office with a document in hand had itself been allowing all kinds of other interactions to happen that promoted the smooth running of the job and even of the larger office, but these interactions were not 'officially' part of the work that the document or employee did. As you walked through the building with your instructions for the printer you noticed which colleagues were in or out, you might stop to chat and exchange information with fellow co-workers. In the print room you could tell how busy they really were, whether they had listened to your instructions or not and whether

you needed to follow up on things later. They could check with you instantly on the paper stock, costings of alternatives, or work-arounds to problems your job might raise. All this was invisible work[279] if you followed only the 'paper trail', but it was vital for the smooth running of both the job and the workplace in general, and all these invisible lines of communication 'went down' once the job was filed by purely electronic means. Informal systems of communication surround our formal ones, and they may be vital not only for maintaining the system but also for other unrelated aspects of the current order of things. Human behaviour is not necessarily linear or narrowly focused, and a material document may be the vehicle for unscheduled yet significant interactions that help make sense of the world and bringing about the pattern of life we have grown used to.

From studies like these, scientists at PARC were coming to understand how significant the physical nature of the document actually was, that its specific material properties were precisely the factors that enabled it to do its particular job of work. But there was a problem: the theorizing that informed the upcoming digital technology took little account of these aspects of material culture and the human behaviours and social structures that interacted with them. The controlling metaphors for the theory of information developed by Claude Shannon in the 1950s had evolved for handling wireless telegraphy. Most professions have a blind spot, what the French call a *déformation professionelle*. What could possibly be the blind spot for a theory founded on wireless telegraphy whose signals pass invisibly through the ether – could it be the lack of an account for the look and feel of things?

Consequently when documents moved, as they began to in the 1990s, from paper to digital media, all the visible and invisible work articulated by this multilevelled system was potentially disrupted. This is the unwritten story behind many of the IT schemes that have shuddered to an ignominious halt within the last decade, from the cancellation of the 'paperless' National Health Service reforms in the United Kingdom in 2011, to the abandonment of the abolition of cheques in the same year. It is also the story that lies behind many notorious lapses in security. It was not simply the scale of the project or the incompatibility

of software that has been a problem, but a more fundamental lack of understanding about the work that documents do *as material artefacts*. Problems arise from thinking of documents simply as 'information', information that can be abstracted from its physical representation and poured from one kind of container to another without loss. In point of fact, as this history has revealed, documents are carefully constructed three-dimensional communicative artefacts; their very materiality (the thing that is lost when they become digital 'information') is implicit to the kinds of work they achieve in specific settings. Of course this is not an argument for *not* facilitating the migration of documents into the digital sphere, but rather for a careful examination of the sophisticated work that paper-based documents already undertake and careful thought about what is going to replace that work – joined-up thinking around documents.

At the same time as this work was being undertaken at PARC in the 1990s, new work was highlighting literacy as a multi-faceted and lifelong skill. Emilia Ferreiro, an Argentinian psychologist who had obtained her PhD under Jean Piaget, argued that 'we must understand literacy as a continuum from childhood to adulthood, and within adulthood a continuum of challenges every time we face a sort of text with which we have no previous experience.' She cited the example of her continued efforts to help her postgraduate students acquire the skills to read specialist articles and, as writers, 'to produce that peculiar kind of academic text called "a thesis"'.

Technological developments in the 1990s demonstrated just how true this observation could be. The year that saw the launch of the World Wide Web, 1993, also saw the launch of the Mosaic web browser by a team at the National Center for Supercomputing Applications (NCSA) at the University of Illinois led by Mark Andreesen. Many browsers were being designed at this time but this was the first to take off. Mosaic was a graphical user interface that made the web accessible in an attractive way; users could both access the web and create their own pages. They could embed graphic images into their text and these images could also have hyperlinks. In the first month of its launch in November 1993,

40,000 copies were downloaded, and there were a million users by the spring of 1994 with versions for Unix, Windows and the Mac.

Also in 1993 commercial short messaging services (SMS) or texting began in Europe and the USA. Today this is the largest communications network for text-based messages, with up to 6 trillion messages being sent a year in 2010.[280] The move to include text-based services alongside telephony dates back to 1982, when it was decided to tackle the incompatibility of early mobile telephone technologies on a Europe-wide basis. As with the introduction of email, SMS piggybacked on this wider scheme using spare capacity on the signalling paths used to control the channels. The introduction of pay-as-you-go SIM cards in 1996 allowed a younger generation to have access to the network, and it was at this point that it became a popular service. Today the development of smart phones with connections to the World Wide Web has led to the convergence of computer and telephone communications technologies. By 2010, whilst the average US user of a mobile phone spent 70 per cent of their time on voice applications, for owners of the iPhone voice conversations over their network represented just 45 per cent of their usage.[281] In the events of the Arab Spring of 2011 a younger generation used these tools to claim public and personal space in a powerful way. As internet and mobile-based services (Facebook, texting, Twitter and mobile phone conversations) coordinated protests and shared information, graffiti writers, street artists and ordinary motivated activists redefined public spaces in other ways.

Behind the intersection of these technologies lay structural changes to the way services over the internet are being delivered. A combination of larger and cheaper data storage facilities, the arrival of high-speed broadband and wireless access to the internet allowed the transfer of much larger files of data between computers over a wider range of locations. With almost limitless storage available and broadband wireless access, computer devices can become 'thinner', with software, text, images and audio files being held off-site (in the Cloud) and beamed down as needed. Drawing on a historic analogy with the supply of electric power, some have argued that computing power has now become a utility, like electricity and water, tapped into when required rather than stored and generated in our own homes.[282]

But in these fast-changing times, speaking at the 26th Congress of International Publishers in 2000, Ferreiro, Professor at the Polytechnic Institute of Mexico, reflected back on the European project of universal literacy and in some sense called its bluff. Eighty per cent of the world population, according to the World Bank, live in areas of poverty. 'We know this eighty per cent exhibits all the indicators of problems for acquiring literacy.' While poor countries have not overcome illiteracy (in 2000 there were approximately one billion illiterate people world-wide – there had been 800 million in 1980), even in rich countries a 'functional' illiteracy was apparent. Today there are many kinds of literacy necessary, for the street, for the workplace, for a social life, for the reading of newspapers or fiction. 'In the first decades of the twentieth century,' Ferreiro writes, 'it seemed that "to understand simple instructions and be able to sign your name" could be considered sufficient. But at the end of the twentieth and the beginning of the twenty-first, such considerations are untenable. Today social and work requirements are much more elevated.'

The picture of writing that was emerging as the twentieth century drew to a close was a multi-faceted one. Human communication was seen to be happening (as indeed it always had happened) on multiple levels, utilizing multiple senses and a range of intersecting but fundamentally different technologies, the possibilities for which fluctuate with changing social, economic, geographical and political realities. Different communities of writers have constantly evolved: in just the last decade of the twentieth century, graffiti writers, users of Post-it notes and fax machines, and those who send text messages. And the mix has since been further enriched by new forms of authorship on the web. Wikis (websites that can be jointly authored), and Blogs (meaning web-log or personal journals on the web) grew in popularity in the late 1990s. Social networking sites were launched in the early noughties. Facebook arrived in February 2003, having grown from a site initially restricted to the campus of Harvard University. YouTube, a site for up-loading and sharing video, was launched in 2005. Microblogging arrived soon afterwards; Twitter, which allows instant messages of up to 140 characters, was launched in 2006. Within three years 40 million Tweets were being sent per day.

Quantity versus quality

With the speed-up of communications systems and expansion of the World Wide Web, the sheer quantity of information that was now available began to seem overwhelming. 'No time to think' was the title of one academic conference held at the University of Washington in Seattle in 2009. In 2010 came Nicholas Carr's *The Shallows: How the internet is changing the way we think, read and remember*, a reminder of how closely interwoven the internet was becoming in many lives and how it was changing our sense of satisfaction with ourselves and, at least in this author's case, making it harder to read deeply. The crucial question was now to become one not of quantity but of quality. How do we turn what we know into embodied wisdom? The question was as old as writing itself. Plato asks as much in his dialogue *The Phaedrus*, written just a few centuries after writing was introduced to Greece. Plato's answer was to argue for the development of a *culture* of reading, writing and debate – and he himself responded by establishing his Academy, which for more than 1,000 years guaranteed the vitality of his thought. The search for ways in which to encourage the mysterious process that somehow transforms knowledge *about* something into instances that we personally *feel and experience as truth* had long been an explicit feature of the paper-based world. Indeed the material culture of this world, the shape of its objects, the nature of the institutions that have grown up alongside them and in which they find currency, *is* the sum of the ways that we human beings have developed, thus far, to engage in this process. It is through a bodily engagement over time – rich in sensual information and channels of knowing – through a contemplative rehearsal, through finding ways of living with the material, in discussion and debate, alongside it in libraries, with books that can be transported to different settings, made with materials and structures that speak to us in satisfyingly embodied ways that we actually digest, coordinate and incorporate the knowledge that documents bear. This is one reason why the history of the material culture of writing is important, and this culture penetrates right down to the level of the individual letter.

Classical Roman typography, for instance, is geared towards enabling readers to give their attention to a text over many hours; to encourage the eye to flow smoothly down a line of writing without tiring. Line length, size of type, margins, the proportions and the heft of a traditional book are all calculated to serve this kind of sustained concentration. Certain letterforms suggest a cultural milieu against which a text is to be read, invoking Luther's Reformation or the classical revival of Greek and Roman literature, a particular age, country or scholarly circle. The centuries-long work on dividing up a text, starting with the *scriptura continua* of the ancient world that required a reader to prepare for a reading (like a present-day musician wrestling with a score), to the much more sophisticated parsing and punctuating of text in eighteenth-century France, all this is part of the process of finding ways of bringing more out of the text by its visible arrangement. The aesthetics of the medium, the choice and feel of paper and vellum, colour, gilding, illustration, the flow and flourish of written lines, were calculated to enable us to engage at all levels with the text – with the full range of our senses. The three-dimensional nature of these artefacts was exploited to separate out different levels of texts that needed different kinds of reading: notes and references, prefaces, indexes and the body of the text. Certain institutions have also grown up around these objects – the library with its special atmosphere and furniture, its codes of behaviour all geared towards encouraging this transformation of knowledge into wisdom. And if the digital medium is to be a useful one for writing and reading, it too will have to develop and interact with similar structures and institutions.

Nonetheless amidst all these new possibilities for authorship and engagement it had been clear at the close of the century that paper-based communication remained strong, a fact that was vividly brought home during the events of 11 September 2001.

As the dust cloud from the falling first tower of the World Trade Center in New York City rolled down the streets of lower Manhattan, it was late at night in Kobe, Japan, where I was teaching calligraphy. I was rooted to the spot, horrified, unable to go to bed. In the days that followed

my computer screen became a window on to events in New York. I watched as written and printed notices appeared outside hospitals and were stuck to the walls of subway stations, appealing for information about missing persons. As time passed these documents became the focus for grieving; other photographs, handwritten poems and notes, flowers and candles appeared. People wrote with everything they could, felt tips, pencils, chalking on the pavements. Within Ground Zero itself fingers had traced inscriptions in the dust on car windscreens and in a deserted hotel lobby. Outside the boundary fences families stood with hand-coloured signs made from large sheets of cardboard which they waved in support of the emergency workers inside. Written artefacts were answering a deep-seated need – not only to ask for information and make sense out of chaos, but to remember, to mark a plot of ground as sacred, to lend their own presence to it. All the pundits' pronouncements about the end of writing in our internet age seemed straw in the wind. The continued significance of paper in the business world could also be seen – strewn across the ground throughout lower Manhattan. The streets were littered with paper.*

One reason I was scouring the internet in those awful days was that I had a friend who worked in downtown Manhattan. He lived opposite the twin towers on the New Jersey shore. At the time the first plane hit, if Dave was following his usual route to work near City Hall, he would have been walking past the building. Ringing his cell phone, his number at work and at home yielded no replies and nor did email, and so it continued for days, indeed months.

On a website dedicated to showing ordinary New Yorkers' images of the disaster I found a photograph; it looked like Dave, his red shirt bundled up over his face to help him breathe, lost in a cloud of dust, ash smudging the lens. Later when the book of photos from the website was published I bought it. I also posted a letter from my home in Brighton to the photographer in New York City and eventually received a copy of the photograph in return. When I next visited New York I found my

* In the Great Fire of London, papers were found as far away as Richmond, 18 kilometres (11 miles) further down the Thames.

way to the temporary venue in SoHo, where all these photographs hung from the ceiling in lines. It was filled with people; hardly any spoke.

Looking back at how I negotiated the interior and exterior landscapes of this tragedy I could not help but notice the wide range of media and written artefacts that I had used, from phone to computer screen; to book and mail and printed photographs; to the plane tickets that took me back to New York City, the maps and signs that guided me to the door of the exhibition, the currency that enabled me to move around and live in the city, the journal I kept most nights. And the paper trail was not over yet. Three years later I designed and wrote a twenty-four-page portfolio of calligraphy about my friend's disappearance which now forms part of a twentieth-century collection of calligraphy in a British museum.[283] Although digital technology dominates our discussion of communication, the reality of our practice is rather different. We live in a world of intersecting technologies.

At the same time I was struck by the ordinary New Yorkers' desire to write: in the face of this disaster there was an upwelling of carefully crafted written artefacts – just as there had been a few years earlier in London following the death of Princess Diana. Writing remained deeply embedded in our society; it answered people's need to feel involved. It continued to offer rich opportunities for engaging with words (and one's fellow humans) in a deep and satisfying way – there is something about the process that changes one. By writing one acts something out, there can be something transformative about this. This appeal reaches far back in time and spans cultures. But why might the physicality of writing still speak to us?

Slowly, during the last century, our awareness in the west of what it means to be human has been changing. Feminist perspectives have brought new understandings, as has an urgent environmental awareness; alternative medicine and body-based therapies, and issues of diet and psychological wellbeing, have all contributed to the gradual desta-bilization of the Cartesian perspective that divided our humanity into body and mind: two irreconcilably different kinds of substances. Antonio Damasio, a leading researcher into human consciousness, describes our 'sense of self' as an awareness emerging as a result of embodied

processes, not just of mind. It is the product of our body's monitoring, and being affected by, the fluctuating composition of the blood and other body chemistry. Combined with proprioceptive feedback from muscles and organs, this gives us a preverbal sense of feeling that we know what is happening and knowing that we know. Consciousness, and a sense of presence to ourselves and the world around us, comes from being in the process of this flow of sensations and feedback. We become aware of our feelings and 'sense of self', in the first instance, by noticing how this ongoing play of sensations and feelings is changed as we move through different encounters with places, people and things. It is precisely through the interplay of all these capacities that writing traditionally worked. It had scent, texture, sheen, scale, colour, architecture, weight, shape and duration, in full measure.

In the hands of artists there can be great refinement in the choice of materials used and messages conveyed. In the Arabic tradition, paper was often tinted by the calligrapher; white was thought too tiring on the eyes and might show the dirt. So madder root, linden blossom, tea, saffron, tobacco, onion peel, henna, pomegranate peel, green verdigris and yellow orpiment were used. Paper could also be scented with musk, ambergris or rosewater.[284] Paper was given a coating of size made from starch or beaten egg white and alum, to stop the ink bleeding into the surface, and then it was polished so the pen could slide easily without catching on a fibre; jade, glass and onyx were used as burnishers. Finally it was trimmed to size. The long scissors for this were a calligrapher's treasured possession, as were the toughened steel knives for cutting the reed pen, and the ivory *makta* on which it was placed for the final nibbing.

Why do these experiences matter? They stand for a way of being human, sensually alive in and with the world.

Writing and dancing, movement and time

Writing is much more than a mere record of speech. Some script elements, colours, changes of styles of lettering, from roman to italic or gothic, have no direct reference to speech, and there is much that writing of course can miss: intonation, speed, rising and falling volume,

the way speech and facial expressions interact, as well as the alliance of speech with gesture, in an interplay of choreographed signals passing between speaker and listener. None of this writing captures.

But writing also does more than speech. It communicates through different senses, colour, shape, heft, texture. It also has a different relationship to time. Its substrates can last for a long period, often way beyond the lifetime of the author. It can physically travel through great distances, it can be constructed collaboratively, its length can 'go on' for far longer than someone can talk without pause. It can be revisited. Writing can also be integrated with illustrations. It can arrange things visually, in tabular and radial and nested forms that are difficult to do in spoken language (think of Eusebius's books); there is no aural equivalent to the index and contents page. Writing is implicated in the way we arrange our relationships and build and coordinate our institutions, precisely taking off at that point where things become too vast (as in the nineteenth-century factory) or too complex (the encyclopaedia) for speech to work effectively. As one of the early readers of this book, Mike Hales, expressed it to me: 'Writing and speech enjoy a partnership, our lives potentially unfolding through the choreography of now one, now the other', like two cranes dancing in an elaborate courtship.

The other aspect of the primitive materiality of writing that we should not forget is the writer's own movement: the very act of writing itself, which swings through arcs of activity, and also slows and pauses whilst thoughts are gathered. When a pen finally falls into action, the joy of being a fluent writer and a calligrapher is released. It is as if you are a free-runner in a city of letterform, surmounting all the special problems in an instant: how do I make a **W** and an **O** appear harmonious? How do I flow from the bottom of a capital **S** up into and out of a capital **H** all in one movement? This delight in movement is shared by all traditions. The aim is to go beyond technique and feel the form in the entire body. When that point is reached, the whole world around one begins to speak in terms of form, movement and structure. And it is a two-way process, as you experience the world differently so your awareness of your own aliveness is changed; and as your sense of your aliveness in your body alters, so you discover the world around you in yet another

light. This cycle keeps repeating itself. This is why calligraphy offers a lifelong path of exploration and discovery. Though I am only moving the tip of a pen, it is as if my whole self is tumbling after it.

The practice of calligraphy can make us more aware of ourselves and heighten our appreciation of the movement of life in and around us – for writing is a gestural art. Jean François Billeter in his book *The Chinese Art of Writing* describes a particular feature of the process:

> [When] the manner of perceiving external reality changes: it is no longer things in themselves that hold our attention, but the movement which quickens them and the expression which emanates from them. It is no longer a face, but the hint of a smile; nor a woman, but a particular step and bearing; not the kitten, but his pranks. Observation becomes quicker and more nimble. It catches on the wing what we may call 'expressive moments': not fixed instants, such as a snapshot might record, but 'moments' of a quality which only a gesture can reproduce – a musical or calligraphic gesture for instance. It is these 'moments'…which the calligrapher perceives with increasing keenness as he progresses, and which he puts into his calligraphy.[285]

Chinese calligraphy is full of anecdotes about breakthrough events, when calligraphers glimpsed a new way to move. Chang Hsü (*c.* 658–748) – the (often drunk) master of 'mad cursive' – discovered the final secret to his calligraphy through several times watching the performance of the famous woman sword dancer, Kung-sun. There are stories of calligraphers having their writing transformed by experiences as varied as listening to a waterfall, seeing a snake fight or watching the tussle between a princess and a burly porter as they try to pass each other, without touching, on a narrow pavement. The point of all these incidents is not that they are seen by the eye, but that they are experienced as a flow of movement within the body of the watching writer. Billeter quotes from Ting Wen-chün, who writes in his *Essential Principles of Calligraphy:*

> Let me explain, anything in this world can become a figure: in the earthly realm, flowing waters, towering mountains, splintering cliffs,

peaks growing bare; in the celestial realm, the stars clustering around the Great Bear and those scattered far and wide, the setting sun and the moon brightening as it rises; in the human realm, a girl decking her hair with a flower or the warrior brandishing his sword; in the realm of the air, the passing winds and scudding clouds, the gathering mists and lifting fogs; in the realm of living beings, the swan winging across the sky or the pond-lily rocked by the water.

When we perceive these figures and internalise them, we transform them into pregnant figures which we subsequently externalise in various arts.[286]

As Billeter explains, the key thing here is that Ting Wen-chün speaks of perceiving the natural world in dynamic form: 'Mountains *tower up*...cliffs *splinter*, peaks *grow bare*'. What he is sensing is not a purely visual phenomenon but particular kinds of activity within and behind phenomena.

This experience of sensing movement in the natural world and transferring it into the felt movement of writing is shared across many traditions. The great Persian fifteenth-century calligrapher, Mir Ali of Tabriz, is reported to have invented the *Nastaliq* style of calligraphy after a dream of a flight of geese. His letters hang in the air whilst descending gently through the word in the direction of the writing; some of the line lengths are drawn out, and some are very small, even while the whole is still carefully regulated according to a system of proportional measurement using the rhomboid dot.

And here is Zasd in more recent times:

I perceive structures and move within them...A tangle of branches in winter, or in summer, a stone, fire, a child's drawing, the flight of a formation of birds above a city, a moving train, hair wafting in the wind, the sea, the cityscape but also the melody of birdsong, a rattling sound in a subway station, the silence of a place...I just let the film roll...then the style flies to me.

Zasd is a contemporary German graffiti writer; so is Akim. 'A word can be felt. A word can also be danced.'[287]

Mark-making and experience of the present moment

At the root of this experience I recognize a phenomenon described by the psychologist Daniel Stern, which he calls 'vitality affects'. The ability to experience the world through movements, gestures or figures is essential to a basic human communicative process, through which we build our understanding of each other's subjective experience. Stern has looked at these affects from a number of perspectives. In the mother/ infant relationship work for which he is famous, Stern found certain pre-verbal dynamic features of the exchanges jumping out at him. A key observation was how mothers show babies they understand, or share what a baby is feeling. He gives an example:

> A ten-month-old girl is seated on the floor facing her mother. She is trying to get a piece of a puzzle into its right place. After many failures she finally gets it. She then looks up into her mother's face with delight and an explosion of enthusiasm. She 'opens up her face' (her mouth opens, her eyes widen, her eyebrows rise) and then closes back down. The time contour of these changes can be described as a smooth arch (a crescendo, high point, decrescendo). At the same time her arms rise and fall at her sides. Mother responds by intoning, 'Yeah' with a pitch line that rises and falls as the volume crescendos and decrescendos: 'yeeAAAaahh.' The mother's prosodic contour matches the child's facial-kinetic contour. They also have the exact same duration.[288]

The point Stern makes is that the mother shows the baby that she understood her joy and delight, not by directly imitating what the baby did but by switching to a different modality – from a bodily movement to a sound:

> But she kept the dynamic features faithfully, i.e. there was a matching of the vitality form … The girl then understood that her mother was not just imitating, but that something similar was in the mother's known experience and was shareable between the two. The match

thus becomes a match of internal feeling states, not overt behaviours. Some sense of mutual understanding has been established.

The 'vitality affect' is the particular pattern of this surge of feeling and falling away that both mother and baby experienced.

Stern's interest in these interactions came from a curiosity about how we develop our felt understanding of what it is like to be another person, our sense of inter-subjectivity. His later work, looking at the present moment, also focused on those shared moments when we know we understand and are understood; and specifically, the moments in therapy when transformative change becomes possible. This led him to understand that: 'There is another aspect of the subjective "now" that is both startling and obvious. The present moment does not whiz by and become observable only after it is gone. Rather, it crosses the mental stage more slowly, taking several seconds to unfold. And during this crossing, the present moment plays out a lived emotional drama. As the drama unfolds it traces a temporal shape like a passing musical phrase'[289] ...or like that child's smile in the previous example.

In other words the present moment actually has a duration and it has a sense of a dynamic event, almost a small story lying within it. This dynamic has a shape or 'figure', best described in terms of adjectives or adverbs like exploding, surging, accelerating, gliding, pulsing, fluttering, tense, weak, fading. These are all different vitality affects, different patterns of intensity in our neuronal firings – before they ever become registered as emotions. These temporal patterns are similar to the affects being described by Ting Weng-chüng: rising up, splintering, becoming bare, clustering, scudding, lifting up like mist; or again by Zasd, who said his style is inspired by fire, or hair wafting in the wind, or a rattling sound in the subway: and they are also the dynamics that enabled the tenth-century Swiss monk mentioned in Chapter 3 to encapsulate a capital letter's structure in a short scriptural quotation and story.

In the shapes of its strokes and letters and characters, calligraphy expresses temporal dynamic forms, through movements of the body that incorporate specific material objects and media. The elements that

make up letters are expressing subtle combinations of affects – traces of movements that produce shoulders, angles, curves, rising lines, falling lines, accelerating lines or ones that fade away; this is especially so when they are orchestrated into families of related forms. When combined together and allowed to expressively modulate letter structure in subtle ways, these dynamics put the art into writing, just as they do into musical phrasing, the precise articulation of a piece of choreography, or the way a movie is edited. This is why writing as an activity – expressive mark-making – can add an important dimension to the written word.*

It seems that making sense of our inner experience of being, via marks and images, may go back a very long way. Leroi Gourhan, the French palaeo-archaeologist, believed that writing co-evolved with speech, not recording it but creating what he called 'graphism', the capacity to express thought and feeling in material symbols.[290] He suggested that the capacity grew from the kinds of movements that accompanied story-telling, chanting and acting out the mythic world – gestures that built up around rhythmic tool use (drumming, slicing, incising) and mark-making using coloured pigments. All this dates, Gourhan argued, from at least 35,000 BCE and perhaps much earlier.

It is possible that in future some of the discoveries that cognitive archaeologists are making, about the nature of art in the palaeolithic period and in the decoration of the earliest built dwellings in settlements such as Çatalhöyük on the Konya plain in Turkey, may also become part of the explanation of the origins of writing. Members of these societies seem to have placed visual and neural experiences (which perhaps they did not understand – though they are normal and sometimes enhanced experiences of shifting human consciousness) in a cosmological context. This was part of an adjustment at a social level 'to make shared sense of the diverse mental states everyone experiences'.[291] The cosmos they structured included animals that entered and left the rock surface as they entered and left our dreams or waking states, and they included rhythmic marks: grids, sets of parallel lines, bright dots, zigzags or undulating lines, nested arcs and sections of vortex. These

* For Stern's fullest view on vitality in the arts, see his *Forms of Vitality*, Oxford, 2010.

perhaps referenced phenomena in vision or other bodily experiences. From the locations where palaeolithic and neolithic artists positioned these motifs, in ritual sites and burial chambers, we can see that they appear to signify and enact communication or transmission through different layers of reality, as these societies then conceived their world. As regards writing, it is interesting to note that the combination of images from the animal kingdom with specific types of geometric patterns is similar to the graphic material exploited in a number of early writing systems.

Perhaps writing at its very origins was a particular kind of focal activity that by partially separating a thought or experience out from ourselves (putting it out there) allowed us and others to approach it (and us) in another way. So the process was one of partial disassociation and then re-association or reincorporation in another modality – almost as the act of cell division allows an organism to grow and develop. No wonder the Chinese thought of writing as incorporating the very energy of life itself.

Information and material culture

Towards the end of his book *The Information*, James Gleick, the American author, journalist and biographer, introduces a caveat to the systematic application of Claude Shannon's theory of information that Gleick's book takes as its principal theme. 'The birth of information theory came with its ruthless sacrifice of meaning – the very quality that gives information its value and its purpose. Introducing *The Mathematical Theory of Communication*, Shannon had to be blunt. He simply declared meaning to be "irrelevant to the engineering problem". Forget human psychology: abandon subjectivity.'[292]

As the author Nicholas Carr writes in his review of Gleick's book, 'Even some of Shannon's contemporaries expressed fears that his theories might end up warping our understanding of knowledge and creativity.' As Gleick himself documented, 'The physicist Heinz von Foerster worried that, in separating meaning from message, Shannon risked reducing communication to a series of "beep beeps." Information,

he argued, can only be understood as a product of the human search for meaning – it resides not "in the beeps" but in the mind…The danger in taking a mathematical view of information, with its stress on maximizing the speed of communication, is that it encourages us to value efficiency over expressiveness, quantity over quality. What information theorists call redundancy, it's worth remembering, is also the stuff of poetry.'[293]

So my plea as I come to the end of this history of the written word is that we do not let a lack of attention to the look and feel of things in our framing of digital technology limit its potential. Men such as Steve Jobs and his designer at Apple Jonathan Ive (as well as the market response to their ideas) have clearly shown that design and craftsmanship have a part to play in the digital sphere. But there is so much more we could do: invest in decent typefaces for use on screens, bring writing to life through animation (it is after all something of a performance art), and look at the way different technologies, paper and digital, could speak one to another. To those of us who spin the golden thread of written communication I commend each tiny fibre that twists, knots and entangles itself into the thread as time goes by, celebrate their intersections, their parallel paths, and their differences and may this spinning never cease.

Writing, at its best, can celebrate the whole way we explore the material world and its sensuality to think and communicate; this *is* what writing does. My belief is that future generations will continue to search for and respond to joy in writing and reading and beauty in written artefacts, and to generously share these experiences. We should expect and demand to be supported – in the digital domain as elsewhere – in pursuing these profoundly human aims.

I began this book in Venice, just across the canal from the church of Madonna dell'Orto (the church of the Madonna in the garden), in Cannaregio. Just behind the church, the *vaporetti* ply out to Murano and beyond to Torcello, where the first residents of the city came after the destruction of nearby Roman towns by the Huns. From the end of the lane that the house is on, I could turn right to the ghetto, the metal

workers' quarter where the Jewish inhabitants of the city still have their synagogues, or immediately left to the Campo dei Mori, the square of the Moors. Ten minutes further in that direction I would find the area where Marco Polo lived, that early explorer of China. I am surrounded by different script traditions. Over the bridge on the way to the super-market I pass the church where the funeral service for Nicolas Jenson, the type-maker, was held one September, 530 summers ago. Down by St Mark's, the palace still stands where Tagliente plied his pen in the service of the Doge. Opposite is the St Mark's Library (Biblioteca Marciana) where Petrarch's books came to rest and, though I didn't know it when I began this book, now, as I come to the end of it, my next job, lying ready waiting for me in my workroom upstairs, is for an exhibition in the Correr Library, next door to the Marciana. The first piece of callig-raphy I have done since I began this book (other than a Christmas prayer book for the eponymous Miss Bliss), it's a contribution to an exhibition on 'The Poetics of Written Space'.

This city, *La Serenissima*, is a good metaphor for everything this history of writing has been about. Like the city's occupants, writing finds many employments and has done for centuries. As the new day dawned in the 1500s, lawyers reached into the muniments chest and took out their papers, merchants heaved huge ledgers off the shelves, schoolchildren placed their writing materials in bags to take to school, cooks and shoppers of all kinds drew up lists and ticked off purchases, mariners unrolled their charts, musicians unfolded their scores, and the clergy of St Mark's creaked open elderly manuscripts to chant from – as they do, much the same, to this day. On the tombs of Titian and the Doges of Venice incised letters catch the light; around the Bellini in the Frari letters gleam in the golden mosaic above the Virgin. In the homes and guildhalls of the city citizens debate and vote, love and hate. Today, tourists add another layer of paper documents: tickets and passports, hotel bookings, credit cards, receipts; the guidebooks and maps they unfold, the posters that draw them to exhibitions. This is the world of the written word; all happening simultaneously; all coexisting – the credit card in the machine in the shops by the Rialto, with Sanvito's books in the Marciana. It is like a profuse garden,

a kitchen of activity, a parliament of voices, come cook, come live, come write!

Oh, luxuriant, dancing, alluring and bedevilled writing, 'gone out, gone beyond, gone beyond me...'*

* The final line of 'Plutonian Ode' by Allen Ginsberg, 1978; *Symphony No. 6, Plutonian Ode*, by Philip Glass, Orange Mountain Music, 2005.

Newport Community Learning & Libraries

Notes

1 See D. M. Levy, *Scrolling Forward. Making Sense of Documents in the Digital Age*, Arcade, 2001.

2 From a 1997 conference speech for Apple third party software developers, quoted in the obituary for Steve Jobs, *Guardian*, 6 October 2011.

3 From the obituary for Steve Jobs, *New York Times*, 6 October 2011.

4 R. D. Woodard, *Greek Writing from Knossos to Homer*, Oxford University Press, 1997.

5 S. V. Tracy, 'Athenian Letter-Cutters and Lettering on Stone in Vth to Ist Centuries B.C.', in M. S. Macrakis (ed.), *Greek Letters: from Tablets to Pixels*, Oak Knoll Press, 1997, and also 'The Lettering of an Athenian Mason', *Hesperia: Supplement XV*, American School of Classical Studies at Athens, 1975.

6 H. T. Wade-Gery, 'A Distictive Attic Hand', in *Annual of the British School at Athens*, 33, 1935, pp. 122–35.

7 For the origins of this erasure, see H. Flower, *Ancestor Masks and Aristocratic Power in Roman Culture*, Oxford University Press, 1996, pp. 173–6.

8 R. Laurence, *The Roads of Roman Italy*, Routledge, 1999, p. 157.

9 Now in the offices of the Mobil Corporation in Chicago.

10 Greek writing in Egypt has shown the influence of such a pen from as early as the third century BCE. See Berlin, Staatliches Museum, P. Berol. 13270, in S. Morison, *Politics and Script*, Clarendon, 1972, p. 17.

11 Musée of Arles and Provence: marble votive shield, a copy of a golden shield awarded by the Senate to Augustus.

12 Giessen Hochschulbibliotek Pap. Landana 90 (inv.210). For illustration of main text see http://bibd.uni-giessen.de/papyri/images/piand-inv210recto.jpg. Accessed 5 September 2011. And see J. Austin, *Cicero's Books and the 'Giessener Verres'*, published electronically, 2008, at http://www.academia.edu/676268/Ciceros_books.

13 Learning writing or 'acting as a scribe' was prohibited to slaves from 1740 in North Carolina and many other states followed; reading was encouraged up until the 1830s but then forbidden out of fear of communication between slaves and the power of knowledge of a wider world.

14 See J. Svenbro, *Phrasikleia: An Anthropology of Reading in Ancient Greece*, Cornell, 1993.

15 P. Mich.III, 166.

16 For a complete translation of Diocletian's Edict on Maximum Prices see F. Tenney, *An Economic History of Ancient Rome*, vol. 5, Johns Hopkins, 1940, pp. 310–421.

17 Translation from L. Casson, *Libraries of the Ancient World*, Yale, 2001, p. 104.

18 See C. H. Roberts and T. C. Skeat, *The Birth of the Codex*, Oxford University Press, 1983, pp. 37–9.

19 Throughout this section I am heavily indebted to the account in A. Grafton and M. Williams, *Christianity and the Transformation of the Book: Origen, Eusebius, and the Library of Caesarea*, Harvard University Press, 2006. This particular reference comes from p. 69.

20 ibid., p. 79.

21 ibid., pp. 132–232.

22 Burgerbibliothek Bern Ms 36, an addition at the very end of the manuscript.

23 See E. Clayton, *Embracing Change: Spirituality and the Lindisfarne Gospels*, privately published, 2003.

24 See R. McKitterick, *The Carolingians and the Written Word*, Cambridge University Press, 1989, pp. 77–135.

25 See L. Thorpe (trans.), *Two Lives of Charlemagne*, Penguin Classics, 1969.

26 Paris BNF, MS Lat 1203.

27 For details see C. de Hamel, *The Book. A History of The Bible*, Phaidon, 2001, p. 70. This and de Hamel's *A History of Illuminated Manuscripts*, Phaidon, 1986, are the most engaging treatments of the medieval book.

28 De Hamel, *The Book. A History of The Bible*, p. 68.

29 P. Johnston, *Edward Johnston*, Faber, 1959, p. 265.

30 See the text capitals in the St Bavo Cartulary B.L. Add. Ms. 16952, S. Knight, *Historical Scripts*, Oak Knoll Press, 1998 (2nd edn), pp. 62–3.

31 The Rule of St Benedict chapter 57, translation by D. Parry, *Households of God*, DLT, 1980, pp. 150–51.

32 See entry for 1085 in *The Anglo-Saxon Chronicle* at Project Gutenberg http://www.gutenberg.org/ebooks/657. Accessed 18 October 2010.

33 M. T. Clanchy, *From Memory to Written Record*, Blackwell, 1993 (2nd edn), p. 83.

34 For numbers of charters, see ibid., pp. 28–9, 50.

35 See McKitterick, *The Carolingians and the Written Word*, pp. 77–134.

36 See N. Orme, *Medieval Schools*, Yale, 2006, p. 48.

37 See I. Illich, *In the Vineyard of the Text*, Chicago University Press, 1993, p. 15. I rely on Illich's account of the *Didascalicon* in this section.

38 E. Clayton, 'Workplaces for Writing', in M. Gullick, *Pen in Hand: Medieval Scribal Portraits, Colophons and Tools*, Red Gull Press, 2006, pp. 1–17.

39 Bibliothèque Royale Albert 1er 9278–80, f.10r.

40 Metropolitan Museum of Art, Robert Lehman Collection, Acc. 1975.1.2487.

41 For a lens on a stand, see Vincent of Beauvais in his study at BL. Royal 14E.i, vol. 1, f.3.

42 See the de Brailes Hours (BL Add. 49999).

43 De Hamel, *A History of Illuminated Manuscripts*, p. 167.

44 E. Duffy, *Marking the Hours*, Yale, 2006, p. ix.

45 Details in L. Pl V. Febvre and H.-J. Martin, *The Coming of the Book: The Impact of Printing 1450–1800*, Verso, 1976, p. 28.

46 P. Beale, *England's Mail: Two Millennia of Letter Writing*, Tempus, 2005, p. 99.

47 Translated by David Burr, History Department, Virginia Tech, Blacksburg, VA, athttp://www.history.vt.edu/Burr/Boccaccio.html, sourced 6 January 2010.

48 K. R. Bartlett, *The Civilization of the Italian Renaissance: A Sourcebook*, University of Toronto Press (2nd edn), 2011, p. 29.

49 ibid., p. 28.

50 See E. H. Gombrich, 'The Revival of letters to the reform of the arts: Niccolò Niccoli and Filippo Brunelleschi', in D. Fraser et al. (eds.), *Essays in the History of Art presented to Rudolf Wittkower*, pp. 71–82. Reprinted in *The Heritage of Apelles*, Lund Humphries, 1976.

51 ibid., p. 103.

52 B. L. Ullman, *The Origin and Development of Humanistic Script*, Edizioni di storia e letteratura, 1960, p. 132.

53 See A. C. de la Mare, 'The Book Trade', *Journal of the Warburg and Courtauld Institutes*, vol. 39 (1976), pp. 239–45.

54 See P. Shaw, 'Bartolomeo Sanvito, Part two', *Letter Arts Review*, vol. 19, no. 2, 2004, pp. 19–23, and also P. Shaw, 'Poggio's Epitaph', *Alphabet*, Summer 2008, pp. 11–17, where he suggests a role for Poggio Bracciolini in the development of the carved epigraphic capital.

55 Mary Bergstein, 'Donatello's Gattamelata and its humanist audience', *Renaissance Quarterly*, September 2002.

56 See A. C. de la Mare and L. Nuvoloni, *Bartolomeo Sanvito. The Life and Work of a Renaissance Scribe*, Association Internationale de Bibliophilie, 2009, p. 21.

57 See P. Shaw and S. K. Meyer, 'Towards a New Understanding of the Revival of Roman Capitals and the Achievement of Andrea Bregno', in C. Crescentini and C. Strinati (eds.), *Andrea Bregno: Il Senso della Forma nella Cultura Artistica del Rinascimento*, M & M Maschietto Editore, 2008.

58 J. Wardrop, *The Script of Humanism*, Oxford University Press, 1963, p. 8.

59 B. Platina, *Lives of the Popes*, BiblioLife, 2009 (original 1474), pp. 275ff.

60 See Shaw, 'Bartolomeo Sanvito, part two', *Letter Arts Review*, p. 23.

61 See Martin Davies, 'Juan de Carvajal and Early Printing: The 42-line Bible and the Sweynheym and Pannartz Aquinas', *The Library*, 6th series, vol. 18, no. 3, 1996, pp. 193–215.

62 De Hamel, *The Book: a History of the Bible*, pp. 194–6.

63 See Shen C. Y. Fu, *Traces of the Brush*, Yale, 1977, p. 4.

64 H.-J. Martin, *The History and Power of Writing*, University of Chicago Press, 1994, p.211.

65 An accessible account of Gutenberg's invention, including its logistical implications, can be found in J. Man, *The Gutenberg Revolution*, Review, 2002.

66 Blaise Agüera y Arcas, 'Temporary Matrices and Elemental Punches in Gutenberg's DK type', in K. Jensen (ed.), *Incunabula and Their Readers: Printing, Selling and Using Books in the Fifteenth Century*, British Library, 2003, pp. 1–12.

67 See Peter Spencer, 'Scholars press for printing clues', *Princeton Weekly Bulletin*, http://www.princeton.edu/pr/pwb/01/0212/. Accessed 21 January 2010.

68 See Gombrich, *Heritage of Appelles*, p. 103.

69 A. Pettegree, *The Book in the Renaissance*, Yale, 2010, p. 54.

70 ibid., pp. 54–5. Pettegree cites numerous sources for his position on these pages.

71 R Hirsch, 'Stampa e Lettura fra il 1450 e il 1550', in A. Petrucci (ed.), *Libri, editori e pubblico nell'Europa moderna: guida storica e critica*, Laterza, 1977, p. 17.

72 A. Kapr (trans. D. Martin), *Johann Gutenberg: The Man and his Invention*, Scolar Press, 1996, pp. 180–83.

73 See H. Carter, *A View of Typography up to about 1600*, Hyphen Press, 2002, first published Oxford University Press, 1969, p. 74.

74 They have a similar feeling to inscriptional capitals from the period of the Emperor Antoninus (ruled 138–161 CE), flowing tails to the bowls of **R**, **P** bigger than bowls of **R**, slightly narrowed **H**, **M** and **N** with serifs on the top left-hand stroke; see (CIL XIV, 5326), a dedication of an altar to Concordia after 140 CE (http://commons.wikimedia.org/wiki/File:Inscription_Faustina_Antoninus_Ostia_Antica_2006-09-08.jpg), and an inscription from Puteoli from 139 CE (CIL X.1642), reproduced in J. Muess, *Das Römische Alphabet*, Callwey, 1989, pl. 78, p. 89.

75 From the dedication to Cesare Borgia of an edition of Petrarch (1503) quoted in J. Kostylo (2008), 'Commentary on Aldus Manutius's Warning against the Printers of Lyon (1503)', in *Primary Sources on Copyright (1450–1900)*, ed. L. Bently and M. Kretschmer, www.copyrighthistory.org.

76 See Carter, *A View of Typography up to about 1600*, p. 74.

77 See P. Bain and P. Shaw (eds.), *Blackletter: Type and National Identity*, Princeton Architectural Press, 1998, p. 48.

78 A. Kapr, *The Art of Lettering*, Saur, 1983, p. 96.

79 M. Lyons, *A History of Reading and Writing*, Palgrave Macmillan, 2010, p. 47.

80 John Calvin's contribution runs to fifty-nine volumes in the *Corpus Reformatorum*, published under various editorships between 1863 and 1900.

81 See Orme, *Medieval Schools*, for an account of schooling in Britain in this period.

82 Quintilian, *Institutes of Oratory*, Book I, Ch.I, trans. H. E. Butler, 1920, at http://www.molloy.edu/sophia/quintilian/education.htm. Accessed 27 July 2010.

83 Codex Vaticanus 6852.

84 S. Morison (see 'Introduction' to *The Mollyus Alphabet*, Pegasus, 1927, p. 17) argued for the lettering section being written as early as 1483.

85 See R.E. Taylor, *No Royal Road: Luca Pacioli and His Times*, University of North Carolina, 1942, p. 275.

86 Other works in this vein included *Opera del Modo de Fare le Littere Maiuscole Antique* by Francesco Tourniello, Milan, 1517, Albrecht Dürer's set of capitals in *Underweysung der Messung*, Nuremberg, 1525, and Geoffrey Tory's in *Champ Fleury: L'art et science de la proportion des lettres*, Paris, 1529.

87 Ludovico degli Arrighi in the Preface to his *Operina* of 1523, trans. J. H. Benson, *The First Writing Book*, Yale, 1954.

88 Translation from Benson, *The First Writing Book*.

89 Translation from E. R. Chamberlin, *The Sack of Rome*, Batsford, 1979, pp. 175–6.

90 British Library, Cott. Vit. B. IX, f.121.

91 See S. Morison, *Early Italian Writing-Books*, British Library, 1990, p. 78.

92 He published four: the *Essemplare* (1560); *Il Perfetto Scrittore* (1570); *Il Perfetto Cancellaresco Corsivo* (1579); and a compilation of his works by Silvio Valesi, *Il Quatro Libro* (1596).

93 A. S. Osley, *Scribes and Sources*, Faber, 1980, p. 243.

94 ibid.

95 H. Zapf, *Feder und Stichel*, Stemple, 1949.

96 Osley, *Scribes and Sources*, pp. 160–70.

97 A. Petrucci, *Public Lettering, Script, Power, and Culture*, University of Chicago Press, 1993 (originally published in Italian as *La Scrittura: Ideologia e rappresentazione*, 1980).

98 M. Butor, *Les mots dans la peinture*, Skira, 1969, p. 65.

99 H. D. L. Vervliet, *French Renaissance Printing Types: A Conspectus*, Bibliographical Society, Printing Historical Society and Oak Knoll Press, 2010, p. 15.

100 Carter, *A View of Early Typography up to about 1600*, p. 125.

101 Translated in R. Chartier, *The Order of Books*, Stanford, 1994, p. 49.

102 V. Nutton, *Matthioli and the Art of Commentary*, at http://www.summagallicana.it/lessico/m/Mattioli%20Pierandrea.htm. Accessed 1 December 2010.

103 See M. Infelise, 'Roman Avvisi: Information and Politics in the Seventeenth Century', in G. Signorotto and M. A. Visceglia (eds.), *Court and Politics in Papal Rome, 1492–1700*, pp. 212–28.

104 H. Love, *The Culture and Commerce of Texts: Scribal Publication in Seventeenth-Century England*, Oxford University Press, 1993, p. 10.

105 See under C for Charlatan in Voltaire's *The Philosophical Dictionary* (1764), trans. H. I. Woolf, Knopf, 1924, at http://history.hanover.edu/texts/voltaire/volindex.html. Accessed 24 November 2010.

106 Pettegree, *The Book in the Renaissance*, pp. 338–9.

107 Love, *The Culture and Commerce of Texts*, p. 74.

108 See P. Sutton, *Love Letters: Dutch Genre Paintings in the Age of Vermeer*, Bruce Museum and National Gallery of Ireland, 2003, p. 28.

109 S. E. Whyman, *The Pen and the People. English Letter Writers 1660–1800*, Oxford University Press, 2009, p. 49.

110 See J. How, *Epistolary Spaces: English Letter-writing from the Foundation of the Post Office to Richardson's Clarissa*, Ashgate, 2003, p. 54.

111 Whyman, *The Pen and the People*, p. 53.

112 See http://www.essentialvermeer.com/documents/vermeerdocuments.html. Accessed 16 January 2013.

113 J. M. Montias, *Artists and Artisans in Delft*, Princeton, 1982, p. 229.

114 A. J. Adams, 'Disciplining the Hand, Disciplining the Heart: Letter-writing, Paintings and Practices in Seventeenth-Century Holland', in Sutton, *Love Letters*, n. 58, p. 75.

115 Translation as in C. Mediavilla, *Calligraphy*, Scirpus, 1993, pp. 223–4.

116 Martin Billingsley, *The Pen's Excellencie or the Secretaries Delight*, London, 1618; the entire book can be found http://www.english.cam.ac.uk/ceres/ehoc/billingsley/simple.html.

117 Quoted in M. Ogborn, 'Geographia's pen: writing, geography and the arts of commerce, 1660–1760', *Journal of Historical Geography*, vol. 30, issue 2, April 2004, pp. 294–315, originally from T. Watts, *An Essay on the Proper Method for Forming the Man of Business* (4th edn), London, 1722 (originally published in 1716), p. 17.

118 See a range of references in M. Caruso, 'Hacer Buena letera': *The disciplinary power of writing in early modern Spain*, a paper presented at the CIES Annual Conference, New York, 2008, p. 8 at http://huberlin.academia.edu/MarceloCaruso/Papers/145756/Hacer_buena_letra._The_disciplinary_power_of_writing_in_early_modern_Spanish_pedagogy. Accessed 20 April 2011.

119 See map in I. Barnes and R. Hudson, *Historical Atlas of Europe*, Arcadia, 1998, p. 93.

120 See J. Guy, *Tudor England*, Oxford Paperbacks, 1990, p. 418.

121 J. Humphries, *Childhood and Child Labour in the British Industrial Revolution*, Cambridge University Press, 2010, p. 307.

122 Martin, *The History and Power of Writing*, p. 339.

123 Discussed in Beale, *England's Mail*, pp. 225–6.

124 D. Cressey, *Literacy and the Social Order, Reading and Writing in Tudor and Stuart England*, Cambridge University Press, 2006, pp. 177–8.

125 Originally published as *Le Secrétaire de la cour*, Paris, 1625. See L. Green, 'French Letters and English Anxiety', in *Huntington Library Quarterly*, vol. 66, no. 3/4, pp. 260–74. The 1641 edition with the new title was printed in Amsterdam and was reprinted ten times and translated into English, Dutch, German and Italian.

126 Whyman, *The Pen and the People*, pp. 30–45.

127 J. Evelyn (ed. G. de la Bédoyère), *Diary*, Woodbridge, 1995, p. 24, 16 July 1635.

128 Whyman, *The Pen and the People*, p. 30 and n. 95, p. 262.

129 Wardrop, *The Script of Humanism*, p. 2.

130 See Pettegree, *The Book in the Renaissance*, pp. 307–11, and Versalius's own preface to *De Corporis Fabrica* at http://www.stanford.edu/class/history13/Readings/vesalius.htm. Accessed 24 May 2012.

131 See Galileo Galilei, 'Letter to Madame Christina of Lorraine, Grand Duchess of Tuscany, Concerning the Use of Biblical Quotations in Matters of Science', in S. Drake (trans.), *Discoveries and Opinions of Galileo*, Doubleday Anchor Books, 1957, pp. 172–216.

132 Serenus Cressy, *Sancta Sophia. Or Directions for the Prayer of Contemplation &c. Extracted Out of More Than XL. Treatises Written by the Late Ven. Father F. Augustin Baker*, Iohn Patté & Thomas Fievet, 1657.

133 Principally under the editorship of the Anglican parish priest John Clark. *Analecta Cartusiana*, Salzburg, Austria: Institut fur Anglistik und Amerikanistik, Universitat Salzburg, 1997– .

134 See Robert Boyle's *Work diary* 21, entry 201 and 203, archives of the Royal Society London. http://cell.livesandletters.ac.uk/Boyle/boyle_index.php?wd=21&idx=2&option=both&version=editorial. Accessed 1 January 2013.

135 T. Sprat, *The History of the Royal-Society of London, for the improving of natural knowledge*, Martyn, 1667; ed. J. I. Cope and H. W. Jones, 1959; reprinted 1966, London: Routledge & Kegan Paul.

136 See M. Ogborn, '*Geographia*'s pen: writing, geography and the arts of commerce, 1660–1760', *Journal of Historical Geography*, vol. 30, issue 2, April 2004, p. 305.

137 G. Bickham, *The British Monarchy*, London, 1748 edn, A.8 following.

138 M. Ogborn, *Indian Ink*, Chicago University Press, 2007. I am heavily indebted to Ogborn for the following account, and I recommend his book for its fascinating insights into the use of writing and print in this era.

139 S. Pepys, *Memoires relating to the state of the royal navy of England, for ten years, determined December 1688*, London, 1689, p. 112.

140 L. Boyle, 'Diplomatics', in J. Powell, *Medieval Studies, An Introduction*, Syracuse University Press, 1992, p. 93.

141 The best survey of the development of Diplomatic studies is L. Boyle, 'Diplomatics', in J. Powell, *Medieval Studies*, pp. 82–113. The translation

of Papenbroek's letter is from J. W. Thompson, *A History of Historical Writing, Vol. II*, Macmillan, 1943, p. 12.

142 J. Moxon, *Mechanick Exercises on the Whole Art of Printing*, Dover, 1978, p. 6.

143 ibid., p. 22.

144 A later name given to the type perhaps by the typographer Pierre-Simon Fournier; see S. Knight, *Historical Types*, Oak Knoll Press, 2012, E1, p. 67.

145 See blogs by James Mosley, www.typophile.com/node/70542 and 27378. Accessed 14 March 2011.

146 See J. André and D. Denis Girou, 'Father Truchet, the typographic point, the *Romain du roi*, and tilings', in *TUGboat*, vol. 20, no. 1, 1999, p. 8ff. Accessed at http://www.tug.org/TUGboat/Articles/tb20-1/tb62andr.pdf 16 May 2011.

147 See Knight, *Historical Types*, p. 13 for succinct explanation.

148 For private systems, see for instance the analysis of Griffo's Aldine faces in P. Burnhill, *Type spaces: in-house norms in the typography of Aldus Manutius*, Hyphen Press, 2003.

149 A copy and transcription of the act can be found at http://www.copyrighthistory.com/anne.html. Accessed 24 June 2011.

150 *The Rambler*, No. 145, Tuesday, 6 August 1751.

151 D. Brown, *Calligraphia*, Edward Raban printer to the University of St Andrews, 1622, Sect. 1 p. 71.

152 T. P. Thornton, *Handwriting in America: a Cultural History*, Yale, 1996, pp. 24–41.

153 Quoted in ibid., p. 35.

154 http://www.oldbaileyonline.org/.

155 Pliny the Elder, *The Natural History*, Book XIII, Ch. 26. A copy can be found at http://www.perseus.tufts.edu/hopper/text?doc=Perseus%3atext%3a1999.02.0137. Accessed 11 February 2012.

156 Suetonius, *The Lives of the Twelve Caesars*, trans. R. Graves, Penguin, 1957, Augustus 87.3.

157 ibid., Nero 52.3.

158 C. Baldi, *Trattato come de una lettera missiva si cognoscano la natura qualita della scrittore*, Carpi, 1622.

159 L. Dutens (ed.), *Gothofredi Guillelmi Leibnitii Opera Omnia*, vol. iv, Geneva, 1768, section on *doctrina de moribus*.

160 J. K. Lavater, *Physiognomische Fragmente zur Beförderung der Menschenkenntnis und Menschenliebe*, Leipzig, 1775–8.

161 J. K. Lavater, *Essays on Physiognomy*, trans. C. Moore, London, 1797, vol. 4, p. 200.

162 Baskerville's date of birth is often given as 1706, but at that time Britain still followed the Julian calendar, when the yearly date changed not on 1 January but on 25 March. With his birthday in early January, Baskerville's year of birth by modern reckoning was in 1707; see

the note by James Mosely on Baskerville's tercentenary at http://
typefoundry.blogspot.com/2006/01/baskervilles-french-cannon-
roman.html. Accessed 15 July 2011.

163 See J. Dreyfus, 'The Baskerville Punches 1750–1950', *The Library*, 5th
series, vol. 5, 1951, n. 3 p. 27, originally privately printed as J. Dreyfus,
The Survival of Baskerville's Punches, Cambridge, 1949.

164 P.-S. Fournier, *Manuel Typographique*, vol. II, 1776.

165 B. Warde, 'The Baskerville types, a critique', *Monotype Recorder*, 221,
1927.

166 J. Van der Velde, *Spieghel der Schrijfkonste, inden welcken ghesien worden
veelderhande Gheschriften met hare Fondementen ende onderrichtinghe*, 1605,
p. 57, 'Dissectio Literarum Latinarum'.

167 J. A. Ayres, *Tutor to Penmanship*, 1697/8, Part one, pl. 22.

168 C. Snell, *The Art of Writing*, 1712, pl. 28.

169 G. Shelley, *Alphabets in all the hands Done for the use of Christ's Hospital
London*, 1710 (?), pl. 7.

170 For more detailed background see J. Mosley, 'English Vernacular',
Motif, no. 11, Shenval Press, 1963, pp. 3–55.

171 Whyman, *The Pen and the People*, p. 215. The figure had declined to
10 per cent by 1799.

172 See D. Fenning, *The Universal Spelling Book or a New and Easy Guide to
the English Language*, Bassam, London, 1755, pp. 69–70. It also appears
as such in the manuscript, vellum-bound notebook (1789) of Richard
Hall, Hosier of No. 1 London Bridge, see M. Rendell, *The Journal of a
Georgian Gentleman*, Book Guild, 2011, p. 26.

173 I. Watt, 'The Comic Syntax of *Tristram Shandy*', in *Studies in Criticism
and Aesthetics 1660–1880*, ed. Howard Anderson and John S. Shea,
University of Minnesota Press, 1967; reprinted in *Modern Critical
Interpretations: Laurence Sterne's Tristram Shandy*, ed. Harold Bloom,
New York: Chelsea, 1987, pp. 43–57.

174 ibid.

175 V. Mylne, 'The Punctuation of Dialogue in Eighteenth-Century French
and English Fiction', *The Library*, s6-I (1), pp. 43–61.

176 Quoted in R. Wittman, 'Was there a Reading Revolution at the End of
the Eighteenth Century?' in G. Cavallo and R. Chartier (eds), *A History
of Reading in the West*, Blackwell, 2003, p. 285.

177 ibid., pp. 74–111.

178 'Analysing the alphabet of any language, one not only can find similar
lines in many different letters, but will also find that all of them can
be formed with a small number of identical parts, combined and
disposed in various ways.' G. Bodoni, *Manuale tipographico del cavaliere
Gambattista Bodoni*, Parma, 1818, p. 107.

179 Diary: 10 July 1826 : 'This morning I was visited by a W. Lewis, a smart
Cockney, whose object is to amend the hand-writing. He uses as a
mechanical aid a sort of puzzle of wire and ivory, which is put upon

the fingers to keep them in the desired position…It is ingenious and may be useful.' A. Heal, *English Writing Masters*, Cambridge University Press, 1931, p. 70.

180 Thornton, *Handwriting in America*, p. 43.

181 M. Sanderson, 'Literacy and Social Mobility in the Industrial Revolution in England', *Past and Present*, 1972, 56 (1), pp. 75–103.

182 ibid., pp. 81–2.

183 A. Roberts (ed.), *Mendip Annals, or a Narrative of the Charitable Labours of Hannah and Martha More, being The Journal of Martha More*, Nisbet, London, 1859, p. 6.

184 Full details in E. Kindel, 'Delight of men and gods: Christiaan Huygens's new method of printing', *Journal of the Printing History Society*, New Series, 14, Autumn 2009, pp. 5–40.

185 Another debt to James Mosley's masterly blogs at http://typefoundry. blogspot.com/2010/03/lettres-jour-public-stencil-lettering.html. Accessed 25 September 2011.

186 C. S. Houston, T. Ball, M. Houston, *Eighteenth-century Naturalists of Hudson Bay*, McGill-Queens, 2003, p. 197.

187 This figure and all the information is this paragraph are taken from the report of a lecture at the Royal Institution by Dr Faraday on 'The Manufacture of Pens', 27 March 1835, in R. Thomson and T. Thomson, *Records of General Science Vol. 1*, Taylor, 1835, pp. 397–9.

188 Houston et al., *Eighteenth-century Naturalists of Hudson Bay*, p. 197.

189 Thomson and Thomson, *Records of General Science Vol. 1*, p. 399.

190 Translated by Harry Carter, included in F. Smeijers, *Counterpunch: making type in the sixteenth century, designing typefaces now*, Hyphen Press, 1996, pp. 99–100.

191 S. H. Steinberg, *Five Hundred Years of Printing*, Faber, 1959, p. 199.

192 E. Rowe More, *A dissertation upon English typographical founders and founderies* (1778), Oxford University Press, 1962, p. 77.

193 For English vernacular lettering in the eighteenth and nineteenth centuries, see J. Mosley, 'English Vernacular: A Study in Traditional Letter Forms', *Motif*, 11, 1963, pp. 3–55.

194 A precursor to Fournier's Tuscan-looking typeforms can be seen on the engraved title page to Le Boeuf's *Nouveau Livre d'Ecriture*, 1735.

195 See J. Mosley, 'The Nymph and the Grot', *Typographica* (new series), 12, 1965, pp. 2–19, but especially see his update of this article which appears on his blog at http://typefoundry.blogspot.com/2007/01/nymph-and-grot-update.html.

196 J. Mosley, http://typefoundry.blogspot.co.uk/2007/01/nymph-and-grot-update.html.

197 J. Mosley, 'An essentially English type', *Monotype Newsletter*, no. 60, 1960, pp. 6–8.

198 I am grateful to the discussion on Typofile.com and James Mosley's illustrated posting of 3 February 2007 for this wording.

199 On educators, see M. Twyman, 'Textbook design: chronological tables and the use of typographic cueing', *Paradigm*, No. 4, December 1990.

200 For a detailed history, see J. Moran, *Printing Presses: History and Development from the Fifteenth Century to Modern Times*, Faber, 1973. For the statistics quoted here, see p. 192.

201 W. Smith, *Advertising When? Where? How?*, Routledge, Warne, and Routledge, 1863, pp. 86–7. Read on-line at http://archive.org/details/advertisehowwheoosmitgoog. Accessed 24 May 2012.

202 ibid., p. 119.

203 ibid., p. 156.

204 ibid., p. 161.

205 Hansard, ix, p. 798 nn. And quoted in J. L. Hammond and B. Hammond, *The Town Labourer 1760–1832*, Longmans Green and Co., 1917, p. 57.

206 Martin, *The History and Power of Writing*, p. 400.

207 ibid., p. 400.

208 ibid., pp. 398–9.

209 R. Hill, *Post office reform: its importance and practicability*, privately printed, 1837.

210 ibid., p.7.

211 R. Nash, 'Benjamin Franklin Foster', in *Calligraphy and Paleography*, ed. A. S. Osley, Faber, 1965, p. 115.

212 J. Yates, *Control through Communication: The Rise of System in American Management*, Johns Hopkins University, 1993. I am indebted to JoAnne Yates for the perspective included in this section.

213 See http://www.typewritermuseum.org/collection/index.php3?machine=hansen&cat=kd and http://www.malling-hansen.org/the-writing-ball.html.

214 K. Yasuoka and M. Yasuoka, 'On the Pre-history of QWERTY', *Zinbun*, No. 42, March 2011, pp. 161–74. http://repository.kulib.kyoto-u.ac.jp/dspace/bitstream/2433/139379/1/42_161.pdf. Accessed 17 January 2012.

215 Martin, *The History and Power of Writing*, p. 403.

216 Written testimony to the US Congress submitted by the Commission on Preservation and Access of the Council on Library and Information Resources, text in newsletter May 1995, http://www.clir.org/pubs/cpanews/cpanl79.html. Accessed 23 March 2010.

217 A. Dunton et al., *Manual of Free-hand Penmanship*, Gillman, 1877, pp. 7–8.

218 'A short Biography of Mr Vere Foster', untitled newspaper, 30 January 1888. The Irish Emigration Data Base http://ied.dippam.ac.uk/records/38384. Accessed 25 January 2012.

219 Thornton, *Handwriting in America*, p. 69, and J. Higham, 'The Reorientation of American Culture in the 1890s', in *The Origins of Modern Consciousness*, ed. J. Weiss, Wayne State University, 1965, pp. 25–48.

220 See http://www.officemuseum.com/filing_equipment_cabinets.htm. Accessed 15 March 2010.

221 J. G. Herder, *Vom Erkennen und Empfingen der menschlichen Seele*, Hartnoch, 1778, vol. VIII, p. 208.

222 D. Charlton (ed.), *E. T. A. Hoffmann's Musical Writings: Kreisleriana, The Poet and the Composer, Music Criticism*, Cambridge, 1989, p. 236.

223 J. H. Schooling, *Handwriting and Expression*, Kegan Paul, Trench, Trübner & Co., 1892, p. 6.

224 See a letter from Percy Bysshe Shelley to Thomas Peacock 22 July– 2 August 1816, in D. Wu, *Romanticism, an Anthology*, Blackwell, 1994, p. 1100.

225 Charlton (ed.), *E. T. A. Hoffmann's Musical Writings*, p. 238.

226 T. Byerley, 'On Characteristic Signatures', *Relics of Literature*, Thomas Boys, 1823, p. 370.

227 J.-H. Michon, *Système de graphologie*, Payot, 1875.

228 J.-H. Michon, *Méthode pratique de graphologie*, Bibliothèque Graphologique, 1878.

229 From the introduction to Schooling, *Handwriting and Expression*, p. 9. This book is itself largely a translation of J. Crépieux-Jamin, *L'ecriture et le caractère*, Felix Alcan, 1888.

230 Translation from Shaike Landau, 'Michon and the Birth of Scientific Graphology', http://www.britishgraphology.org/analyses/ MichonAndTheBirthOf ScientificGraphology.pdf. Accessed 2 July 2010.

231 Schooling, *Handwriting and Expression*, p. xiii.

232 ibid., pp. 72–84.

233 'Doe on the Demise of Mudd v Suckermore Nov. 1836', in J. L. Adolphus and T. F. Ellis, *Reports of Cases argued and determined in the Court of King's Bench Vol. V*, Saunders and Benning, 1838, pp. 705–6.

234 See T. Ingold, 'Walking the Plank: Meditations on a process of Skill', *Being Alive*, Taylor & Francis, 2011, p. 51ff.

235 John Ruskin, *The Stones of Venice*, vol. II, chapter VI, paragraph 16, 1853.

236 This phrase was used by T. J. Cobden-Sanderson, Walker's future partner in the Doves Press (1900), in T. J. Cobden-Sanderson, *Ecce Mundus Industrial Ideals & The Book Beautiful*, Hammersmith Publishing Society, 1892 (unpaginated). http://archive.org/stream/ eccemundusindusoosangoog#page/n36/mode/2up. Accessed 3 March 2012.

237 Detailed treatment in J. Dreyfus, 'New Light on the Designs for the Kelmscott and Doves Presses', *The Library*, 1974 series, 5-XXIX (1), pp. 36–41.

238 See M. Tidcombe, *The Doves Press*, Oak Knoll Press and British Library, 2002, pp. 13–15.

239 T. J. Cobden-Sanderson, 'The Three-fold Purpose of the Doves Press', in *Catalogue Raisonné*, Doves Press, 1908, p. 8.

240 See T. J. Cobden-Sanderson, 'The Book Beautiful', in *Ecce mundus*, p. 5.

241 J. S. Dearden, 'John Ruskin, the Collector: With a Catalogue of the Illuminated and Other Manuscripts formerly in his Collection', *The Library*, 1966.

242 Rev. William J. Loftie, *Lessons in the Art of Illuminating: a Series of Examples selected from works in the British Museum, Lambeth Palace Library, and the South Kensington Museum*, Blackie & Son, 1885.

243 All the quotations in the paragraph are from P. Johnston, *Edward Johnston*, Faber, 1959, pp. 74–5.

244 ibid., p. 199.

245 ibid., p. 201.

246 See Phil Baines, 'Changing the world', in E. Clayton (ed.), *Edward Johnston: Lettering and Life*, Ditchling Museum, 2007, p. 24.

247 F. T. Marinetti, 'Destruction of Syntax – Imagination without Strings – Words-in-Freedom' (1913), in *Futurist Manifestos*, ed. U. Apollonio, MFA Publications, 2001, pp. 104–5.

248 See Baines, 'Changing the world', in Clayton (ed.), *Edward Johnston*, p. 24.

249 See introduction by Elizabeth McCombie, *Stéphane Mallarmé: Collected Poems and Other Verse*, trans. E. H. and A. M. Blackmore, 2006, Oxford University Press, 2006, pp. ix–xxvii.

250 See his *Interventionist Demonstration* collage (1914) and his last contribution to Futurism, *Guerrapittura* (War Painting), a book from 1915.

251 R. Koch, 'Maximilian – und Frühling-Schrift', *Archiv für Buchgewerbe*, no. 7/8, 1918, pp. 92–3, as translated in G. Cinamon, *Rudolf Koch*, Oak Knoll Press and British Library, 2000, p. 28.

252 See the Offenbach Friedenskirke's website at http://www.plan-becker.de/friedenskirche-offenbach/. Accessed 13 March 2012.

253 *Die Zeitgemäße Schrift*, Issue 38, Heintze & Blanckertz, 1936.

254 W. Weaver, in 'Recent Contributions to the Mathematical Theory of Communication', in C. Shannon and W. Weaver, *The Mathematical Theory of Communication*, University of Illinois Press, 1949, pp. 114–15.

255 An interview with John Markoff given by Robert Taylor at the 40th Anniversary conference at SRI 2008, viewable at http://www.sri.com/engelbart-event-video.html.

256 From the historical note introducing G. Lavendel (ed.), *A Decade of Research from PARC 1970–1980*, Bowker, 1980.

257 For the first account of the Alto, see Lavendel (ed.)., *A Decade of Research from PARC 1970–1980*.

258 Reported in D. Smith and R. Alexander, *Fumbling the Future. How Xerox invented, and then ignored, the first personal computer*, toExcel 1999, p. 209.

259 From *The Triumph of the Nerds, Part 3*, PBS. http://www.pbs.org/nerds/part3.html. Accessed 28 July 2010.

260 ibid.

261 A. Herzfeld, *Revolution in the Valley*, O'Reilly, 2004, p. 192.

262 R. Southall, *Printer's type in the twentieth century. Manufacturing and Design methods*, British Library and Oak Knoll Press, 2005, p. 140.

263 Sumner Stone, personal communication.

264 Term for an enlarged initial letter, employed by Johnston following E. F. Strange, *Alphabets*, 1895. Strange thought it signified a place to 'turn to' (Verso) for reading aloud (with thanks to Stan Knight for the reference).

265 Sumner Stone, personal communication.

266 R. Sassoon, *Handwriting of the Twentieth Century*, Intellect Books, 2007, pp. 16–20.

267 F. Thomas, 'Une question de writing', *Improving Schools*, March 1998, pp. 30–32.

268 Sassoon, *Handwriting of the Twentieth Century*, p. 181.

269 M. Mai and A. Remke, *Urban Calligraphy and Beyond*, Die Gestalten Verlag, 2003.

270 From 'Theory and Function of the Duende', in *Frederico Garcia Lorca, Selected Poems*, trans. M. Williams, Bloodaxe, 1992, p. 225.

271 ibid., p. 229.

272 K. Haffner and M. Lyon, *Where Wizards Stay Up Late: The Origins of the Internet*, Touchstone, 1996, p. 194.

273 J. C. R. Licklider and A. Vezza, 'Applications of Information Networks', *Proceedings of the IEEE*, vol. 66, no. 11, November 1978, pp. 43–59.

274 J. C. R. Licklider and R. Taylor, 'The Computer as a Communication Device', in *Science and Technology: For the Technical Men in Management*, No. 76, April 1968, pp. 21–31. Also reprinted in 'In Memoriam: J. C. R. Licklider: 1915–1990', Report 61, Systems Research Center, Digital Equipment Corporation, Palo Alto, California, 7 August 1990, pp. 21–41.

275 Interview with John Markoff: http://www.sri.com/engelbart-event-video.html.

276 T. Berners-Lee and M. Fischetti, *Weaving the Web*, Harper, 1999, p. 37.

277 ibid, p. 1.

278 Lucy Suchman, personal correspondence, 11 July 2010.

279 On invisible work, formulated by the sociologist Susan Leigh Starr, see S. L. Starr and A. Strauss, 'Layers of Silence, Arenas of Voice: The Ecology of Visible and Invisible Work', *Computer Supported Cooperative Work*, 8: 9–30, 1999, and http://users.tkk.fi/daviding/1999_CSCW_v8_n1-2_p9_Star_Strauss.pdf. Accessed 24 April 2012.

280 Referenced from J. Naughton, '20 years on…4 billion people feel the joy of text', *Guardian*, 6 May 2012.

281 See *Morgan Stanley Internet Trends Report April* 2010, slide 62, at http://www.morganstanley.com/institutional/techresearch/pdfs/Internet_Trends_041210.pdf.

282 N. Carr, *The Big Switch: Rewiring the World, from Edison to Google*, Norton, 2008.

283 The Crafts Study Centre: University Museum for Modern Crafts, University for the Creative Arts, Falkner Road, Farnham, Surrey GU9 7DS, (tel. +44 (0)1252 891450), http://www.csc.ucreative.ac.uk/.

284 M. McWilliams and D. Roxburgh, *Traces of the Calligrapher. Islamic Calligraphy in Practice*, c.1600–1900, Museum of Fine Art, Houston, 2007, p. 26.

285 Jean François Billeter, *The Chinese Art of Writing*, Skira, 1990, p. 176.

286 Ting Wen-chün, *Essential Principles of Calligraphy*, original edn 1938, reprinted 1983, Chung-kuo shu-tien, Beijing, part 2, pp. 1–2.

287 Both quotations from Akim in Mai and Remke, *Urban Calligraphy and Beyond*, pp.104 and 98.

288 Quoted in D. Stern, *Forms of Vitality*, Oxford, 2010, p. 41; originally in D. Stern, *The Interpersonal World of the Infant*, Basic Books, 1985, p. 140.

289 D. Stern, *The Present Moment in Psychotherapy and Everyday Life*, Norton, 2004, p. 4.

290 See L. Gourhan, *Gesture and Speech*, MIT Press, 1993.

291 D. Lewis-Williams and D. Pearce, *Inside the Neolithic Mind*, Thames & Hudson, 2005, p. 57.

292 J. Gleick, *The Information*, Fourth Estate, 2011, p. 416.

293 N. Carr, 'Drowning in Beeps', *The Daily Beast*, 1 March 2011, http://www.thedailybeast.com/articles/2011/03/01/the-information-by-james-gleick-review-by-nicholas-carr.html. Accessed 2 May 2012.

Bibliography

The bibliography and guide to further reading is divided by period. At the end of the bibliography I have added a more detailed section for those who may wish explore the art of handwriting, calligraphy and lettering. I have excluded original manuscripts and writing manuals from the list unless they appear in accessible facsimiles.

CUP = Cambridge University Press; UCP = University of Chicago Press; OUP = Oxford University Press.

General Reference

Armstrong, H. (ed.), *Graphic Design Theory: Readings from the Field* (Princeton Architectural Press 2009)

Baines, P. & Haslam, A., *Type and Typography* (Lawrence King 2002)

Bartram, A., *Typeforms: A History* (OakKnoll/The British Library 2007)

Bately, J., Brown, M. & Roberts, J., *A Paleographer's View: Selected Writings of Julian Brown* (Harvey Miller 1993)

Boyle, L. E., *Medieval Latin Paleography: A Bibliographical Introduction* (University of Toronto 1984)

Bringhurst, R., *The Elements of Typographic Style* (Hartley & Marks, Vancouver 1992)

Brown, M. P., *A Guide to Western Historical Scripts from Antiquity to 1600* (British Library 1990)

Brown, T. J., 'Latin Paleography since Traube', in *Codicologica I*, ed. A. Gruys (Brill 1976)

Coulmas, F., *The Writing Systems of the World* (Blackwell 1989)

De Hamel, C., *A History of Illuminated Manuscripts* (Phaidon 1986)

De Hamel, C., *The Book: A History of The Bible* (Phaidon 2001)

Fairbank, A., *A Book of Scripts* (Penguin 1949, Faber & Faber 1979)

Fairbank, A., *The Story of Handwriting: Origins and Development* (Faber & Faber 1970)

Finkelstein, D. & McCleery, A. (eds), *The Book History Reader* (Routledge 2002)

Fischer, S. R., *A History of Writing* (Reaktion 2001)

Gaur, A., *A History of Writing* (British Library 1984)

Gelb, I. J., *A Study of Writing* (UCP 1963)

Gray, N., *A History of Lettering* (Phaidon 1986)

Gray, N., *Lettering as Drawing* (OUP 1971)

Gray, N., *Lettering on Buildings* (Reinhold 1960)

Hambridge, J., *The Elements of Dynamic Symmetry* (Dover 1967)

Jackson, D., *The Story of Writing* (Studio Vista 1981, Barrie & Jenkins 1987)

Knight, S., *Historical Scripts: A Handbook for Calligraphers* (A&C Black 1984, Oak Knoll/British Library 1998)

Knight, S., *Historical Types from Gutenberg to Ashendene* (Oak Knoll 2012)

Lewis, J., *The Anatomy of Printing: The Influence of Art and History on its Design* (Faber & Faber 1970)

Lyons, M., *A History of Reading and Writing* (Palgrave Macmillan 2010)

Manguel, A., *A History of Reading* (Flamingo 1997)

Maunde Thompson, E., *Greek and Latin Paleography*, 3rd edn (OUP 1912)

McLean, R., *Manual of Typography* (Thames and Hudson 1992)

Mediavilla, C., *Calligraphy* (Scirpus 1993)

Morison, S. & Day K., *The Typographic Book 1450–1935* (Ernest Benn 1963)

Morison, S., *Politics and Script* (OUP 1972)

Reynolds, L. D. & Wilson, N. G., *Scribes and Sources: A Guide to the Transmission of Greek and Latin Literature* (OUP 1974)

Sampson, G., *Writing Systems* (Stanford University Press 1985)

Steinberg, S. H., *Five Hundred Years of Printing*, rev. J. Trevitt (Oak Knoll/British Library 1996)

Sutton, J. & Bartram, A., *An Atlas of Typeforms* (Lund Humphries 1968)

Tracy, W., *Letters of Credit: A View of Type Design* (Gordon Fraser 1986)

Tschichold, J., *Treasury of Alphabets and Lettering* (Reinhold 1966, Omega 1985)

Updike, D. B., *Printing Types: Their History, Forms and Use* (Harvard University Press 1951)

Whalley, J. I. & Kaden, V. C., *The Universal Penman* (HMSO 1980)

The Ancient World

Algaze, G., *Ancient Mesopotamia at the Dawn of Civilisation* (UCP Press 2008)

Baines, J., *Visual and Written Culture in Ancient Egypt* (OUP 2007)

Bottero, J., *Mesopotamia: Writing, Reasoning, and the Gods* (UCP 1992)

Bowman, A. K. & Thomas, J. D., *Vindolanda: The Latin Writing Tablets* (Society for the Promotion of Roman Studies 1983)

Bowman, A. K., *Life and Letters on the Roman Frontier: Vindolanda and its People* (British Museum 1994; 2nd edn 1998, rev. edn 2003)

Bradley, K., Slavery and Society at Rome (CUP 1994)

Casson, L., *Libraries of the Ancient World* (Yale 2001)

Catich, E., *The Origin of the Serif: Brush Writing and Roman Letters* (Catfish 1968, St Ambrose 1992)

Catich, E., *The Trajan Inscription in Rome* (Catfish 1961)

Cook, B. F., *Greek Inscriptions* (British Museum 1987)

Cooley, A. E., *The Cambridge Manual of Latin Epigraphy* (CUP 2012)

Evetts, L. C., *Roman Lettering* (Pitman 1938)

Flower, H., *Ancestor Masks and Aristocratic Power in Roman Culture* (OUP 1996)

Friggeri, R., *The Epigraphic Collection of the Museo Nazionale Romano at the Baths of Diocletian* (Electa 2001)

Gordon, A. E., *An Illustrated Introduction to Latin Epigraphy* (University of California 1983)

Grafton, A., & Williams, M., *Christianity and the Transformation of the Book: Origen, Eusebius, and the Library of Caesarea* (Harvard University Press 2006)

Herodotus, *The Histories*, trans. rev. J. Marincola, from A. de Sélincourt (1954, Penguin 2003)

Hodgkin, T., *Letters of Cassiodorus*, Variae XII.21 (OUP 1886)

Laurence, R., *The Roads of Roman Italy* (Routledge 1999)

Lowe, E. A., *Codices Latini Antiquiores*, vols I–XI (Clarendon 1934–66) and *The Supplement* (Clarendon 1971)

Muess, J., *Das Römische Alphabet* (Callwey 1989)

Plato, 'The Phaedrus', *The Dialogues of Plato*, vol. 1, trans. B. Jowett, 3rd edn (OUP 1892)

Pliny the Elder, *The Natural History*, ed. J. F. Healy (Penguin 1991)

Powell, B., *Writing: Theory and History of the Technology of Civilization* (Wiley-Blackwell 2012)

Roberts, C. H. & Skeat, T. C., *The Birth of the Codex* (OUP 1983)

Robinson, A., *The Story of Writing: Alphabets, Hieroglyphics and Pictograms* (Thames and Hudson 1995)

Schmandt-Besserat, D., *When Writing Met Art, From Symbol to Story* (University of Texas 2007)

Seider, R., *Paläographie Der Lateinischen Papyri*, vols 1–3 (Hiersemann 1972–81)

Suetonius, *The Lives of the Twelve Caesars*, trans. R. Graves (Penguin 1957)

Susini, G., *The Roman Stonecutter: An Introduction to Latin Epigraphy* (Blackwell 1973)

Svenbro, J., *Phrasikleia: An Anthropology of Reading in Ancient Greece* (Cornell 1993)

Tenney, F., *An Economic History of Ancient Rome*, vol. 5 (John Hopkins 1940)

Tracy, S. V., 'Athenian Letter-Cutters and Lettering on Stone in Vth to Ist Centuries B.C.', in *Greek Letters: from Tablets to Pixels*, ed. M. S. Macrakis (Oak Knoll 1997)

Tracy, S. V., 'The Lettering of an Athenian Mason', *Hesperia: Supplement XV* (American School of Classical Studies at Athens 1975)

Wade-Gery, H. T., 'A Distinctive Attic Hand', *The Annual of The British School at Athens*, 33 (1935)

Woodard, R. D., *Greek Writing from Knossos to Homer* (OUP 1997)

Woodhead, A. G., *The Study of Greek Inscriptions* (CUP 1959, 1981)

The Medieval World

Aris, R., *Explicatio Formarum Litterarum (The Unfolding of Letters from the First Century to the Fifteenth)* (The Calligraphy Connection 1990)

Backhouse, J., Turner, D. H. & Webster, L., *The Golden Age of Anglo-Saxon Art, 966–1066* (British Museum 1984)

Bischoff, B., *Latin Paleography* (CUP 1990)

Bishop, T. A. M., *English Caroline Minuscule* (OUP 1971)

Brown, M. P., *The Lindisfarne Gospels: Society, Spirituality and the Scribe* (British Library 2003)

Brown, P., *The Book of Kells* (Thames & Hudson 1980)

Clanchy, M. T., *From Memory to Written Record* (Blackwell 2nd edn 1993)

Clayton, E., *Embracing Change: Spirituality and the Lindisfarne Gospels* (Clayton 2003)

De la Mare, A. C. & Barker-Benfield, B. C. (eds.), *Manuscripts at Oxford* (Bodleian 1980)

Delaisse, L. M. J. 'Towards a History of the Medieval Book', *Codicologica I* (1976)

Duffy, E., *Marking the Hours* (Yale 2006)

Gullick, M., *Pen in Hand: Medieval Scribal Portraits, Colophons and Tools* (Red Gull Press 2006)

Hector, L. C., *The Handwriting of English Documents* (Arnold 1966)

Hunter-Blair, P., *Northumbria in the Days of Bede* (Gollancz 1976

Illich, I., *In the Vinyard of the Text* (UCP 1993)

Kendrick, T. D. & Brown, T. J. *et al.*, *Evangeliorum quattuor codex Lindisfarnensis*, 2 vols (Olten 1956–1960)

Knight, S., 'Scripts of the Grandval Bible', Parts I, II & III, *The Scribe*, nos 44, 45, 46, (1988–89)

Knowles, Dom D., *The Monastic Order in England, 943–1216* (CUP 1963, 1st edn 1940)

Lowe, E. A., *English Uncial* (OUP1960)

McKitterick, R., *The Carolingians and the Written Word* (CUP 1989)

McKitterick, R. (ed.), *The Uses of Literacy in Early Mediaeval Europe* (CUP 1992)

Nordenfalk, C., *Celtic & Anglo-Saxon Painting* (Chatto & Windus 1977)

O'Neil, T., *The Irish Hand* (Dolmen 1984)

Orme, N., *Medieval Schools* (Yale 2006)

Parkes, M. B., *English Cursive Book Hands, 1250–1500* (Scolar Press 1969)

Parkes, M. B., *Pause and Effect: An Introduction to the History of Punctuation* (University of California Press 1993)

Parkes, M. B., *The Scriptorium of Wearmouth-Jarrow* (The Jarrow Lecture 1982)

Parry, D., *Households of God* (DLT 1980)

Prescott, A., *The Benedictional of St. Aethelwold* (British Library 2002)

Thompson, D. V., *The Craftsman's Handbook, 'Il Libro dell'Arte'* (Dover 1960)

Thompson, D. V., *The Materials and Techniques of Medieval Painting* (Dover 1956)

Thorpe, L. (trans.), *Two Lives of Charlemagne* (Penguin Classics 1969)

Visscher, W., 'Trends in Vellum and Parchment Making', in *The New Bookbinder*, vol. 6 (1986)

Wright, C. E., *English Vernacular Hands from the Twelfth to the Fifteenth centuries* (OUP 1960)

The Renaissance

Agüera y Arcas, B., 'Temporary Matrices and Elemental Punches in Gutenberg's DK type' in *Incunabula and Their Readers: Printing, Selling and Using Books in the Fifteenth Century*, ed. K. Jensen (British Library 2003)

Anderson, D. M., *A Renaissance Alphabet: Il Perfetto Scrittore, Parte Seconda by Giovan Francesco Cresci* (University of Wisconsin 1971)

Bain, P. & Shaw, P. (eds), *Blackletter: Type and National Identity* (Princeton Architectural Press 1998)

Beale, P., *England's Mail* (Tempus 2005)

Benson, J. H., *The First Writing Book: The Operina of 1523 Ludovico degli by Arrighi* (Yale 1954)

Benson, J. H., Pierce, Rev. H. K. & Taylor, E. A. O'D, *The Instruments of Writing* (Berry Hill Press 1953)

Bergstein, M., 'Donatello's Gattamelata and its Humanist Audience', *Renaissance Quarterly,* Sept (2002)

Bird, M. S., *Ontario Fraktur: A Pennsylvania-German Folk Tradition in early Canada* (Feheley 1977)

Blunt, W., *Sweet Roman Hand: Five Hundred Years of Italic Cursive Script* (Barrie 1952)

Butor, M., *Les mots dans la peinture* (Skira 1969)

Carter, H., *A View of Typography up to about 1600* (first published OUP 1969, Hyphen 2002)

Chamberlin, E. R., *The Sack of Rome* (Batsford 1979)

Davies, M., 'Juan de Carvajal and Early Printing: The 42-line Bible and the Sweynheym and Pannartz Aquinas', *The Library*, s6-XVIII (1996)

Davies, M., *The Gutenberg Bible* (Pomegranate/British Library 1997)

De La Mare, A. C., 'The Book Trade', *Journal of the Warburg and Courtauld Institutes*, vol. 39 (1976).

De La Mare, A. C., *The Handwriting of Italian Humanists* (OUP 1973)

De La Mare, A. C. & Nuvoloni, L., *Bartolomeo Sanvito: The Life and Work of a Renaissance Scribe* (Association Internationale De Bibliophilie 2009)

Eisenstein, E. L., *The Printing Revolution in early Modern Europe* (CUP 1983)

Englehart, B. & Brand, C., 'Gerard Mercator, Cartographer and Writing Master', in *Calligraphy and Paleography*, ed. A. S. Osley (Faber & Faber 1965)

Fairbank, A. & Berthold, W., *Renaissance Handwriting* (Faber & Faber 1960)

Febvre, L. P. V. & Martin H-J., *The Coming of the Book: The Impact of Printing 1450–1800* (Verso 1976)

George, W. & Waters, E. (trans.), *The Vespasiano Memoirs* (Routledge 1926)

Gombrich, E. H., 'The Revival of Letters to the Reform of the Arts: Niccolò Niccoli and Filippo Brunelleschi', *The Heritage of Apelles* (Lund Humphries 1976)

Harvard, S., *The Cataneo Manuscript* (Taplinger/Pentalic 1981)

Hirsch, R., '*Stampa e Lettura fra il 1450 e il 1550*', in *Libri, editori e pubblico nell'Europa moderna: guida storica e critica*, ed. A. Petrucci (Laterza 1977)

Hofer, P., 'Variant issues of the first edition of Arrighi's Operina', in *Calligraphy and Paleography*, ed. A. S. Osley (Faber & Faber 1965)

Kapr, A., *Johann Gutenberg: The Man and His Invention*, trans. D. Martin (Scolar Press 1996)

Kapr, A., *The Art of Lettering* (Saur 1983)

Man, J., *The Gutenberg Revolution* (Review 2002)

Morison, S., *The Mollyus Alphabet* (Pegasus 1927)

Morison, S., *Early Italian Writing-Books* (British Library 1990)

Martin, H-J., *The History and Power of Writing* (UOC 1994)

Ogg, O., *Three Classics of Italian Calligraphy* (Dover 1953)

Osley, A. S., 'Francisco Luca: Creator of the Spanish Bastarda', in *Scribes and Sources* (Faber & Faber 1980)

Osley, A. S., *Scribes and Sources* (Faber & Faber 1980)

Petrach, '*Epistola de Rebus Senilibus*' XVI, 2, *The First Modern Scholar and Man of Letters*, trans. J. H. Robinson (Putnam 1909)

Petrucci, A., *Public Lettering, Script, Power and Culture* (UCP 1993)

Pettegree, A., *The Book in the Renaissance* (Yale 2010)

Platina, B., *Lives of the Popes* (BiblioLife 2009)

Shaw, P., 'Bartolomeo Sanvito, Part two', *Letter Arts Review*. vol. 19, no. 2 (2004)

Shen, C. Y. Fu, *Traces of the Brush* (Yale 1977)

Taylor, R. E., *No Royal Road: Luca Pacioli and His Times* (University of North Carolina 1942)

Ullman, B. L., *The Origin and Development of Humanistic Script* (Edizioni di Storia e Letteratura 1960)

Vervliet, H. D. L., *French Renaissance Printing Types: A Conspectus* (The Printing Historical Society and Oak Knoll Press 2010)

Voet, L., *The Golden Compasses: The History of the House of Plantin-Moretus* (Routledge & Keegan Paul 1969)

Wardrop, J., *The Script of Humanism: Some Aspects of Humanistic Script, 1460–1560* (OUP 1963)

The Enlightenment

Adams, A. J., 'Disciplining the Hand, Disciplining the Heart: Letter-writing, Paintings and Practices in Seventeenth Century Holland', in *Love letters: Dutch Genre Paintings in the Age of Vermeer*, ed. P. Sutton (Bruce Museum & National Gallery of Ireland 2003)

André, J. & Denis Girou, D., 'Father Truchet, the typographic point, the *Romain du roi*, and tilings', in *TUGboat*, vol. 20, no.1 (1999)

Baldi, C., *Trattato come de una lettera missiva si cognoscano la natura qualita della scrittore* (Carpi 1622)

Barnes, I. & Hudson R., *Historical Atlas of Europe* (Arcadia 1998)

Bartram, A., *The English Lettering Tradition from 1700 to the Present Day* (Lund Humphries 1986)

Beale, P., *England's Mail: Two Millennia of Letter Writing* (Tempus 2005)

Bickham, G., *The British Monarchy* (London 1748)

Boyle, L., 'Diplomatics', in Powell, J., *Medieval Studies: An Introduction* (Syracuse University Press 1992)

Brewer, J., 'Authors, publishers and the making of literary culture', in *The Book History Reader*, eds D. Finkelstein & A. McCleery (Routlege 2006)

Brown, D., *Calligraphia* (Edward Raban printer to the University of St Andrews 1622)

Burnhill, P., *Type spaces: In-house norms in the typography of Aldus Manutius* (Hyphen Press 2003)

Caruso, M., 'Hacer Buena letera': The disciplinary power of writing in early modern Spain*, paper presented at the CIES Annual Conference (2008)

Cavallo, G. & Chartier, R. (eds), *A History of Reading in the West* (Blackwell 2003)

Chartier, R., *The Order of Books* (Stanford 1994)

Cressey, D., *Literacy and the Social Order: Reading and Writing in Tudor and Stuart England* (CUP 2006)

Dreyfus, J., 'The Baskerville Punches 1750–1950', *The Library*, s5-V (1951)

Dutens, L. (ed.), *Gothofredi Guillelmi Leibnitii Opera Omnia*, vol. IV (Geneva 1768)

Evelyn, J., de la Bedoyere, G. (ed.), *Diary* (Woodbridge 1995)

Fenning, D., *The Universal Spelling Book or a New and Easy Guide to the English Language* (Bassam 1755)

Fournier, P. S., *Manuel Typographic*, vol. I–II (Paris 1764–1766)

Galileo G., 'Letter to Madame Christina of Lorraine, Grand Duchess of Tuscany, Concerning the Use of Biblical Quotations in Matters of Science', in *Discoveries and Opinions of Galileo*, trans. S. Drake (Doubleday Anchor Books 1957)

Green, L., 'French Letters and English Anxiety', in *Huntington Library Quarterly*, vol. 66, nos 3/4

Guy, J., *Tudor England* (Oxford Paperbacks 1990)

Heal. A., *English Writing Masters* (CUP 1931)

How, J., *Epistolary Spaces: English Letter-writing from the Foundation of the Post Office to Richardson's Clarissa* (Ashgate 2003)

Howes, J., 'The Complete Caslon', *Type and Typography: Highlights from Matrix* (Mark Batty 2003)

Humphries, J., *Childhood and Child Labour in the British Industrial Revolution* (CUP 2010)

Hutchinson, S. C., The History of the Royal Academy, 1768–1968 (Taplinger 1968)

Infelise, M., 'Roman Avvisi: Information and Politics in the Seventeenth Century', in *Court and Politics in Papal Rome, 1492–1700*, eds G. Signorotto & M. A. Visceglia (CUP 2004)

Knowles, D., 'Jean Mabillon', *The Historian and Character and Other Essays* (CUP 1963)

Lavater, J. K., *Physiognomische Fragmente zur Beförderung der Menschenkenntnis und Menschenliebe* (Leipzig 1775–78)

Lavater, J. K., *Essays on Physiognomy*, vol. 4, trans. C. Moore (London 1797)

Love, H., *The Culture and Commerce of Texts: Scribal Publication in Seventeenth-Century England* (OUP 1993)

Martin, H-J., *The History and Power of Writing* (UCP 1994)

Meynell, F., 'According to Cocker', in *Calligraphy and Paleography*, ed. A. S. Osley (Faber & Faber 1965)

Montias, J. M., *Artists and Artisans in Delft* (Princeton 1982)

Mosley, J., 'English Vernacular: A Study in Traditional Letter Forms', *Motif*, 11 (1963)

Moxon, J., *Mechanick Exercises on the Whole Art of Printing* (Dover 1978)

Mylne, V., 'The Punctuation of Dialogue in Eighteenth-Century French and English Fiction', *The Library*, s6-I (1979)

Ogborn, M., '*Geographia*'s Pen: Writing, geography and the arts of commerce, 1660–1760', *Journal of Historical Geography*, vol. 30, issue 2 (2004)

Ogborn, M., *Indian Ink* (UCP 2007)

Pardoe, F. E., *John Baskerville of Birmingham: Letter-founder and Printer* (Frederick Muller 1975)

Pepys, S., *Memoires relating to the state of the royal navy of England, for ten years, determined December* 1688 (London 1689)

Rendell, M., *The Journal of a Georgian Gentleman* (Book Guild 2011)

Ryder, J., *Lines of the Alphabet in the Sixteenth Century* (Stellar and Bodley Head 1965)

Sprat, T., *The History of the Royal-Society of London, for the improving of natural knowledge* (Martyn 1667), eds J. I. Cope & H. W. Jones (1959, Routledge & Kegan Paul 1966)

Sutton, P., *Love Letters: Dutch Genre Paintings in the Age of Vermeer* (Bruce Museum and National Gallery of Ireland 2003)

The Rambler, no. 145, Tuesday, 6 August 1751

Thompson, J. W., *A History of Historical Writing*, vol. II (Macmillan 1943)

Thornton, T. P., *Handwriting in America: A Cultural History* (Yale 1996)

Warde, B., 'The Baskerville types, a critique', *Monotype Recorder* 221 (1927)

Watt, I., 'The Comic Syntax of *Tristram Shandy*', in *Studies in Criticism and Aesthetics* 1660–1880, eds H. Anderson and J. S. Shea (University of Minnesota Press 1967)

Watts, T., *An Essay on the Proper Method for Forming the Man of Business* (London 1716)

Whyman, S. E., *The Pen and the People: English Letter Writers* 1660–1800 (OUP 2009)

Wolpe, B., *A Newe Booke of Copies* 1574 (Lion & Unicorn 1959)

The Industrial Era

'Doe on the Demise of Mudd v Suckermore Nov. 1836', in J. L. Adolphus & T. F. Ellis, *Reports of Cases argued and determined in the Court King's Bench*, vol. V (Saunders and Benning 1838)

Backemeyer, S., & Gronberg, T. (eds), *W. R. Lethaby* 1857–1931: *Architecture, Design and Education* (Lund Humphries 1984)

Bartram, A., *Tombstone Lettering in the British Isles* (Lund Humphries 1978)

Bartram, A., *Fascia Lettering in the British Isles* (Lund Humphries 1978)

Bartram, A., *Street Name Lettering in the British Isles* (Lund Humphries 1978)

Bodoni, G., *Manuale tipographico del cavaliere Gambattista Bodoni* (Parma 1818)

Burgert, H-J., *The Calligraphic Line: Thoughts on the Art of Writing* (Burgertpressse 1989)

Byerley, T., 'On Characteristic Signatures,' *Relics of Literature* (Thomas Boys 1823)

Charleton, D. (ed.), *E. T. A. Hoffman's Musical Writings: Kreisleriana; The Poet and the Composer; Music Criticism* (CUP 1989)

Child, H. (ed.), *Calligraphy Today* (Black 1988)

Crellin, V. H., *Writing by Rote* (University of Reading 1982)

Desbarolles, A. & Michon, J-H., *Les mystères de l'écriture* (Garnier 1872)

Disraeli, I., 'Autographs', *First and Second Series of Curiosities of Literature* (Pearson 1835)

Dreyfus, J., 'Emery Walker's 1888 lecture on "Letterpress Printing": A Reconstruction and a Reconsideration', *Craft History One* (Combined Arts 1988)

Dunton, A., *et al, Manual of Free-hand Penmanship* (Gillman 1877)

Faraday, M., 'The Manufacture of Pens', lecture given on 27 March 1835, in R. Thomson & T. Thomson, *Records of General Science*, vol. 1 (Taylor 1835)

Folsom, R., *The Calligrapher's Dictionary* (Thames & Hudson 1990)

Golby, J. M. & Purdue, A. W., *The Civilisation of the Crowd: Popular Culture in England 1750–1900* (Sutton 1999)

Hammond, J. L. & Hammond, B., *The Town Labourer 1760–1832* (Longman Green and Co. 1917)

Higham, J., 'The Reorientation of American Culture in the 1890s', in *The Origins of Modern Consciousness*, ed. J. Weiss (Wayne State University 1965)

Hill, R., *Post Office Reform: Its Importance and Practicability* (privately printed 1837)

Houston, C. S., Ball, T. & Houston, M., *Eighteenth-Century Naturalists of the Hudson Bay* (McGill-Queens 2003)

Huygen, F., *British Design, Image & Identity* (Thames & Hudson 1989)

Ingold, T., 'Walking the Plank, Meditations on a process of Skill', *Being Alive* (Taylor and Francis 2011)

Kindel, E., 'Delight of men and gods: Christiaan Huygens's new method of printing', *Journal of The Printing History Society* (new series), 14 (2009)

MacCarthy, F., *William Morris* (Faber & Faber 1994)

Michon, J-H., *Système de graphologie suivi de Méthode pratique de graphologie*, (Payot 1875)

Moran, J., *Printing Presses: History and Development from the Fifteenth Century to Modern Times* (Faber & Faber 1973)

Mosley, J., 'The Nymph and the Grot', *Typographica* (new series), 12 (1965)

Nash, K., 'Benjamin Franklin Foster', in *Calligraphy and Paleography*, ed. A. S. Osley (Faber & Faber 1965)

Naylor, G., *The Arts and Crafts Movement: A Study of its Sources, Ideals, and Influence on Design Theory* (Trefoil 1990)

Needham, P., Dunlap, J. & Dreyfus, J., *William Morris and the Art of the Book* (OUP 1976)

O'Donnell, T., *Lettering in the Twentieth Century: A report on the practise, development and teaching of lettering in Britain this century* (Crafts Study Centre 1982)

Petroski, H., *The Pencil: A History of Design and Circumstance* (Alfred Knopf 1990)

Reed, T. B., *A History of the Old English Letter Foundries: A new edition revised and enlarged by A. F. Johnson* (1887, Faber & Faber 1952)

Roberts, A. (ed.), *Mendip Annals, or a Narrative of the Charitable Labours of Hannah and Martha More, being The Journal of Martha More* (Nisbet 1859)

Rowe More, E., *A dissertation upon English typographical founders and founderies –* 1778 (OUP 1962)

Sanderson, M., 'Literacy and Social Mobility in the Industrial Revolution in England', *Past and Present*, 56 (1) (1972)

Senefelder, A., *The Invention of Lithography*, trans. J. Muller (Fuch & Lang 1911)

Schooling, J. H., *Handwriting and Expression* (Kegan Paul, Trench, Trübner & Co. 1892)

Smith, W., *Advertising When? Where? How?* (Routledge, Warne, and Routledge 1863)

Standard, P., *Calligraphy's Flowering, Decay, & Restauration, with hints for its wider use today* (Crowell 1948, Pentalic 1978)

Steinberg, S. H., *Five Hundred Years of Printing* (Faber & Faber 1959)

Thornton, T. P., *Handwriting in America* (Yale 1996)

Twyman, M., *Printing 1770–1970* (Eyre and Spottiswoode 1970)

Twyman, M., 'Textbook design: chronological tables and the use of typographic cueing', *Paradigm*, no. 4 (1990)

Walker, S., 'How Typewriters Changed Correspondence: An Analysis of Prescription and Practice', *Visible Language*, vol. 18 (1984)

Yasuoka, K. & Yasuoka, M., 'On The Pre-history of QWERTY', *Zinbun*, no. 42 (2011)

Yates, J., *Control through Communication: The Rise of System in American Management* (John Hopkins University 1993)

The Modern Era

Argetsinger, M., *Thinking in Script: A Letter of Thanks from Edward Johnston to Paul Standard* (RIT 1997)

Austin, L. J., 'Mallarmé on music and letters', Bulletin of the John Rylands Library, 42 (1) (1959)

Baines, P., *Penguin by Design: A Cover Story 1935–2005* (Allen Lane 2005)

Baines, P., 'Changing the world', in *Edward Johnston: Lettering and Life*, ed. E. Clayton (Ditchling Museum 2007)

Baudin, F. & Dreyfuss J., *Dossier A to Z* (ATypI 1973)

Bent Flyvbjerg, B. & Budzier, A., 'Why your IT project may be riskier than you think', *Harvard Business Review*, 89 (9) (2011)

Berners Lee, T. and Fischetti, M., *Weaving the Web* (Harper 1999)

Betts, P., *The Authority of Everyday Objects* (University of California Press 2004)

Bigelow, C. & Day, D., 'Digital Typography', *Scientific American* (August 1983)

Bigelow, C. & Ruggles, L. (eds), 'The Computer and the Hand in Type Design', *Visible Language*, XIX (1985)

Billeter, J. F., *The Chinese Art of Writing* (Skira 1990)

Caflisch, M., *Typography needs Type* (ATypI 1977)

Calderhead, C., *Illuminating the Word* (Liturgical Press 2005)

Carr, N., *The Big Switch: Rewiring the World, from Edison to Google* (Norton 2008)

Carter, S., *Twentieth Century Type Designers* (Trefoil 1987)

Child, H., Collins, H., Hechle, A. & Jackson, D., *More than Fine Writing: Irene Wellington, Calligrapher* (Pelham 1986)

Cinamon, G., *Rudolf Koch* (British Library 2000)

Clayton, E., 'Calligraphy and Lettering in the UK', *Crafts Study Centre Essays for the Opening* (Canterton 2004)

Clayton, E., 'The Inscriptions of David Jones', in *David Jones, Diversity in Unity*, eds B. Humfrey, & A. Price-Owen (University of Wales Press 2000)

Clayton, E. & Fleuss, G., *Font: Sumner Stone, Calligraphy and Type Design in a Digital Age* (Ditchling Museum 2000)

Clayton, E., 'Eight photographs of blackboard demonstrations by Edward Johnston, 1926', *Matrix*, 26 (2005)

Clayton, E. (ed.), *Edward Johnston: Lettering and Life* (Ditchling Museum 2007)

Cobden-Sanderson, T. J., *Ecce Mundus Industrial Ideals & The Book Beautiful* (Hammersmith Publishing Society 1892)

Cobden-Sanderson, T. J., 'The Three-fold Purpose of the Doves Press', in *Catalogue Raisonné* (Doves Press 1908)

David, M., *Scrolling Forward: Making Sense of Documents in the Digital Age* (Arcade 2001)

Dearden, J. S., 'John Ruskin, the Collector: With a Catalogue of the Illuminated and Other Manuscripts formerly in his Collection', *The Library*, s5-XXI (1966)

Die Zeitgemäße Schrift, issue 38 (Heintze & Blanckertz 1936)

Dreyfus, J., 'New Light on the Designs for the Kelmscott and Doves Presses', *The Library*, s5-XXIX (1974)

Dreyfus, J., *Morris and the Printed Book: A reconsideration of his views on type and book design in the light of later computer-aided techniques* (William Morris Society 1989)

Dreyfus, J., 'Emery Walker: A Victorian Champion of Chancery Italic', in *Calligraphy and Paleography, Essays presented to Alfred Fairbank* (Faber & Faber 1965)

Dreyfus, J., 'Emery Walker's 1888 lecture on "Letterpress Printing": A Reconstruction and a Reconsideration', *Craft History One* (Combined Arts 1988)

Fern, A., 'The Count and the Calligrapher', in *Apollo*, vol. 79, no. 25 (1964)

Fleuss, G., *Tom Perkins* (Calligraphic Enterprises 1998)

Flint Sato, C., *Japanese Calligraphy: The Art of Line and Space* (Mitsuru Sakui 1999)

Frayling, C., *The Royal College of Art: 150 years of Art and Design* (Barrie & Jenkins 1987)

Frazer, H. & Oestreicher, C., *The Art of Remembering* (Carcarnet 1998)

Gill, E., *An Essay on Typography* (1931, Sheed & Ward 1936)

Gleick, J., *The Information* (Fourth Estate 2011)

Gourhan, L., *Gesture and Speech* (MIT Press 1993)

Gray, M. & Armstrong, R., *Lettering for Architects and Designers* (Batsford 1962)

Gray, N., *The Painted Inscriptions of David Jones* (Fraser 1981)

Gunderson, W. & Lehman, C., *The Calligraphy of Lloyd Reynolds* (Oregon Historical Society 1988)

Haffner, K. & Lyon, M., *Where Wizards Stay Up Late: The Origins of the Internet* (Touchstone 1996)

Halbey, H., *Rudo Spemann 1905–1947: Monographie und Werkverzeichnis Seiner Schriftkunst* (Klingspor Museum 1981)

Harling, R., *The Letter Forms and Type Designs of Eric Gill* (Svennson 1976, rev. 1978, 1979)

Harrod, T., *The Crafts in Britain in the Twentieth Century* (Yale 1999)

Harrop, D., *Sir Emery Walker* (Nine Elms 1986)

Herzfeld, A., *Revolution in The Valley* (O'Reilly 2004)

Hochuli, J. and Kinross, R., *Designing Books: Practise and Theory* (Hyphen Press 1996)

Holme, C. G. (ed.), *Lettering of Today* (Studio 1937, 1941)

Howes, J., *Johnston's Underground Type* (Capital Transport 2000)

Hunt, J. D., Lomas, D. & Corris, M., *Art, Word and Image* (Reaktion 2010)

Ichiro, H., 'The History and present status of Japanese Calligraphy', *Eloquent Line* (International Sculpture Centre 1993)

Ingold, T., *The Perception of the Environment: Essays in Livelihood, Dwelling and Skill* (Routledge 2000)

Ingold, T., *Lines: A Brief History* (Routledge 2007)

Ishikawa, K., *Taction: The Drama of the Stylus in Oriental Calligraphy* (International House Press 2011)

Jackson, D., *The St. John's Bible*, vols 1–7 (The Liturgical Press 2005–12)

Johnston, E., 'A statement by E. Johnston as to the pens and copybooks submitted to him by Dr. Garnett for the LCC Education Committee Books and Apparatus Sub-Committee', *Report of the Books and Apparatus Sub-Committee* (1906)

Johnston, E., *Formal Penmanship and other papers*, ed. H. Child (Lund Humphries 1971)

Johnston, E., *Lessons in Formal Writing*, eds H. Child & J. Howes (Lund Humphries 1986)

Johnston, P., *Edward Johnston* (Faber & Faber 1959)

Johnstone, W., 'Graphic Design at the Central School', *Penrose Annual*, 49 (1953)

Karow, P., *Digital Formats for Typefaces* (URW 1988)

Kindersley, D., *Optical Letter Spacing for New Printing Systems* (Wynkyn de Worde Soc. 1966, 1976)

Kindersley, R. & Jennings, M., *Architectural Lettering: A Reassessment* (Royal Inst. British Architects 1981)

Kinnier, J., *Words and Buildings: The art and practice of public lettering* (Architectural Press 1980)

Kinross, R., *Modern Typography* (Hyphen Press 1992)

Lange, W. H., *Rudolf Koch ein Deutscher Schreibmeister* (Heintze & Blanckerzt 1938)

Larisch, R. von, *Unterricht in ornamentaler Schrift* (1904, Elfte Veranderte Auflage 1934)

Lavendel, G. (ed.), *A Decade of Research from PARC 1970–1980* (Bowker 1980)

Lévi-Strauss, C., *Tristes Tropiques*, trans. D. Weightman & J. Weightman (Atheneum 1974)

Levy, D., 'Fixed or Fluid?: Document stability and new media', *Proceedings of the 1994 ACM European Conference on Hypermedia* (ACM 1994)

Lawson, A., *Anatomy of a Typeface* (Hamish Hamilton, David Godine 1990)

Lewery, A. J., *Signwritten Art* (David & Charles 1989)

Lewis-Williams, D. & Pearce, D., *Inside the Neolithic Mind* (Thames and Hudson 2005)

Lewisohn, C., *Street Art: The Graffiti Revolution* (Tate 2008)

Licklider, J. C. R. & Albert Vezza, A., 'Applications of Information Networks', in *Proceedings of the IEEE*, vol. 66 (11) (1978)

Licklider, J. C. R. & Robert Taylor, R., 'The Computer as a Communication Device', in *Science and Technology: For the Technical Men in Management*, no. 76 (1968)

Loftie, Rev. W. J., *Lessons in the Art of Illuminating: A Series of Examples selected from works in the British Museum, Lambeth Palace Library, and the South Kensington Museum* (Blackie and Son 1885)

Lorca, F. G., 'Theory and Function of the Duende', in *Frederico Garcia Lorca, Selected Poems*, trans. M. Williams (Bloodaxe 1992)

Mai, M. & Remke, A., *Urban Calligraphy and Beyond* (Die Gestalten Verlag 2003)

Marinetti, F. T., 'Destruction of Syntax – Imagination without Strings – Words-in-Freedom' (1913), in *Futurist Manifestos*, ed. U. Apollonio (MFA publications 2001)

McCombie, E., *Stéphane Mallarmé, Collected Poems and Other Verse*, trans. E. H. and A. M. Blackmore (OUP 2006)

McLean, R., *Jan Tschichold: Typographer* (Godine 1975)

McWilliams, M. & Roxburgh, D., *Traces of the Calligrapher: Islamic Calligraphy in Practice, c.1600–1900* (Museum of Fine Art, Houston 2007)

Miles, J. & Shiel, D., *David Jones: The Maker Unmade* (Seren 1995)

Miner, D. E., Carlson, V. I. & Filby, P. W., *Two Thousand Years of Calligraphy* (Walters Art Gallery 1965, Muller 1972)

Moholy-Nagy, L., 'Typophoto', in *Looking Closer 3: Classic writings on graphic design*, ed. M. Bierut (1925, Allworth 1999)

Nash, J. R., 'English Brush Lettering, the Workshop of William Sharpington', *The Scribe*, no. 45 (1989)

Neuenschwander, B., *Letterwork: Creative Letterforms in Graphic Design* (Phaidon 1993)

Neuenschwander, B., *Textasy* (Toohcsmi 2006)

Nunberg, G., *The Places of Books* (Representations 1993)

Owens, L. T., *J. H. Mason 1875–1951: Scholar-Printer* (Muller 1976)

Perkins, T., 'Calligraphy as a basis for Letterdesign', in *The Calligrapher's Handbook*, ed. H. Child (A&C Black 1985)

Prestianni, J. (ed.), *Calligraphic Type Design in the Digital Age* (Ginko 2001)

Reiner, I., *Monograms* (Publix 1947)

Reynolds, L., *Straight Impressions* (TBW Books 1979)

Richardson, J., *A Life of Picasso*, vols I–III (Random House 1991–2007)

Rose, S., 'The School of Graphic Design at the R.C.A.', *Penrose Annual*, 48 (1954)

Ruskin, J., *The Stones of Venice* (1853)

Sassoon, R., *Handwriting of the Twentieth Century* (Intellect Books 2007)

Schmidt, H., *Vom Linearen zum Voluminösen* (Klingspor Museum 2008)

Schreuders, P., *The Book of Paperbacks: A visual history of the paperback book* (Virgin 1981)

Sennet, R., *The Craftsman* (Allen Lane 2008)

Shahn, B., *Love and Joy about Letters* (Cory Adams and Mackay 1964)

Shaw, M., *David Kindersley: His Work & Workshop* (Cardozo Kindersley 1989)

Shiel, D., 'David Jones: Making Space for the Warring Factions', *Diversity in Unity*, eds. B. Humfrey & A. Price-Owen (University of Wales Press 2000)

Shinoda, T., 'Sumi Infinity', in *Kateigaho International Edition*, trans. E. Seidensticker, (Autumn 2003)

Shōnagon, S., *The Pillow Book*, trans. M. McKinney (Penguin 2006)

Skelton, J., 'Memories of Herbert Joseph Cribb', *Eric Gill & the Guild of St. Joseph and St. Dominic* (Hove Museum & Art Gallery 1990)

Smith, D. & Alexander, R., *Fumbling the Future: How Xerox invented, and then ignored, the first personal computer* (iUniverse 1999)

Smith, P. J. D., *Civic and Memorial Lettering* (A&C Black 1946)

Southall, R., *Printer's Type in the Twentieth Century* (Oak Knoll 2005)

Sparrow, J., *Visible Word: A Study of Inscriptions in and as Books and Works of Art* (CUP 1969)

Speight, R., *The Life of Eric Gill* (Methuen 1966)

Spencer, H., *Pioneers of Modern Typography* (Lund Humphries 1969, 1982)

Starr, S. L. & Strauss, A., 'Layers of Silence, Arenas of Voice: The Ecology of Visible and Invisible Work', *Computer Supported Cooperative Work*, 8: 9–30 (1999)

Stern, D., *Forms of Vitality* (OUP 2010)

Stern, D., *The Interpersonal World of the Infant* (Basic Books 1985)

Stern, D., *The Present Moment in Psychotherapy and Everyday Life* (Norton 2004)

Stone, S., *Typography on the Personal Computer* (Lund Humphries 1991)

Strand, R., *A Good Deal of Freedom: Art and Design in the public sector of higher education 1960–1982* (CNAA 1987)

Suchman, L., *Human-Machine Reconfigurations: Plans and Situated Actions*, 2nd edn (CUP 2007)

Tanahashi, K., *Brush Mind* (Parallax 1990)

Thomas, F., 'Une question de writing', *Improving Schools* (March 1998)

Tidcombe, M., *The Doves Press* (The British Library / Oak Knoll 2002)

Ting Wen-chün, *Essential Principles of Calligraphy* (1938, Chung-kuo shu-tien 1983)

Turner, F., *From Counter Culture to Cyberculture* (UCP 2006)

Uyehara, C. H., 'The Origins and Evolution of Japanese Calligraphy', *Eloquent Line* (International Sculpture Centre 1993)

Varnedoe, K. & Gopnik, A., *High & Low: Modern Art & Popular Culture* (Museum of Modern Art 1991)

Weaver, W., in 'Recent Contributions to the Mathematical Theory of Communication', in Shannon & Weaver, *Mathematical Theory* (University of Illinois 1949)

Yanagi, S., *The Unknown Craftsman: A Japanese Insight into Beauty* (Kodansha 1972)

Zapf, H., *Herman Zapf and His Design Philosophy* (Soc. of Typographic Arts Chicago 1989)

Zapf, H., *Alphabet Stories* (Mergenthaler, RIT 2007)

Current Practice in Handwriting, Calligraphy and Lettering

Andersch, M., *Symbols, Signs, Letters* (Design Press 1989)

Anderson, D. M., *The Art of Written Forms: The Theory & Practise of Calligraphy* (Holt, Rinehart & Winston 1969)

Angel, M., *Painting for Calligraphers* (Pelham 1984)

Benson, J. H. & Carey, A. G., *The Elements of Lettering* (McGraw-Hill, 1940, 1950)

Brown, N. & Sink, A., *Inks and Pigments, Parts 1–3, Alphabet* (Summer and Fall 1983, Spring 1984)

Burman, P. & Stapleton, Very Rev. H. (eds), *The Churchyards Handbook* (Council for the Care of Churches 1988)

Camp, A., *Pen Lettering* (Dryad 1958, A & C Black 1984)

Campedelli, M., *Applied Calligraphy and Graphic Design* (Links 2010)

Calderhead, C., *Calligraphy Studio* (Sterling 2012)

Chappel, W., *The Little ABC Book of Rudolf Koch* (Stemple 1939, Godine 1976)

Clayton, E., *The Calligraphy of the Heart* (Gilbert 1996, Lorini Artigrafiche 2011)

Drogin, M., *Medieval Calligraphy: Its History and Techniques* (Allanheld & Schram 1980)

Fairbank, A., *A Handwriting Manual* (Dryad 1932, Faber & Faber 1978)

Fisher, M. T., 'Ink', *The Calligrapher's Handbook*, ed. H. Child (A&C Black 1985)

Gardener, W., *Alphabet at Work* (A & C Black 1982)

Goudy, F., *The Alphabet and Elements of Lettering* (first published 1908, Bracken 1989)

Gourdie, T., *Handwriting for Today* (Pitman 1971)

Grasby, R., *Lettercutting in Stone* (Anthony Nelson 1989)

Harvey, M., *Creative Lettering, Drawing and Design* (Bodley Head 1985)

Harvey, M., *Carving Letters in Stone and Wood* (Bodley Head 1987)

Hewitt, G., *Lettering* (Seeley Service 1930)

Hufton, S., *Step-by-step Calligraphy* (Weidenfeld and Nicholson 1995)

Hutton, D., 'Pigments and Media', *The Calligrapher's Handbook*, ed. H. Child (A&C Black 1985)

Ingmire, T., *Codici I* (Scriptorium of St Francis 2003)

Jackson, D., 'Preparation of Quills and Reeds', *The Calligrapher's Handbook*, ed. H. Child (A&C Black 1985)

Jackson, D., 'Gilding', *The Calligrapher's Handbook*, ed. H. Child (A&C Black 1985)

Johnston, E., *Writing and Illuminating, and Lettering* (Hogg 1906, later editions Pitman, A&C Black, Dover)

Johnston, E., *Formal Penmanship & Other Papers*, ed. H. Child (Lund Humphries 1971)

Kindersley, D. & Lopes Cardozo, L., *Letters Slate Cut* (Kindersley & Lopes-Cardozo 1990)

Lamb, C. M., *The Calligrapher's Handbook* (Faber & Faber 1956)

Middleton, R., 'The Physical Properties of Steel Nibs', *The Scribe*, no. 58 (1993)

Neugebauer, F., *The Mystic Art of Written Forms* (Neugebauer Press 1980)

Peace, D., *Glass Engraving: Lettering and Design* (Batsford 1985)

Pearce, C., *The Little Manual of Calligraphy* (Taplinger 1981, Collins 1982)

Perkins, T., *The Art of Letter Carving in Stone* (Crowood 2007)

Reynolds, L. J., 'Notes on Movement involving Touch', *Calligraphy and Paleography*, ed. A. S. Osley (Faber & Faber 1965)

Russell, P., *Lettering for Embroidery* (Batsford 1971, 1985)

Sasson, R., *Handwriting: A new perspective* (Stanley Thornes 1990)

Somerville, S., 'Parchment and Vellum', *The Calligrapher's Handbook*, ed. H. Child (A&C Black 1985)

Stewart, B., *Signwork: A Craftsman's Manual* (Granada 1984)

Turner, S., & Skiold, B., *Handmade Paper Today* (Lund Humphries 1983)

Waters, S., *Foundations of Calligraphy* (John Neal 2006)

Wellington, I., *The Irene Wellington Copy Book*, Omnibus Edition (1957, Taplinger/Pentalic 1983)

Wenham, M., 'Simple Letter-Cutting in Wood', *The Scribe*, no. 31, (1984)

West, S., *Working with Style: Traditional and modern approaches to layout and typography* (Watson-Guptill 1990)

Acknowledgments

A book such as this is formed over a long period. I owe a debt of gratitude to many people for encouraging me in this specialized interest – most of all to my family. I was fortunate to grow up near an extraordinary village, Ditchling in Sussex. I found support there from my teenage years from those who commissioned work from me: my godmother Joy Sinden, the Bourne sisters Joanna, Hilary and Marjorie Broadbent, Grace Denman and my fellow members of the Ditchling Handworkers Guild. I am also grateful to Priscilla Johnston and Irene Wellington for the confidence they placed in me at an early age and Professor Julian Brown, who gave me the gift of attending all his paleography lectures and seminars as a 'craft' observer for a year. Donald Bullough, at the University of St Andrews, nurtured my love of the study of original documentary material. Back in Ditchling I joined the Guild of St Joseph and St Dominic founded by Eric Gill and Hilary Pepler. I owe my perspective on the value of 'making' as a way of being in the world to the members of that Guild, to Tom Phelan of the Rennselear Polytechnic Institute and to my perceptive calligraphy teacher, Ann Camp. I am grateful that she always asked me what my intentions were for a project, rather than told me how to do it.

Of direct help in the making of this book have been those who generously read portions of the work and gave me their comments: Stan Knight, David Levy, Sumner Stone, Lucy Suchman and Stephen Tracy. I hasten to add that any faults in the text are wholly mine. Also helpful with advice were Jerry Cinamon, Michela Antonello, Mari Bohley, Andrew and Angela Johnston, John Neilson, Brody Neuenschwander, Lieve Cornil, Mike Pratley, Lisa Perkins, Hilary Williams and several generations of staff at Ditchling Museum. Manny Ling and the staff at the University of Sunderland have been generous beyond expectations in the time they have allowed me for this project. A big thank you

to Marcia Freidman who ensured I backed everything up – two Macs burned out by the end of the writing.

The mental and physical effort involved in writing was made easier by Sue Hartridge with innumerable acts of kindness and practical assistance, and by Ashok Jansari who was unfailingly encouraging whenever my energy flagged. It was with Ash, in the house of his friends Alessandro Paoli and Paola Bonardo, that I began this book; I cannot think of a better beginning. My brother Mathew, who has acted as my agent, has contributed a vital creative impulse to the project from beginning to end, and thank you for suggesting it, Mathew. My two editors Richard Milbank and James Nightingale have been a dream to work with – thanks to Richard who had the unenviable job of taming my enthusiasms and getting me to think of structure. Mike Hales was also of immense assistance here – I hope our monthly coffees at the bandstand café on Brighton seafront continue! Most especially, however, I have two debts of gratitude – to all the students and colleagues who have ever asked me questions and to my friend David Levy. David it was who drew me out to Xerox PARC; our conversation on these matters has now extended over several decades and has been a constant source of revelation and delight.

Illustrations

Index

Page numbers in *italics* refers to an illustration

Newport Library and
Information Service

24/3/15